Early Valley Treasures

As Seen through the Lens of "Pop" Laval

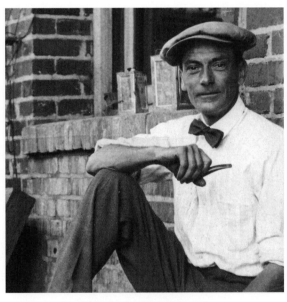

Claude C. "Pop" Laval

Elizabeth M. Laval

with William J. Conway, Jr.
Stephen L. Brown, Photographic Editor

Word Dancer Press

Sanger, California

Published by

Word Dancer Press
1831 Industrial Way, Ste. 101
Sanger, CA 93657
1-800-497-4909
QuillDriverBooks.com

Word Dancer Press titles may be purchased in quantity at special discounts for educational, fund-raising, business, or promotional use. Please contact Special Markets, Quill Driver Books/Word Dancer Press, Inc., at the above address, toll-free at 1-800-497-4909 or by e-mail: Info@QuillDriverBooks.com

WORD DANCER PRESS and colophon are trademarks of Quill Driver Books/Word Dancer Press, Inc.

Printed in the United States of America
ISBN 884995-47-0

First printing

Quill Driver Books/Word Dancer Press, Inc. project cadre:
Mary Ann Gardner, Stephen Blake Mettee

For Constant and "Pop," Claude, Jr. and Jerry

May those who are destined yet to follow possess the spiritual prescience to recognize the majesty of the treasure you have bestowed upon them and the relentless conviction to eternally nurture and cherish your precious legacy.

I called upon the ones that came before us, angels all,
This treasure's much too heavy, from my shoulders it may fall
Your whispers laid the path on which we strive now to prevail
With gentle hands please guide us on this task, we cannot fail

True treasure cannot be bought or sold
Timeless value, more than gems or gold
Begotten by a vision, bold
This priceless gift we now behold

The Laval Family Trust is ever-grateful to Stephen L. Brown and William J. Conway, Jr.
A Promise Fulfilled, A Friendship Honored, Eikyu Aite

Front dust jacket photograph: Bicycles, trolley cars, horse-drawn wagons, pedestrians, and automobiles all share Fresno's Van Ness Avenue on a vibrant, yet normal weekday. Circa 1913.

Library of Congress Cataloging-in-Publication Data

Laval, Claude C., 1882-1966.
 Early valley treasures : as seen through the lens of Claude C. "Pop" Laval / [compiled] by Elizabeth M. Laval ; research & photographic editor, Stephen L. Brown ; contributing author, William J. Conway, Jr.
 p. cm.
 ISBN 1-884995-47-0
 1. Fresno Region (Calif.)—History—20th century—Pictorial works. 2. Fresno Region (Calif.)—Social life and customs—20th century—Pictorial works. 3. San Joaquin Valley (Calif.)—History—20th century—Pictorial works. 4. San Joaquin Valley (Calif.)—Social life and customs—20th century—Pictorial works. I. Laval, Elizabeth M. II. Brown, Stephen L. III. Conway, William J. IV. Title.

F869.F8L385 2005
979.4'83053—dc22
 2004024887

Contents

Foreword

*T*he history of a community is preserved in three ways—through oral narratives, the written word, and visual images. Of these three, it is the visual images that provide the greatest impact. Photographs bring a sense of immediacy to the viewer. Suddenly, the past is alive—people can be seen on the streets of a city going about their lives. They may be dressed differently, the streets may not be paved, horses may be seen instead of cars.

Photographs allow us to preserve, in a sense, the historical architecture of our community. Buildings, long since gone, appear to us in photographs. Their architectural details can be appreciated once more. For the few moments we view them, they exist again. A photograph may show the site the building occupied on a particular block, helping the historian to recreate a neighborhood or section of a city's historic downtown. Photographs can help to document costumes, events, and even some of the social mores of a period in history. The photographer plays an important role in capturing the essence of a city.

Fresno has been blessed to have had talented photographers in its midst. The earliest photos of the pioneer city of Fresno were taken by Roderick W. Riggs. If it had not been for his use of the camera, we might not know what the first frame house looked like, we might not have portraits of many of the early pioneers, and we might not have a tangible record of the earliest streetscapes of our city. Other photographers followed—notably, E.R. Higgins, Maxwell & Mudge, and H.H. Alexander.

The arrival of photographer Claude C. "Pop" Laval in Fresno in 1911, marked the beginning of a commercial photography career that would span fifty-five years. During this time "Pop" Laval took pictures

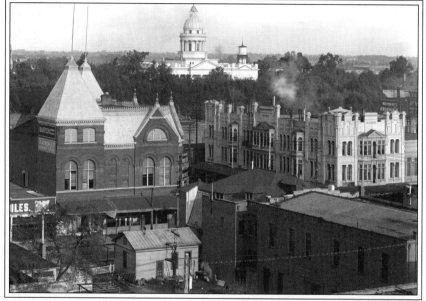

Circa 1913, looking across the intersection of Fulton and Fresno Streets, framed the courthouse cupola between the Barton Opera House on the left and the Helm Block Building to the right.

of mountains, crops, businesses, streetcars, presidents, streetscapes, and ordinary people. Although his photos of Fresno comprised the largest part of his work, he also covered other Valley communities from Stockton to Bakersfield. At the time of his death, in 1966, he left a body of photographic work that is priceless. He left a photographic record of Fresno that covered the years of Fresno's greatest growth.

In 1975, Jerome Laval honored his grandfather's legacy by publishing the first volume of *As "Pop" Saw It*, a book containing many of "Pop's" photos. More volumes followed. After Jerry's death, the photograph collection became part of the Laval Family Trust administered by Elizabeth Laval, Jerome Jr., and Jennifer Laval. The Laval photographs have given the people of Fresno and the Valley an opportunity to view their historic community. The popularity of the *As "Pop" Saw It* books attests to the importance of "Pop's" work to the community.

When Elizabeth asked me to write this foreword, I was deeply honored. The Laval family and my family have been friends for three generations. Claude Laval, Sr., and my Uncle Bill were close buddies at Fresno High. Claude's son Jerry was my good friend all my life. We shared an enthusiasm for local history and had hoped to do a project together. *The Heartland's Heritage* book that was published after Jerry's death fulfilled to some extent that dream, but it wasn't the project we had envisioned. Some things are not meant to be. Now Elizabeth's friendship brings us to another generation. Her devotion to the restoration of her great-grandfather's work honors both him and her father. It will also leave an invaluable legacy to the Central Valley.

— Catherine Morison Rehart
Author of *The Valley's Legends & Legacies*

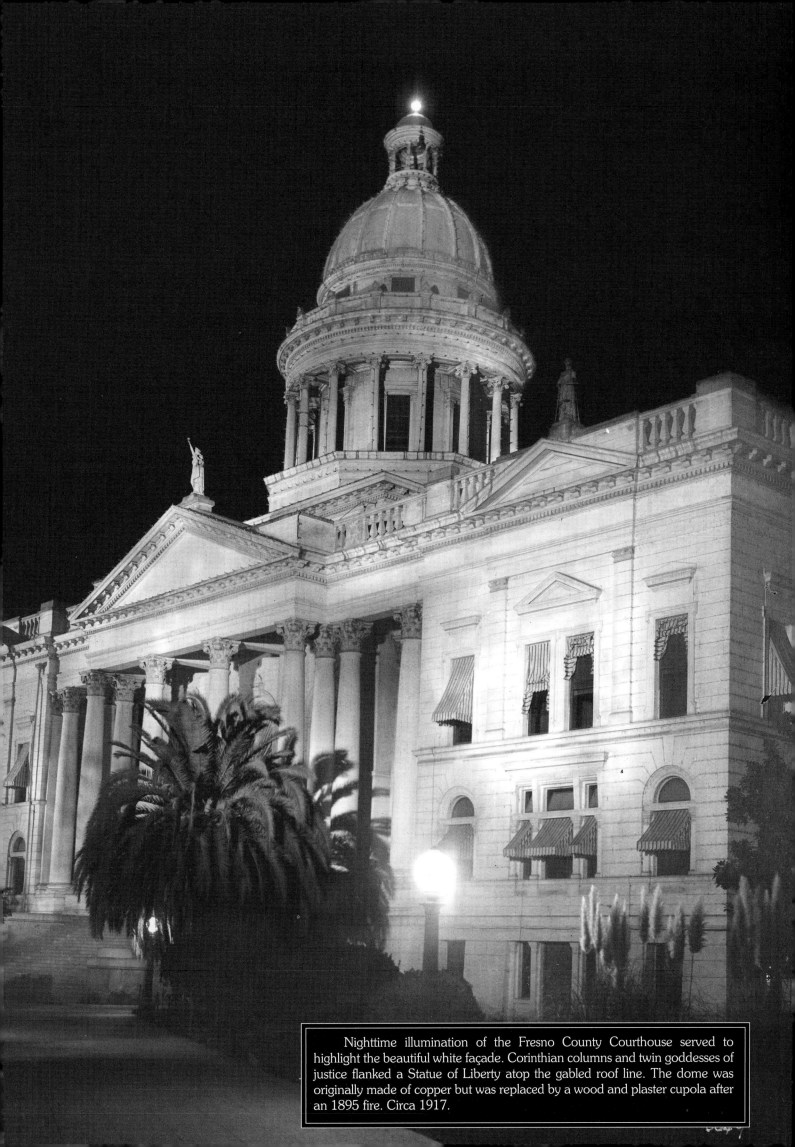

Nighttime illumination of the Fresno County Courthouse served to highlight the beautiful white façade. Corinthian columns and twin goddesses of justice flanked a Statue of Liberty atop the gabled roof line. The dome was originally made of copper but was replaced by a wood and plaster cupola after an 1895 fire. Circa 1917.

Pop Says...

San Joaquin Valley Residents Have Priceless Gift

I have just come in from out of doors to sit down and hunt and peck out my weekly Chit-Chat with all you good folks out there.

It's one of these wonderful days, a` deep blue sky overhead, trimmed here and there with a few fleecy white clouds, and a soft breeze blowing. I couldn't help but look back through the years when back in New York and Pennsylvania, at this time of year, I used to do battle with the elements 'most of the time, trudging along to work in a heavy snow storm, the sidewalks were slippery and sometimes just plain slush, depending on how low the temperature had dropped.

Now I am living out here in the great and wonderful San Joaquin Valley, "God's Country" I call it. Here one can enjoy the fun of frolicking on the snow by simply getting in his car, and in a couple of hours, one can roll in it, toboggan, ski, if you like, and then get back down to the floor of the valley with no discomfort whatsoever.

Just sitting here thinking, with all our problems on our minds, if we ever stop long enough to give thought to the priceless gift we have. We live in this wonderful, fertile San Joaquin Valley with its towering mountains, lakes, waterfalls, and streams, finally reaching the lower foothills, bringing its life-giving moisture to the beautiful orange groves and on down to the floor of the Valley, helping to develop the great vineyards and orchards. And with the help of man, then flowing westwards across what was once arid land covered with sage brush, but now produces vast acreages of cotton and grain.

These are PRICELESS GIFTS that enhance in value as each season rolls around. Priceless because the Man upstairs has seen fit to bestow them upon us. And every night, I get down on my knees and give Him my thanks for the privilege I have enjoyed in spending over 50 Christmases in this wonderful part of the world.

'Bye now, I'll be seeing you.
"Pop"

From *The Fresno Guide*, December 15, 1960

Claude C. "Pop" Laval wrote a column "Pop Says..." for *The Fresno Guide* newspaper in the 1950s and 1960s. A number of the columns are reproduced in this book.

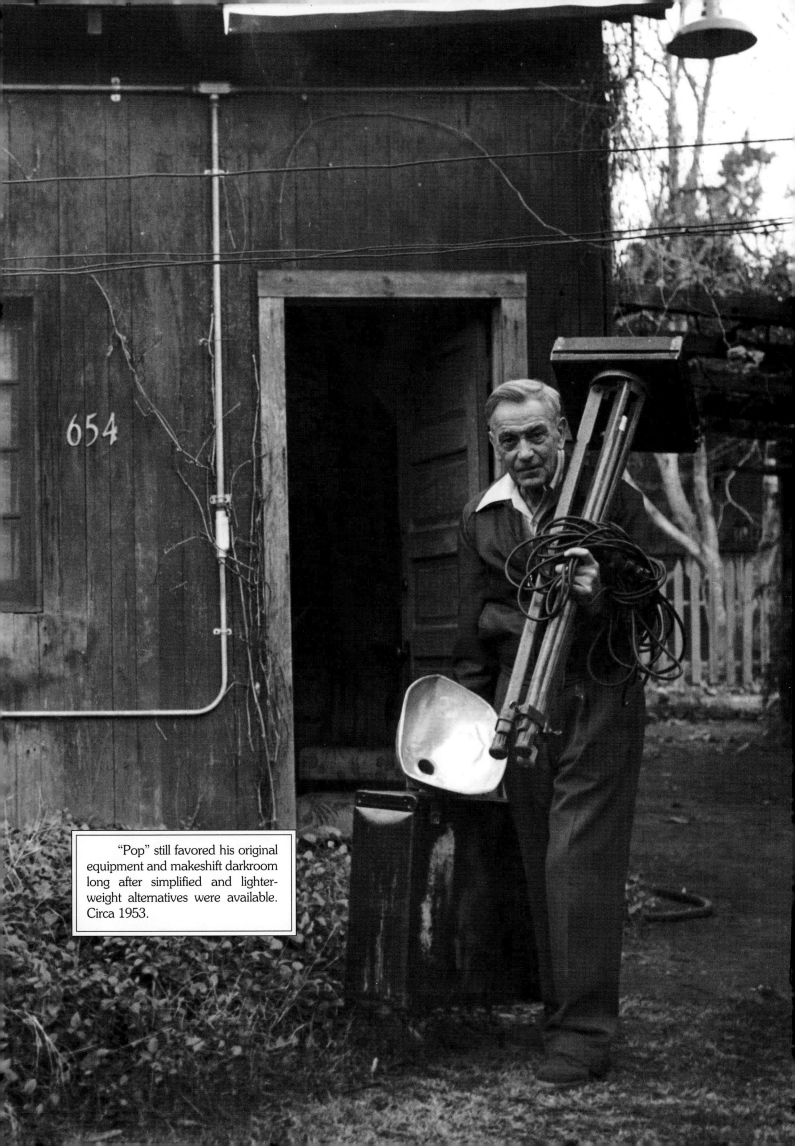

654

"Pop" still favored his original equipment and makeshift darkroom long after simplified and lighter-weight alternatives were available. Circa 1953.

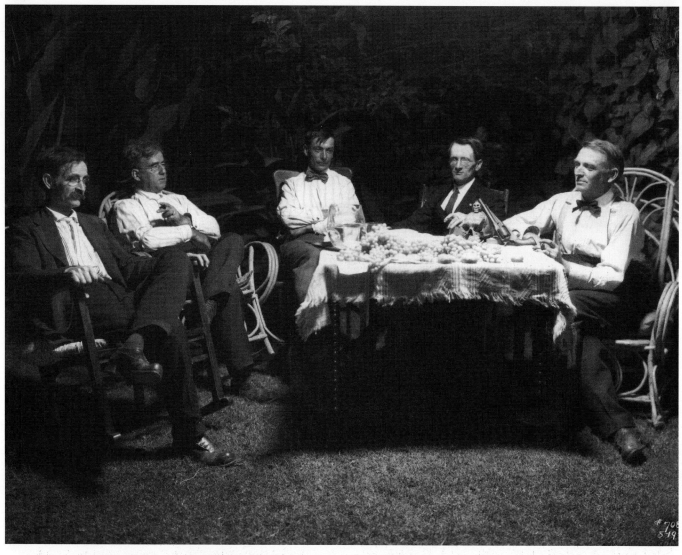

A meeting of the Commercial Photographers' Club. Left to right: Jacob O. Avery, Fred Ninnis, Claude C. "Pop" Laval, James A. G. Brown, John F. Maxwell. August 18, 1918.

\mathcal{M}uch of Fresno's rich photographic heritage is due to the innovative and prodigious efforts of a number of local cameramen. In the early days of the twentieth century, a small band of creators, known as the Commercial Photographers' Club, frequently met to exchange ideas and stories about a profession of which few had any knowledge. The group included Jacob Avery, Fred Ninnis, John Maxwell, James Brown, and "Pop" Laval. It is only because they allowed themselves the luxury of being captured on glass, usually in comedic poses or with a variety of props such as the skull and pistol on the table here, that we even have a visual record of these ingenious characters.

So unlike the business world of today, photographers of a century ago often worked together on projects and even traded negatives. Additionally, in the case of the Laval Company, "Pop" had several partners who eventually donated or sold to him their own negative collections. Therefore, while the vast majority of the body of work known as the "Pop" Laval Photographic Collection was taken by "Pop" himself, his son, Claude, Jr. or one of "Pop's" many employees, there are some images that predate his arrival in Fresno as well.

Although the exact nature of "Pop's" acquisitions are "mysteries of history," the Laval Family Trust is confident that all elements of this collection were procured by the mutual agreement of both camera artists. The trust salutes with gratitude and appreciation the often unnamed endeavors of all those whose images have united to make the "Pop" Laval Photographic Collection the priceless treasure we are striving to preserve.

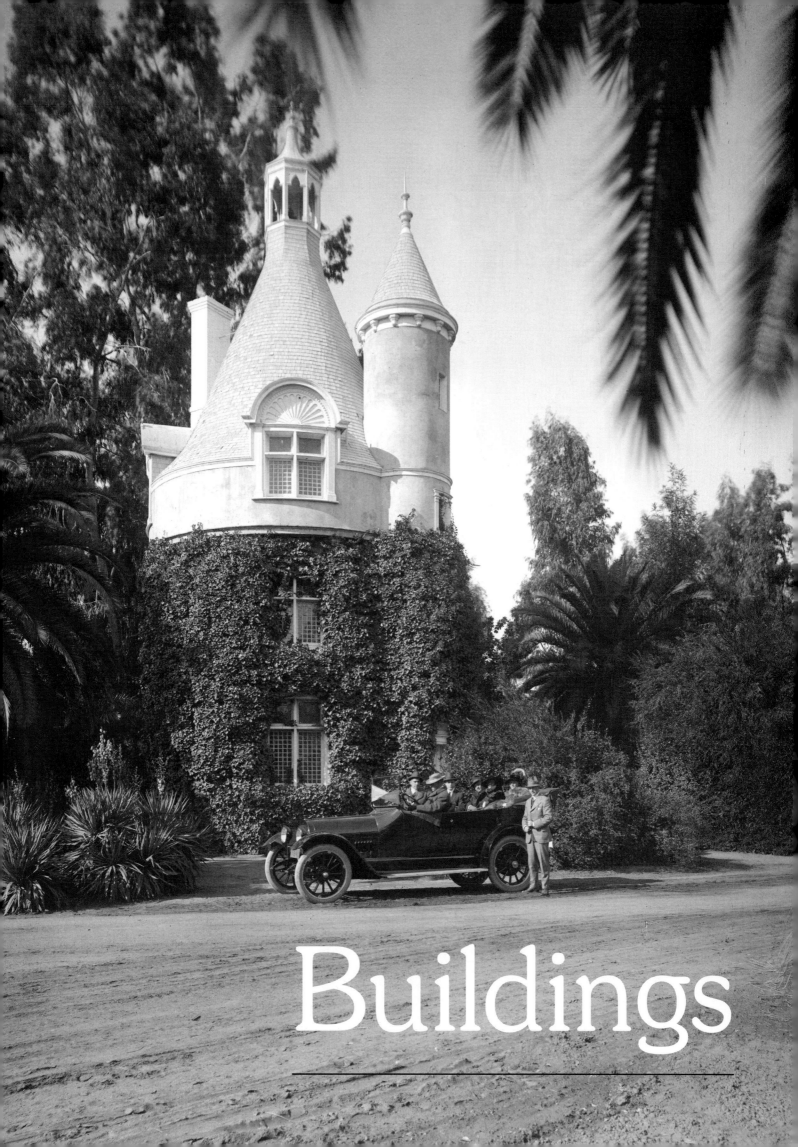

Buildings

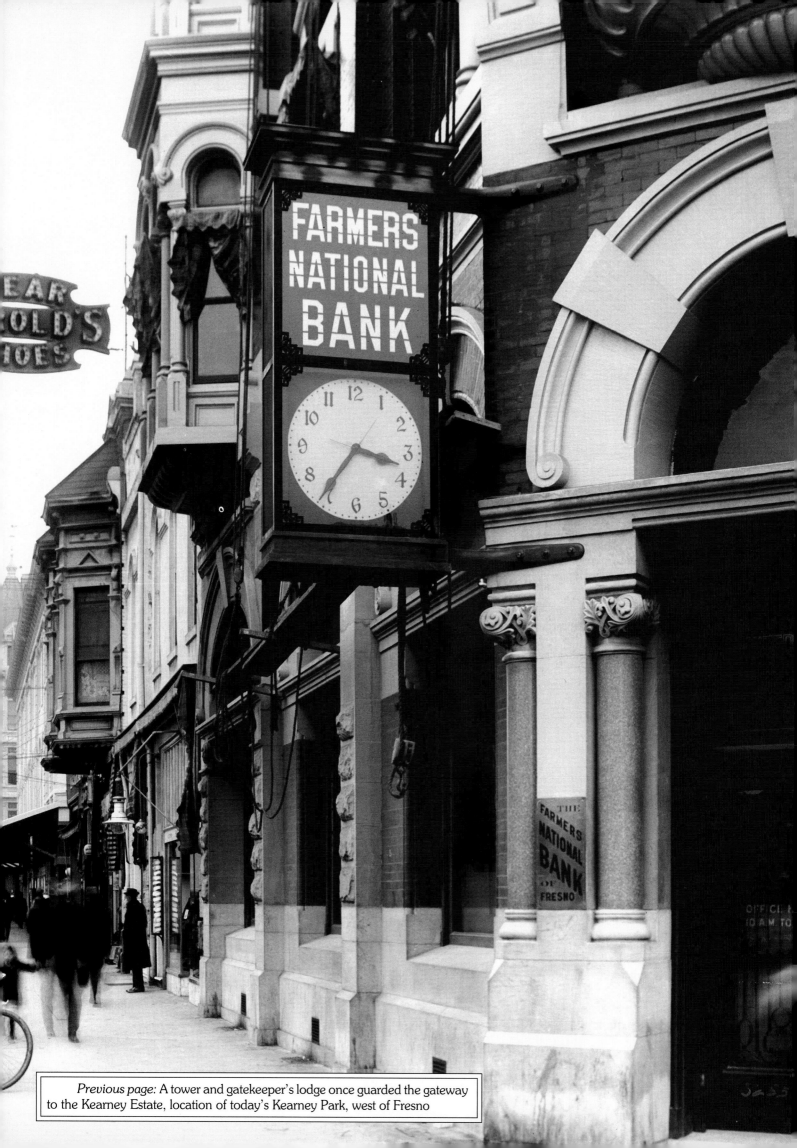

Previous page: A tower and gatekeeper's lodge once guarded the gateway to the Kearney Estate, location of today's Kearney Park, west of Fresno

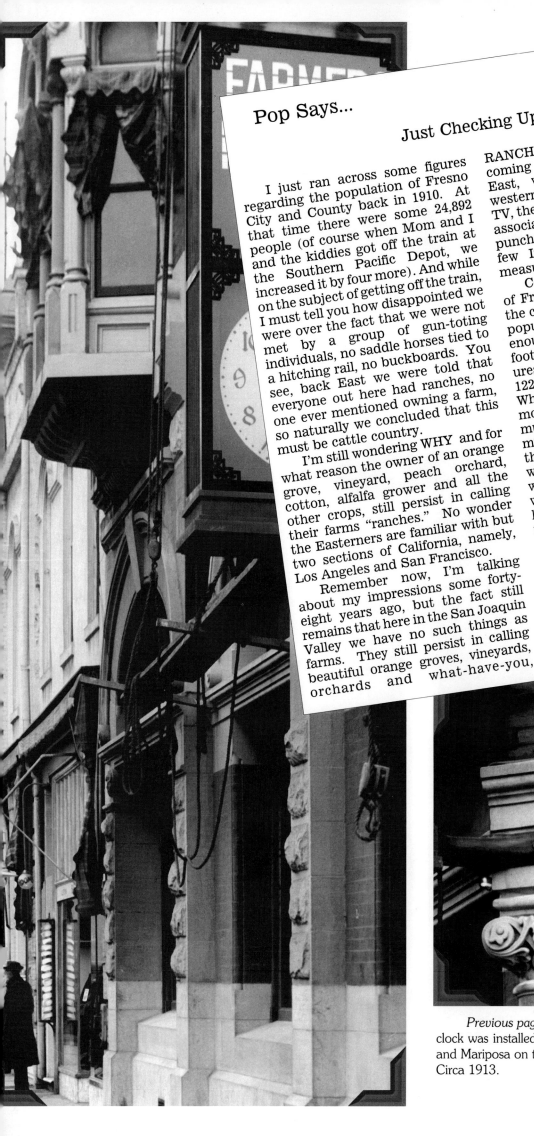

Pop Says...

Just Checking Up

I just ran across some figures regarding the population of Fresno City and County back in 1910. At that time there were some 24,892 people (of course when Mom and I and the kiddies got off the train at the Southern Pacific Depot, we increased it by four more). And while on the subject of getting off the train, I must tell you how disappointed we were over the fact that we were not met by a group of gun-toting individuals, no saddle horses tied to a hitching rail, no buckboards. You see, back East we were told that everyone out here had ranches, no one ever mentioned owning a farm, so naturally we concluded that this must be cattle country.

I'm still wondering WHY and for what reason the owner of an orange grove, vineyard, peach orchard, cotton, alfalfa grower and all the other crops, still persist in calling their farms "ranches." No wonder the Easterners are familiar with but two sections of California, namely, Los Angeles and San Francisco.

Remember now, I'm talking about my impressions some forty-eight years ago, but the fact still remains that here in the San Joaquin Valley we have no such things as farms. They still persist in calling beautiful orange groves, vineyards, orchards and what-have-you,

RANCHES, and to the up and coming younger generation back East, with the help of all the westerns that are showing up now on TV, the name RANCH will be always associated with gun-toting cow punchers and herds of cattle with a few Indians thrown in for good measure.

Coming back to the population of Fresno City in 1910 (24,892) and the county at that time boasted of a population of 75,651—just about enough to fill the Rose Bowl for a football game—now the latest figures for the City of Fresno are 122,944, and for the County, 328,000. Which to my mind should impress most everyone that this city of ours must be a mighty prosperous community to live in, and that goes for the county, too, despite the fact that we still seem to persist in telling the whole cockeyed world that this wonderful agricultural land of ours has been developed by RANCHERS, not farmers

Oh, well, I guess it's all a matter of taste, and speaking of TASTE, as one fellow puts it, "There's no accounting for taste, unless it's the taste of lipstick."

'Bye, now, I'll be seeing you.
"Pop."

From The Fresno Guide, February 20, 1958

Previous page and this page: Fresno's first electric clock was installed in 1913 at the corner of Broadway and Mariposa on the Farmer's National Bank Building. Circa 1913.

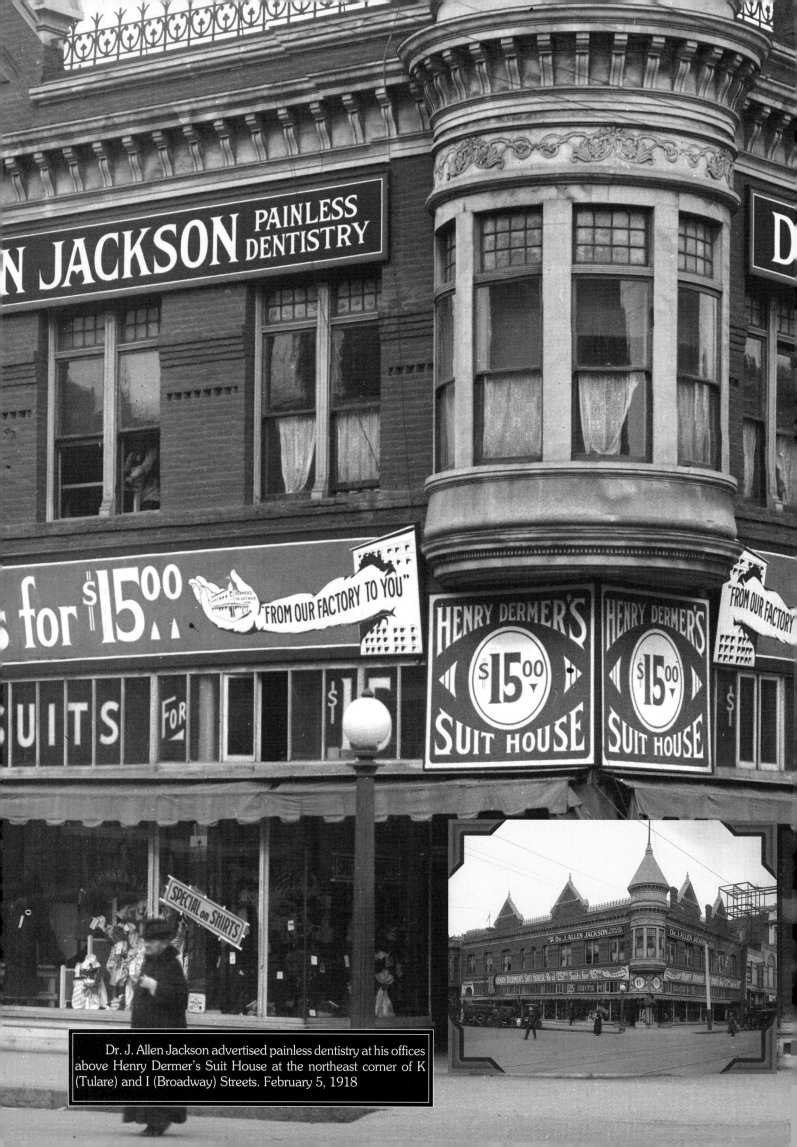

Dr. J. Allen Jackson advertised painless dentistry at his offices above Henry Dermer's Suit House at the northeast corner of K (Tulare) and I (Broadway) Streets. February 5, 1918

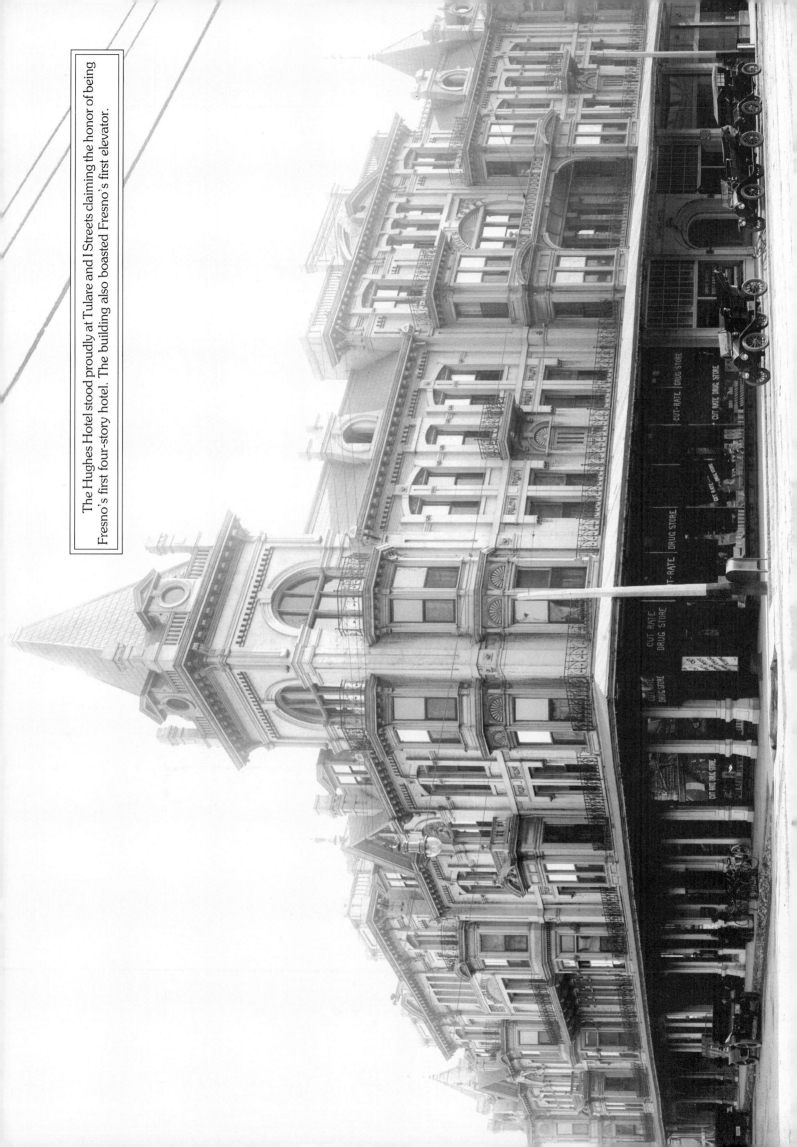

The Hughes Hotel stood proudly at Tulare and I Streets claiming the honor of being Fresno's first four-story hotel. The building also boasted Fresno's first elevator.

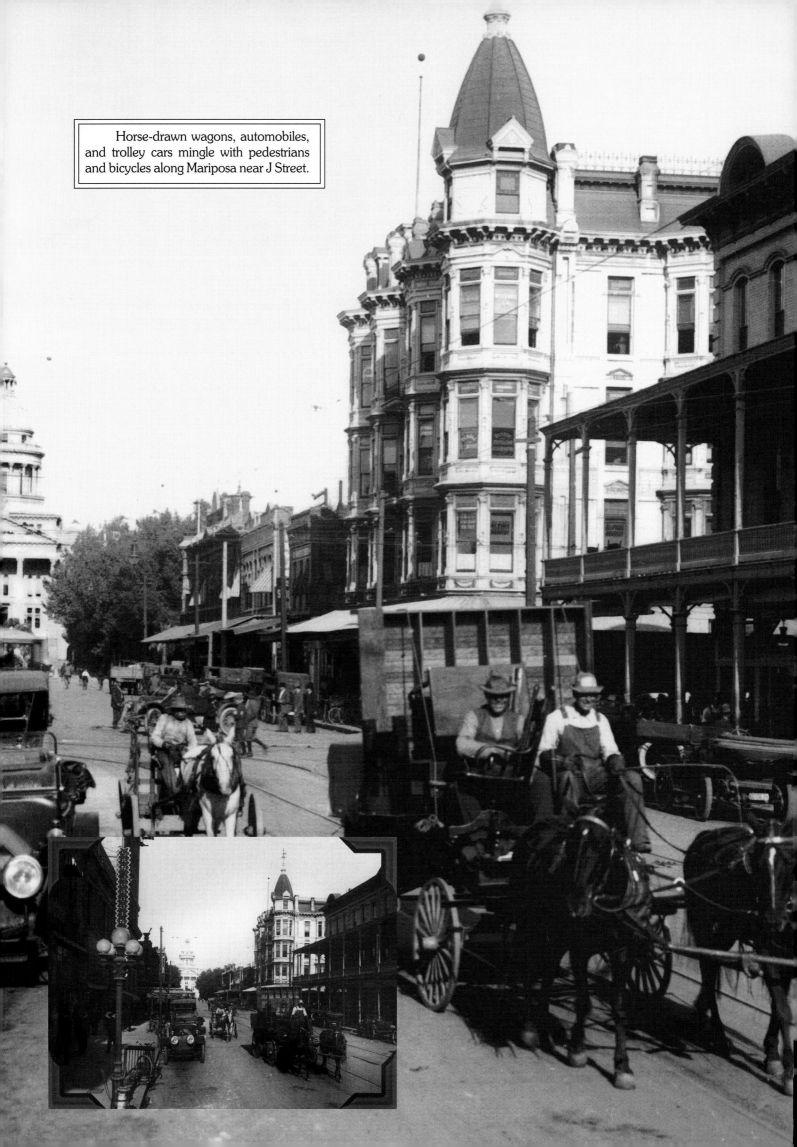

Horse-drawn wagons, automobiles, and trolley cars mingle with pedestrians and bicycles along Mariposa near J Street.

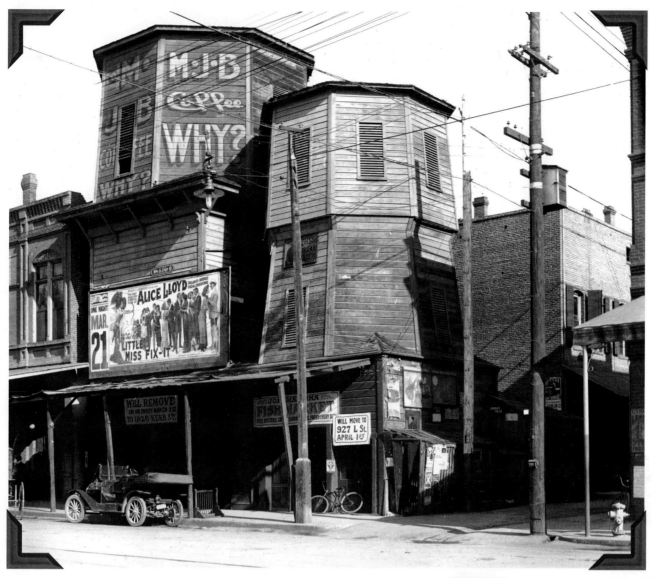

Prior to the opening of the Fresno Water Works in July, 1876, water had to be brought from the San Joaquin River by railroad tank cars. Lyman Andrews and George McCullough drilled a 100-foot well and, using a steam pump, raised the water to a three-story, 23,000-gallon tank. Located on Fresno Street between Broadway and J (Fulton) streets, the well cost a family of five $1.50 per month with an additional $0.50 for the household's cow. The Mattei Building and later the Guarantee Savings Building occupied the same site. Circa 1911.

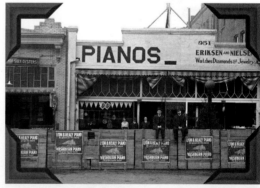

Frank Belle's Piano House was located next to Eriksen-Neilsen Jewelers in downtown Fresno. December 12, 1915

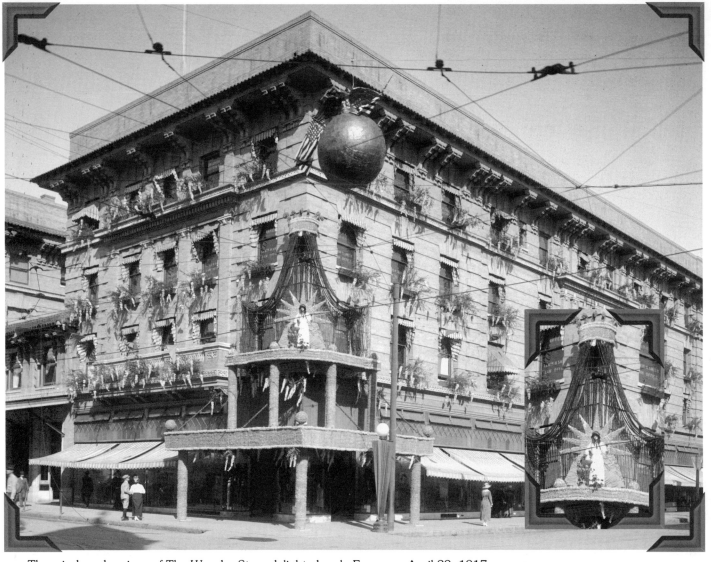

The window dressings of The Wonder Store delighted early Fresnans. April 29, 1917

Automobiles were rapidly replacing horse-drawn means of transportation as is seen in this scene of the Fresno Post Office at Tulare and Van Ness, in 1918.

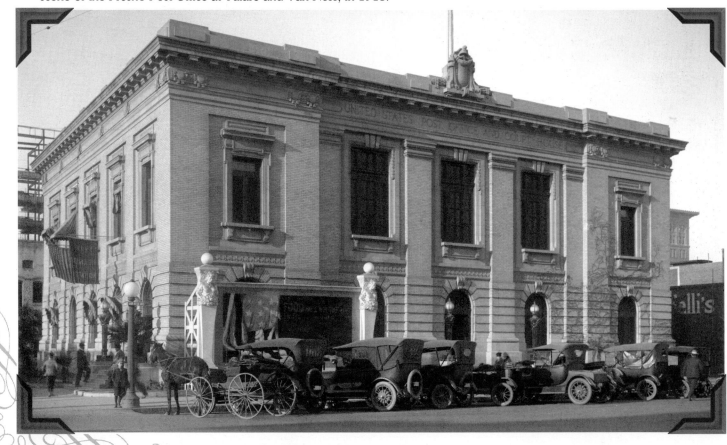

After less than a decade in its previous location, booming business required the thriving Gottschalk's Department Store to expand. Construction of the new and improved building was off to a firm start in 1913.

Sign installers prepared to lift their creation into place while avoiding street repair work and the wet cement of a newly poured sidewalk. Early summer, 1914.

Pop Says...

Character Lines In The Face Of Our Town

Life's a funny proposition. After all, we're here for a day then old and gray like the rose that buds and blooms then slowly fades away.

Day by day, in every way, we old timers who are still here are really and truly facing the fact that, slowly but surely, the town we helped to build, like any healthy child, has grown up, stepping out on its own and along with the help of many newcomers, inaugurating new ideas, giving the old town what one might term a face lifting treatment and in the process of doing so, removing every character line in its features so that in a very short time, these grand old pioneers will never recognize their own offspring.

At the present moment, there is a lot of feverish activity going on in preparation of the town's seventy-fifth anniversary, its Diamond Jubilee. Thank the good Lord the historical old court house, which represents one of the outstanding character lines in the features of this great community of ours, a character line which, at the present moment, the beauty experts propose to eliminate, will be seen and admired by many visitors, who, no doubt, will come and attend the celebration.

There is one more structure which stands out prominently representing another historical character line in the face of our community, which, so far, no mention has been made by the beauty experts of any threats of altering its outward appearance or removing it entirely, and that is the old historical water tower located on the southwest corner of Fresno and O Streets. This beautiful piece of architecture, the plans for which were drawn up by an architect from New York in collaboration with the father of one of our prominent architects, Mr. Fred Swartz, back around 1886 and 1887, and actually built in 1888. It is interesting to note here that when the bids for the construction of the

tower were called for, only one man had the courage to tackle the job and that was a man by the name of John H. Minard, who, by the way, is the father of another prominent citizen, Mr. Frank F. Minard, better known to his buddies as "two-by-four" seeing as how for 58 years he was affiliated with the Pierce Lumber Company, and, I might add right

here, that both these fine old timers sincerely hope that these beauty experts will keep their hands off this historical structure.

Coming back for a moment as to why John H. Minard was the only man to bid on the job to build this tower, was the fact that it was circular in design and the other contractors just didn't want to tackle that type of structure. The water tank is made of Swedish steel, the walls are brick covered with cement. The brick, by the way, was furnished by the Craycroft Brick Company, another old, established Fresno firm still doing business at the old stand.

I know that I voice the feelings of most of those grand old timers when I say that at least these two

structures, the court house and the water tower, which so beautifully depict the historical character lines, visible to the eye, something concrete that one can feel, touch and point to with pride telling one and all that here in these two structures they are looking at, is the tangible evidence of the faith those hardy pioneers had when they chose to locate and build the City of Fresno seventy-five years ago on what was then practically nothing but barren-looking land.

You know, it takes years of struggle and hard work to form character lines in one's features, lines that most old timers are proud to have show up in their faces, lines that bring out the character of the individual, and so let us hope that, in their anxiety to keep up with the times, these beauty operators will realize that in destroying these two old structures, they will wipe out the last visible, tangible, historical character lines of one of the most prosperous communities in the state of California. Let's all think it over before a decision is made.

'Bye now, I'll be seeing you.

"Pop."

From The Fresno Guide, July 7, 1960

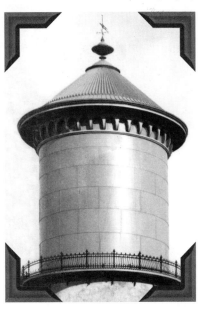

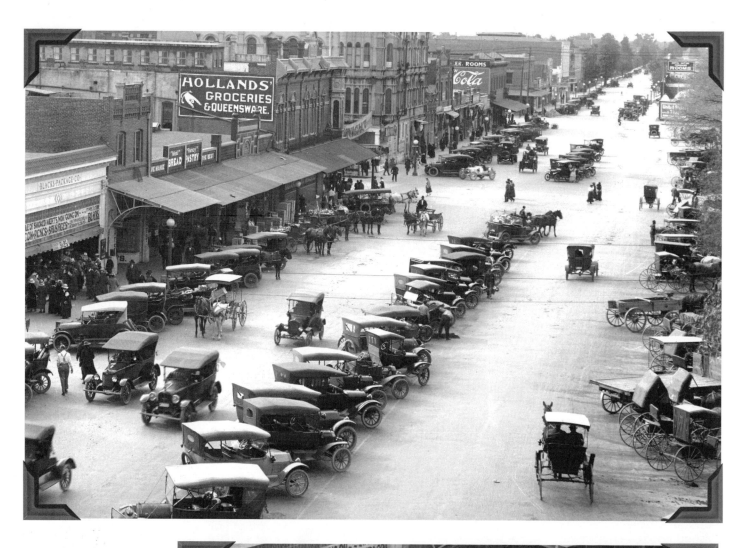

The hustle and bustle of downtown Fresno is recorded in this view looking north from the corner of Van Ness and K (Tulare) streets. Cars were well on the way to outnumbering horses, and parking was already a problem. April 2, 1917.

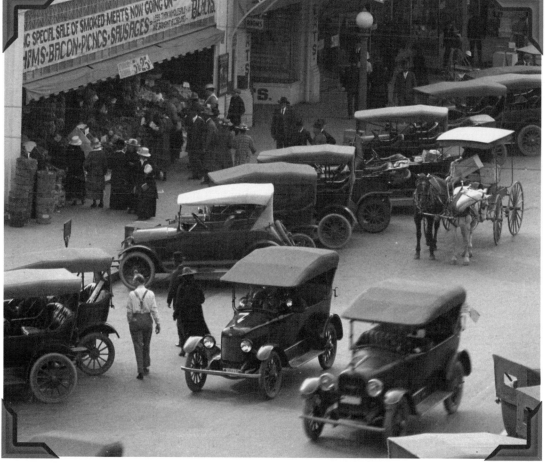

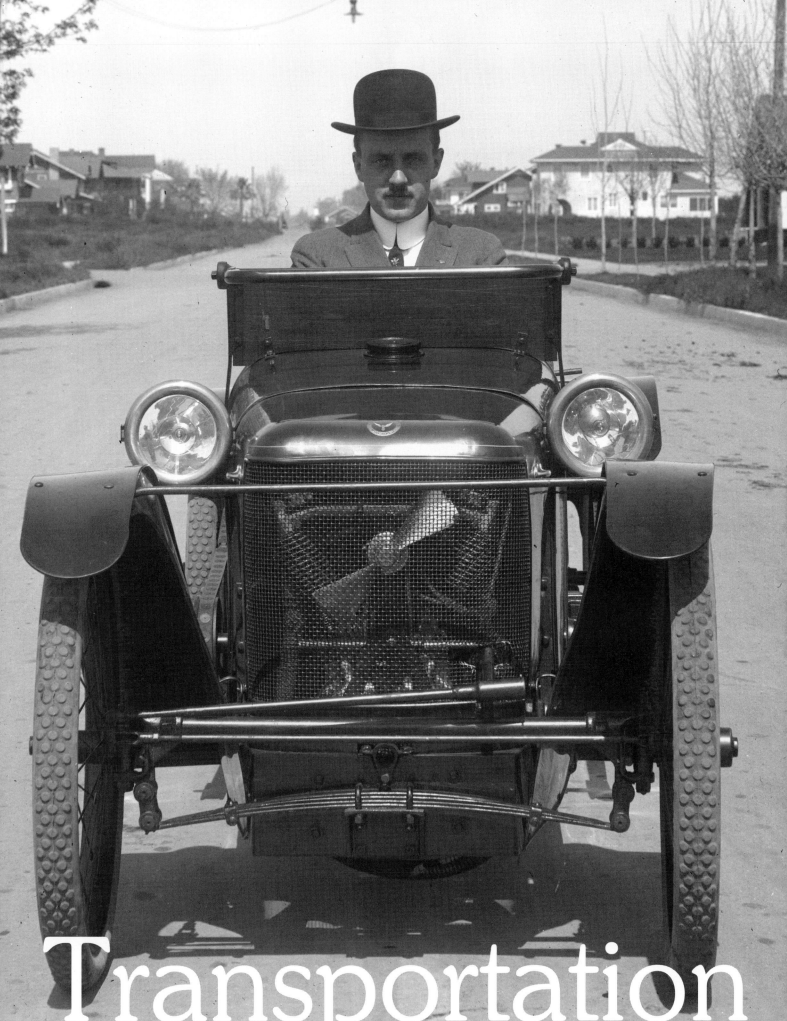

Transportation

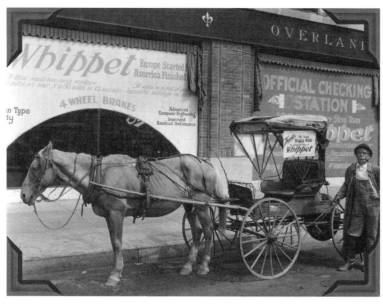

*J*ohn North Willys was a super salesman and something of a wheeler and dealer. The Fresno dealership carried through on his enthusiasm with the unique idea of offering an old-time buggy ride before a spin in a new Whippet automobile. The Whippet was a product of the Willis-Overland Co. that later became American Motors and is now owned by Chrysler Corporation. From 1914, the company was known for its Knight patent "sleeve-valve" automobiles and sold a good product at the middle level of the market. Later models introduced many innovative firsts. In the center of the steering wheel was a button that, if properly manipulated, did just about everything possible on a car of the day. Pull it up and it was the starter, push it down and it was the horn. When turned, if you were lucky, headlights came on. The 1916 Model 75LH, or left-hand steering wheel model, was available since the right- versus left-drive controversy had not yet been. At $850 FOB ($14,590.00 in 2004 dollars), the Model 75 was one of the cheapest and most durable cars on the market and the forerunner of the more common Model 90 Overland.

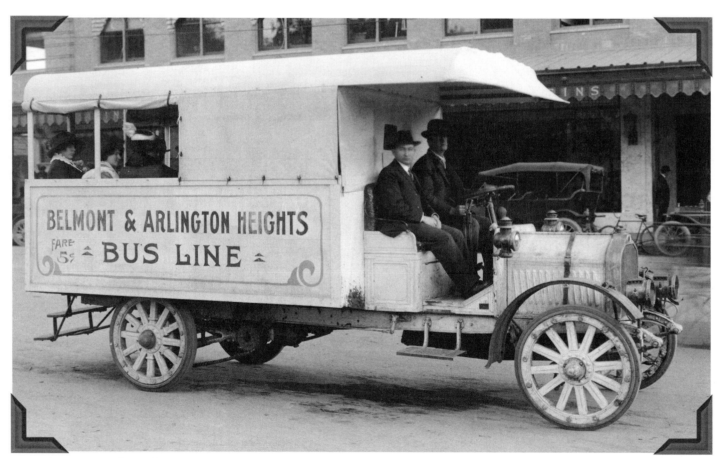

A sensation when it first appeared on the street, the Belmont & Arlington Heights Bus Line offered customers amenities never before seen. Five cents bought you a ride from the heart of the city to the newly developing suburb of Arlington Heights, just north of today's Community Medical Center. Traveling at about 15 miles per hour, the coach featured mud guards, solid rubber tires and presto-lite lamps, not to mention side curtains for protection from rainy weather—for everyone but the driver. Circa 1914.

Previous page: A gentleman who looks to have stepped out of GQ magazine, sporting a diamond bumblebee tie tack, would certainly be expected to drive an exquisitely crafted machine such as this. Note the wooden windscreen and white dove logo atop the radiator cowling, details which hint that the builders had refined sensibilities in addition to an awareness of practical needs. Date Unknown.

Pop Says...

Once Upon A Time

Yes, my good friends, this heading may lead you into thinking that "Pop" is going to entertain you today with some kind of a fairy tale, but such is not the case.

This scene actually was taking place right here in FRESNO, back around 1914, when you could pay the driver FIVE CENTS, climb up those two little steps you see at the rear, and enjoy perhaps a rather bumpy ride into town, all the way from Arlington Heights, a little over two miles from the heart of the City.

They used to call Arlington Heights in those days "THE HILL," it being supposedly the highest plot of ground around Fresno. And, incidentally, my good old friend Fred Billings, who was subdividing Arlington Heights at the time, used to ride out to the property on his bicycle to show prospective customers some choice lots.

But coming back to the Belmont & Arlington Heights Bus Line, just stop and think what a LUXURY this venture was to the people of Fresno at that time. When it first appeared on the street it was a sensation, and to think one could actually ride all that distance for ONLY FIVE CENTS, one nickel.

Yes, my friends, a nickel went a long way in those days. But today your nickel goes a long way; that is, one can carry it around for weeks before you find something you can buy with it! The only thing it is good for nowadays is to get the wrong number on the telephone, or perhaps drop it into a parking meter, at which time you hope and pray that the meter is in good working order and isn't going to double-cross you by running up the red flag some thirty minutes before the sixty minutes you paid for had expired.

One used to be able to get a good FIVE CENT CIGAR, but the five cent cigar you get today takes FIVE CENTS WORTH OF MATCHES to keep it going.

Yes, my good friends, those were the days when a person could really and truly enjoy a bus ride around the city for FIVE CENTS, one nickel. Now one has to dig up twenty cents to go the same distance, perhaps not even that far.

I just thought that a lot of you old timers out there would enjoy looking back through some forty-five years and perhaps reminisce a bit, even recalling when you and your BEST GIRL rode to town on what was then an innovation in the community, a SENSATION, with mud guards, solid rubber tires and, believe it or not, presto-lite lamps, not to mention side curtains for protection of all except the driver, who would have a rough time on a rainy day. You could ride in an honest-to-goodness MOTOR DRIVEN BUS, and what's more, the fare was only FIVE CENTS.

'Bye now, I'll be seeing you.

"Pop."

From *The Fresno Guide*, February 19, 1959

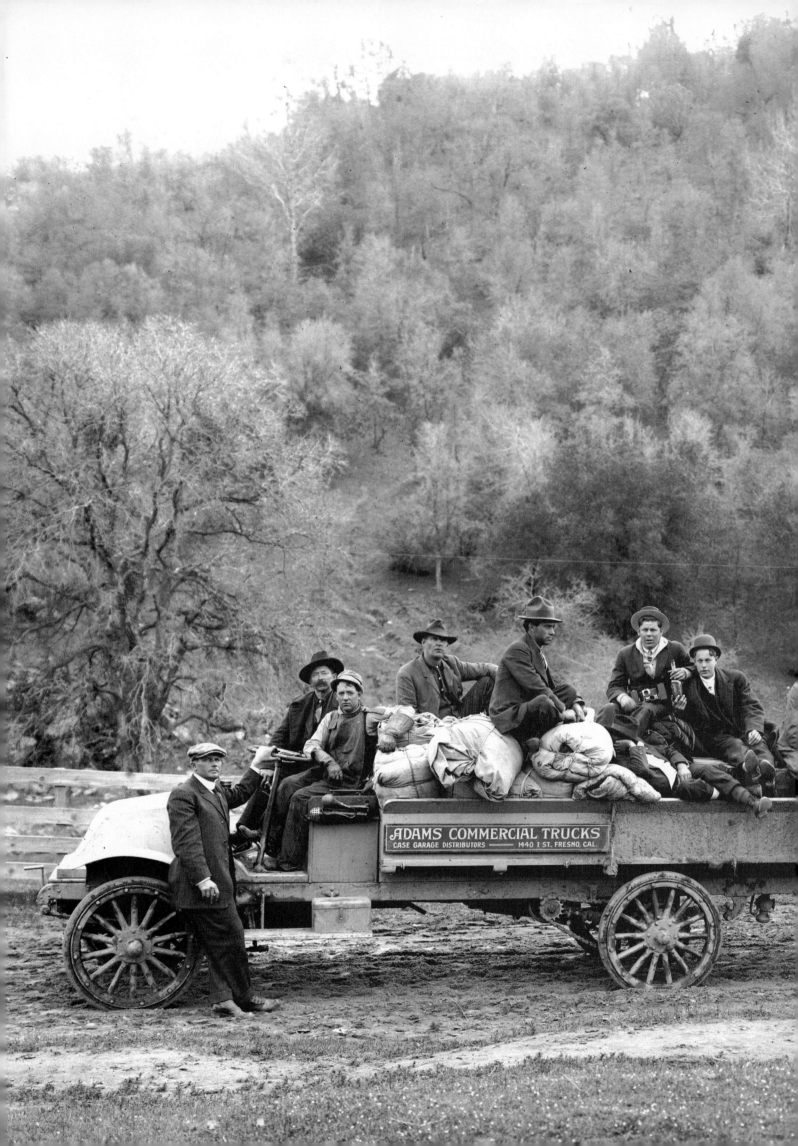

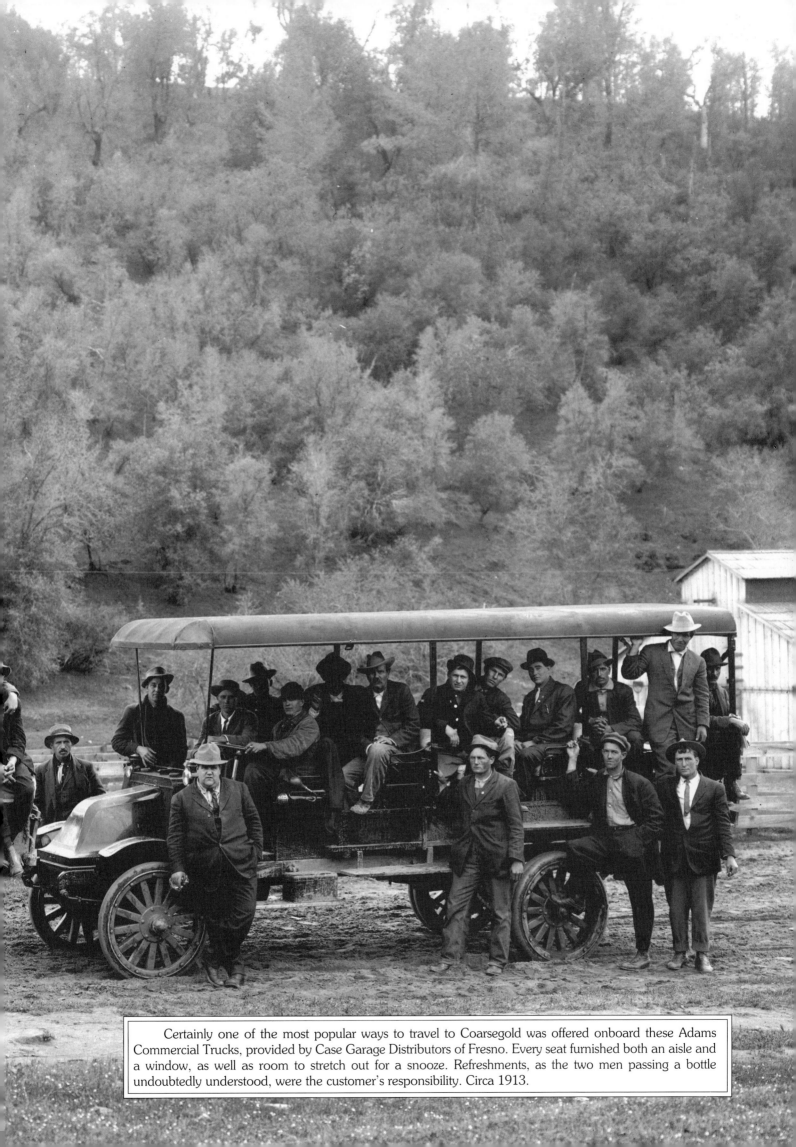

Certainly one of the most popular ways to travel to Coarsegold was offered onboard these Adams Commercial Trucks, provided by Case Garage Distributors of Fresno. Every seat furnished both an aisle and a window, as well as room to stretch out for a snooze. Refreshments, as the two men passing a bottle undoubtedly understood, were the customer's responsibility. Circa 1913.

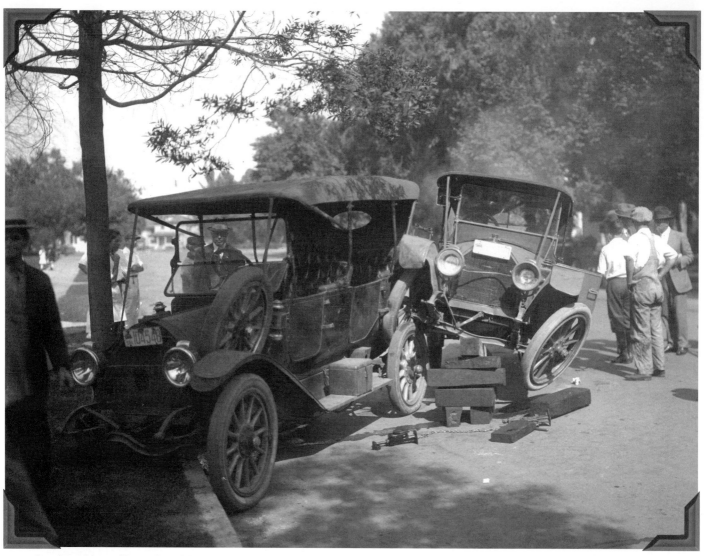

Looking like a "Laurel and Hardy" caper, this photo documented a Van Ness Avenue fender bender for insurance company investigators, some of "Pop's" best clients. September 24, 1916

This Ford runabout obviously lost its argument with the tree. Perhaps the Hoover-Persons Spring Co. on Merced Street can convince the Ford owner to install a Hoover bumper and have a better chance of winning in the event of another collision. Date unknown.

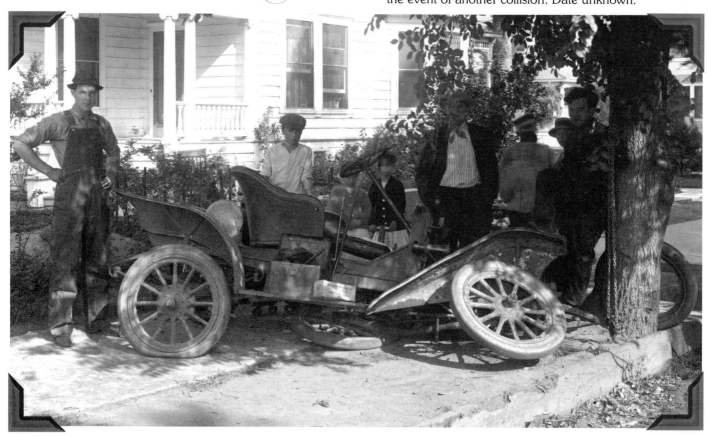

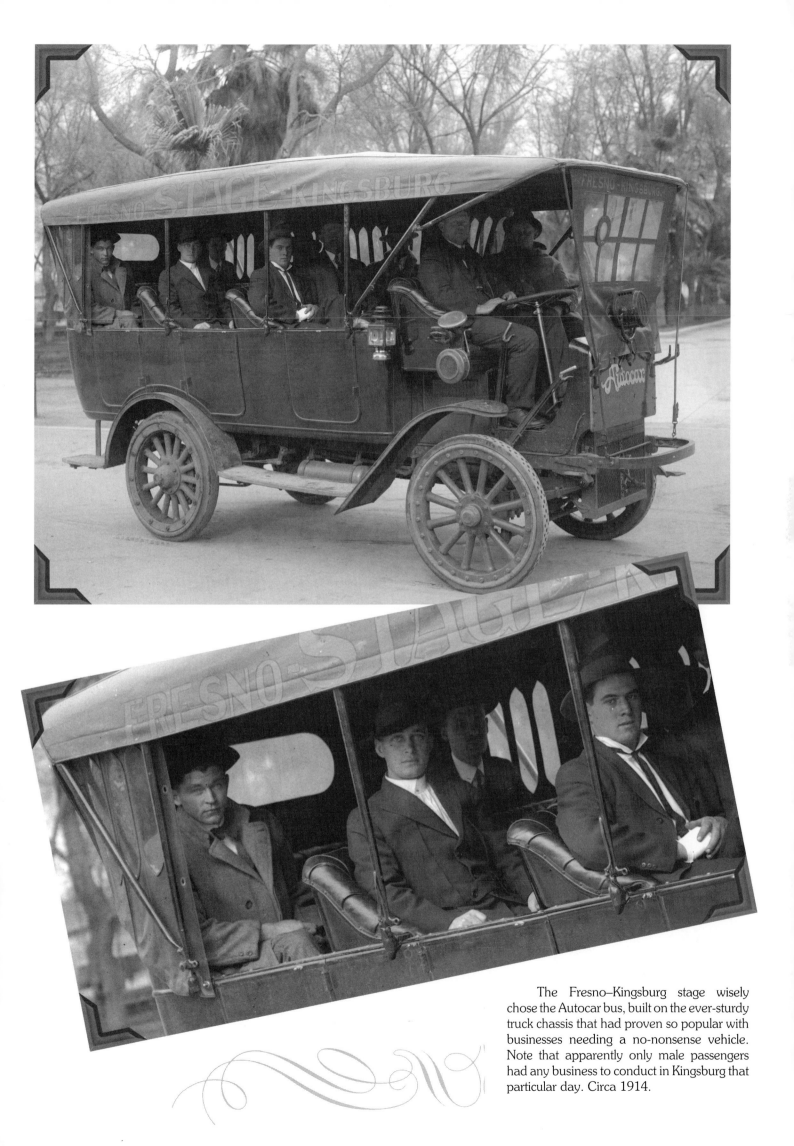

The Fresno–Kingsburg stage wisely chose the Autocar bus, built on the ever-sturdy truck chassis that had proven so popular with businesses needing a no-nonsense vehicle. Note that apparently only male passengers had any business to conduct in Kingsburg that particular day. Circa 1914.

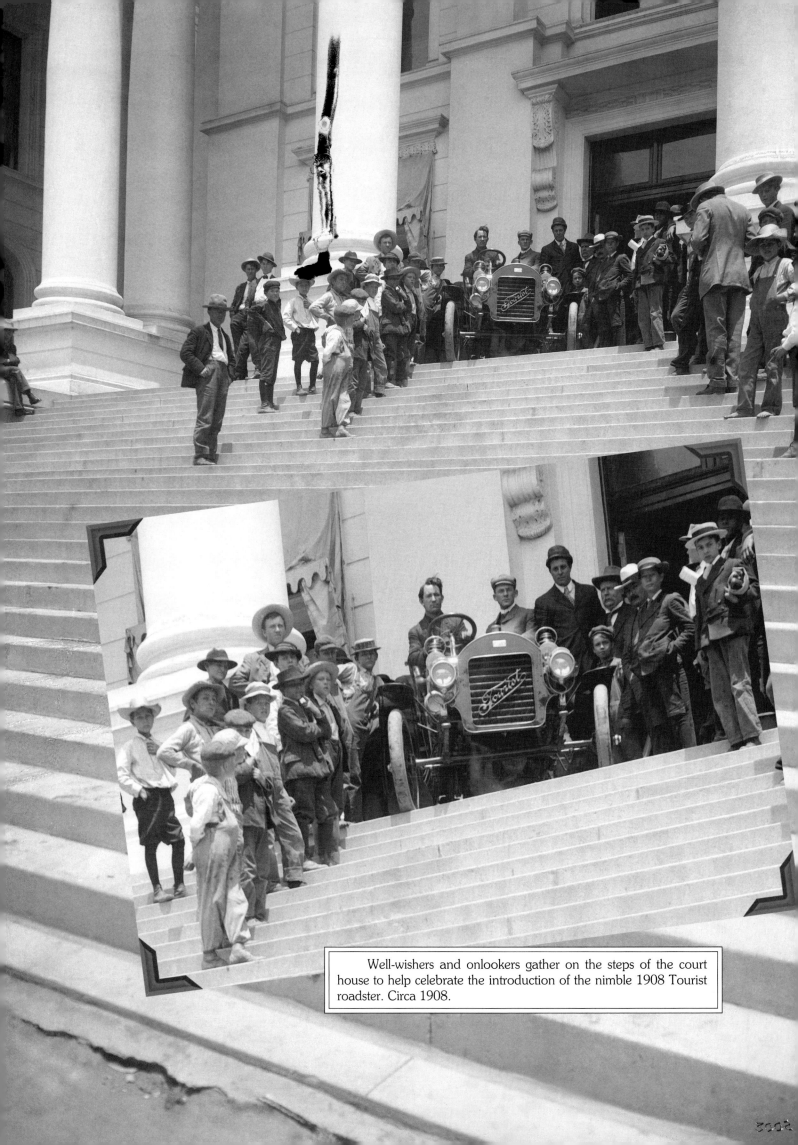

Well-wishers and onlookers gather on the steps of the court house to help celebrate the introduction of the nimble 1908 Tourist roadster. Circa 1908.

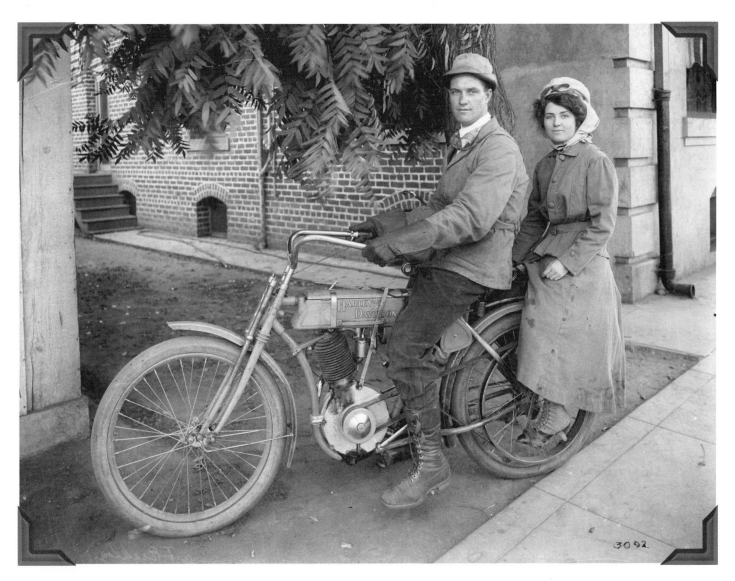

Art Bradley and his lady happily contemplated a day of cruising their pre-1909 Harley on the open road. During 1909, Harley-Davidson would offer a V-twin powered motorcycle with a displacement of 49.5 cubic inches, producing seven horsepower. The image of two cylinders in a 45-degree configuration would fast become one of the most enduring icons of Harley-Davidson. Spare parts for motorcycles became available for the first time that same year. Circa 1909.

Motorcyclist Bert Caughell and his wife suited up for a spin on the family Harley in early 1909. In 1903 William Harley and three brothers Arthur, William, and Walter Davidson, built the first Harley-Davidson motorcycle in Milwaukee, Wisconsin. Basically, it was just a bicycle with a motor, and riders had to help by pedaling when going up hill. The bike became a big hit. Up to 1908, the one Harley model released each year had a battery-fired, single-cylinder engine. Circa 1909.

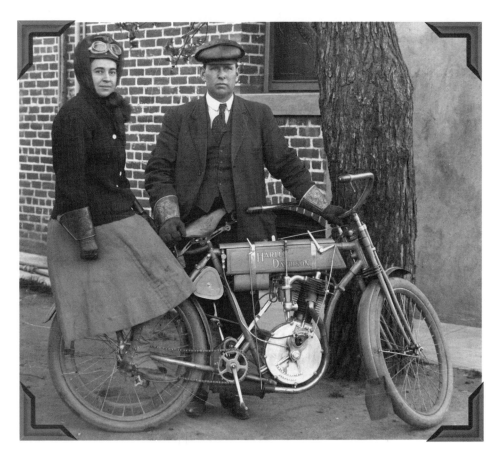

Henry Nyberg of Chicago saw an opportunity in the Anderson, Indiana, area and decided to buy the Rider Lewis plant. The manufacture of a Nyberg was very labor intensive. The cars were literally made by hand, and the Nyberg employees took great pride in their output. This intrepid pair of road warriors returning home to Fresno after their adventure all the way into Mexico is an illustration of the reliability of the Nyberg. Circa 1912.

Customers always received full-service treatment at service stations such as the Standard Oil Station #4 in Fresno. Only one type of gasoline was necessary for automobiles and trucks in 1917. It cost just 20½ cents per gallon, the equivalent of $3.14 in 2004. January 26, 1917

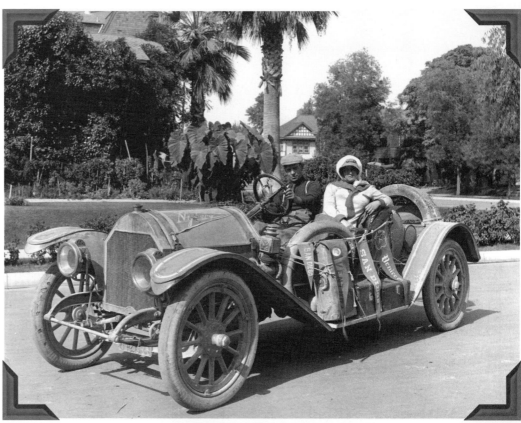

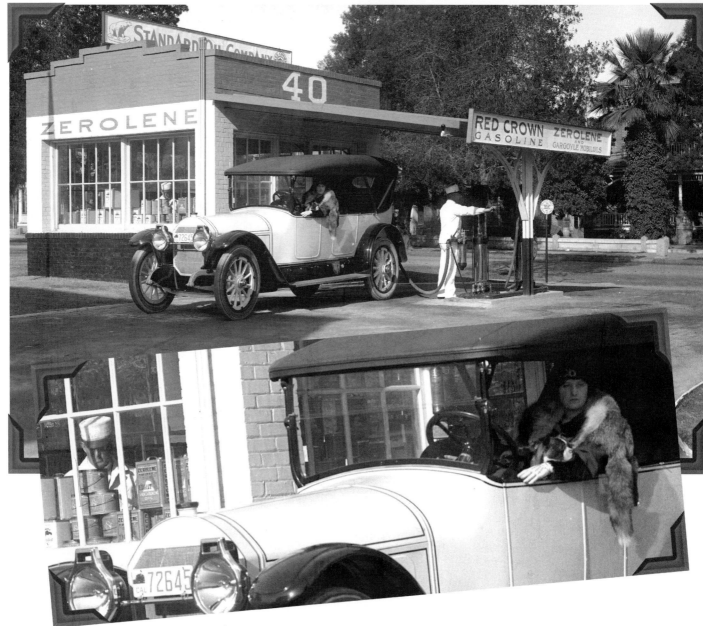

San Joaquin Valley Automobile Industry
Thousands of Automobiles Used In San Joaquin Valley
Use of Trucks for Heavy Work Now Becoming General

The people of the San Joaquin Valley are more prosperous than they have ever been. There are now thirty dealers in automobiles in Fresno. All assert that Big Demand here is enough for moderate-priced cars, and it has become hard to get enough to supply buyers. In 1914, there were 5,400 automobiles in Fresno County as compared with 2,000,000 in the entire United States. It is also true that Fresno County is strong in proportion to the number of auto cars owned, that is, one car for every seven voters. Daily sales of new automobiles in the San Joaquin Valley currently total 13.

Farmers Heavy Buyers

Sales in general during the past year have been very heavy in the rural districts, the farmer and ranchman having discovered that autos are great time savers, hence the demand for commercial cars, particularly lightweight cars and tractors. This demand is certain to continue.

First Agency In Fresno

It was in 1901 that the first automobile agency was established in the San Joaquin Valley, that one being in Fresno, where the old Locomobile steamer was offered to the people of the Valley as the most modern and rapid of all vehicles for use on the highways. Today, a machine of that character on the streets of Fresno would attract as much attention as the old ox team, and it would be almost as obsolete. The man who established that first agency in the Valley is still in the automobile business in Fresno, and the factory that he now represents turns out 600 cars per day and gives employment to 9,200 persons, or, to put it a different way, every sixth family in the city wherein this great plant is located is supported by it.

Among Fresno automobile dealers, a most optimistic view of the industry and of business conditions is taken. If their prophecies prove true, and there is little reason to question them, the business this year will far exceed any heretofore in the history of the industry in the Valley.

Phelan Confident of Quality

Confidence in the future is shown by J. C. Phelan in the building of a new garage at the corner of Van Ness Boulevard and Mono Street into which he has just moved. For this year's business, he has ordered 1,000 Ford cars for Fresno City alone. Ford has just put out a one-ton truck

that is meeting with big demand. Two hundred heavy trucks will also be sold this year.

Cadillac Manager Optimistic

"There is room for 5,000,000 automobiles in the country. The industry was never better than now," is the view of Ted Shelton, manager of Don Lee Cadillac agency for the Valley. "We are doing more business now than ever. To date this year, we have received two car loads of Cadillacs and we will have a greater sale than ever this year. Collections are good, most accounts being paid before they mature, and in general, business conditions are splendid."

Lack of Cars Says Waterman

Waterman Brothers, Inc. complains of inability to get cars. E. B. Waterman, speaking of the auto industry said: "that the amount of material used in the manufacture of motor trucks and other paraphernalia for the European war, coupled with the inexcusable continuation of pleasant weather in the middle and Eastern states, has made discussion of the automobile problem here practically useless—cars can't be had. Employers are getting themselves gray-haired fighting for cars."

Studebaker Business Booming

There are now between 1,500 and 1,600 Studebakers in Fresno County and 3,000 in the San Joaquin Valley. "Sales to date of 1916 models of the Six cylinder type are larger than at any time for the entire year of any previous year. Naturally, therefore, I am optimistic regarding the industry," said Eliot E. Bradley, distributor for the Studebaker Company in the San Joaquin Valley. "Our 1916 commercial line is three new chassis in half-ton wagon, panel, and express type, also one-ton express or hotel bus or so-called fourteen-passenger jitney. Our new 1916 cars carry five and seven passengers, and have more room and more quality at a reduction in price from $100 to $400. General conditions in the industry could not be better."

Thompson-LaCasse On Conditions

"We are building a new $12,000 home in Fresno with the idea in view of making it one of the finest garages in the Valley. This shows our faith in the auto industry," is the expression of George R. Murdock, vice president and manager of the Thompson-LaCasse company. "The first two months of this season, we sold 87 cars and expect to sell 325 Maxwell cars this year. We have also sold thirty Chandler seven-passenger cars since the opening of the season."

Truck Industry Will Boom

All dealers are free in expressing the opinion that the scarcity of horses and mules, due to the number transported to Europe during the war, will stimulate the automobile industry particularly trucks.

From *The Fresno Morning Republican*, October 1, 1915.

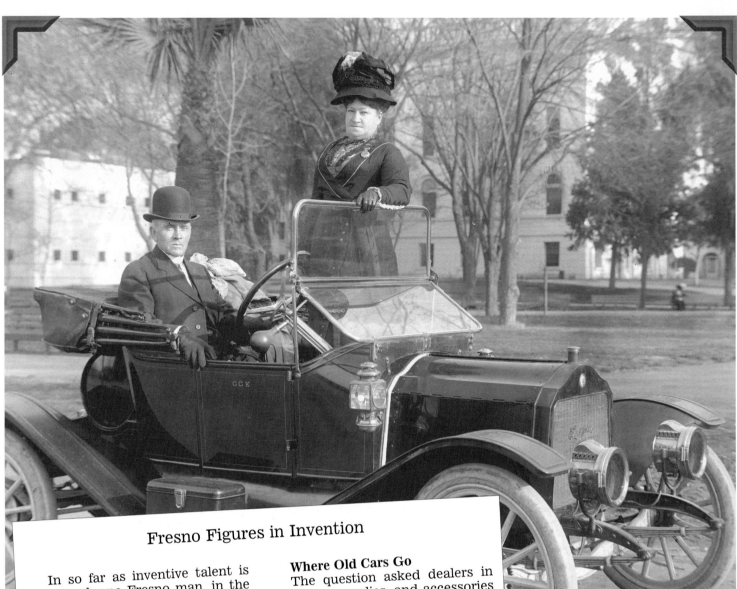

Fresno Figures in Invention

In so far as inventive talent is concerned, one Fresno man, in the person of L. A. Nares, figures directly in the automobile world. The disappearing seat, a feature of one well-known machine, is his idea and he had cars built to order for years in which he realized this idea, having these seats built in.

The Waterman Brothers, well known automobile dealers of Fresno, are indirectly represented in automobile inventive talent, for the first automobile ever built in the world was constructed by their great-grandfather, Dr. Edward Church. The machine was built in London in 1837, the doctor, at that time, being American consul to Paris. The automobile, which was a steamer, was a double-decker, on the same order as are the English busses of today. It was destined to carry thirty passengers. When completed, a number of defects were found, and, while they were being overcome but the rebuilding of parts of the auto, a law was passed which prohibited horseless carriages from running within 60 feet of a public highway, which, of course, killed the machine.

Where Old Cars Go

The question asked dealers in auto cars, supplies, and accessories most frequently is what becomes of the old motor cars?

Dealers make a prompt answer. Owners of old cars convert their machines into light delivery trucks, and ranchers are purchasing their old cars for use in carrying light loads from one place on the ranch to another and in bringing their products to market. These light delivery trucks are supplanting horses and auto dealers assert the belief that in the near future, every ranch will have one or more of these built-over old cars into trucks.

When the highway system of California, as now planned and which is under construction is completed, many of the old cars will be built over and placed on the market at such a modest price that will enable artisans and wage earners, people of moderate means to own cars, so that within a very short time, practically every freeholder can and will own a car.

From *The Fresno Morning Republican*, October 1, 1915.

The Flanders automobile, marketed by Studebaker, was a lightweight car which remained virtually unchanged throughout its life. Manufactured from 1909 through 1912, this runabout was purchased by G. C. Knight and his wife for pleasure motoring. Note the monogram on the door. Circa 1913.

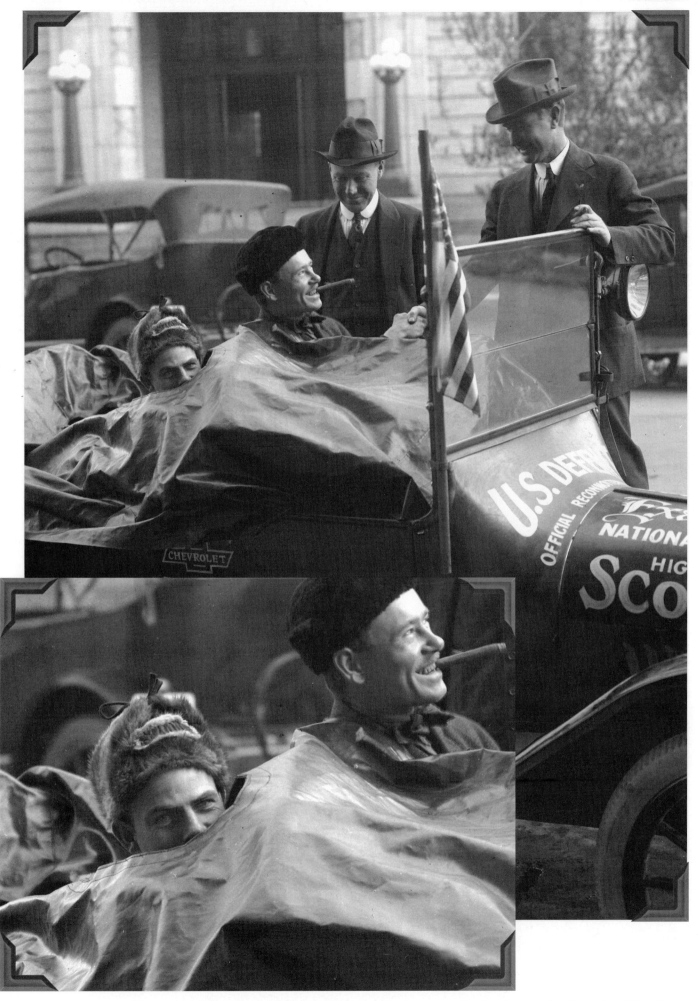

In the early 1900s auto travelers followed an informal network of routes marked by colored bands on telephone poles. Known as the National Auto Trails, this scheme was replaced in 1926 with a Congressionally sanctioned system of numbered highways. Chevrolet generously donated the first car off their Pacific Coast assembly line to aid in scouting desirable routes before the change over. January 19, 1917.

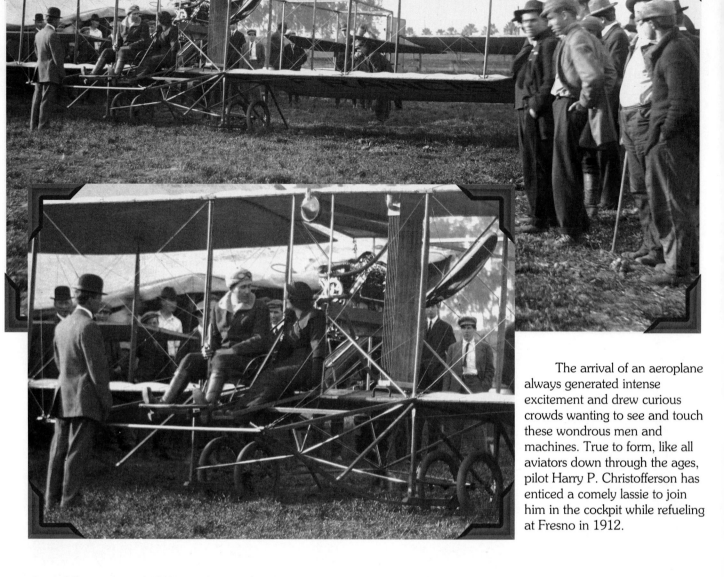

The arrival of an aeroplane always generated intense excitement and drew curious crowds wanting to see and touch these wondrous men and machines. True to form, like all aviators down through the ages, pilot Harry P. Christofferson has enticed a comely lassie to join him in the cockpit while refueling at Fresno in 1912.

In mid September of 1915, employees of Valley Ice Company were ready to help this balky Detroiter auto get under way. The Detroiter Motor Car Company bought parts from other manufacturers to build their machines, which might have had some bearing on the situation pictured here. September 12, 1915.

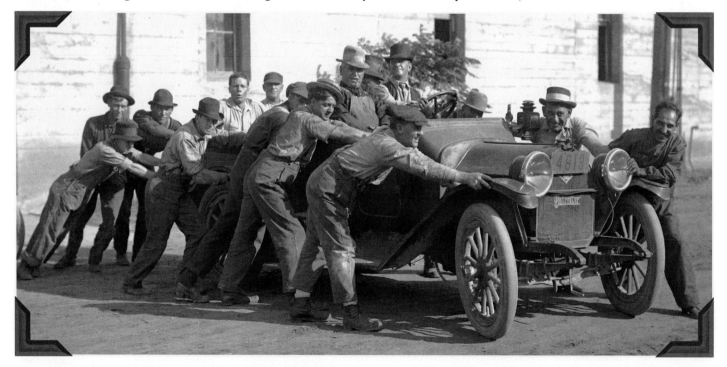

Native Americans

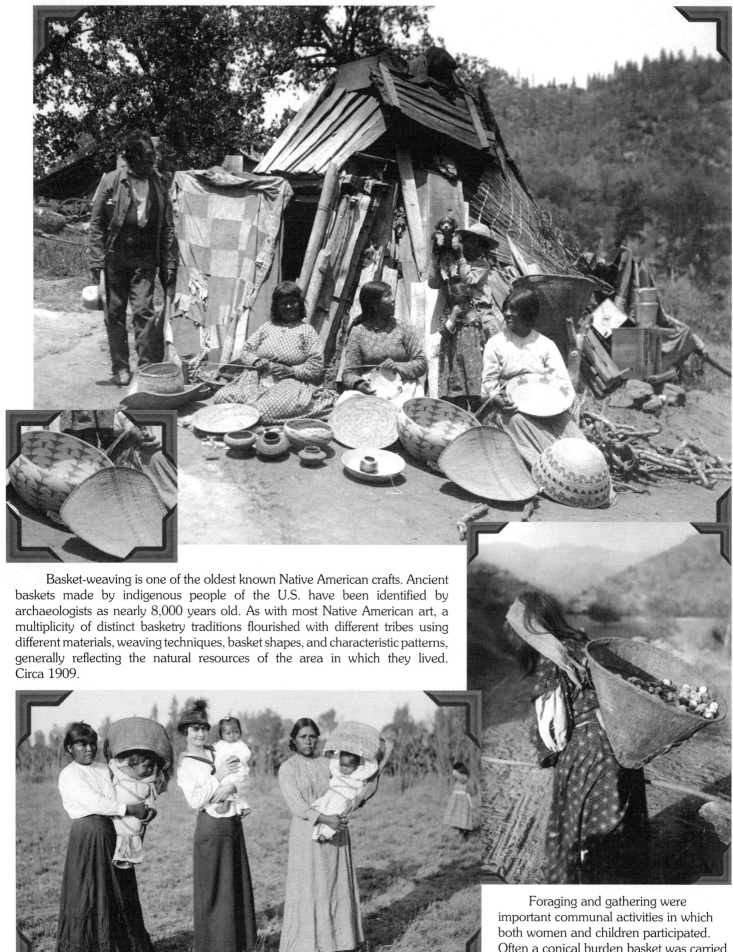

Basket-weaving is one of the oldest known Native American crafts. Ancient baskets made by indigenous people of the U.S. have been identified by archaeologists as nearly 8,000 years old. As with most Native American art, a multiplicity of distinct basketry traditions flourished with different tribes using different materials, weaving techniques, basket shapes, and characteristic patterns, generally reflecting the natural resources of the area in which they lived. Circa 1909.

Foraging and gathering were important communal activities in which both women and children participated. Often a conical burden basket was carried on the back with a support strap that was wrapped around the forehead to help balance the weight. These baskets could hold up to 150 pounds of food. Date unknown.

"Pop" Laval's sister, Lorraine, couldn't resist the allure of a little baby when meeting two Clovis Indian women and their bundles of joy. September 9, 1915.

Previous page: A Clovis Indian woman, with papoose, visited the Fresno area during the annual trek to the Valley floor for harvest work. September 19, 1915

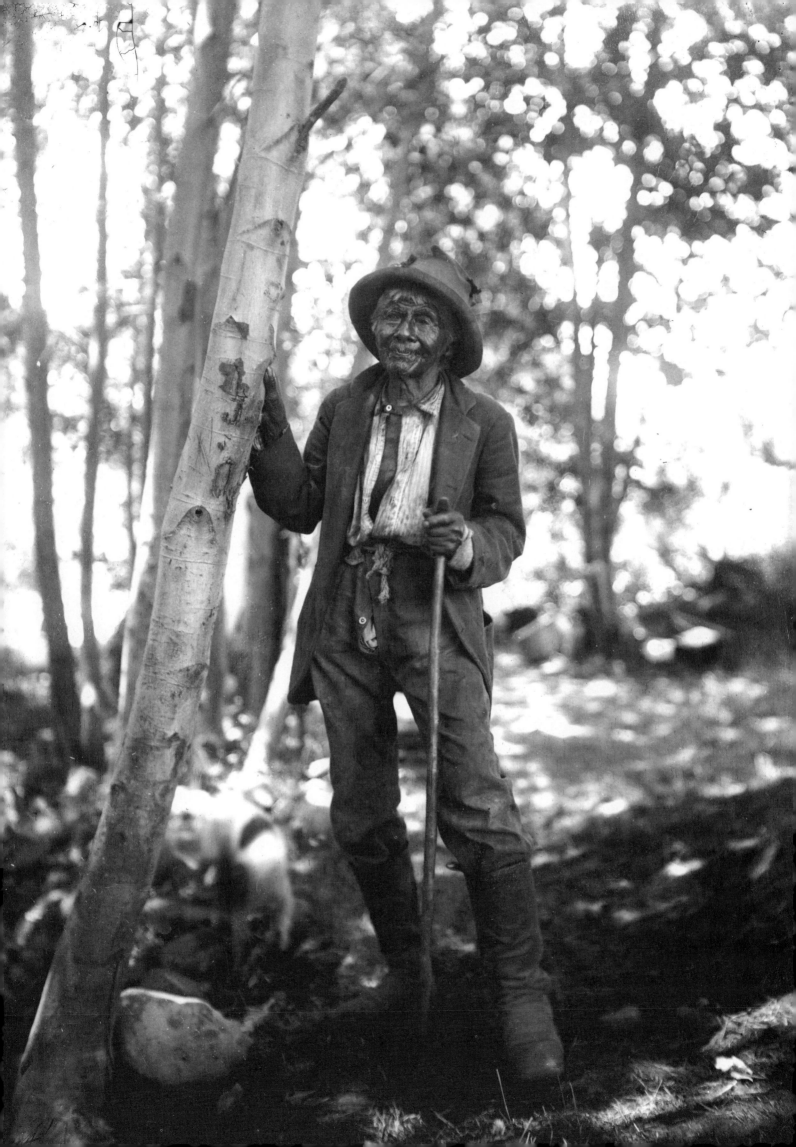

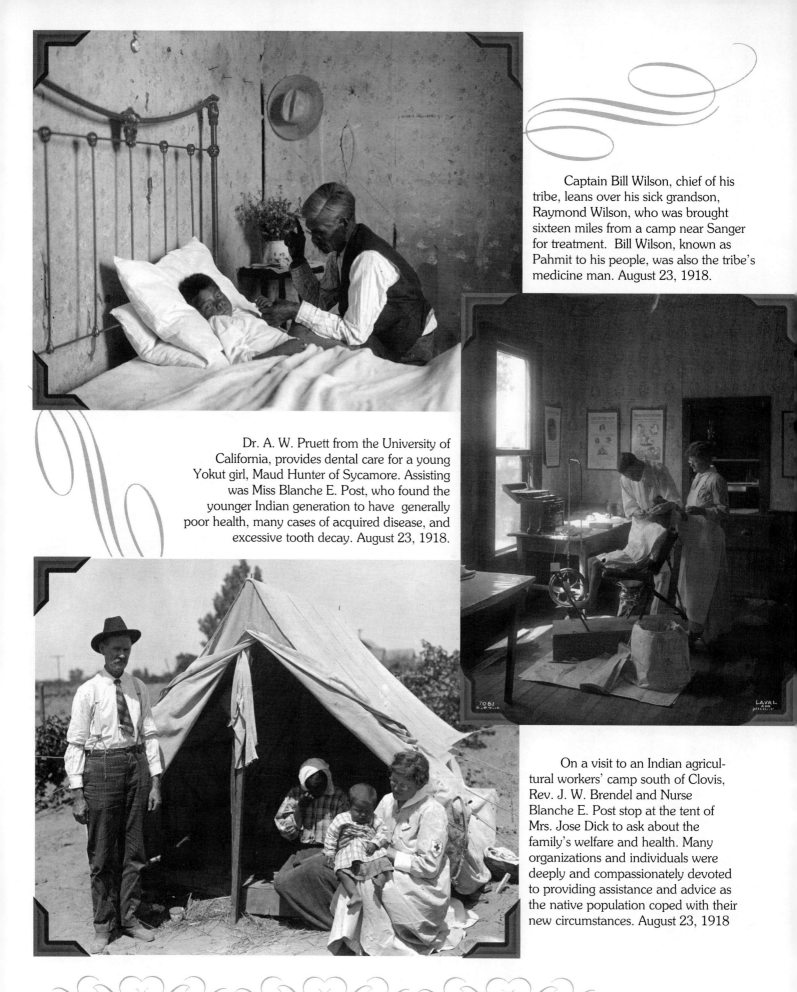

Captain Bill Wilson, chief of his tribe, leans over his sick grandson, Raymond Wilson, who was brought sixteen miles from a camp near Sanger for treatment. Bill Wilson, known as Pahmit to his people, was also the tribe's medicine man. August 23, 1918.

Dr. A. W. Pruett from the University of California, provides dental care for a young Yokut girl, Maud Hunter of Sycamore. Assisting was Miss Blanche E. Post, who found the younger Indian generation to have generally poor health, many cases of acquired disease, and excessive tooth decay. August 23, 1918.

On a visit to an Indian agricultural workers' camp south of Clovis, Rev. J. W. Brendel and Nurse Blanche E. Post stop at the tent of Mrs. Jose Dick to ask about the family's welfare and health. Many organizations and individuals were deeply and compassionately devoted to providing assistance and advice as the native population coped with their new circumstances. August 23, 1918

Previous page: Over the years, one of the most recognizable images in the "Pop" Laval Photographic Collection has been Chief Hawa, also know in his tribe as Muc-cha (grasshopper). A Chukchansi chief, he was believed to be 101 years old at the time he was photographed in 1901, thereafter living another nine years before his passing. Not much else is yet known about Hawa other than the fact that his granddaughter was married to Fred Ninnis, photographer and onetime partner of "Pop" Laval. It is thought by descendants of both "Pop" and Chief Hawa that it was this connection that brought the valuable photographic negatives of Hawa into the collection. A number of Hawa's family members still live in the Fresno, Coarsegold, and local foothill environs. Circa 1901.

Indian Hospital at Clovis Is First of Kind in West; Dentist and Nurse In Charge

One of the most useful institutions which have been established in Fresno County recently, and the first of its kind in the west, is the Indian hospital which has been opened at Clovis for the care and treatment of Indians who make their annual pilgrimage from their remote homes in the hills to the Valley to help in the fruit harvest and to lay in a supply of funds to tide them through the winter, which is severer in their mountain homes than here in the Valley section.

The institution is in charge of Miss Blanche E. Post, county school nurse, who is ably assisted by Rev. and Mrs. J. G. Brendel, Indian missionaries; Dr. W. C. Pendergrass, a physician of Clovis; Dr. A. W. Pruett, a dentist from the University of California, and Oscar B. Colley, teacher at the Indian school at Sycamore, and Mrs. Colley his wife, who is housekeeper at the school.

Temporary quarters have been secured in a vacant building a block north of the Hoblett Hotel, and this has been fitted up with all necessary equipment for the treatment of Indians who are ill and in need of medical care, and who have heretofore depended upon the doubtful, crude methods of the Indian medicine man when sickness has overtaken them.

Among the chief causes of sickness with the tribes of Indians who inhabit the hills of Fresno County is tuberculosis. This is today considered the Indians' most dangerous enemy by the federal government. One death out of every four among Indians of the United States is attributable to this disease. Its prevalence is mainly due to the unsanitary conditions in which the Indians live and to the lack of sanitary care of the body, especially as to cleanliness, and to the lack of proper care of the teeth, throat and lungs.

Look After Young Indians
With the idea in view of helping the younger generation of Indians, and to save them from the fate which befell the older ones, many of whom are past human aid, this institution has been established. Several interesting patients have been taken to the institution, given treatment and discharged as well in the three weeks that the institution has been in operation.

How It Was Started
Through the efforts of the Parlor Lecture Club of Fresno, and its sales of Red Cross seals, a nurse was provided for the rural schools of Fresno County. Miss Blanche E. Post was employed and engaged in the work. In looking after the children in these schools, Miss Post learned of

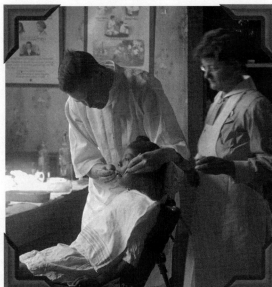

the needs of the Indians. During the summer, while the schools were not in session, she devoted her time to looking after the health of the Indians while many are down from the mountains helping in the fruit harvest. In this work, she is greatly assisted by Rev. and Mrs. J. G. Brendel, the Indian missionaries, who are doing a most wonderful work among the tribes, which necessitates many sacrifices on their part. They have charge of the work in this district, which includes Madera, Fresno, and Tulare counties, and missions at other points in northern California.

For six years, Rev. Brendel and wife have been engaged in this work here, laboring for the physical as well as the spiritual uplift of the race. Through their efforts the Indian is learning much that will benefit his health, mind, and also his finances. Rev. and Mrs. Brendel have been Indian missionaries for many years in the East. But there the government has schools and hospitals, and the Indians receive proper care. When the missionaries came here they found the Indians dying so rapidly that it seemed that a short time must elapse when all would become extinct. They have worked untiringly to bring before the proper

authorities this appalling condition. The missionaries have been forced to see little babies and mothers die for want of medical care way back in the hills, far from help of any kind. With no idea of the laws of health, the Indians have infected whole camps with tuberculosis, trachoma and skin diseases. Living as they do in camps, where there are no means for care, often in little one-room, windowless houses in the hills, where in winter they subsist on acorn mush and meat that is secured by hunting and later dried by hanging in the trees. Being unprotected from flies and other disease-carriers, they developed various forms of ailments. Another source of sickness is the fact that along in the summer the food supply runs low before the hunting season opens. And when harvest time in the Valley arrives the Indians, whose bodies from lack of proper nourishment are not up to standard, come down into the Valley where food is plentiful, and sickness results from overeating and lack of knowledge of how to protect themselves from disease, with the result that many are too ill to work, and lose both time and money.

Treat Pneumonia Patient
One of the first patients to arrive was a little boy, Raymond Wilson, who is four years old. His mother died of tuberculosis when he was a baby. The boy was brought sixteen miles to the hospital to take care of him. Dr. Pendergrass was called and pronounced the trouble as typhoid pneumonia. The little boy has hovered between life and death for nearly two weeks, but is at last gaining. The old grandfather assists the nurse constantly in his care and is very solicitous for his little charge, while the doctor continues his work.

Babies are also brought in sick, and here the nurse teaches the mothers how to feed, bathe and properly clothe their children. The nurse often finds children with from four to seven dresses on.

Daily practical lessons are given the Indians on properly bathing and clothing, caring for the mouth and teeth and in keeping the camps clean, and teaching the lessons of cleanliness and health, that they may go back to the hills in the winter and better care for themselves.

From *The Fresno Morning Republican*, August 25, 1918

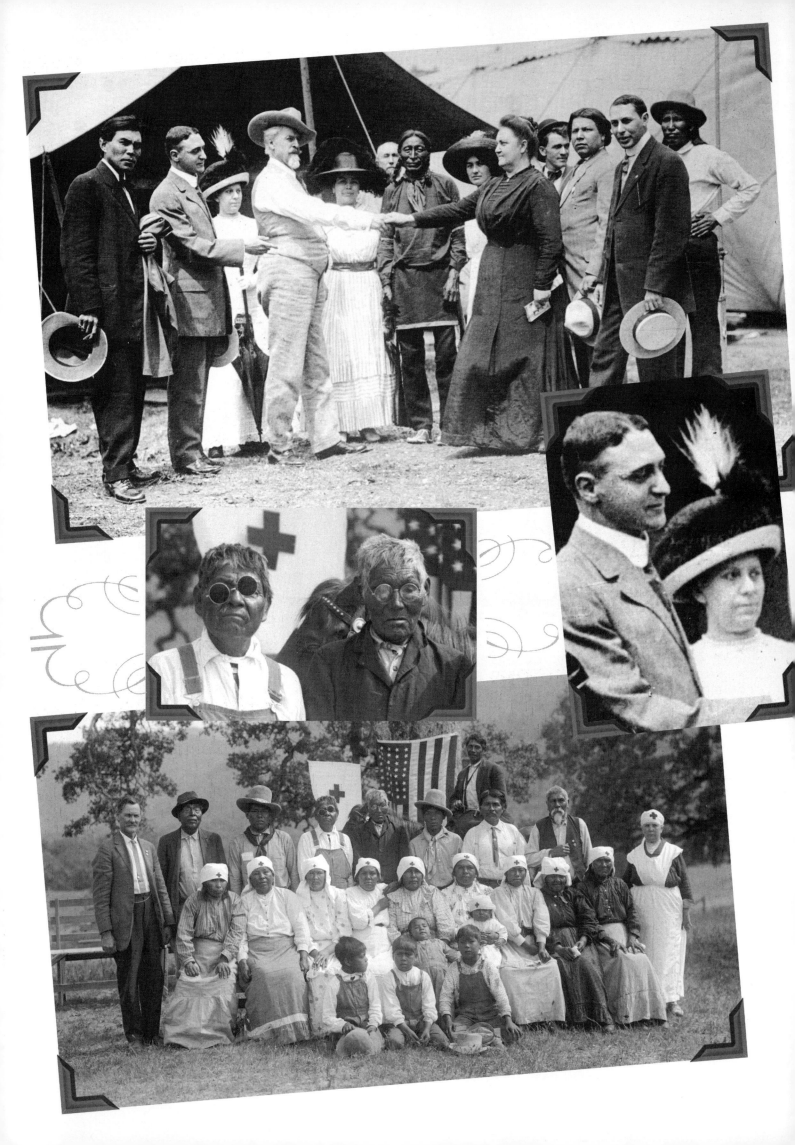

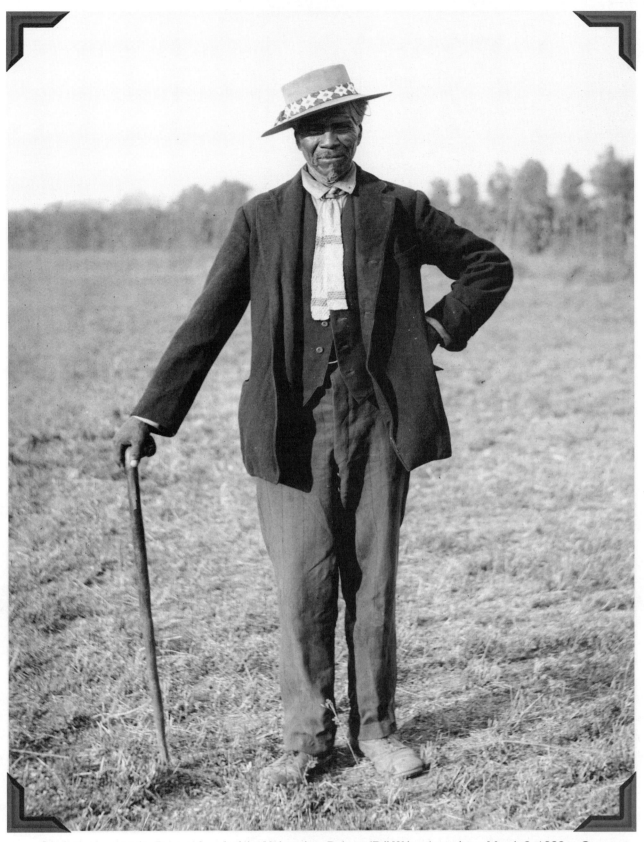

Medicine man to the Dumna band of the Yokut clan, Pahmit (Bill Wilson) was born March 8, 1828 in Coo-you-illik ("Sulphur Water"). This was a Dumna Yokuts village at the later site of Fort Miller. Pahmit was the grandson of the legendary Chief Tom-kit, once the proud, tall, and statuesque chief of many local tribes. When Pahmit died on April 26, 1936, at his home at Table Mountain Rancheria, he claimed to be 111 years of age. (Researcher Frank Latta's 1933 interview indicated another Indian name for Pahmit, Lahm-Pah). September 19, 1915.

Previous page top: Local Yokut natives were referred to as "Clovis" Indians in the early years of 1900. Treaties and handshakes sometimes expressed sincerity, but often served only to deflect attention from planned treachery. After the Gold Rush brought an influx of miners and settlers and the Mariposa War brought several years of genocide, the 1851 signing of a peace treaty was quickly abrogated by the U.S. government. Due to a continued inability to cope with modern weapons, disease, and immigrant influx in huge numbers, the native population came to depend on integration and goodwill for their survival. Date unknown.

Previous page bottom: Over time, the Indian population grew to absorb the lifestyle and institutions of the civilization thrust upon their world, joining the Red Cross and accepting other positions of responsibility whenever possible. May 22, 1918

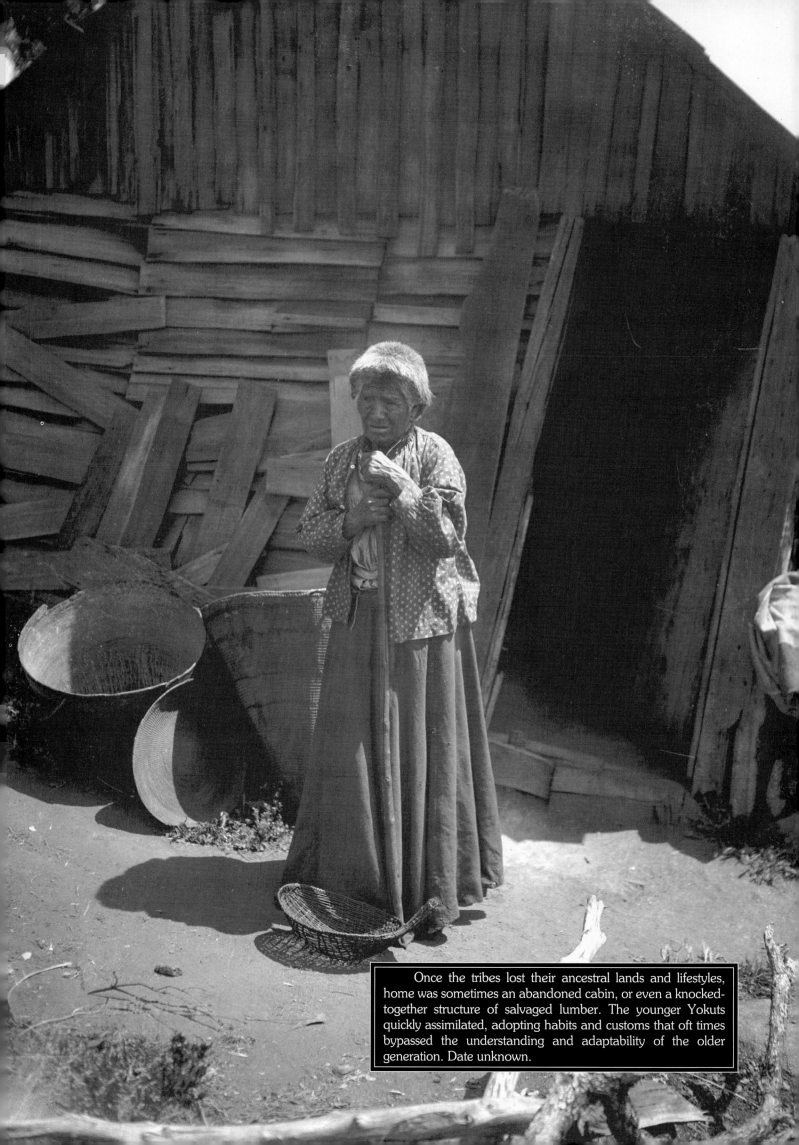

Once the tribes lost their ancestral lands and lifestyles, home was sometimes an abandoned cabin, or even a knocked-together structure of salvaged lumber. The younger Yokuts quickly assimilated, adopting habits and customs that oft times bypassed the understanding and adaptability of the older generation. Date unknown.

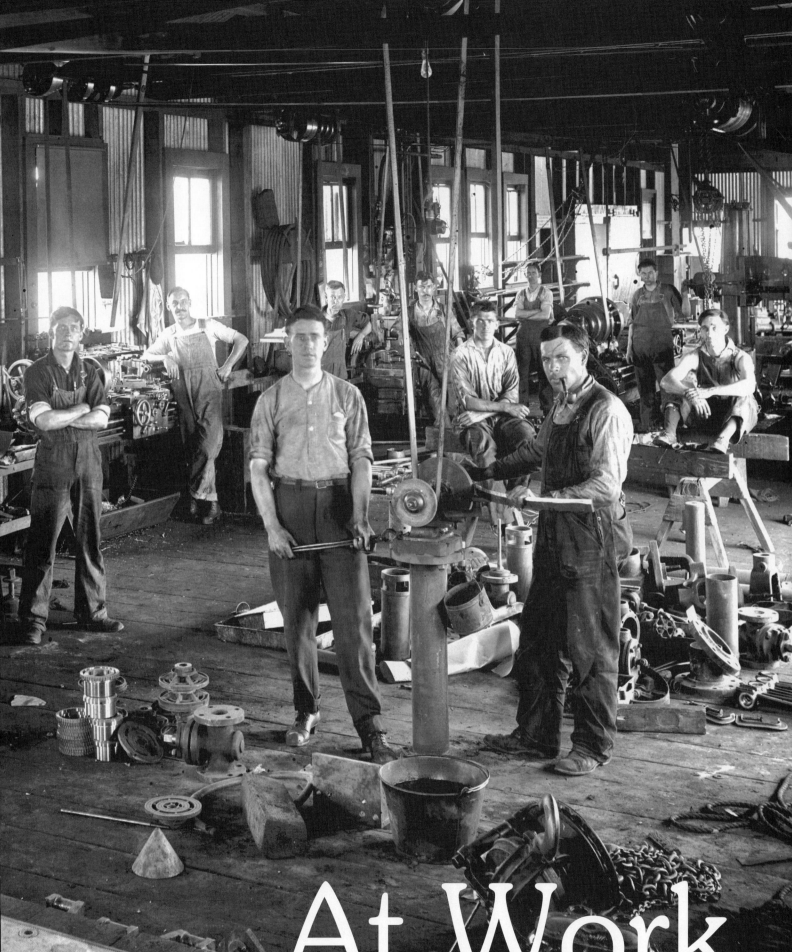

At Work

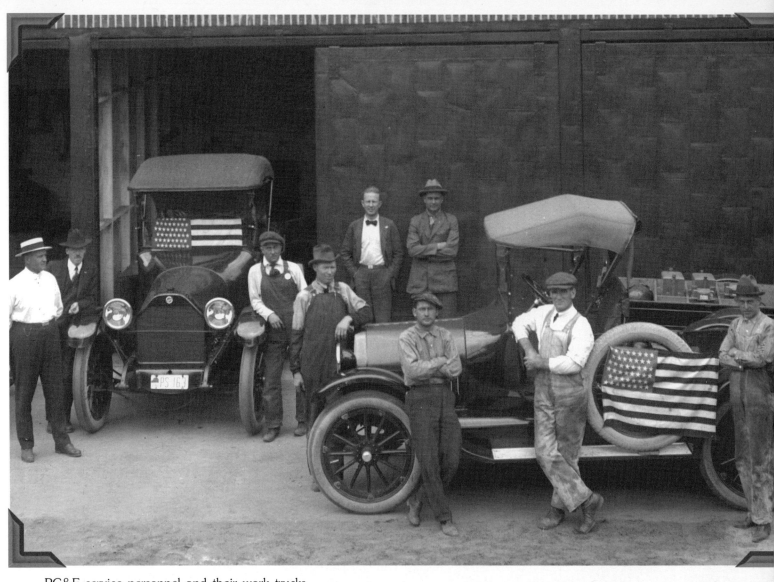

PG&E service personnel and their work trucks ready to tackle the problems of the day. Note that the gas meters in the bed of the truck on the right look the same as today's equipment. May 24, 1917.

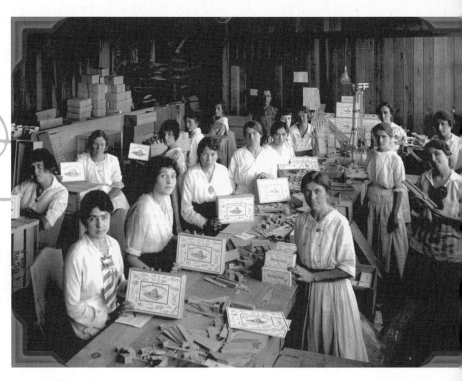

Right and following page: While grateful not to be laboring in the fields, ladies at the packaging tables of Madera's Thurman Sash and Door Company seemed somewhat shy about posing for the camera while boxing the very popular Bungalow Building Blocks. June 27, 1916.

Previous page: Iron craftsmen pause at their duties down on the shop floor at the Inland Iron Company located at 926 H Street. The company was owned by Ole P. Kieldsen. Roy H. Hall served as manager. Date unknown.

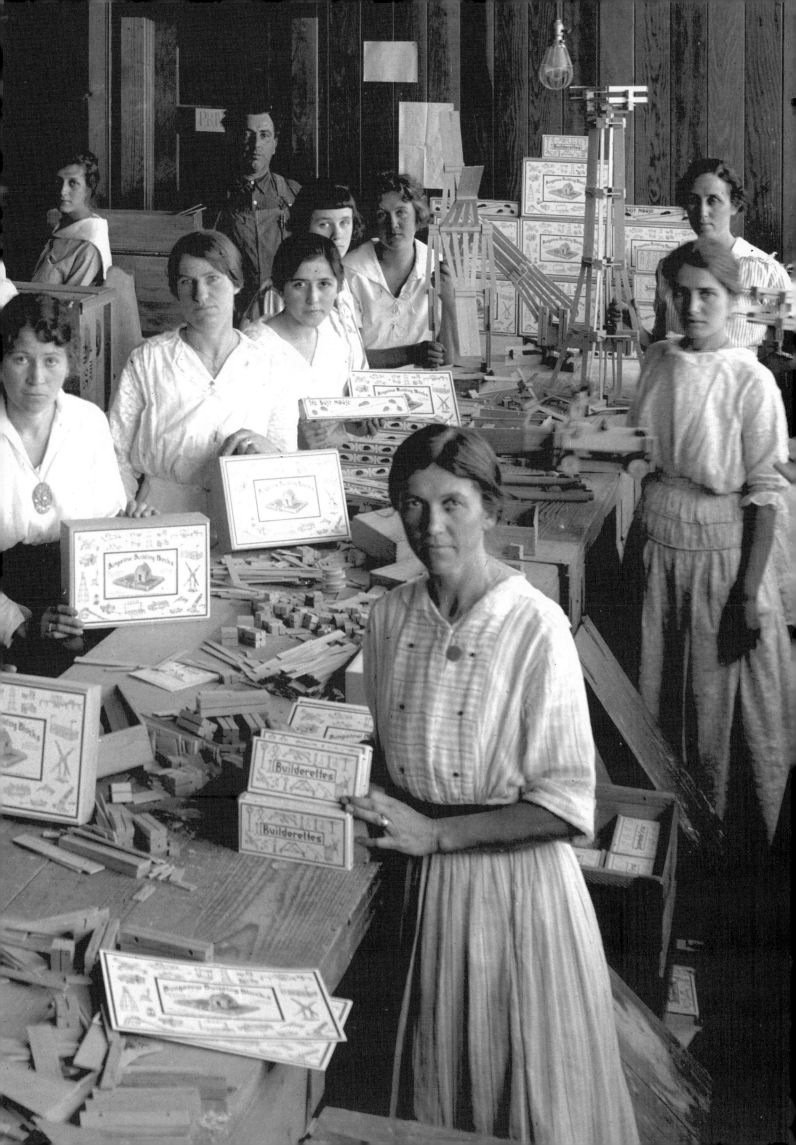

Pop Says...

Write a Letter

I wonder how many times you have looked for the mailman or opened your mailbox only to find it filled with advertising, requests for donations, but NO MAIL. By that I mean a letter from some member of the family away from home, a sweetheart, or some dear friend.

We all like to receive letters. There is always a feeling of anticipation, some sort of a thrill goes through you as you break the seal of an envelope. A cheery note or letter always makes the day so MUCH BRIGHTER.

If you really want to see the different emotions of joy and disappointment a letter can cause, just stand for a few minutes near the general delivery window in the post office. Watch the people who call there for mail. Note the expression of disappointment when the clerk thumbing through a stack of letters turns and says, "Nope, no mail today." And, on the other hand, watch the expression when a letter is handed out. Yes, good folks, there in front of the general delivery window you can see for yourself the joys and disappointments expressed in the faces of those who call there, for most of them do so because they are away from home.

I had a wonderful experience the other day, which brought home to me a real live demonstration of just what a letter can do for a person. I had gone to the office of a friend of mine and, as usual, when I entered, I was greeted by his secretary, a pleasant business-like young lady. But this particular morning she was ALL SMILES, just seemingly bubbling over with HAPPINESS, so much so that I couldn't help but inquire what was the reason for all this extra exuberance. "Well, 'Pop,' you know there's nothing more cheering after a hard day's work at the office to get home and find a letter in the mailbox. The minute I saw it, I didn't have to guess who it was from, for there was the familiar handwriting showing through the window of the box, a wee

bit shaky, but to me it's the grandest writing in the world. It was Dad's, which, of course, meant a LETTER FROM HOME, and tucked in behind the mailbox was a larger envelope also addressed by Dad, containing some of the latest snapshots of both Mom and Dad taken by my brother on his latest visit with the folks, and the fact that they were both enjoying the best of health—but here, wait a minute, look, here's one of Mom and Dad. Don't they look WONDERFUL? And you ask me why I am so happy—for, there's nothing that can cheer one up more than receiving a CHEERY LETTER, especially one from home. In fact a letter or a card from anyone always gives me a tremendous lift.

"Mr. Martin [that's her employer's name] has dealings with quite a number of older folks and, of course, we have their home addresses, so I have a collection of cards with cheery sayings on them. Every so often I mail a card to them just to let them know they are not forgotten after they leave here. From the pleasant responses I receive from them, I know just how much

these cards and letters mean to them, for you know, 'Pop,' there's nothing more depressing than going to the mail box and finding it empty. Sorry to have taken up so much of your time, but you asked me why I was so cheerful this morning. Well, you got your answer!"

Have YOU ever given a thought to the letters you have neglected to write, put off until tomorrow, saying to yourself, "Oh, I must write to Aunt Fanny, or Grandma, perhaps daughter or junior away at college, some friend who is ill? You know the disappointment you feel when you look in the mail box and find NO MAIL TODAY?

You see, it works both ways. The same disappointment is experienced by your own relatives and friends when they do not hear from you.

It isn't necessary to write long, lengthy letters. A cheerful note, a "hello, just don't want you to think that you are forgotten," "out of sight doesn't mean that you are out of mind," "We think of you every day"—oh, there are so many things and thoughts that can be expressed in a few words that will make the day so much cheerier for the recipient. Don't say, "I'll do it *manyana*," DO IT TODAY.

Let's look over the letters we have received the past week or so, see how many we have neglected to answer. And, remember, sometimes those we were going to write to are no longer with us, and there is no consolation in saying to yourself, "I should have written," or "I meant to write."

Take your pen or pencil in hand, WRITE TO THE FOLKS, SOME GOOD FRIENDS, SPREAD A LITTLE SUNSHINE, WRITE A LETTER—you'll be happily surprised at what a feeling of satisfaction you'll experience. You know, "Procrastination is the thief of time." DO IT NOW, TODAY, not "manyana!"

'Bye now, I'll be seeing you.

"Pop."

From *The Fresno Guide*, October 16, 1958

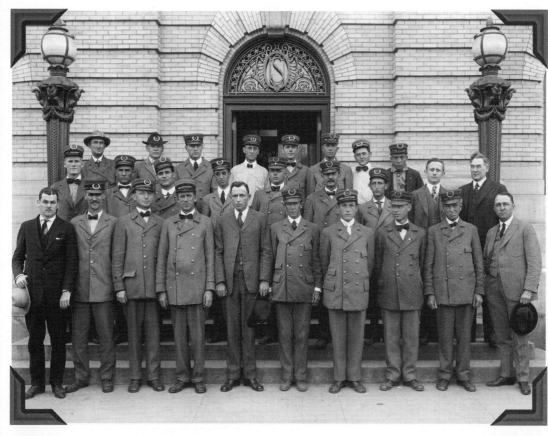

Twenty-two of the men of the Fresno Post Office were asked to help local Rotarians in collecting funds for support of the Salvation Army huts in the World War I area of France and Belgium. The men in the picture not in uniform are members of the Rotary Club committee directing the work for the Salvation Army. Top row, left to right, E. C. Shanklin, Irving Crump, Jas. Culwell, S. H. Fortune, Chas. Tochstein, T. B. Starling, Ralph Smith, Tony Mele. Second row, A. C. Scheline, S. L. Gallaher, W. H. Briner, P. R. Carter, M. A. Buechert, Chas H. Hall, G. C. Bingaman, Hugo F. Allardt, Captain Isaacs. Front row, Chase S. Osborn, Jr., S. L. Davis, J. J. Gentry, A. F. Robbins, Earle Hughes, Postmaster W. J. Sutherland, H. C. Selling, Scott Fodr, P. P. Reed, M. L. Neeley. March 23, 1918.

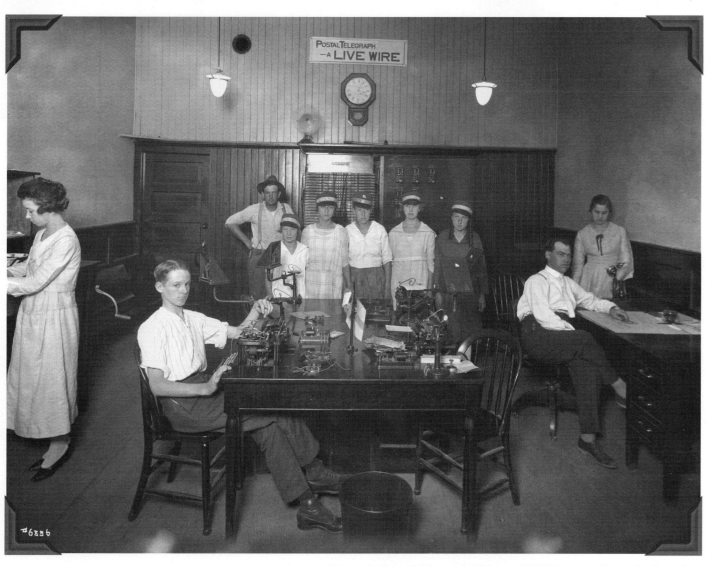

Fresno's Postal Telegraph Office at 1918 Mariposa Street had an alert and efficient staff to serve the city. July 24, 1918.

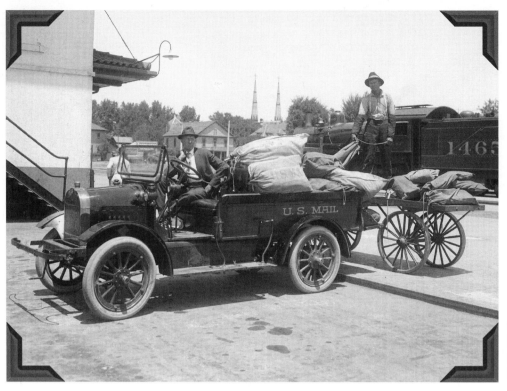

Vim Truck being loaded with mail at the Sante Fe Train Depot. The depot is one of the few remaining historical buildings in Fresno. June 23, 1916.

Bellboys in front of the Hotel Fresno. Circa 1913.

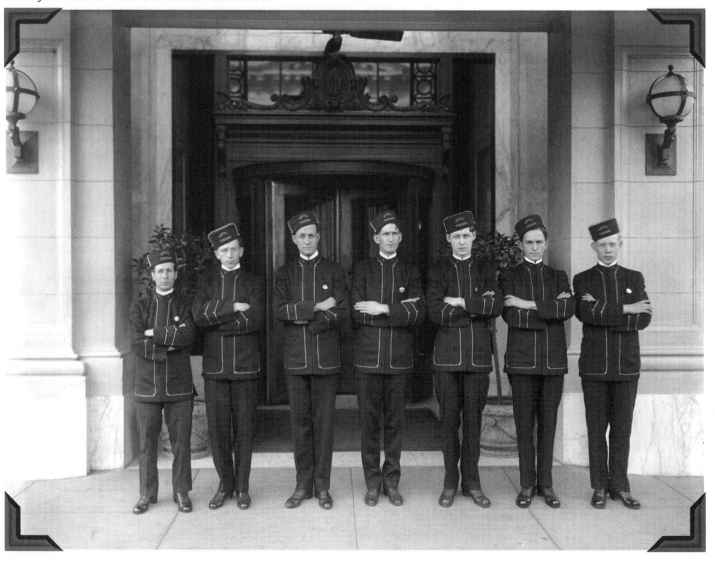

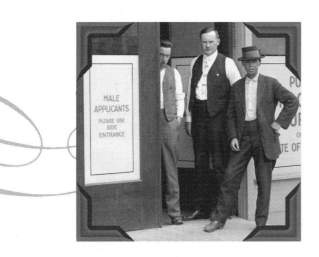

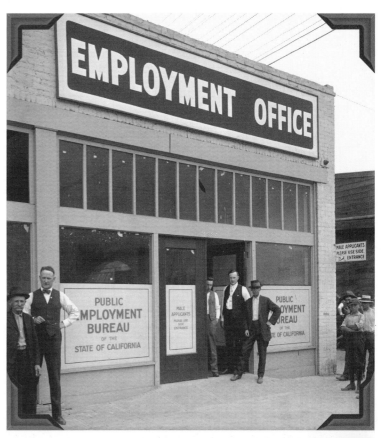

These photos show the interior and exterior of the state employment office. Unemployment hovered at about 4.6 percent and a first-class stamp cost merely two cents in 1917's wartime economy. No wonder these men don't look as grim as they might under other circumstances. Note the formality of wearing coats and vests even at the height of the Valley summer. August 23, 1917.

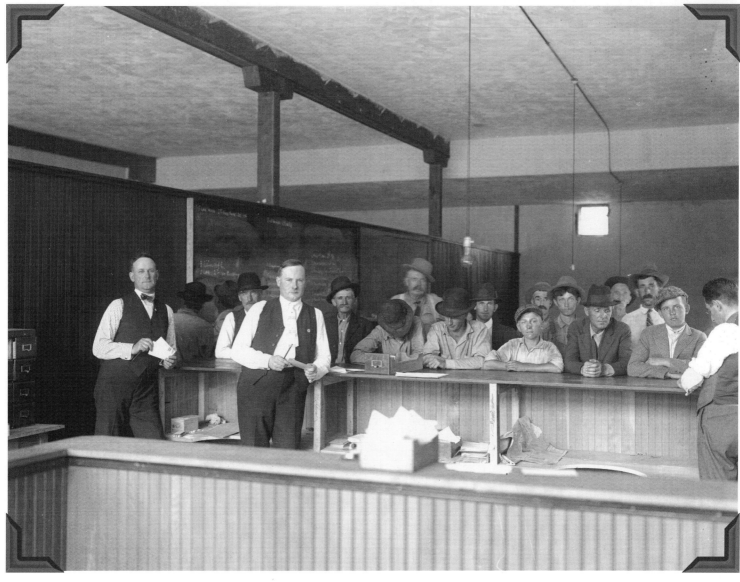

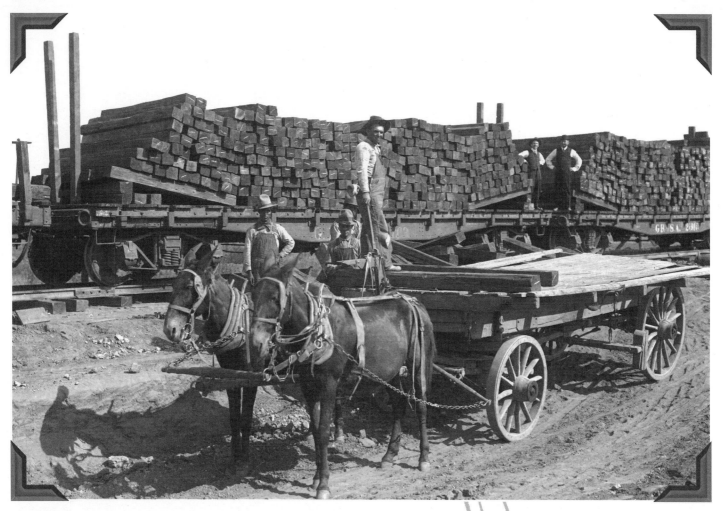

Although by the second decade of the Twentieth Century, motor-driven trucks were becoming the norm, some major hauling was left for the horses, as was the case here when a load of railroad ties was loaded in Biola. Circa 1913.

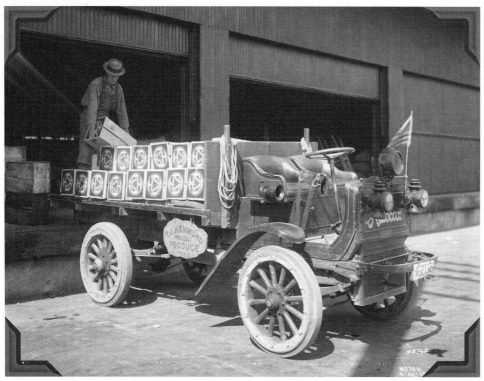

Large crates of the "I Love You California" brand of strawberry rhubarb are unloaded from this patriotic Autocar delivery truck parked at the Southern Pacific depot. Although remembered mainly as rhubarb pie filling, earliest records date back to 2700 BC in China where rhubarb was cultivated for medicinal purposes (its purgative qualities). An unnamed Maine gardener obtained seed or root stock from Europe in the period of 1790–1800, but it wasn't introduced into California until around the turn of the Twentieth Century. April 20, 1918

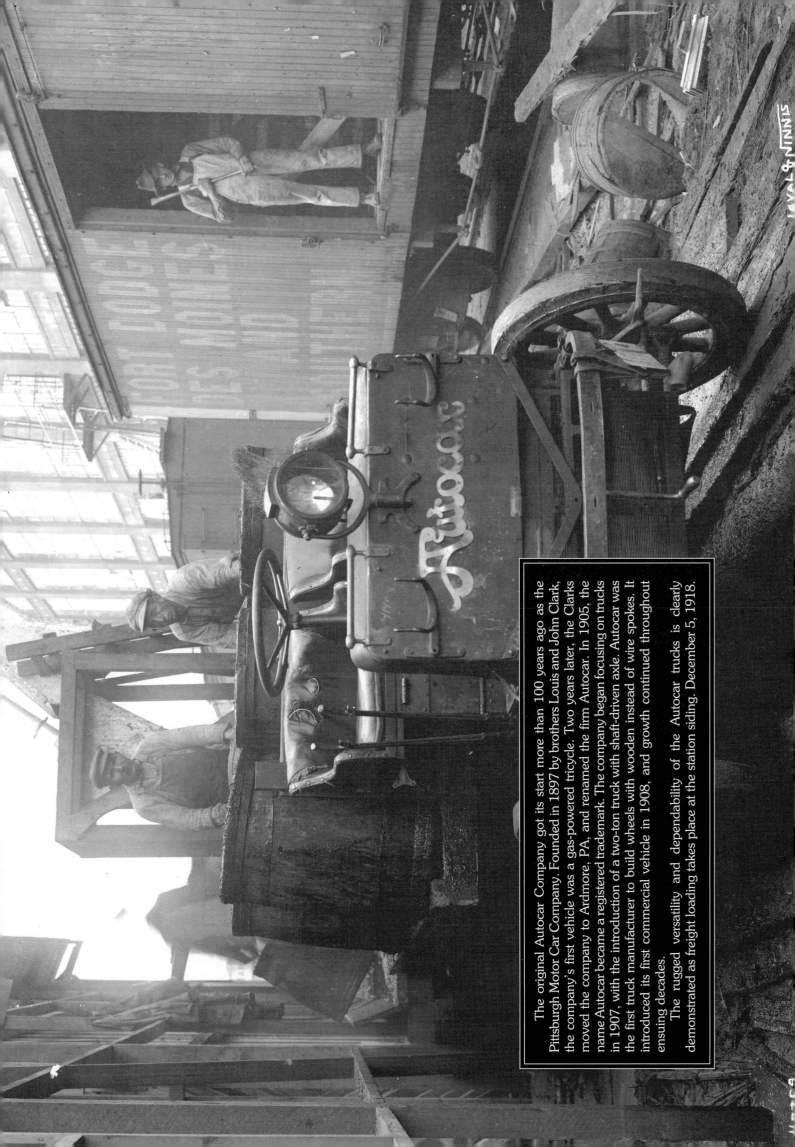

The original Autocar Company got its start more than 100 years ago as the Pittsburgh Motor Car Company. Founded in 1897 by brothers Louis and John Clark, the company's first vehicle was a gas-powered tricycle. Two years later, the Clarks moved the company to Ardmore, PA, and renamed the firm Autocar. In 1905, the name Autocar became a registered trademark. The company began focusing on trucks in 1907, with the introduction of a two-ton truck with shaft-driven axle. Autocar was the first truck manufacturer to build wheels with wooden instead of wire spokes. It introduced its first commercial vehicle in 1908, and growth continued throughout ensuing decades.

The rugged versatility and dependability of the Autocar trucks is clearly demonstrated as freight loading takes place at the station siding. December 5, 1918.

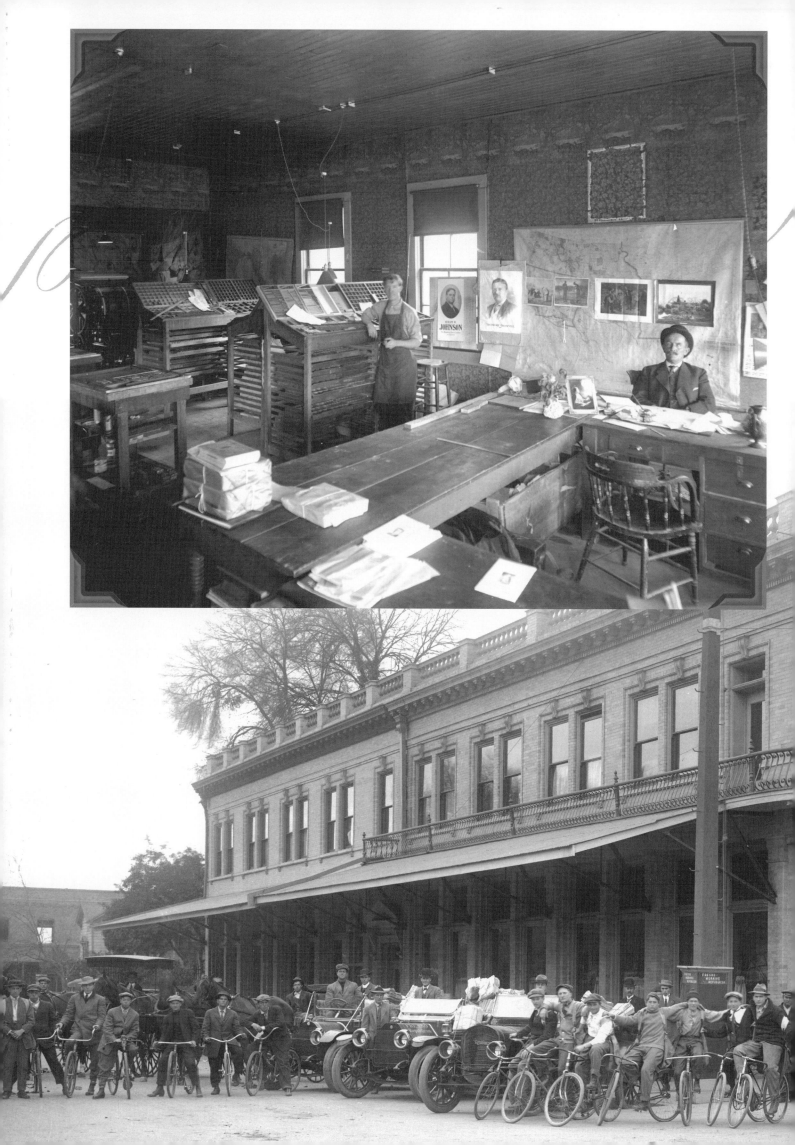

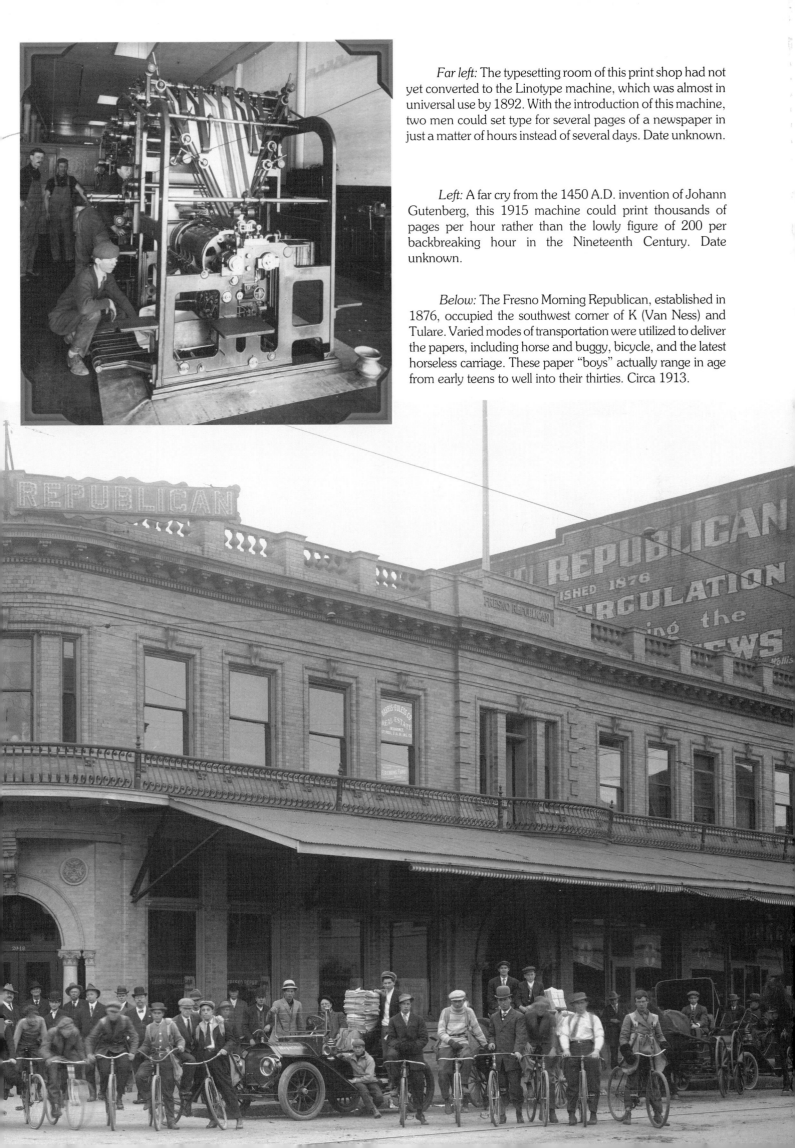

Far left: The typesetting room of this print shop had not yet converted to the Linotype machine, which was almost in universal use by 1892. With the introduction of this machine, two men could set type for several pages of a newspaper in just a matter of hours instead of several days. Date unknown.

Left: A far cry from the 1450 A.D. invention of Johann Gutenberg, this 1915 machine could print thousands of pages per hour rather than the lowly figure of 200 per backbreaking hour in the Nineteenth Century. Date unknown.

Below: The Fresno Morning Republican, established in 1876, occupied the southwest corner of K (Van Ness) and Tulare. Varied modes of transportation were utilized to deliver the papers, including horse and buggy, bicycle, and the latest horseless carriage. These paper "boys" actually range in age from early teens to well into their thirties. Circa 1913.

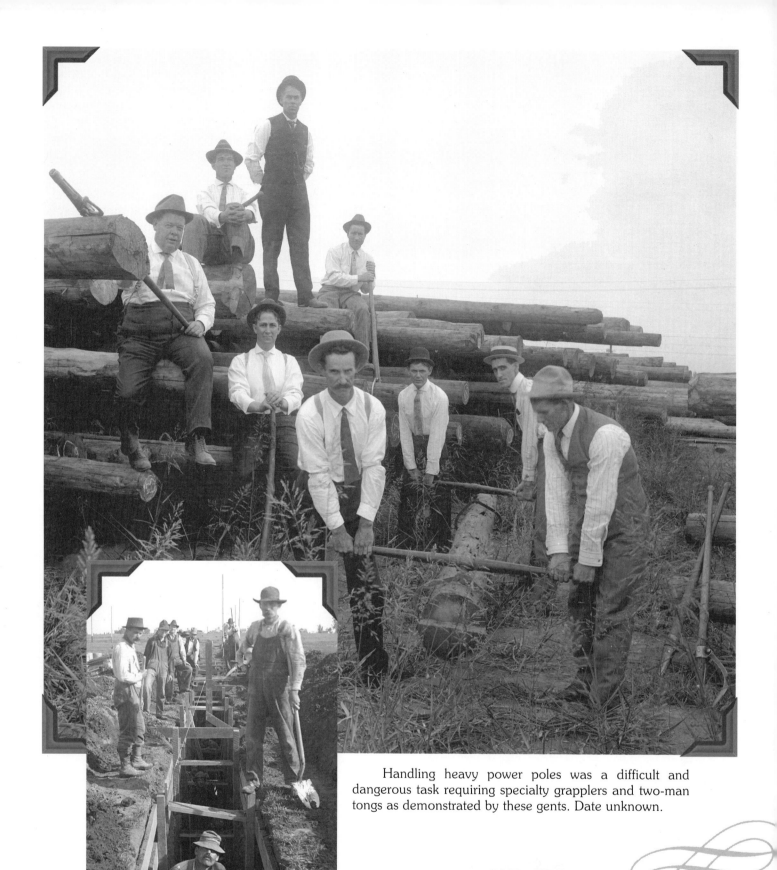

Handling heavy power poles was a difficult and dangerous task requiring specialty grapplers and two-man tongs as demonstrated by these gents. Date unknown.

Dug entirely by hand, this Kearney Boulevard sewer ditch was backbreaking work. The enhanced detail image at the immediate left shows two workers in a deep shadow area of the original image. March 25, 1911

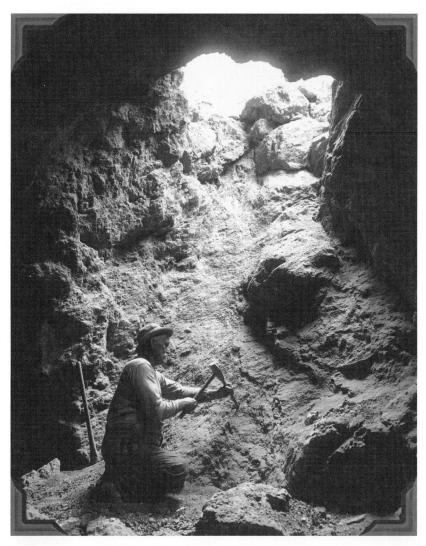

A lone miner named Morris carved out ore in his quicksilver shaft and looked toward the light of a day that had passed him by. September 11, 1915.

This steam "donkey," used to skid logs along the forest floor, is quite likely the one built in 1912 by the Willamette Iron and Steel Works for the Madera Sugar Pine Lumber Company. Date unknown.

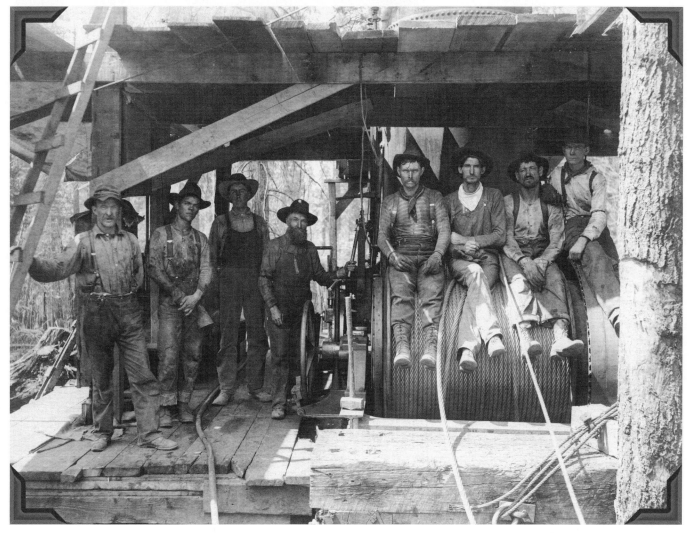

In 1914, Fresno's Benham Ice Cream Company produced 140,000 gallons of premium product and was the largest factory in California. Manager L. W. Wilson and his staff posed in their headquarters at 1420 H Street. Circa 1914.

Men remove and dress finished castings at the Fresno Cooperage Company. Circa 1912.

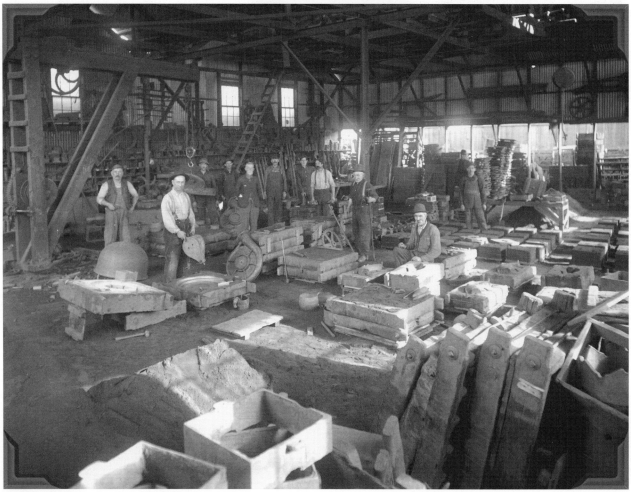

At War

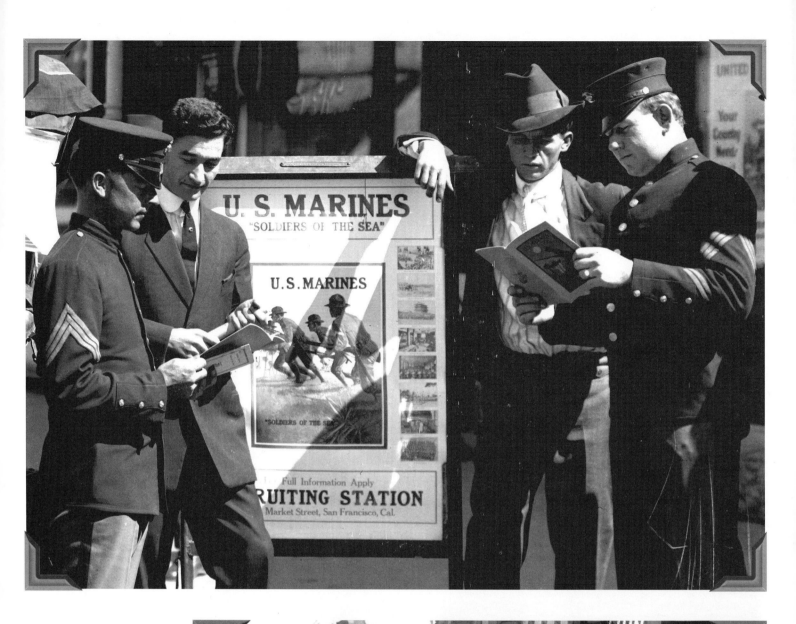

Marine Corps recruiters understood how a handsome, trim, and enthusiastic rifleman would stir patriotic fervor in the heart of a future Marine. May 15, 1917.

Previous page: All mothers who have ever sent their ever-young child out into the world would know the pride and anguished concern churning in this woman's breast as she bid Godspeed to her boy. September 19, 1917.

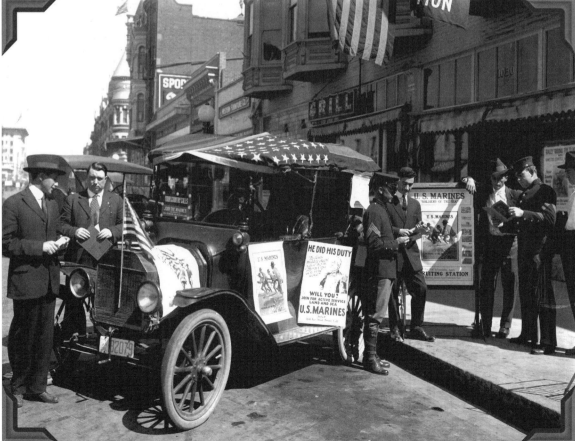

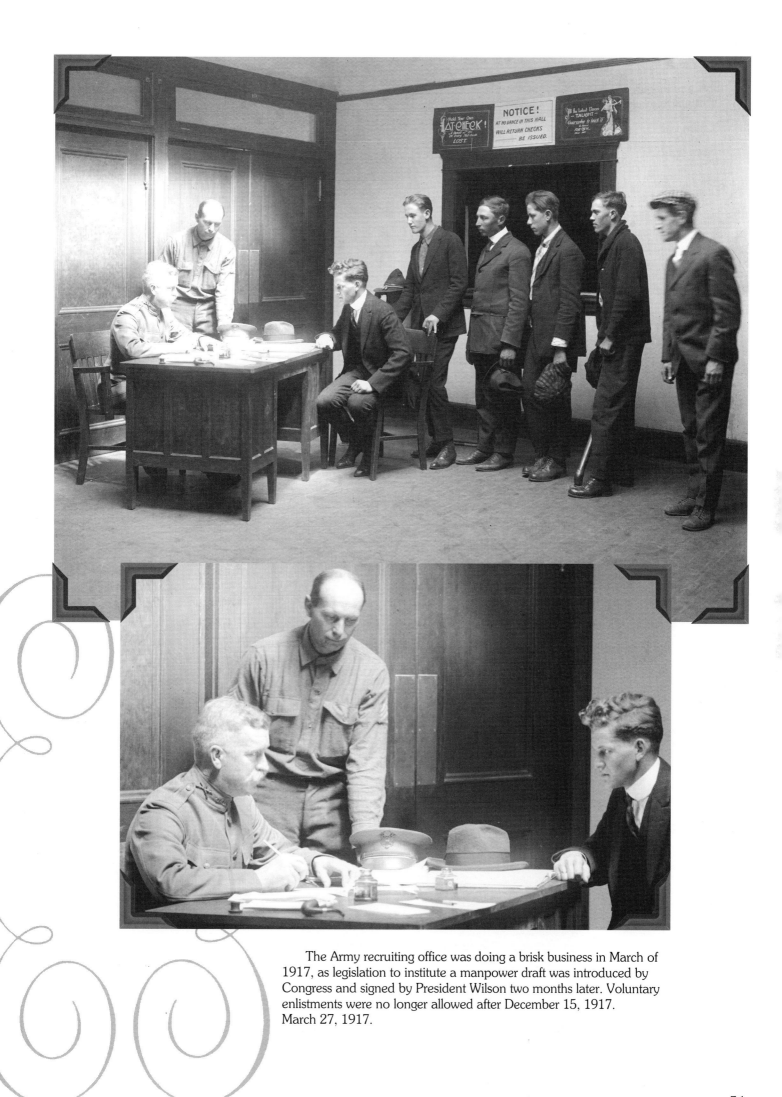

The Army recruiting office was doing a brisk business in March of 1917, as legislation to institute a manpower draft was introduced by Congress and signed by President Wilson two months later. Voluntary enlistments were no longer allowed after December 15, 1917. March 27, 1917.

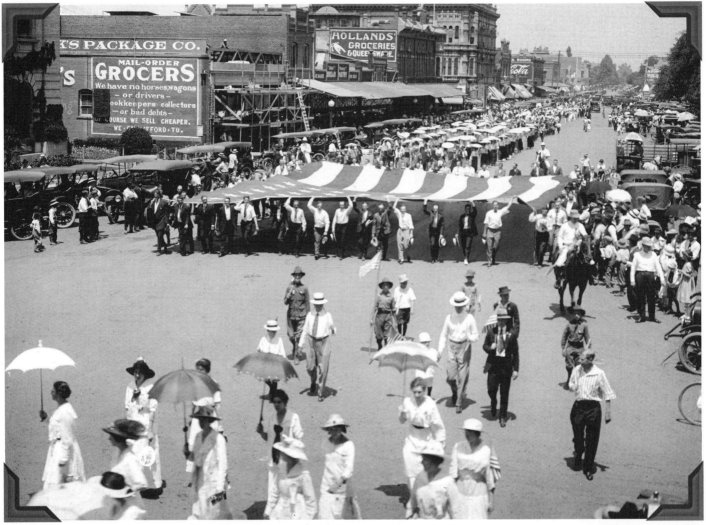

This War Preparedness Parade, in June of 1916, progressed down Van Ness Avenue in this view looking north from Tulare Street. June 14, 1916.

A huge wooden statue of a doughboy in front of the courthouse was intended as a focal point for gatherings that exhorted Americans to buy war bonds in support of the nation's $5 billion goal. October 19, 1917.

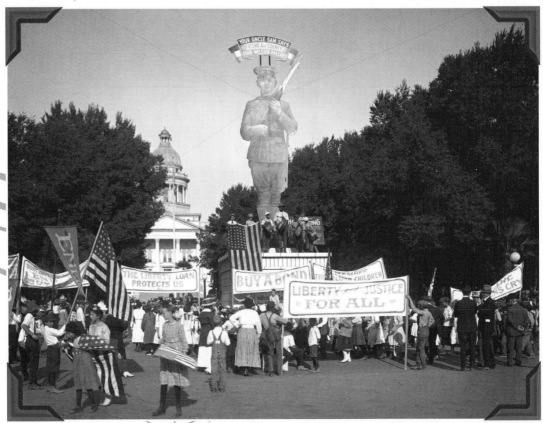

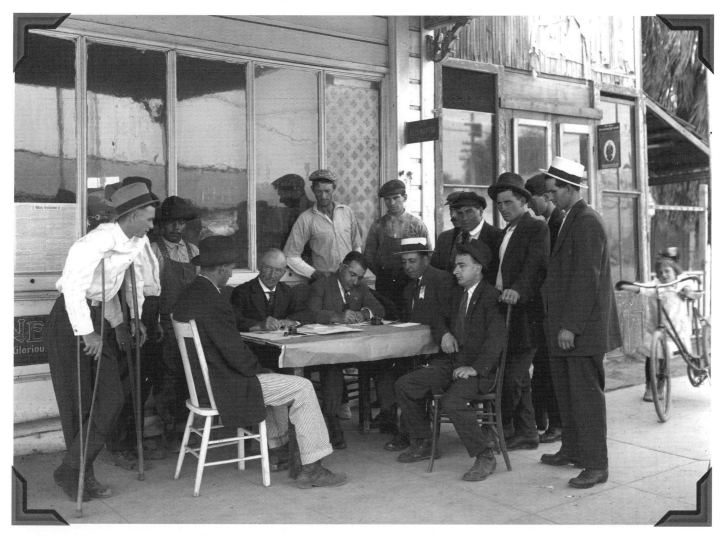

President Woodrow Wilson, on May 18, 1917, signed the Draft Law passed by Congress, declaring that anyone failing to register would be liable for a year in prison. On the first day, about 10 million men nation wide joined these Fresno citizens who answered the call. May 1917.

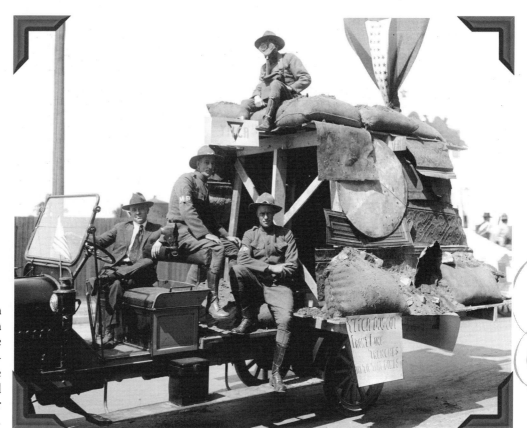

This mock up of a fortified bunker brought a glimpse of life at the battle front, providing the concerned families on the home front with a visual touch of the world of their loved ones. Circa 1917.

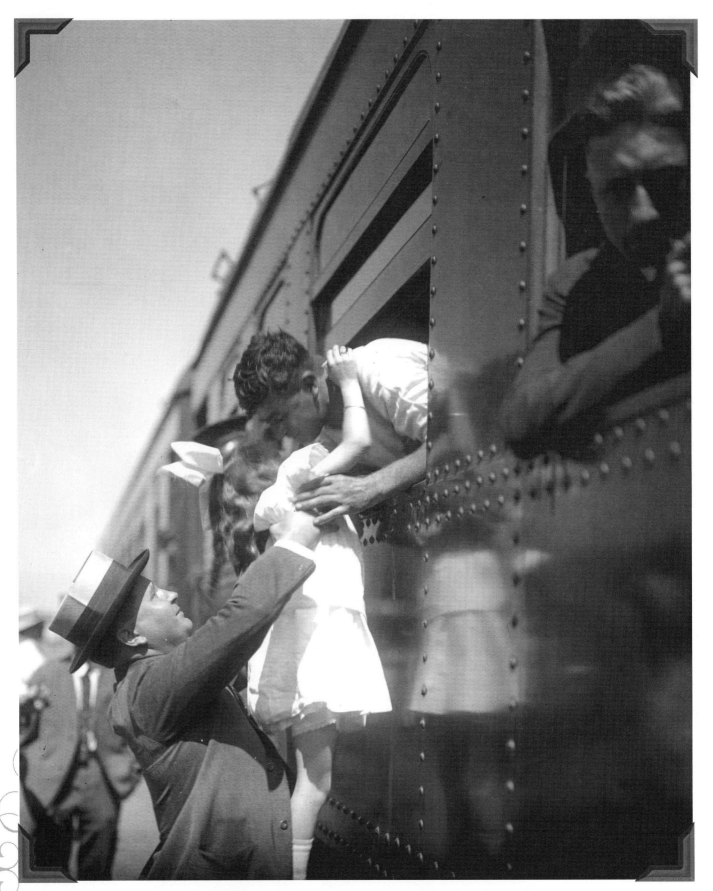

Soon to be a uniformed doughboy, Joe Maulini gave his young sister a heartfelt hug and reminder to keep up a brave heart for him. September 9, 1917.

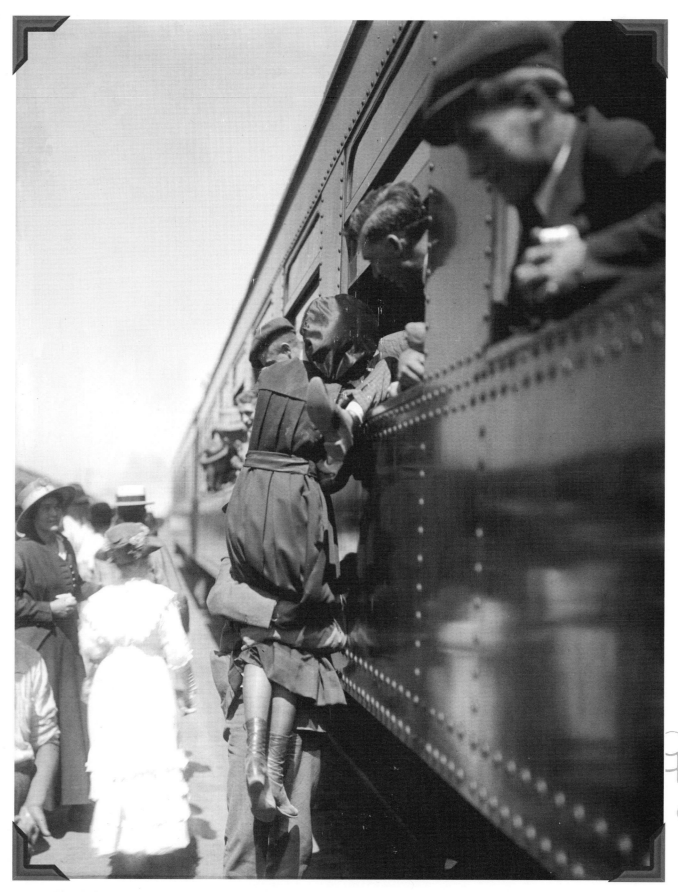

This Selma lass clung to her beau as long as possible, smothering him with a long good-bye kiss which had to last them both until he returned from places unknown. September 9, 1917.

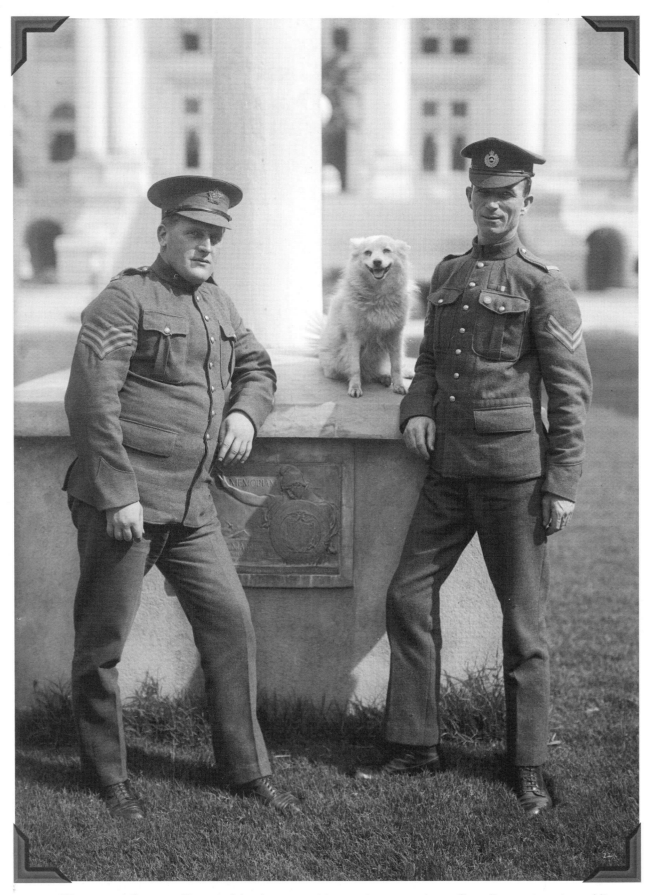

War veteran Sergeant Bomar of the Army recruiting services, escorting a Canadian engineering soldier and his dog "Pom." Corporal Joseph Caray was gravely wounded while serving with his British compatriots in France, yet survived to fight again before trying to inspire American lads to join in the war effort. October 13, 1917.

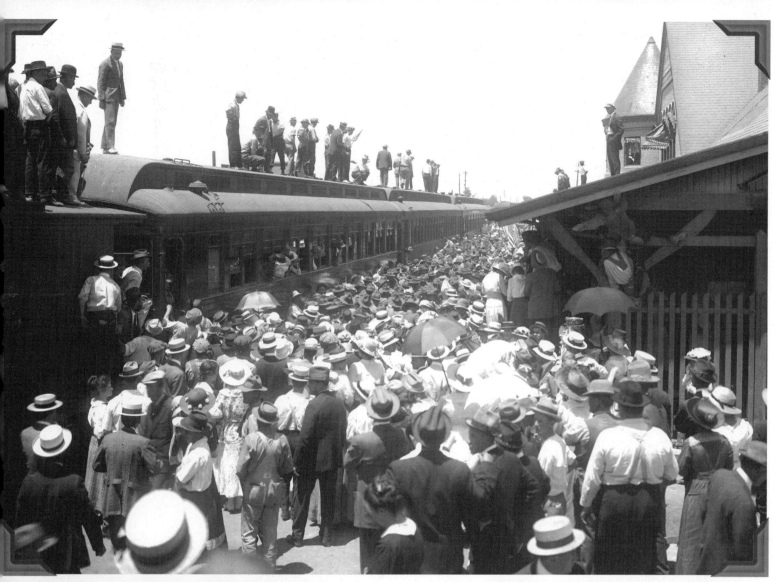

A somber yet determined throng of well-wishers held on for the last touch or sight of their brothers, sons, and friends until the big steam locomotive finally pulled the loaded cars onto the mainline for Sacramento, toward whatever fate held in store. June 23, 1916.

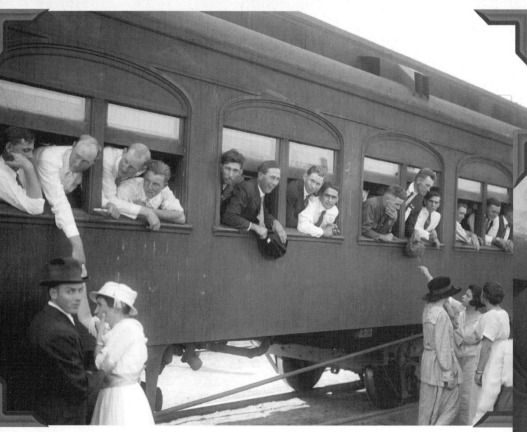

An early batch of inductees departed with brave faces, trying to be of good cheer for the moms, dads, and sweethearts left behind. October 5, 1917.

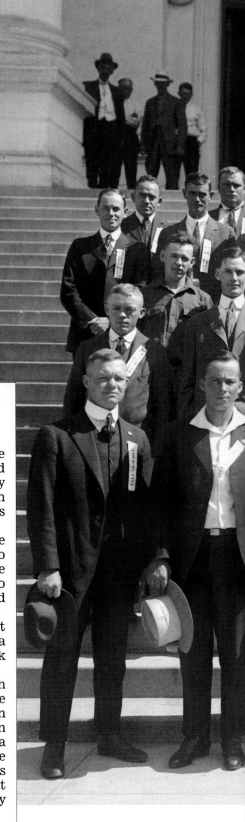

Crowds Honor First Contingent to Leave
for Training Camp; Soldiers Cheered

Amid tears and cheers, Fresno yesterday bade farewell to the forty-five men and boys from this city and county who entrained for American Lake to make up the first contingent for the National Army. Hands were waved, Godspeed was wished the soldiers, and then wet eyes were wiped as the train slowly pulled out of the local yards and the soldiers shouted their final farewell to the crowds at the depot.

It was pathetic, but patriotic and spirited, and rousing cheers were given as Fresno's men marched from the courthouse to the depot and boarded the train.

The men, forty-five in all, gathered at the courthouse yesterday morning. Roll call was held in the courtroom at the courthouse and then the men assembled on the court house steps, facing Mariposa Street.

A band, furnished by the Musicians Union, played several numbers at the park. The crowd along Mariposa Street was large and every one followed to the depot.

Girls kissed their sweethearts, mothers hugged their sons and fathers patted their boys on the back and told them to serve their country well. Fresno's boys were bedecked with buttons and ribbons furnished by the city and county boards. Just

before the train pulled out, the Fresno contingent was presented with a large American flag by Harry Joseph of the Spanish-American War Veterans. Many little presents were presented.

The majority of the boys were cheerful. They were eager to get into training and many expressed the hope to soon be across the ocean to uphold the dignity of the United States.

But the scene was not without touching moments and many a father's eyes were wet as he shook hands with his son.

Drafted men from counties south of Fresno were on the train. There were deafening hurrahs as the men who will train at Camp Lewis met on the depot platform, and it was but a few moments until the boys of the San Joaquin Valley had locked arms and were telling each other what they were going to do when they faced the enemy on the firing line.

One man left a $20 gold piece, his worldly possessions, under his pillow in a local hotel, and he did not discover the loss until a few minutes before time for the train to depart. Dr. Hollingsworth, chairman of Board No. 1, recovered the money and gave it to the soldier just as the train was pulling out.

From *The Fresno Morning Republican*,
September 10, 1917

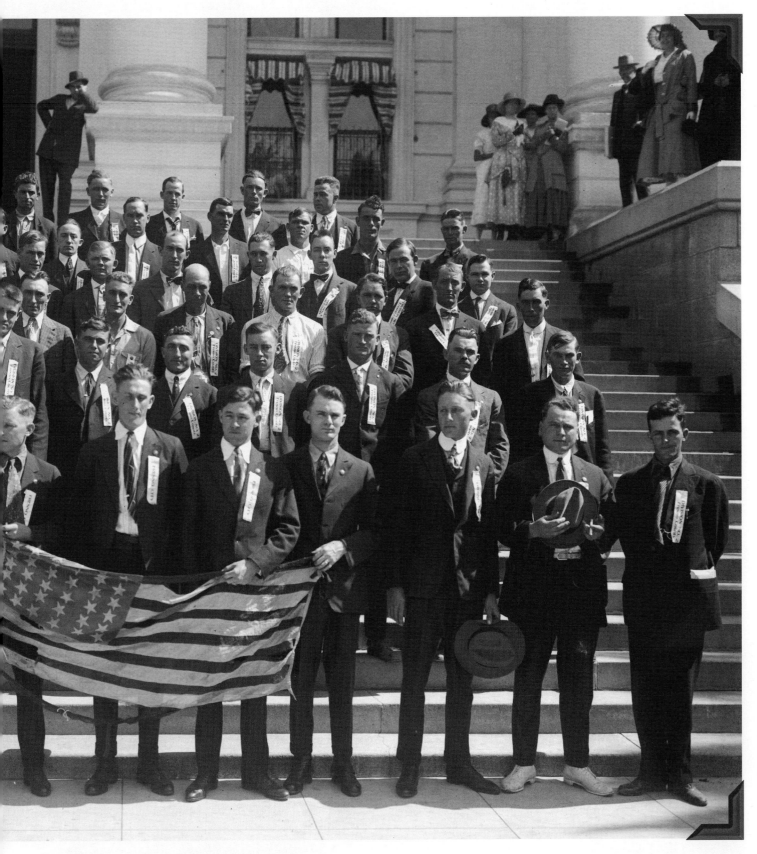

Fresno City and County officials gathered to praise and encourage the first contingent of young men departing for Army training. Lower row, left to right, Carl Thiele, Joseph Armas, Charles Coyle, Chester Malott, Forest Farr, George Peddy, Carl Ellithorpe, Albert Grunewald, Victor Gaines, Others in the picture are: Ronald C. Gillis, Roy T. Ray, Jesse L. Whitlock, Harold W. Sohm, Harold L. Snedecker, James H. Hollingshead, Luigo Puccenelli, Charles Beaver, James B. Sivils, Hans R. Anderson, William A. Baird, Thomas Qualis, Joseph L. Armstrong, Elmer O. Schwab, Joseph W. Hedrick, Roy Lee Head, Frederick C. Coz, Thomas H. Spangles, Benjamin H. Robb, John C. Hammel, Alfred Schloenvogt, Fred H. Edwards, Emmett C. Cockrell, David R. Harris, John V. Spence, Clarge H. Orr, Wilk Fleming , Elmer R. Stites, Hushell D. Myers, James H. McIntire, Berthal M. Jensen, Vaughn K. Taylor, John W. Emmett, Loren A. Buts, Joseph Maulini, Joe A. Ariey. September 9, 1917.

U.S. Army sharp-shooters visited the local recruiting office to answer questions about the training and field operations a new soldier could expect. October 16, 1914.

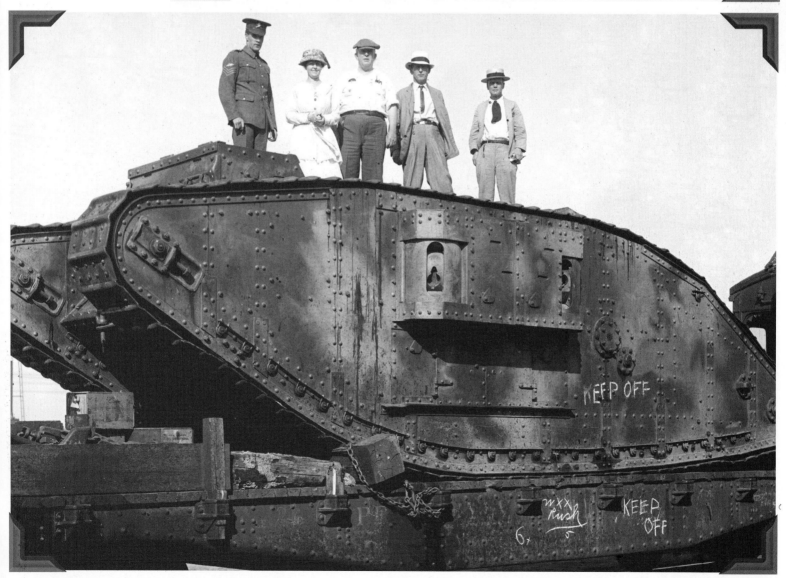

Just a glance at Britannia, the British war tank passing through the Calwa rail yards, was enough to bring home to noncombatants a staggering reality of the devastating conflict raging across Europe. Standing atop the behemoth, left to right, are: Sgt. R. V. Burnside, Mrs. Al Braverman, Fresno Mayor W. F. Toomey, Police Chief John Goehring, and David Anderson. July 6, 1918.

Right: Red Cross Volunteers set up a tea room in the Liberty Theater. This venture, proved highly successful and added many dollars to the Red Cross Fund. October 11, 1918.

Below: Nurses used their skills and training to demonstrate proper bandaging and splinting practices for the home populace, since so many trained medical personnel had left the communities to assist in the war. April 27, 1917.

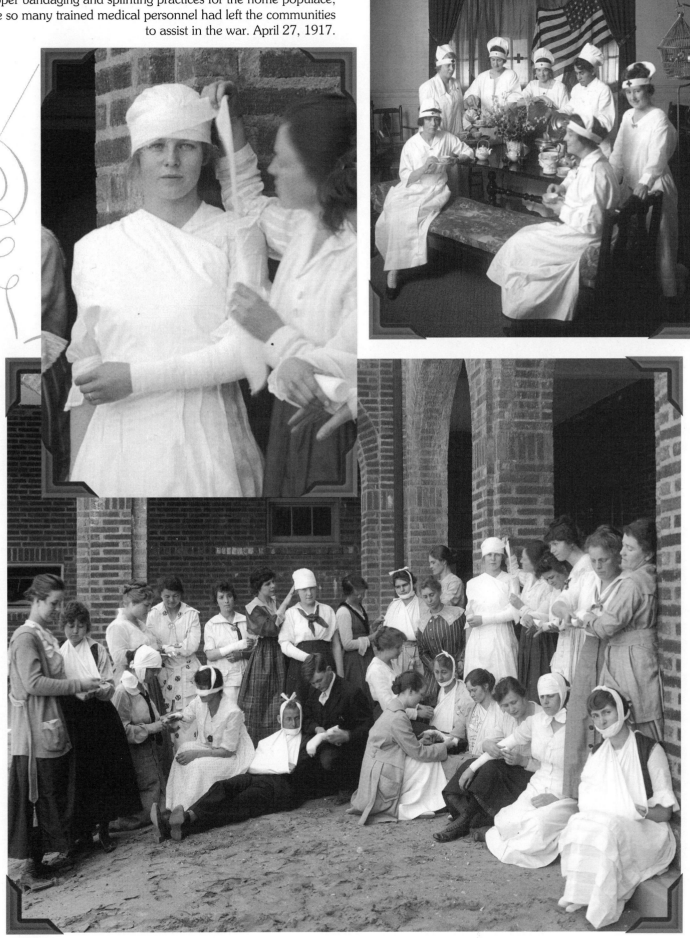

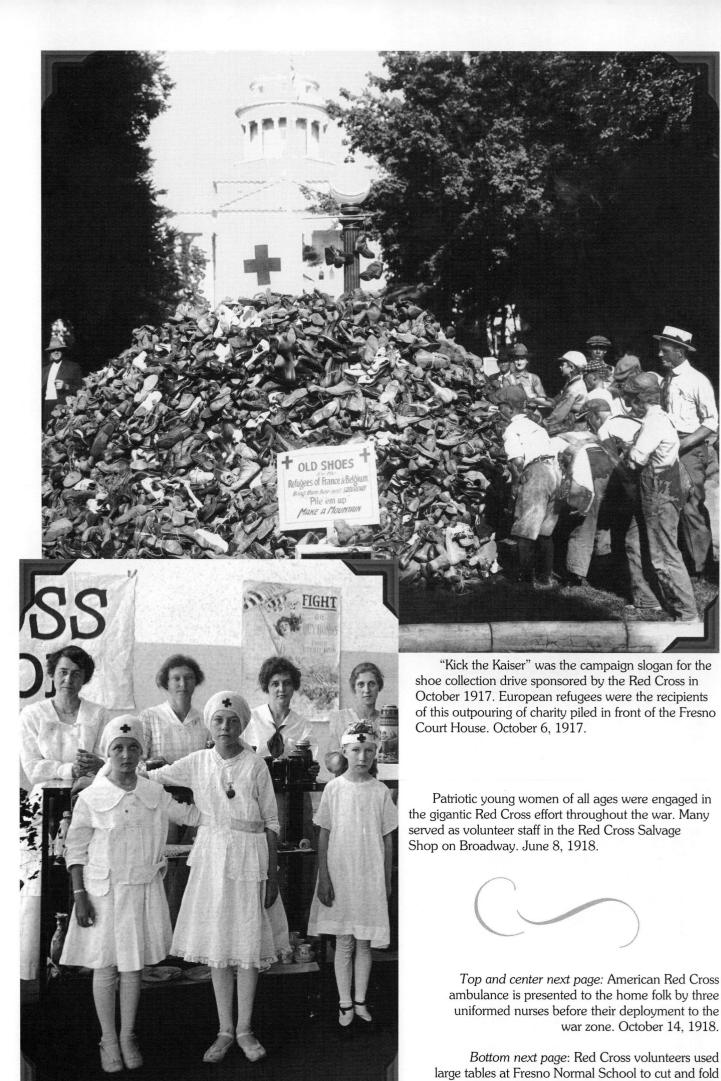

"Kick the Kaiser" was the campaign slogan for the shoe collection drive sponsored by the Red Cross in October 1917. European refugees were the recipients of this outpouring of charity piled in front of the Fresno Court House. October 6, 1917.

Patriotic young women of all ages were engaged in the gigantic Red Cross effort throughout the war. Many served as volunteer staff in the Red Cross Salvage Shop on Broadway. June 8, 1918.

Top and center next page: American Red Cross ambulance is presented to the home folk by three uniformed nurses before their deployment to the war zone. October 14, 1918.

Bottom next page: Red Cross volunteers used large tables at Fresno Normal School to cut and fold bandages needed for the wounded. April 2, 1918.

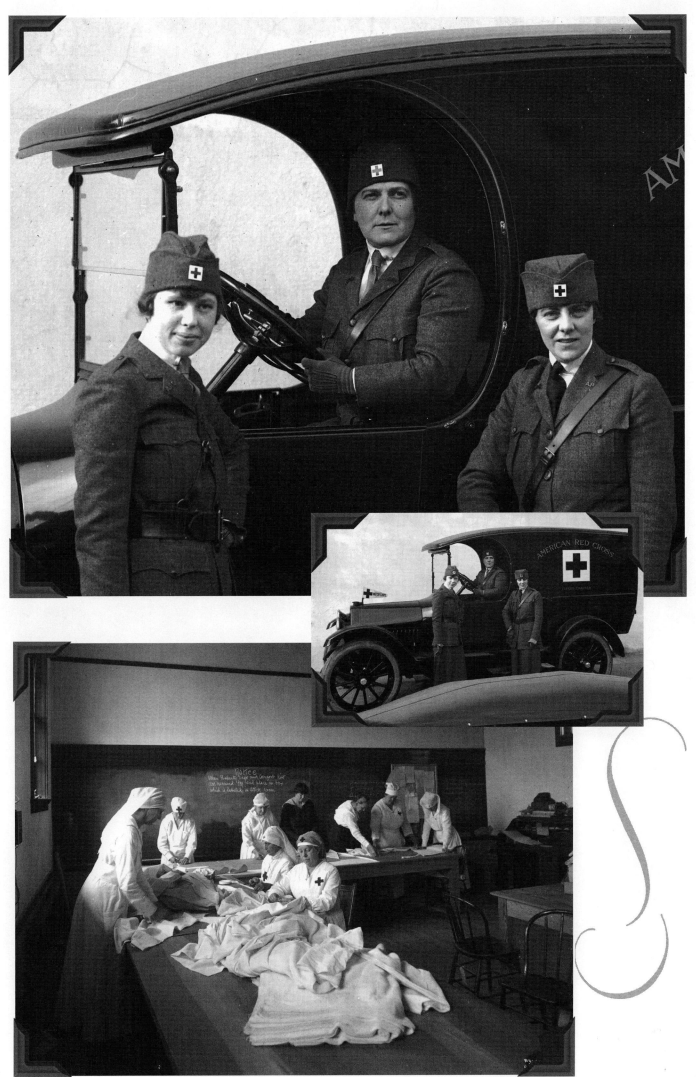

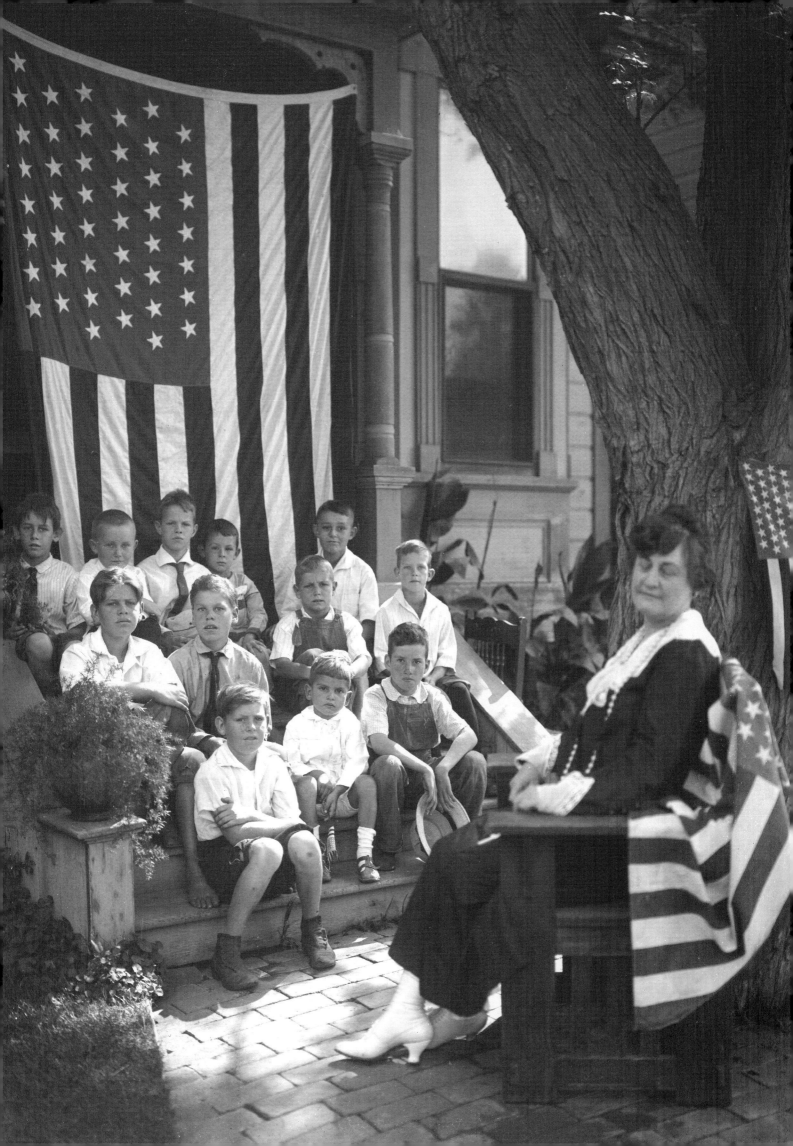

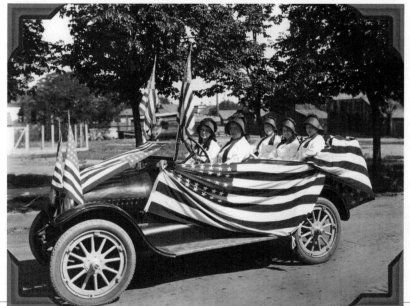

A Buick-full of Sun-Maid beauties supports the war effort at home. Circa 1917.

Pop Says...

Lest We Forget

Just four days from tomorrow, the entire nation is going to celebrate the glorious fourth of July. That's the date back in 1776 (184 years ago). As good old Abe Lincoln put it, when our forefathers brought forth this nation, dedicated to the proposition that all men are created equal. That was the day when the Declaration of Independence was adopted by the Continental Congress back in Philadelphia and signed by John Hancock, its president.

By now you are probably saying to yourself, "We know all this." I just wanted to refresh your memory. With all the turmoil that is going on in the world today, many people are prone to forget and I often wonder how many quite realize the significance of what that momentous occasion means to us today.

Thousands upon thousands of people have been looking forward to this Fourth of July, seeing as how to many it is going to mean a long weekend, a three-day holiday. I, for one, think it would be an appropriate idea if before we start celebrating, in whatever way you propose to do it, we bow our heads and offer a silent prayer of thanks to the good Lord for all the bountiful things that have made this United States of America, the greatest nation in the world today, with freedom and liberty to each and every one of us. All this was made possible when those courageous forefathers of ours had the courage to affix their signatures to the Declaration of Independence.

I sometimes wonder if the majority of people ever stop long enough to evaluate the tremendous impact the signing of this document has meant to you and me personally. To me it means Liberty, the opportunity to worship in whatever creed of my choosing, no matter what denomination, to go and come as I choose. The liberty to express my views and opinions on any question, national or local, the liberty to cast my vote and help select men who shall run our government, from the president on down.

Remember how strongly another of our great orators expressed his feelings regarding freedom when good old Patrick Henry stood up and shouted to the whole world "Give me liberty or give me death." Well, as far as we who are living here today are concerned, we all have been given that liberty.

Lest we forget, this Fourth of July, Old Glory, the most beautiful flag in the world today, will make its first official appearance carrying fifty stars in its field of blue, Hawaii, being the 37th state to be added to the original thirteen. There, my friends, I have expressed by thoughts as to what the Fourth of July, Independence Day, means to me. Love, life, and the pursuit of happiness in this, the greatest country in the world today.

'Bye now, I'll be seeing you.
 "Pop."

From *The Fresno Guide*, June 30, 1960

Left: Feelings of patriotism were high in the mid years of WWI, as Mrs. Hoffman gathered her young students for a question and answer session in the afternoon sunshine. August 21, 1917.

Mrs. Mary Mankins became Fresno's first Gold Star mother. Her son, Private Homer Blevens, who had participated in two wars before reaching the age of eighteen, died in France as the Germans shelled his trench in May of 1918. Gold Star Mother was the name conferred on mothers and widows of WWI and WWII military personnel whose loved ones made the supreme sacrifice during the wars. July 4, 1918.

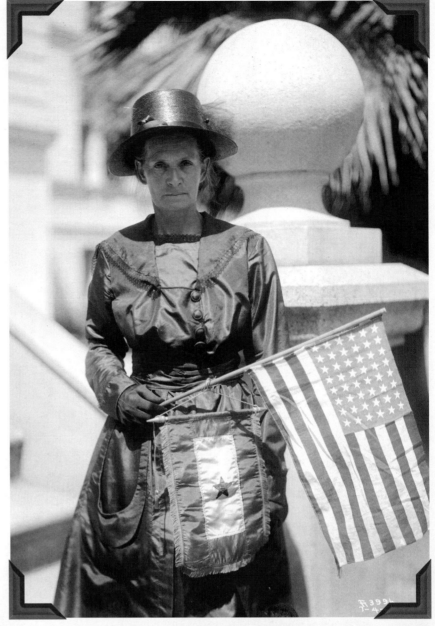

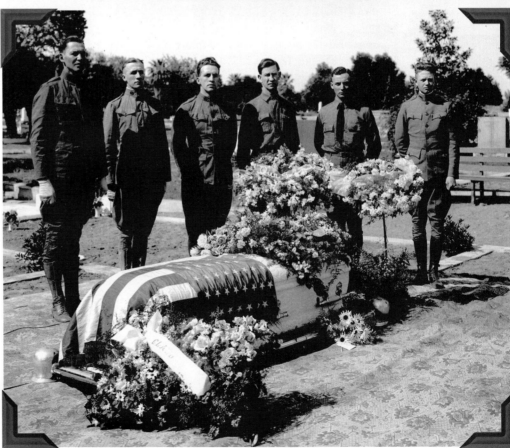

A young hero's return home was all too often accompanied by a military honor guard and a flag-draped coffin, as was the destiny of Claude Whitney. April 25, 1918.

Families

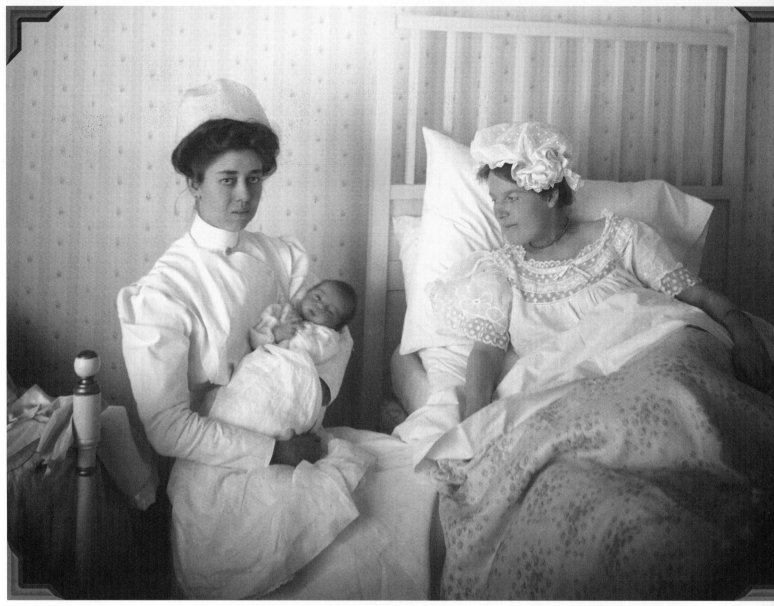

The Cross Sanitorium, at 1060 T Street, was owned by Dr. William W. Cross and managed by Jessie Fraser and Clara Woodside. The facility strived to give the mother-to-be the feeling of home birthing, since less than five percent of newborns were born in a medical facility during the early part of the Twentieth century. Circa 1913.

Has there ever been a mother who could resist showing off her darling baby in a contest? These youngsters display no concern that it is likely they too will become a proud mom or doting grandmother. March 22, 1917.

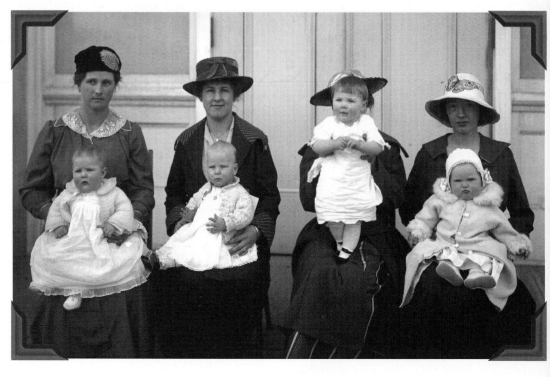

Previous page: Evelyn and Eleanore Roeding pose with their fruit basket. The girls are the daughters of George C. Roeding who, along with his father Fredrick, gave fifty-nine acres to the City of Fresno to develop Roeding Park. January 23, 1915.

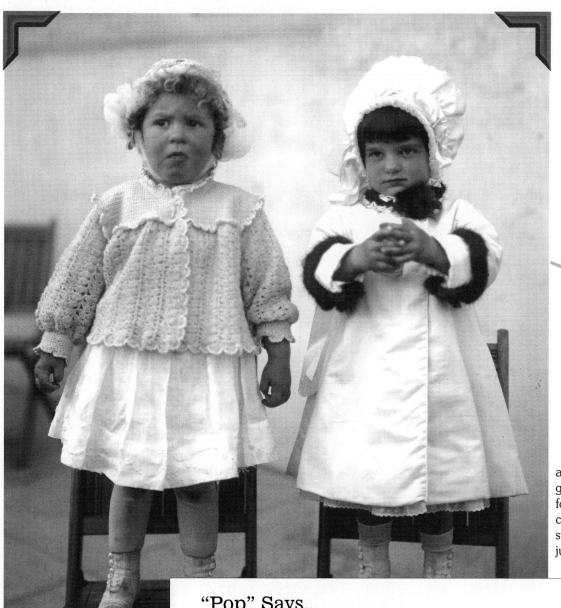

Class D of the baby show attracted these two toddlers, groomed, dressed, and forewarned to avoid the chocolate ice cream and strawberry tarts until after the judging. March 22, 1917.

"Pop" Says...

Babies Are a Blessing

Another cheery good morning to you all out there. Hope you're feeling fine and fit as a fiddle.

...On a very cheerful subject, I sometimes wonder if you have ever given thought as to just what a baby is? Well, to me, it represents an alimentary canal with a loud voice at one end and no responsibility at the other. A native of all countries who speaks the language of none. An inhabitant of Lapland. The most extensive employer of female labor. The morning caller, the noonday crawler, and the midnight brawler.

He or she might be a healthy pink but may also be a loud YELLER. They're the ones that teach Father how to become a floorwalker, and grandmothers—may the Good Lord bless all of them—they are the ones you bring the baby to for an over-mauling, and they often spoil them because one can't very well spank grandmothers. And that goes for grandfathers too, while they may not maul them, they sure like to kiss them, especially those born about twenty years ago.

In this day and age, babies seem to have taken their place in this busy workaday world of ours right from the very start. The babies born in this day and age are brought into the world with the help of all of the latest medical discoveries, for which we should be thankful.

When all is said and done, there is nothing in this whole wide world as HAPPY and CAREFREE and LOV-ABLE as BABIES. May the GOOD LORD BLESS and take care of all of them and those that brought them into this world, help them to watch over and guide them throughout those tender years, the only years throughout the life of every human being that are free from the cares and worries of these turbulent times we are living in. BABIES, the most PRECIOUS things we have in the world today.

'Bye now, I'll be seeing you.
"Pop."

From *The Fresno Guide*, September 14, 1961

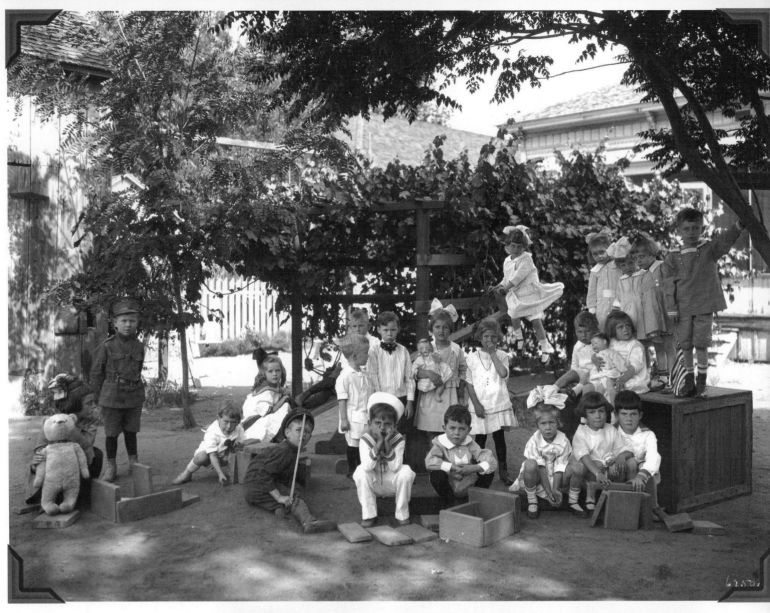

The Teddy Bear Kindergarten boys and girls considered life to be a very serious business in May of 1918. With less than six months until Armistice Day, ending WWI, young boys were eager to emulate their soldier and sailor heroes. May 23, 1918.

Always their father's favorite subject, Claude Laval . Jr., far right, and Virginia Laval, second from right, enjoyed a playful outing in Roeding Park with cousins Eugene and Aimee Laisne. May 9, 1915.

Next page: A marvelously well-mannered group of children decided to move the Keech birthday party outside into the lovely March afternoon sunshine. March 22, 1918.

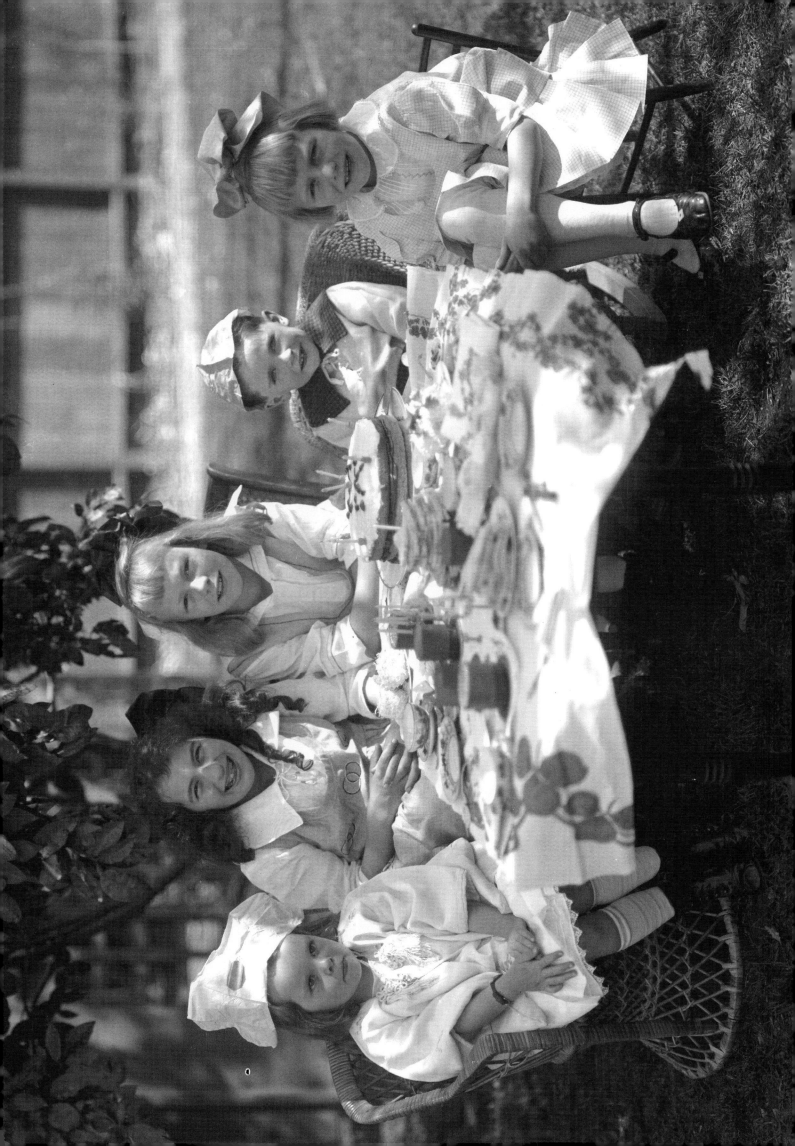

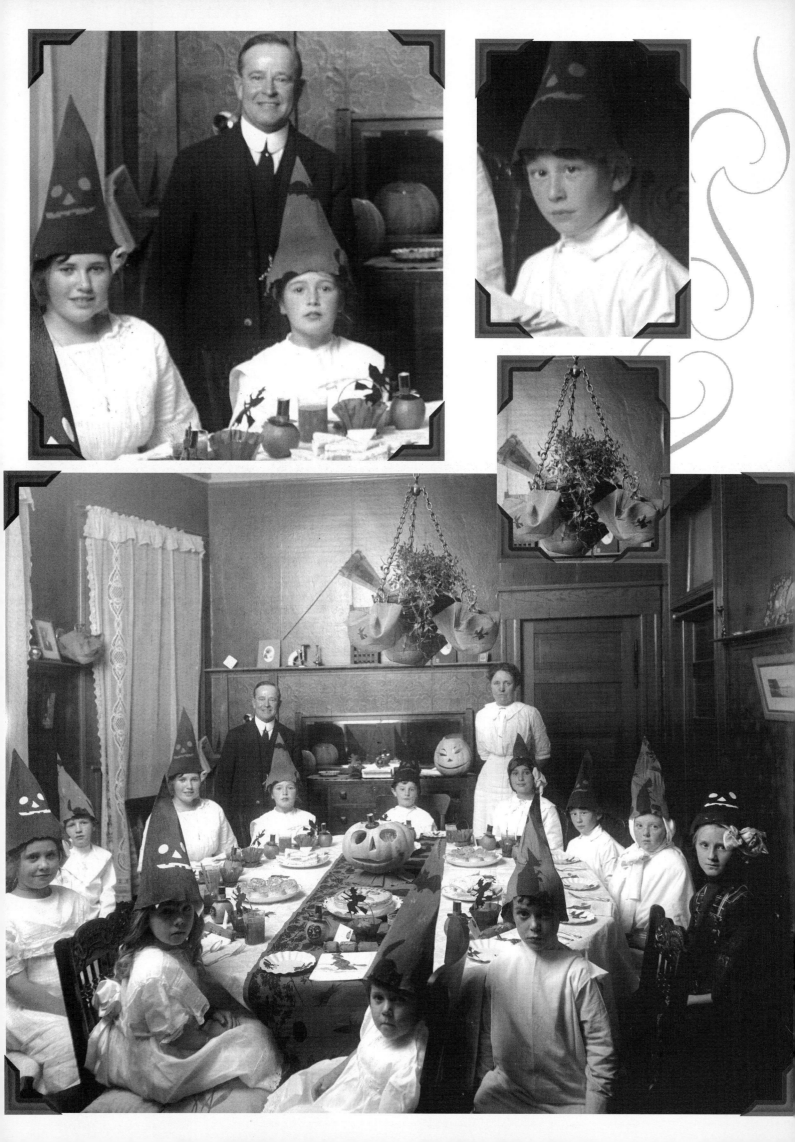

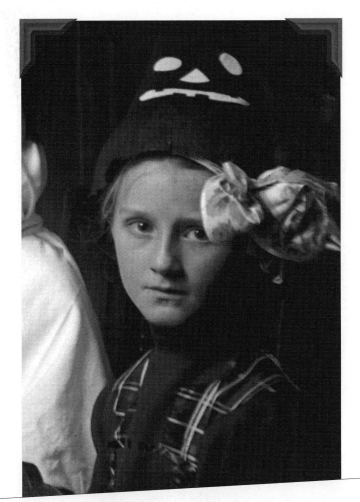

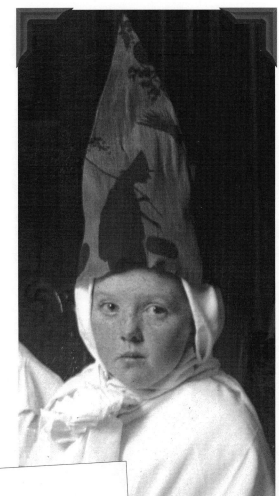

Mom and Pop Goddard invited a large group of costumed goblins in to enjoy a beautifully prepared Halloween party before embarking on their Trick or Treat haunting of the neighborhood. October 1913.

Pop Says...

Trick or Treat

Top of the morning to you all out there, hope your feeling fine and fit as a fiddle ready to meet anyone you come in contact with, throughout the day, with a happy cheery smile on your face and when you return home after your day's work is done that your face will still be wearing that happy cheery smile for you're sure going to be needing it for you may, and again you may not, have thought of it, so I am giving you fair warning that in the early part of the evening your doorbell will be ringing and it won't be Democrats soliciting funds.

Instead it will be one or more HOBGOBLINS who will shout "TRICK OR TREAT," and brothers and sisters, you had better be prepared to hand put some cookies, candies, all-day suckers, bubble gum, anything, but be sure that it is something the GOBLIN can devour, chew, crunch, masticate, or nibble on, for these goblins have a furious appetite.

Yes, folks, this is it, this is the day, October 31st. HALLOWEEN, the eve of All Saints' Day, which occurs on November 1st. So have a smile on your face. I know they will probably interrupt one of your pet TV programs, but remember when you were one of these goblins, when you probably did more then just ring the door bell and say "trick or treat." You may have been one of those who hung your neighbors' front gate on a tree limb, or put old dobbin on the front porch! If you don't go quite that far back, you do remember some of the more modern stunts you pulled that you shouldn't of.

So have plenty of goodies ready to hand out, for these days, most of your GOBLINS WILL BE OF THE SMALL VARIETY, some of them will even be accompanied by their parents who will be standing in the shadows while GOBBY rings the bell.

So, don't let all these interruptions upset you so that you will bark at those LITTLE GOBLINS who come to your door this HALLOWEEN. Remember, they are the ones who will grow up and keep this country sound and prosperous and, I hope, at peace with all the world.

You know that old saying "FOREWARNED IS FOREARMED," and this reminder came to you early this morning, for *The Fresno Guide* was sitting on your doorstep, as it does every THURSDAY and MONDAY.

'Bye, now, I'll be seeing you.
 "Pop."

From *The Fresno Guide*, October 31, 1963

73

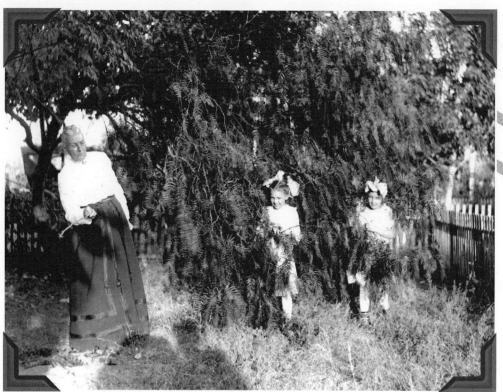

In 1914, Granny wielding a switch was all the motivation needed to encourage acceptable behavior. These two young ladies appear to sense very little threat, despite their grandmother's fearsome display of an impending moment of reckoning. Circa 1914.

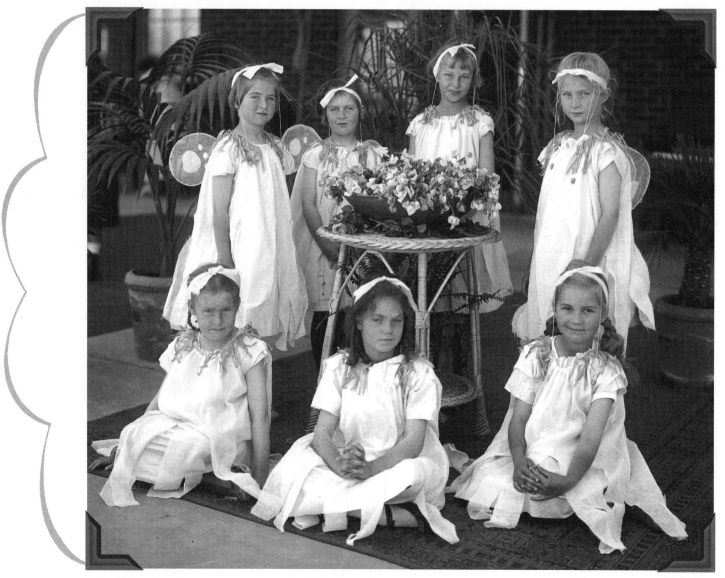

Aspiring young thespians were afforded the perfect opportunity to showcase their talents in this springtime of 1917 presentation of "Hansel and Gretel." April 27, 1917.

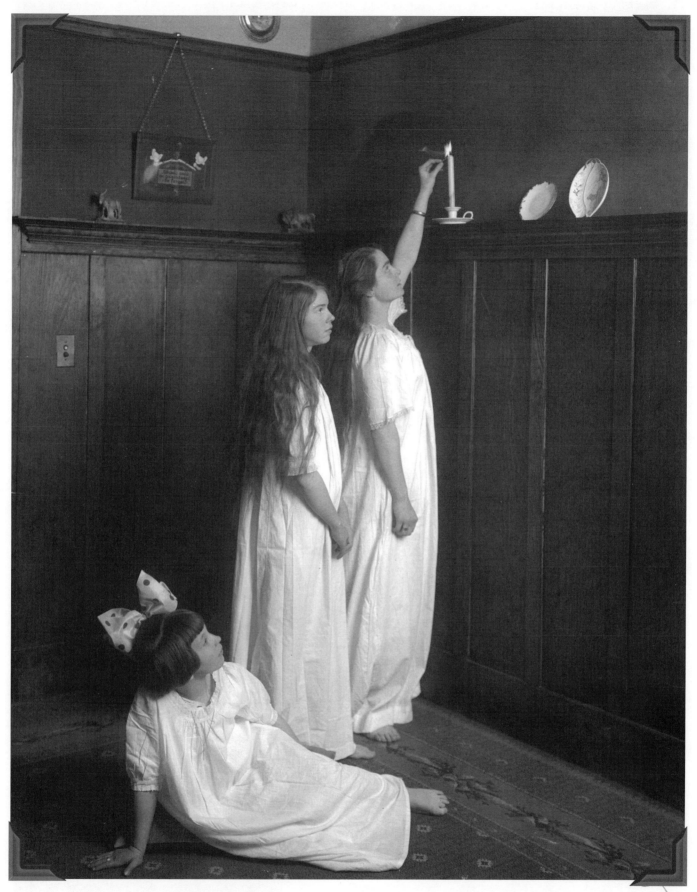

Faces scrubbed and the obligatory one hundred brush strokes of their hair completed, these young ladies lit the night candle before going quietly off to the big feather bed upstairs. Circa 1914.

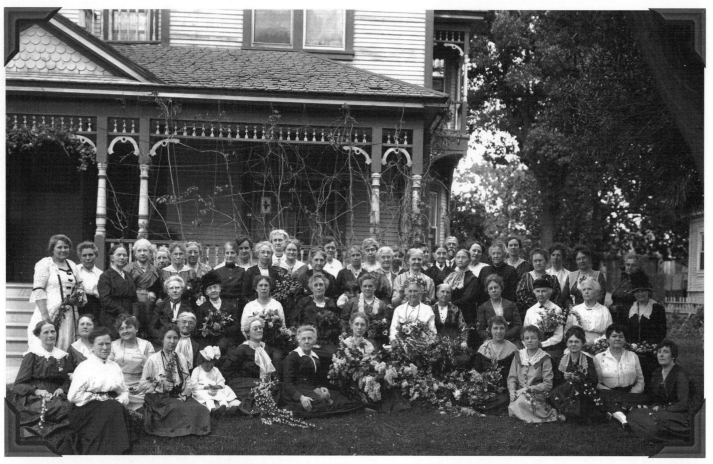

Friends and family gathered to help Mrs. S.E. Daly celebrate her 82nd birthday. April 10, 1918

Freshly back from boot camp, a young soldier poses as the entire Nelson family meets for a farewell dinner before the soldier's departure to the European battle theater. May 5, 1918

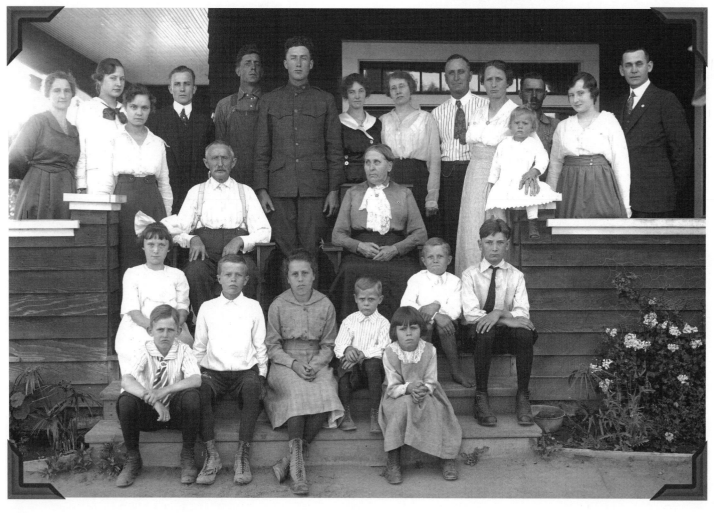

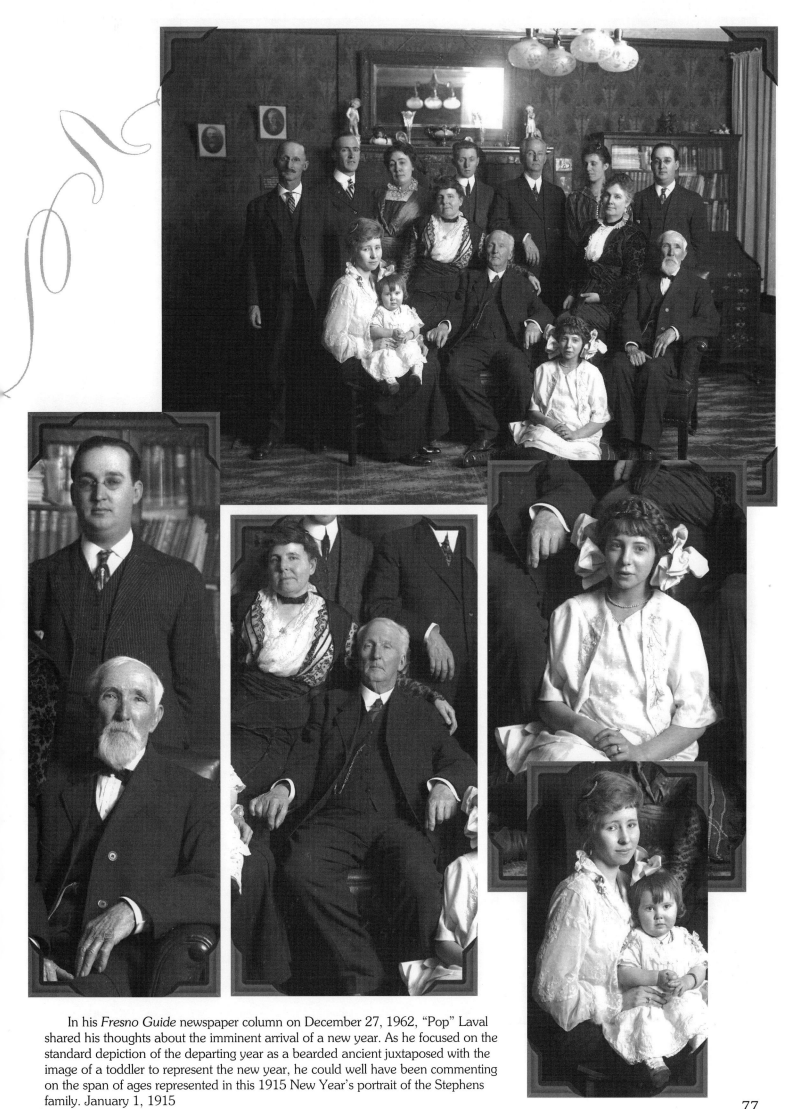

In his *Fresno Guide* newspaper column on December 27, 1962, "Pop" Laval shared his thoughts about the imminent arrival of a new year. As he focused on the standard depiction of the departing year as a bearded ancient juxtaposed with the image of a toddler to represent the new year, he could well have been commenting on the span of ages represented in this 1915 New Year's portrait of the Stephens family. January 1, 1915

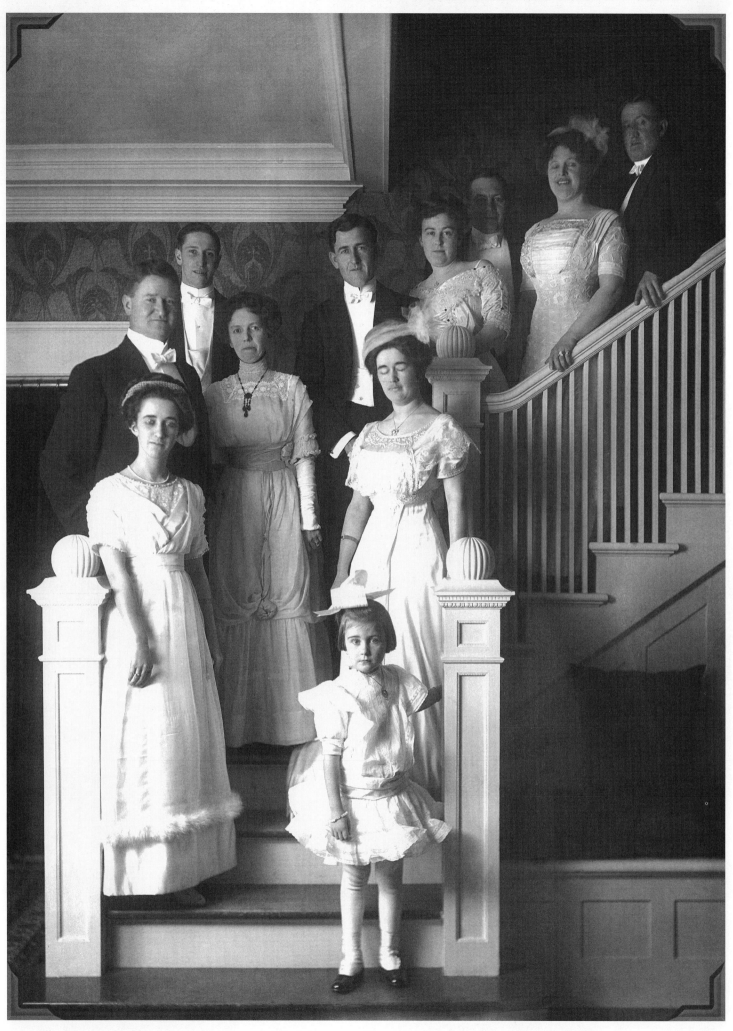

The Romain wedding party commemorated their joyous and important family day by posing on their home's lovely staircase. Circa 1913.

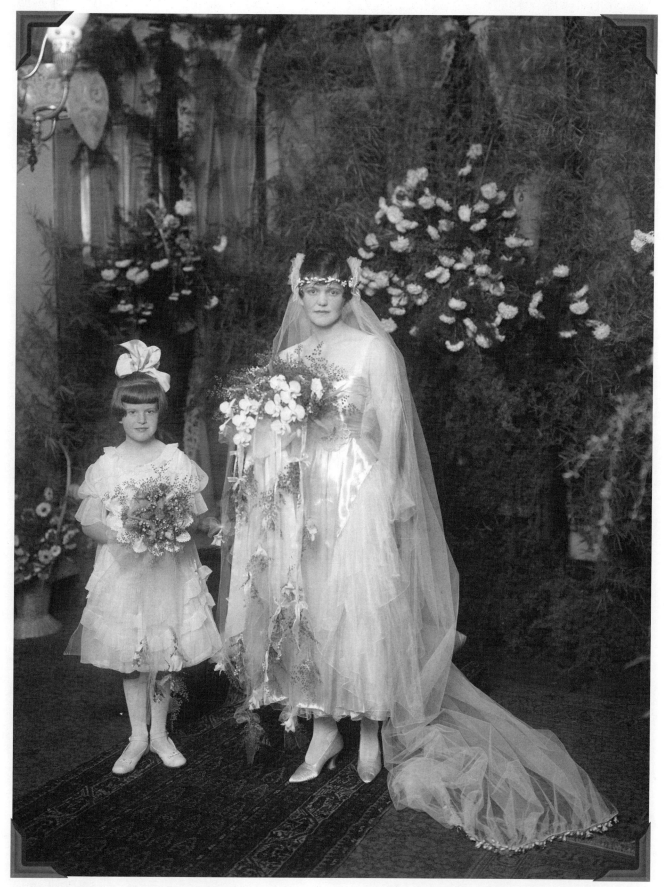

September of 1917 found this lovely bride and her flower girl happy to be photographed after the beautiful Cooper-Collins wedding. September 5, 1917

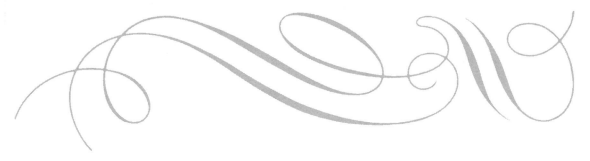

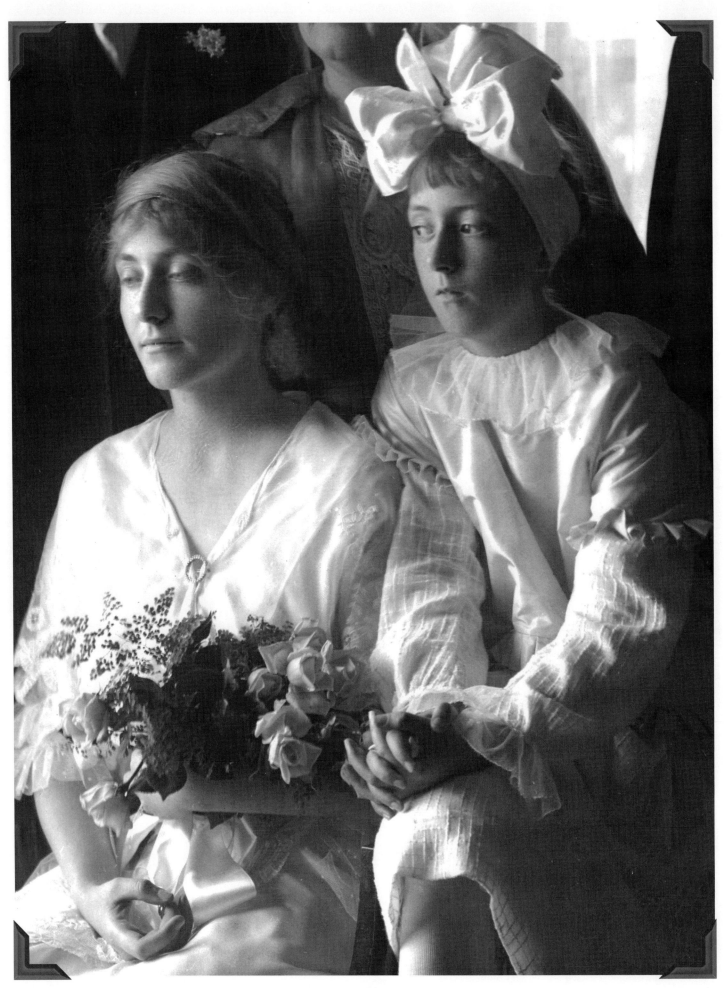

Among the few wedding photographs that "Pop" Laval consented to take is this one of a Rowell-family nuptials in 1914. March 17, 1914

Pop Says...

June Is Busting Out All Over

Yes, good people, it just seems like the month of June is LOADED TO THE MUZZLE. For the past two weeks it seems like I did nothing else but chat with you of the things that are happening or are about to happen this month. I notice I overlooked letting you know that June the 4th was OLD MAIDS' DAY, and that on June the 15th, besides being FATHERS' DAY, was the beginning of NATIONAL BOW TIE WEEK.

I am sure there were other days and weeks credited to the MONTH OF JUNE, which I missed, but the ONE THING that the MONTH OF JUNE is noteworthy for is the number of BRIDES. Seems like most of our young ladies want to get married in the month of June. Of course, there are those who didn't care WHAT MONTH it was, they were so in love, whether it was January or December, or any other month, made no difference. I know Mom and I let the month of June slip by and got married in August. However that's some fifty-three years ago, and it didn't seem to make any difference, for we are still happily married and still just as much in love with each other and looking forward to celebrating our DIAMOND JUBILEE.

But, coming back to the present MONTH OF JUNE and the JUNE BRIDES, seems like DAN CUPID and his crew of arrow shooters are working double time during this month and it keeps our good preachers busy tying knots. The florists are all happy over it and so are the butcher, the baker and the candlestick maker, and all the merchants, seeing as how all these brides have to have showers, and, of course, the usual wedding gifts for the young people. I sometimes

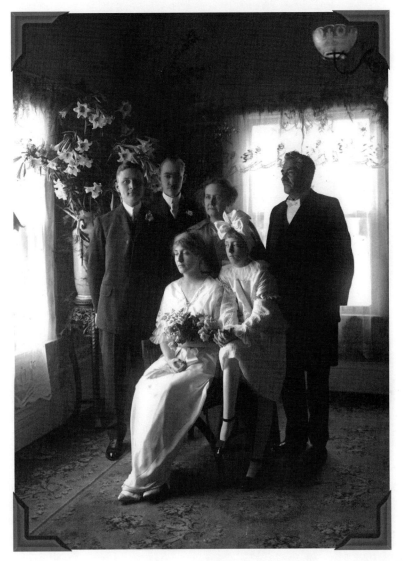

wonder if Dan Cupid and his crew are not in cahoots with the merchants! If they are, you can just bet they are doing it because they love it, for they certainly are not receiving any commissions from these merchants who are benefitting by these joyous occasions!

You know, the young brides of today are far ahead of the young brides of yesteryear. In those days the young lady won her man by her ability as a cook, you know the old saying, "The way to a man's heart is through his stomach." BUT NOT THESE DAYS, no sir. In the first place, she doesn't HAVE to learn HOW TO COOK. EVERYTHING is precooked for her. No more does she have to read a cookbook. All she needs do is WATCH TV and there she learns about one-minute rice, pre-mashed potatoes, whole TV dinners, be it chicken or a fine roast of beef, with all the trimmings.

Now, in order to win her man, she again turns to the TV and learns how to BEAUTIFY HERSELF with pin curls, hair sprays that make your hair wave and glisten in the sunshine, she learns how she can get herself a permanent in practically no time at all by using umpty dump's new spray or what-have-you, she applies lipstick that won't leave ANY telltale marks on her boyfriend's face.

Oh, me, times sure have changed. Guess we old timers will just have to lean back and realize that the JUNE BRIDE OF TODAY has a much easier time than her sister of yesteryear. One thing for sure, those brides of early years were just as PRETTY, just as HAPPY AND LOVABLE as the present-day JUNE BRIDE.

I know you will all forgive an old timer for poking a little fun at you young folks, who are about to take the step that will mean so much to the both of you. May the Man Upstairs bless each and every one of you, for it is to you young people that we old timers look to keep our nation the strongest and the most powerful leader for PEACE AND GOODWILL the world over.

'Bye, now, I'll be seeing you.

"Pop"

From The Fresno Guide, June 19, 1958

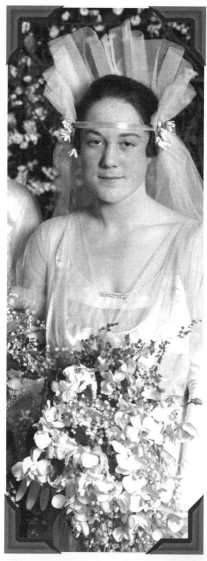

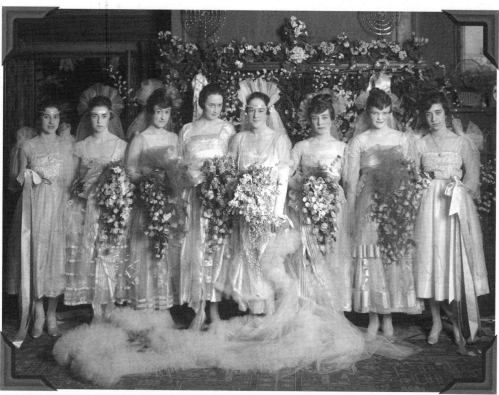

The Patterson wedding, in February of 1917, was one of the most beautifully presented nuptials of the year, as seen in this photograph of the bride and her attendants. February 8, 1917.

The resplendent Pierce wedding party posed after the ceremony and before the festivities. April 29, 1914.

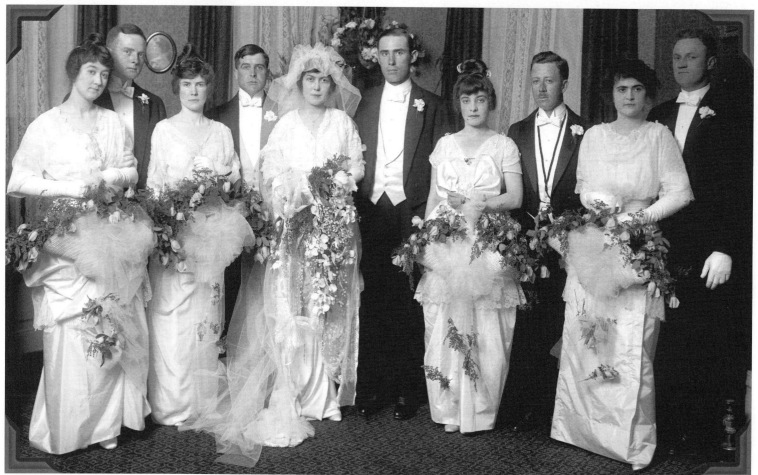

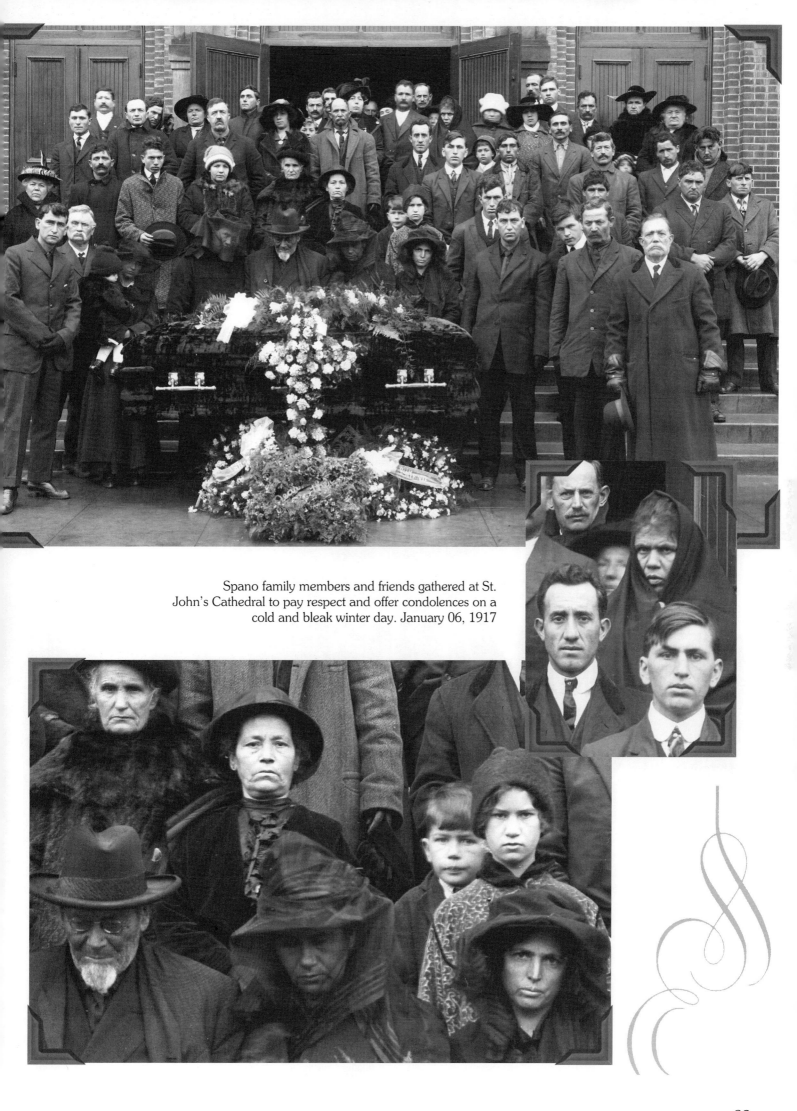

Spano family members and friends gathered at St. John's Cathedral to pay respect and offer condolences on a cold and bleak winter day. January 06, 1917

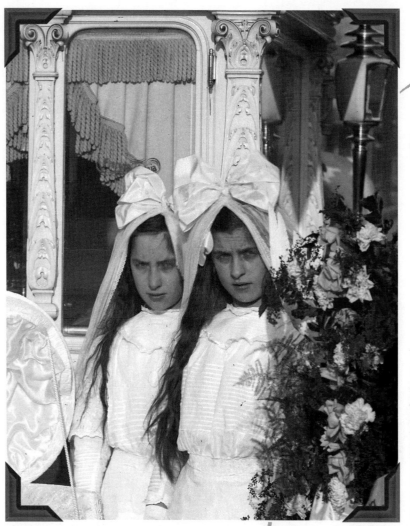

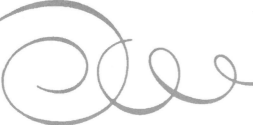

A sad, yet beautiful event in the Martin Yribarren family was the funeral of one of their little daughters in 1913. The young girls pictured acted as the pall bearers: (from left to right) Juanita Yribarren, a sister; Mary, a cousin; and Patty and Emily, sisters. The building in front of which the photo was taken, was the Fresno Hotel (not to be confused with the later Hotel Fresno), built by Martin Yribarren at 923 Santa Fe, and one of Fresno's first Basque hotels. Standing on the porch of the hotel: Mike Espinal, Sebastian Yribarren, and a family friend.

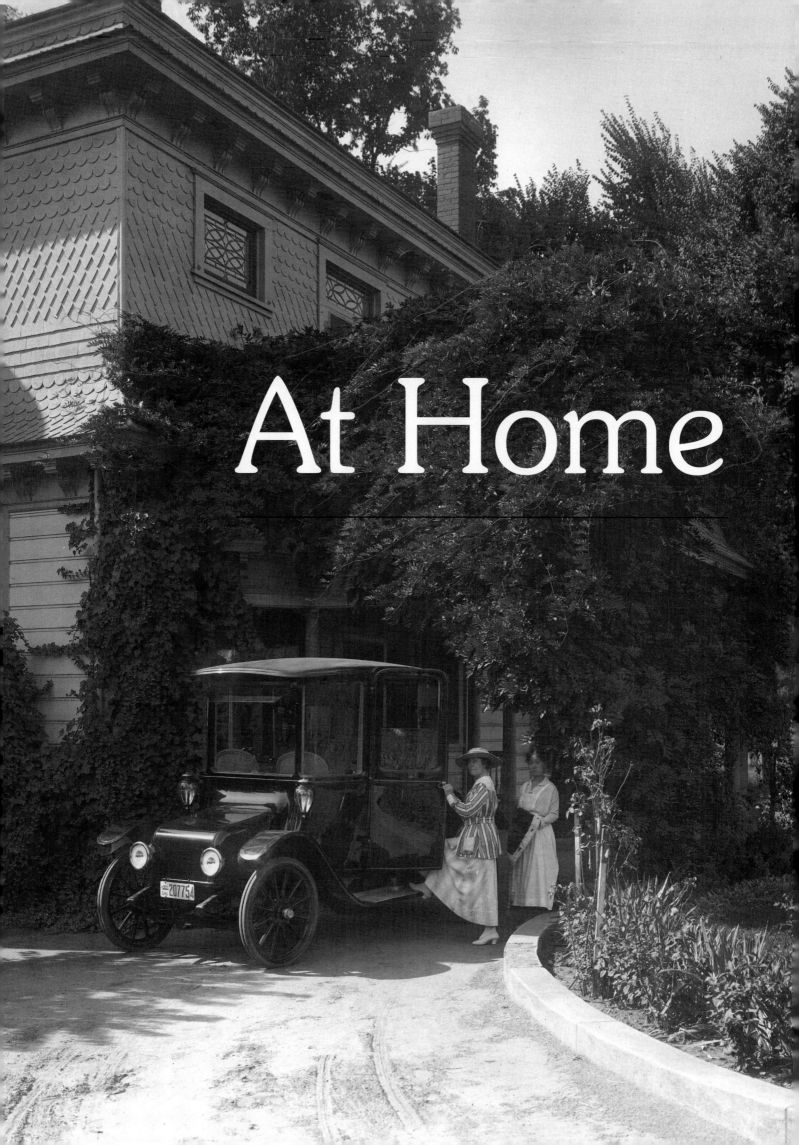

At Home

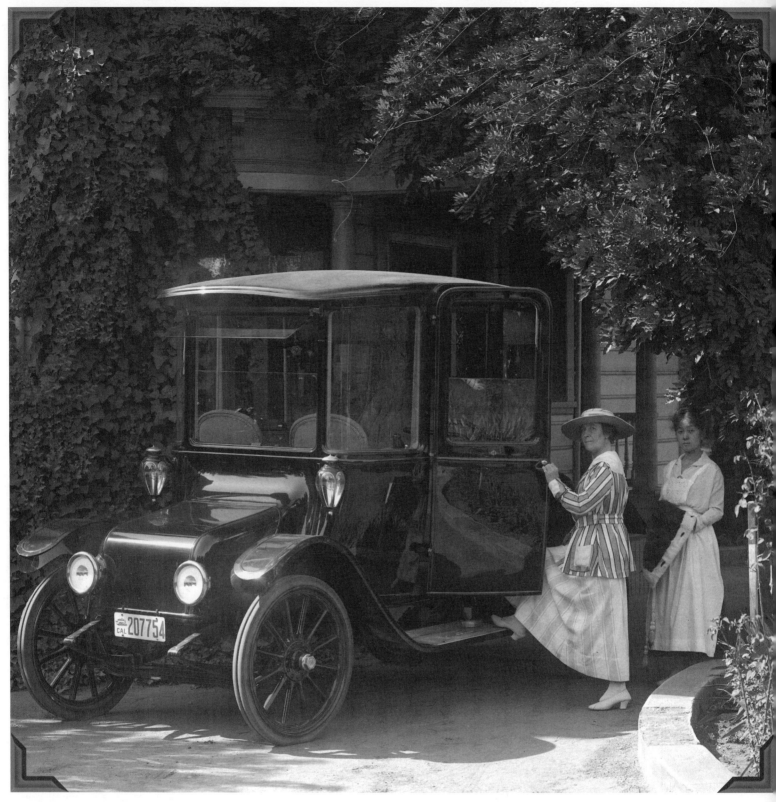

Previous page and above: At the turn of the century, S. N. Griffith built his home on Mariposa near M Street in downtown Fresno. Spacious and luxurious, the residence exemplified prosperous times for the Valley. In this photo, Mrs. Anna Griffith prepares to navigate her monogrammed electric automobile as her personal attendant waits patiently behind her with a lap blanket. September 10, 1916

Next page: Frank H. Short was a leading citizen not only of Fresno and the San Joaquin Valley, but was recognized statewide as a top-notch attorney. Mr. and Mrs. Short had their beautiful home, at Calaveras and Van Ness, available for many civic affairs particularly after the home was expanded into a lavish mansion in 1910. The living room, with its two staircases, was large and imposing. The residence has since been I. Magnin's department store and home to Arte Americas.

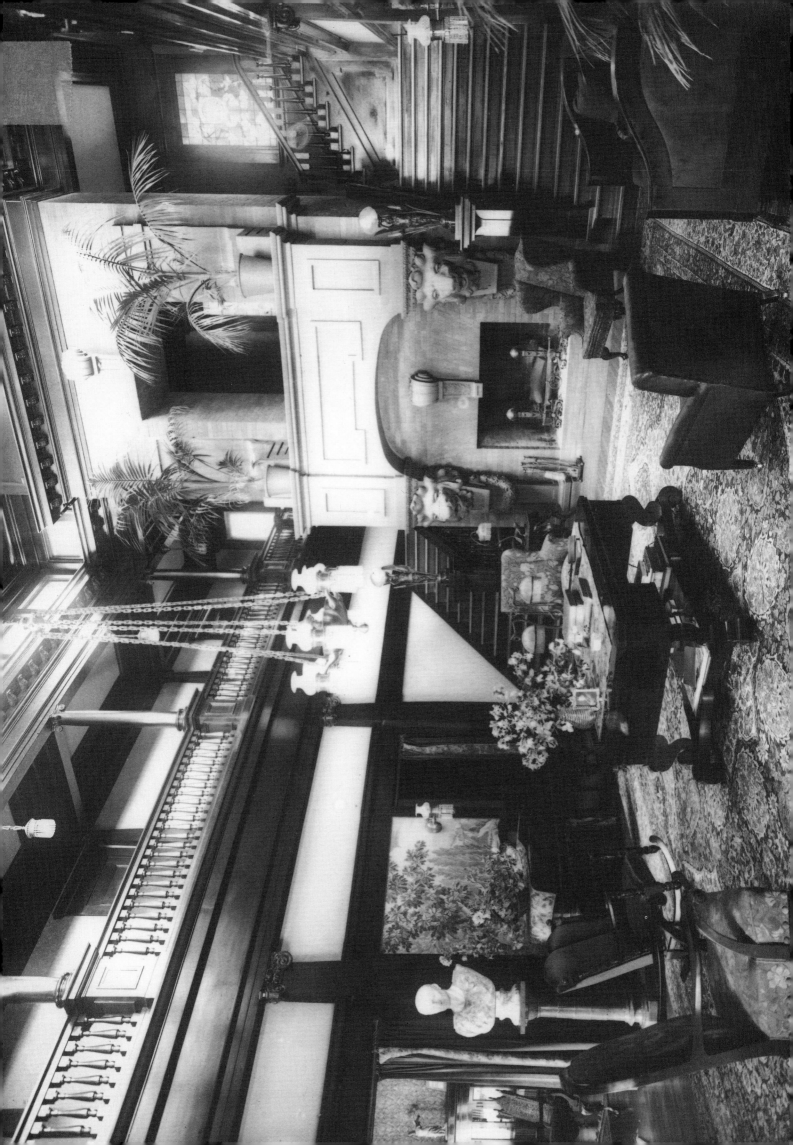

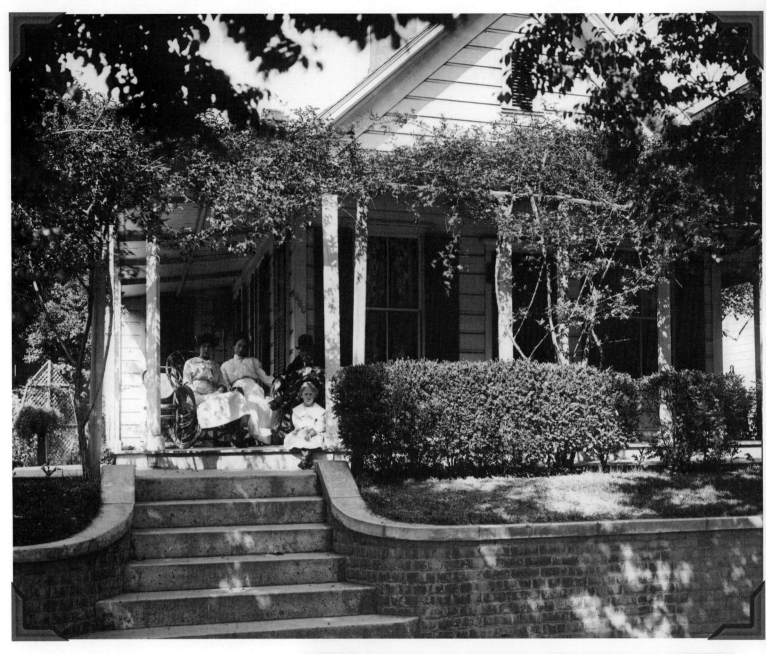

Dr. Chester Rowell, one of Fresno's earliest physicians, and his family relax on the front porch of their K (Van Ness) Street residence. In 1876, Dr. Rowell started *The Fresno Morning Republican* and later served as a state senator for three terms. In 1909, he was elected Fresno's fourth mayor, a largely ceremonial post. Dr. Rowell is credited with bringing "Pop" Laval to Fresno from Pittsburgh because he was intrigued by Laval's photographic skills. The entire community mourned when Rowell died on May 9, 1912. A monument honoring him was soon erected in Court House Park where it remains today.

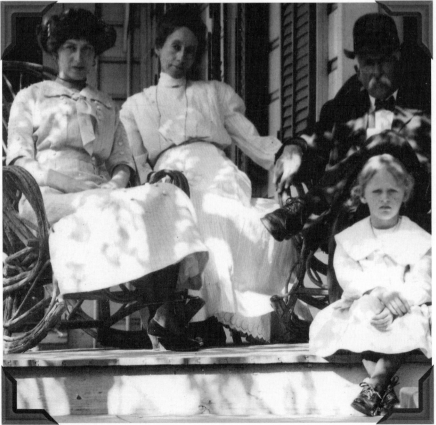

Pop Says...

Strolling Down Memory Lane

Strange heading for this weekly chit-chat of ours, isn't it? But it struck me as that was just what I was doing the other day when I found myself stopping in front of the statue of DOCTOR CHESTER ROWELL, placed for sentimental reasons at the end of the walk in Court House Park at Tulare and Van Ness avenues. There, the life-size figure faces the scene of many years of his activities in the great newspaper, the idol of his heart the *Fresno Morning Republican*, which occupied the building now housing McMahan's Furniture Store, and in which building he had his doctor's office. Directly across the street on the opposite corner looms up the Rowell Building, built on the site which was once occupied by a modest little moss-grown and orange-tree surrounded, rustic covered cottage that had been his humble home for years, so much so that it had become a landmark of the city.

As I stood there and looked up at the face of this wonderful man, it brought back memories. Back in 1911 and the early months of 1912, it had been my privilege to work for Dr. Rowell in his offices, and my close association with him gave me an opportunity to see WHY he was so beloved by everyone, not only in the community but in the entire county. I remembered that at the end of the first month that I was with him, I asked the good doctor if I could help get his bills out for him, and never will I forget his reply: "Bills, Claude, bills? I never send out any bills." When he saw the surprised look on my face, he quickly added "Those are all good people, they will come in all by themselves when they can afford to do so." I remembered the old Dorris car the good doctor used to drive, and on many occasions I would go out with him. Many times he would get a huge quantity of hard candy and we would drive to the various schools where he would chat with the children, giving each one a small bag of this candy.

He loved Roeding Park and watched its development and growth with great interest. Yes, he also was MAYOR of the city, but how he did hate making speeches!

There used to be a balcony that ran around the outside of the building, and I remember well the day the good doctor stood outside on that balcony with his hands stuck in his pockets, watching the removal of that little modest rustic, moss-grown cottage that had been his home, just across the street, being removed in preparation for the laying of the foundation for the present Rowell Building. I often wonder just how that must have affected him, for it wasn't too long after that when he passed on.

There was his monument, erected in his memory by those devoted and admiring friends, people he had helped in their hour of need, sat by their bedsides, brought their children into this world. There are still some old timers here who can tell you that no matter what the weather was, hot or cold, rain or shine, no matter what part of the county, the good doctor never failed them.

There's a plaque on this monument which reads:

ERECTED IN 1914 TO
DR. CHESTER ROWELL
GOOD PHYSICIAN
GOOD FRIEND
GOOD CITIZEN 1844– 1912

Yes, I was strolling down Memory Lane, and I wanted to share my memories with you good folks, especially so many of you who have come to our city to make your homes here among us. I thought you might like to know some of the reasons for the monument and why it was placed where it is.

I have seen many mayors come and go since then, but there is only one monument. I guess the mold must have been broken. There will never be another like him. His memory is enshrined in many a grateful heart.

'Bye, now, I'll be seeing you.

"Pop"

From *The Fresno Guide*, March 13, 1958

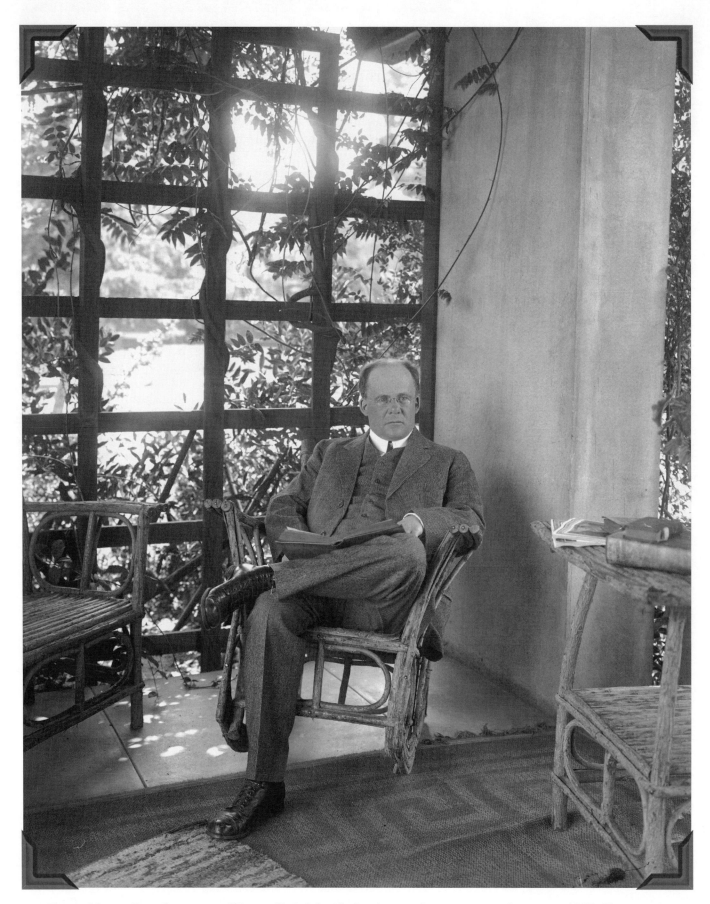

Chester Harvey Rowell was one of Fresno High School's first five teachers, accepting the post in 1885. Three years later, he was named managing editor of *The Fresno Morning Republican* by his uncle, the illustrious Dr. Chester Rowell. The younger Rowell quickly became known throughout the nation as a crusader for cleaning up Fresno's tawdry image of political graft and crime. Chester Harvey Rowell is seen here in a rare moment of peaceful repose. May 10, 1914.

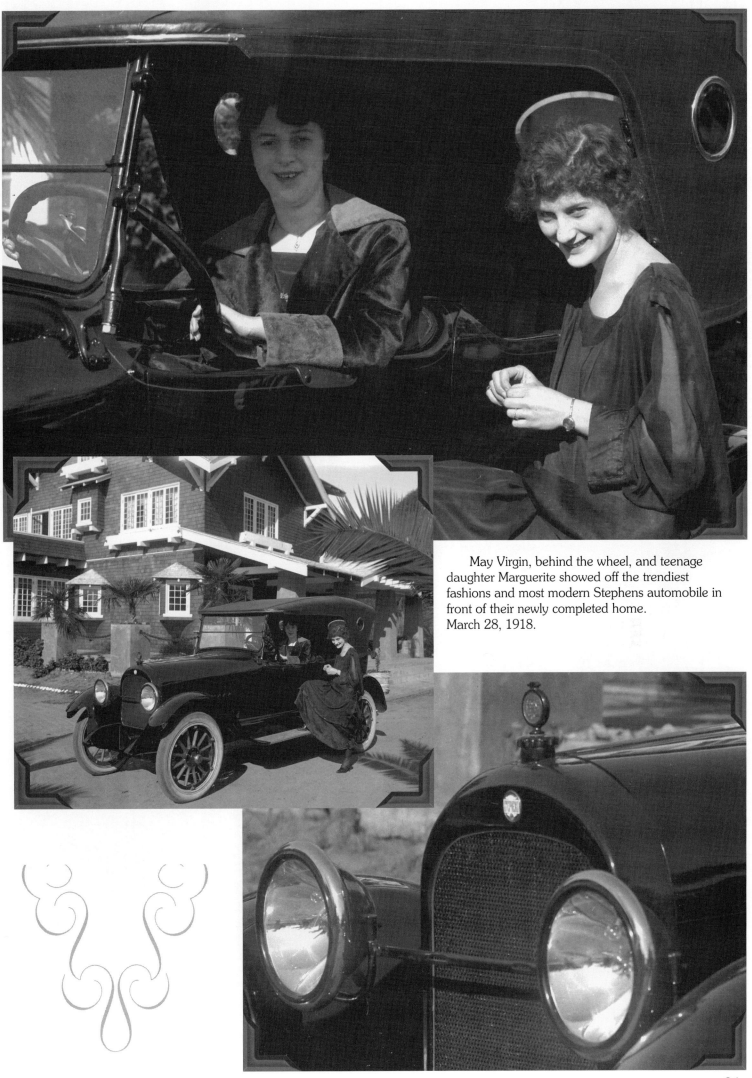

May Virgin, behind the wheel, and teenage daughter Marguerite showed off the trendiest fashions and most modern Stephens automobile in front of their newly completed home. March 28, 1918.

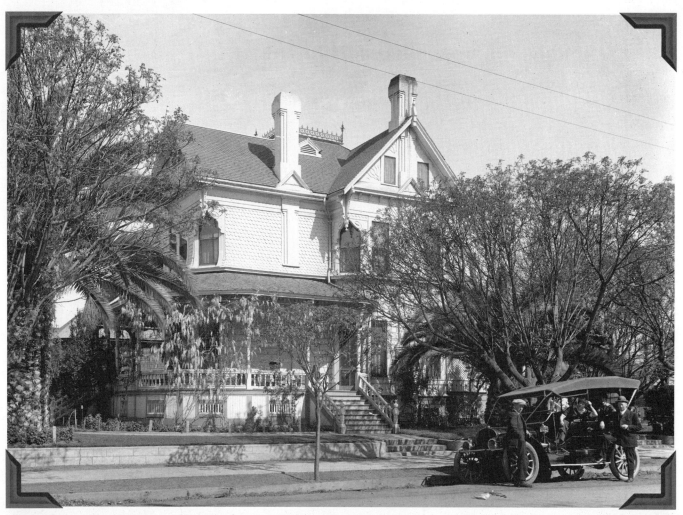

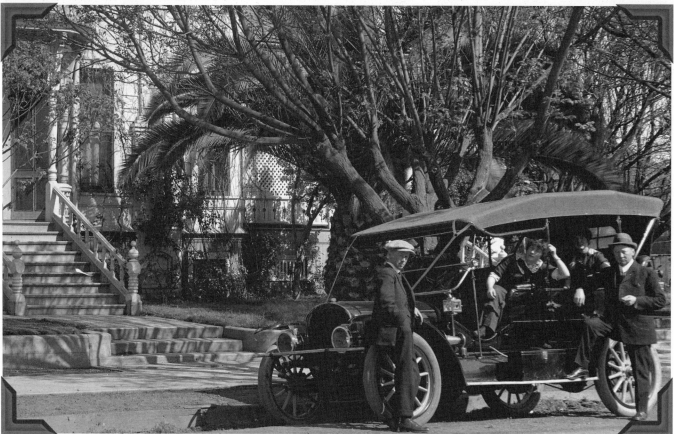

Mr. and Mrs. L. Scholler, along with lodgers Minnie Hodge and Chas. Chambers seemed more than comfortable outside their multistory residence situated on the corner of Tuolumne and R streets. Circa 1912.

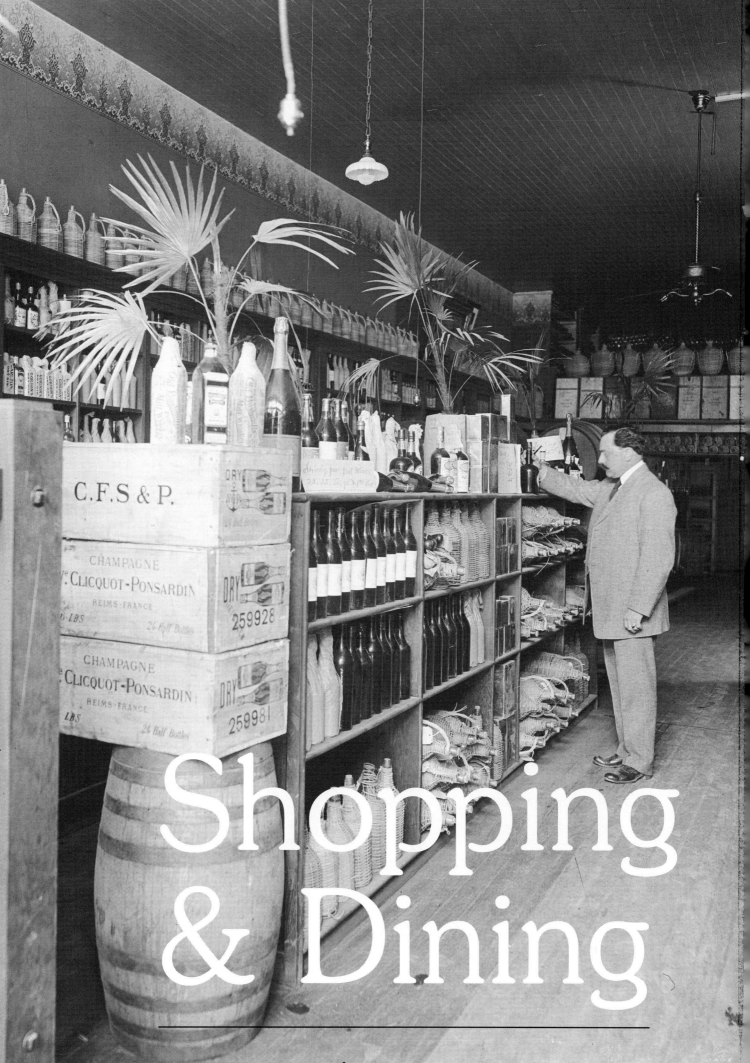

Shopping & Dining

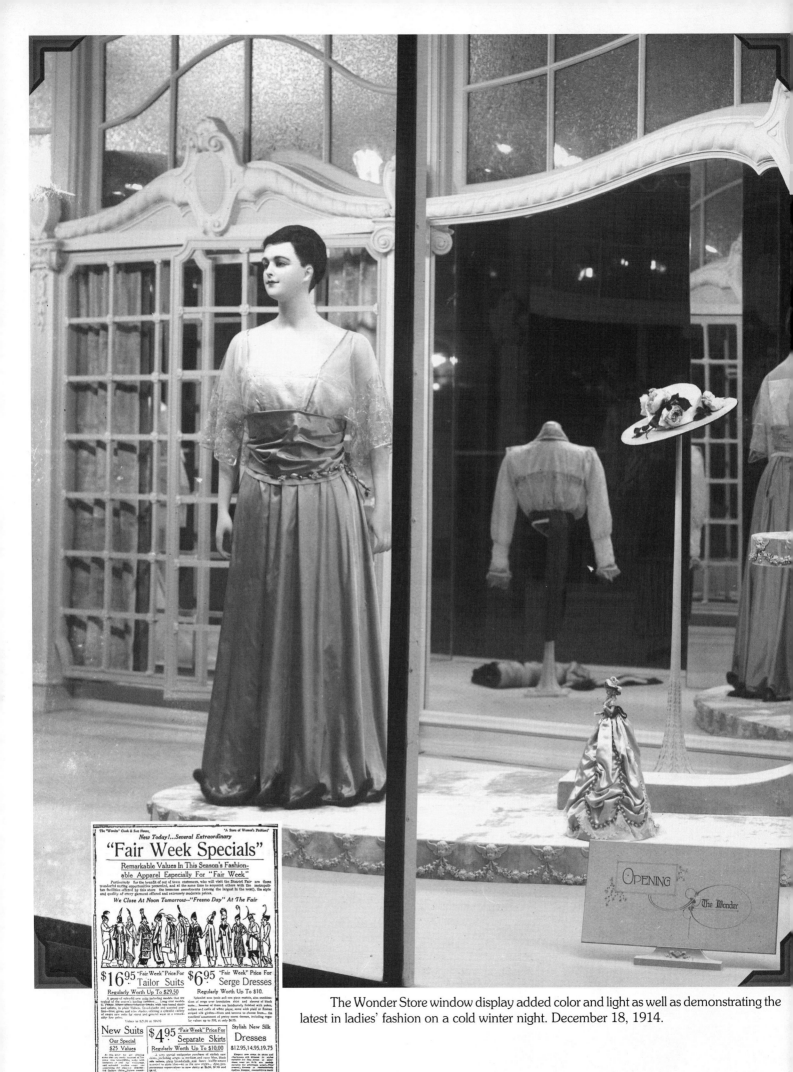

94

The Wonder Store window display added color and light as well as demonstrating the latest in ladies' fashion on a cold winter night. December 18, 1914.

Previous page: In 1909, Peter Loinaz opened a wholesale liquor store at 1919 Tulare Street. He sold wine in bottles and in bulk. Circa 1913.

Fashion Show Attracts Crowd
Remarkable Window Display Teaches History Lesson in Interesting Manner

An epic depicting the evolution of styles in women's dress was studied by thousands of women and many men in the windows of The Wonder last night and today. The display, showing Egyptian, Grecian, Roman, and Louis Quinze rooms and styles of clothing, was opened last night, as a prelude to the fashion show which began at 2:30 o'clock this afternoon.

Nothing was put in the rooms which the age pictured did not demand. In the Egyptian room, with its massive painted and carved pillars, the unmodified coloring is seen. The woman's headdress of 3,000 years ago looks like a bird. From this source, according to Monte Cass, who designed the exhibit, comes the style of plumage in hats of today.

In the Grecian exhibit, the style was all drapes, with a bandeau about the head. The Roman women made little progress toward the present styles. In the Eighteenth Century, however, the dress of women was so nearly modern that some patterns of today are modeled after those worn in the court of Louis XV. A set of remarkable enlarged photographs accompanies the display.

The entire window plan was conceived and executed by Fresno people. Monte Cass, The Wonder display manager, was assisted by Clifford Uridge and Jack Reid. All the columns and panels were made in Fresno. C. C. Laval furnished the pictures.

Three models are posing this afternoon, from 2:30 to 4:30 o'clock. They are Miss Virginia Kirtley, celebrated moving pictures actress of Los Angeles, Miss Aline Foley, of Fresno, who was the 1916 Raisin Day Queen, and Miss Lulu Sheeley, of Los Angeles, who modeled for the Wonder during the last spring season.

From *The Fresno Evening Herald*, September 18, 1916

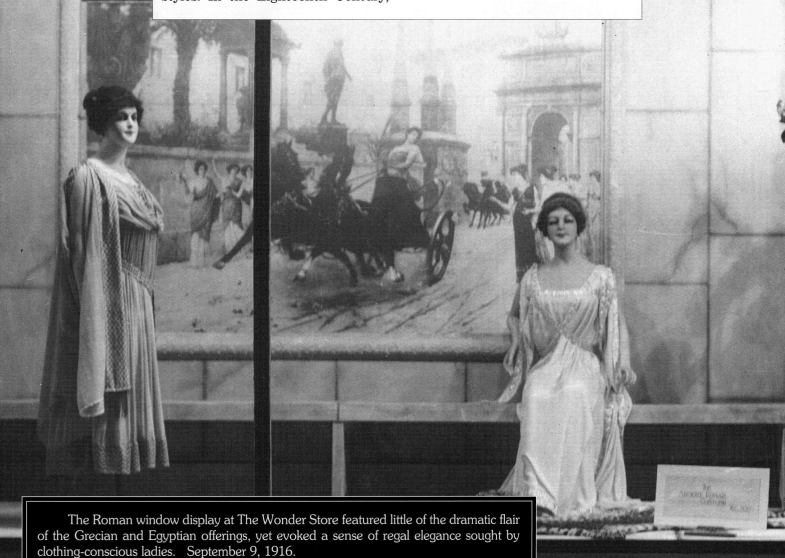

The Roman window display at The Wonder Store featured little of the dramatic flair of the Grecian and Egyptian offerings, yet evoked a sense of regal elegance sought by clothing-conscious ladies. September 9, 1916.

Valley ladies could always count on The Wonder Store to provide them with the latest fashions from head to toe, as these two photos of elegant Wonder Store window displays show. March 5, 1918.

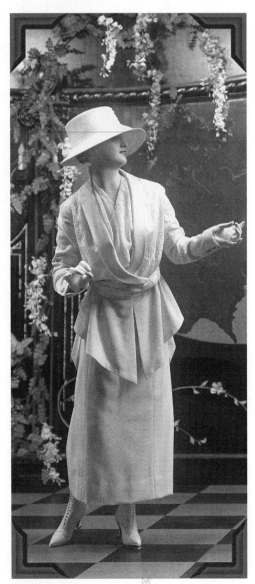

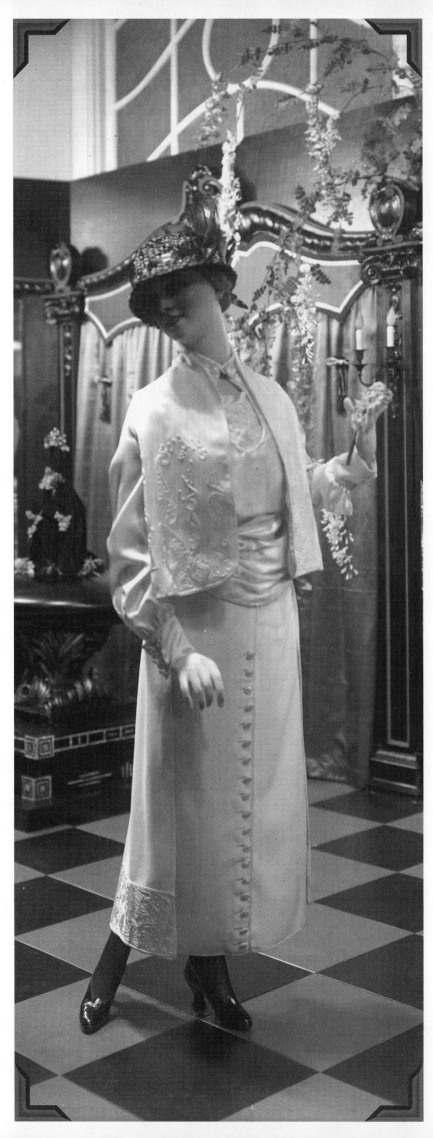

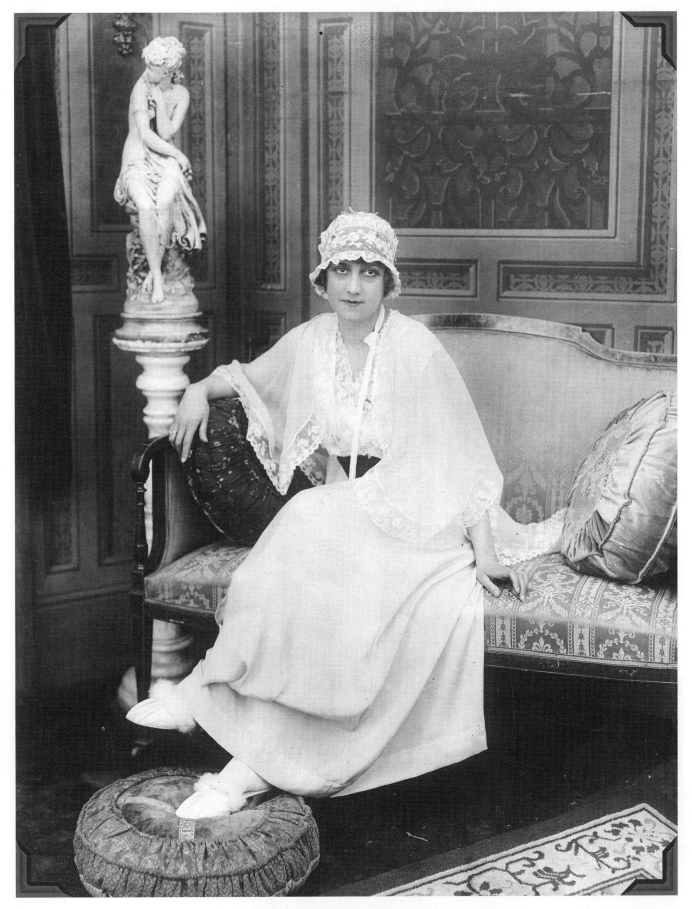

This fetching, young nightwear model for The Wonder Store seems more ready to go out on the town than under the covers. (Does the word "coquettish" come to mind?) September 6, 1916.

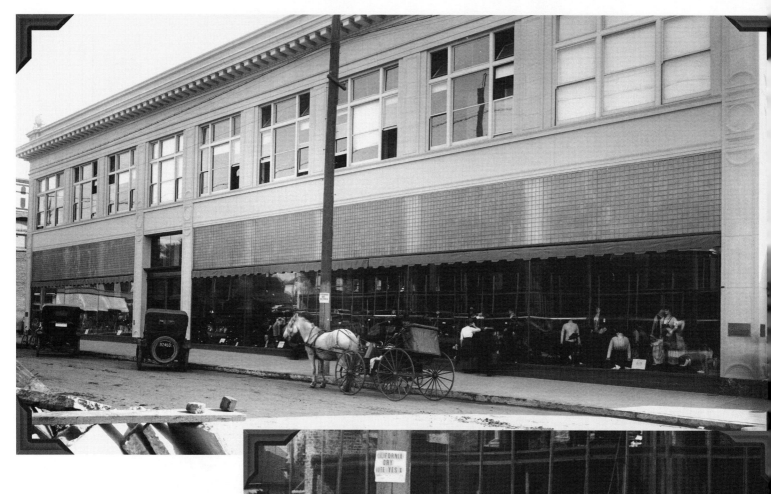

One of many modern structures erected in Fresno's booming business district in the mid-teens, the Gottschalk's building at Kern and J (Fulton) streets complete with decorative awnings, was ready to welcome willing shoppers. The sign above on the post reads "California dry, vote yes." October 29, 1914.

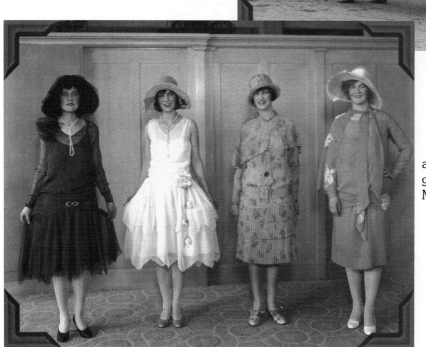

Fashionable Fresno females always looked to Gottschalk's to guide their seasonal style purchases. May 12, 1928.

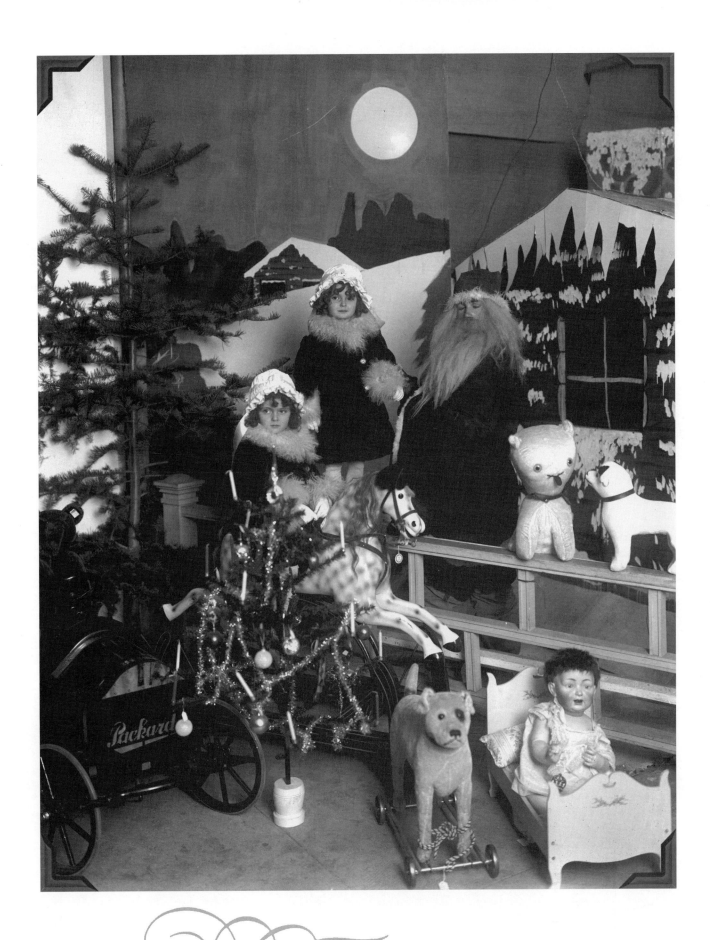

Gottschalk's department store Santa Claus and
his lovely elfish helpers heightened the anticipation of
every boy and girl as their favorite day approached.
December 6, 1916.

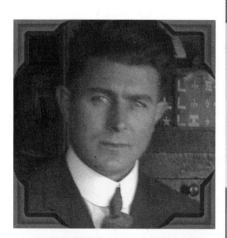

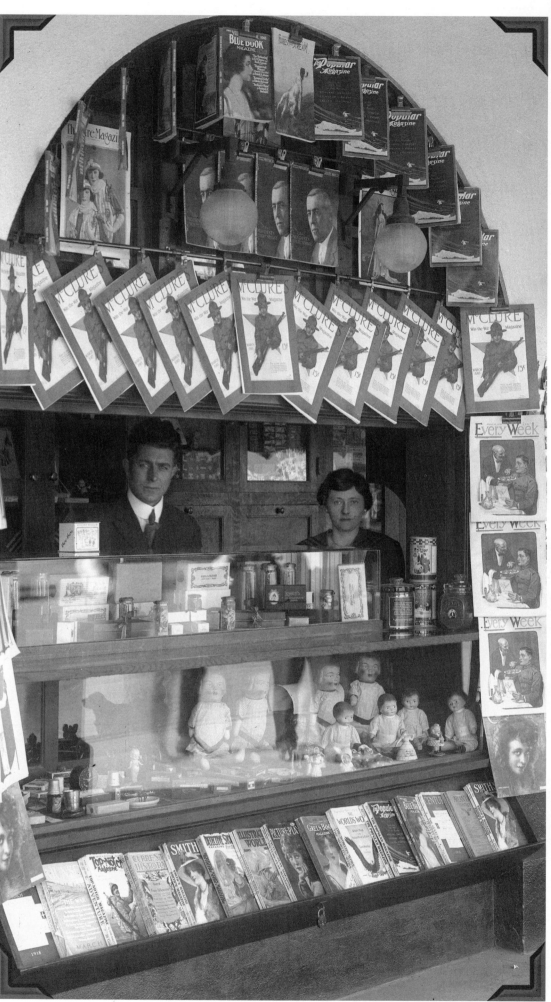

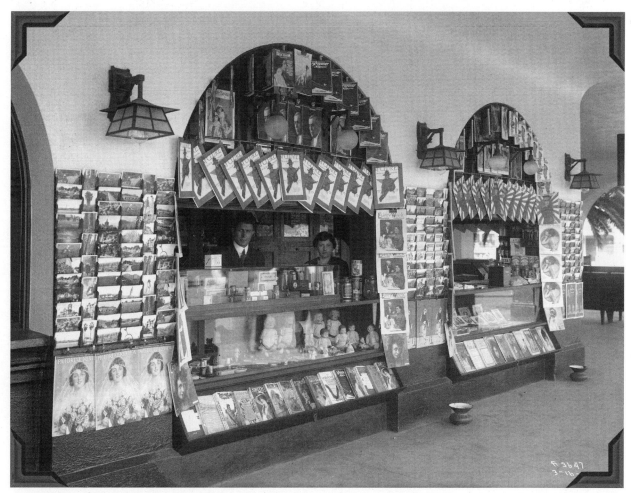

Above and left: Rushing travelers frequented Fresno's well-stocked Santa Fe Depot newsstand to purchase their favorite magazines, including Smith's, Detective Stories, Top Notch, Blue Book, Forest and Stream, and McClures. March 16, 1918.

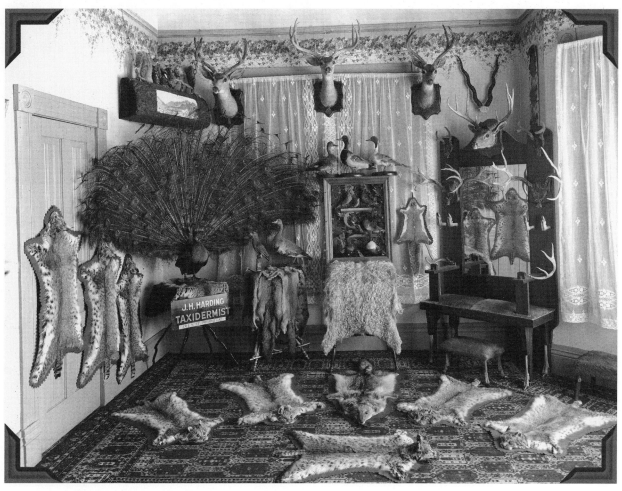

The J. H. Harding, Taxidermy Studio at 201 N Street in Fresno was a popular place with local sportsmen. Circa 1913.

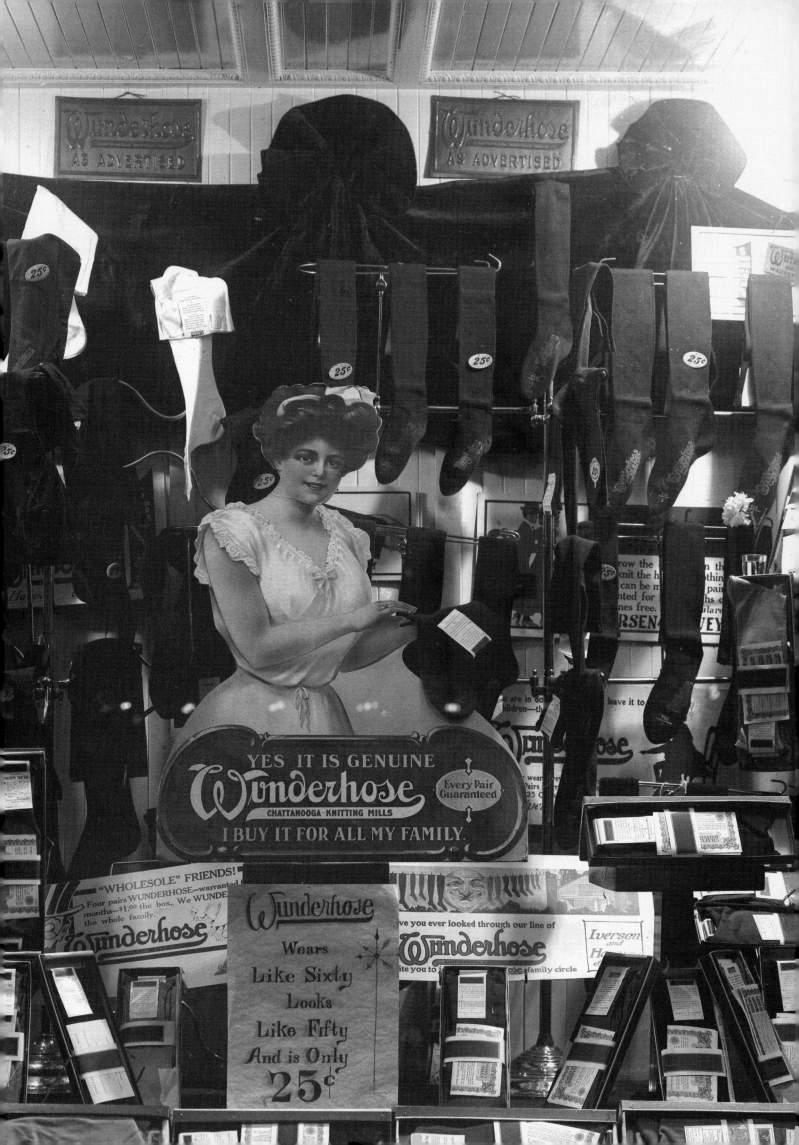

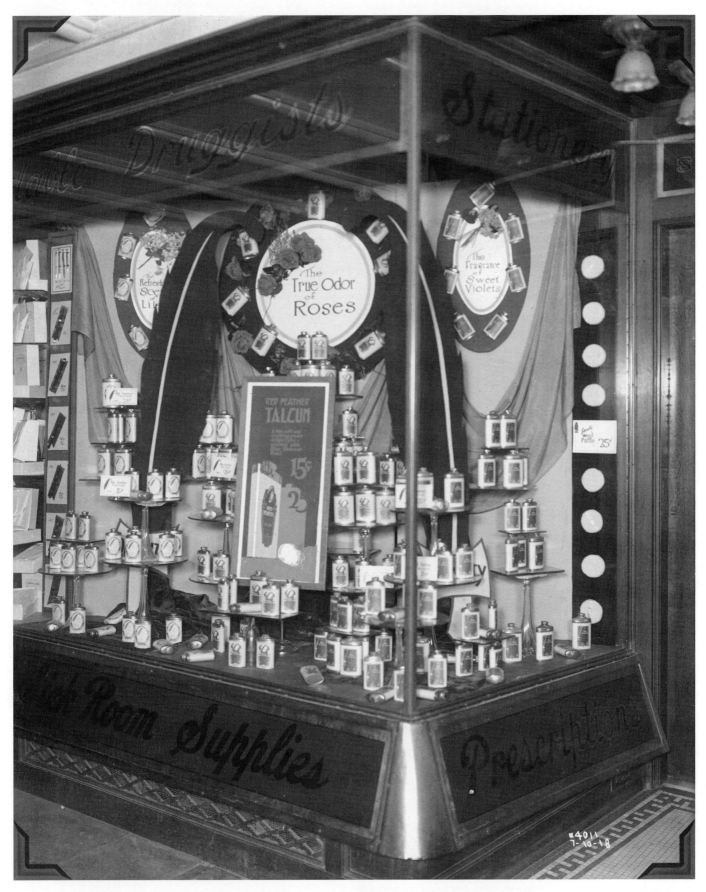

If this display is any indication, talcum powder must have been a big draw for the Owl Drug Company in 1918.
July 10, 1918

Previous page: How could a man afford to pass up treating his feet to a 25-cent pair of Wunderhose? Circa 1918.

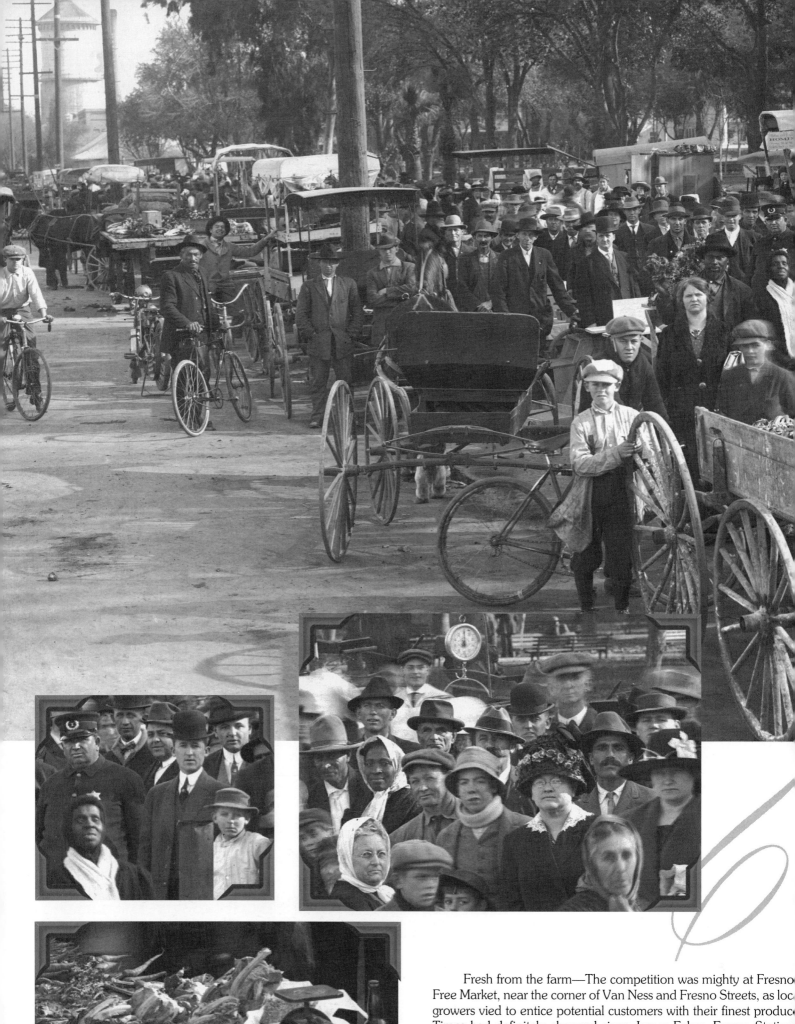

Fresh from the farm—The competition was mighty at Fresno Free Market, near the corner of Van Ness and Fresno Streets, as local growers vied to entice potential customers with their finest produce. Times had definitely changed since James Faber, Fresno Station's first resident and shopkeeper, had set up his tent in the 1870s. Faber had to drop the provisions he had brought along to open his general store from the train as it neared the new town because no freight was allowed to be delivered south of Merced. Circa 1912.

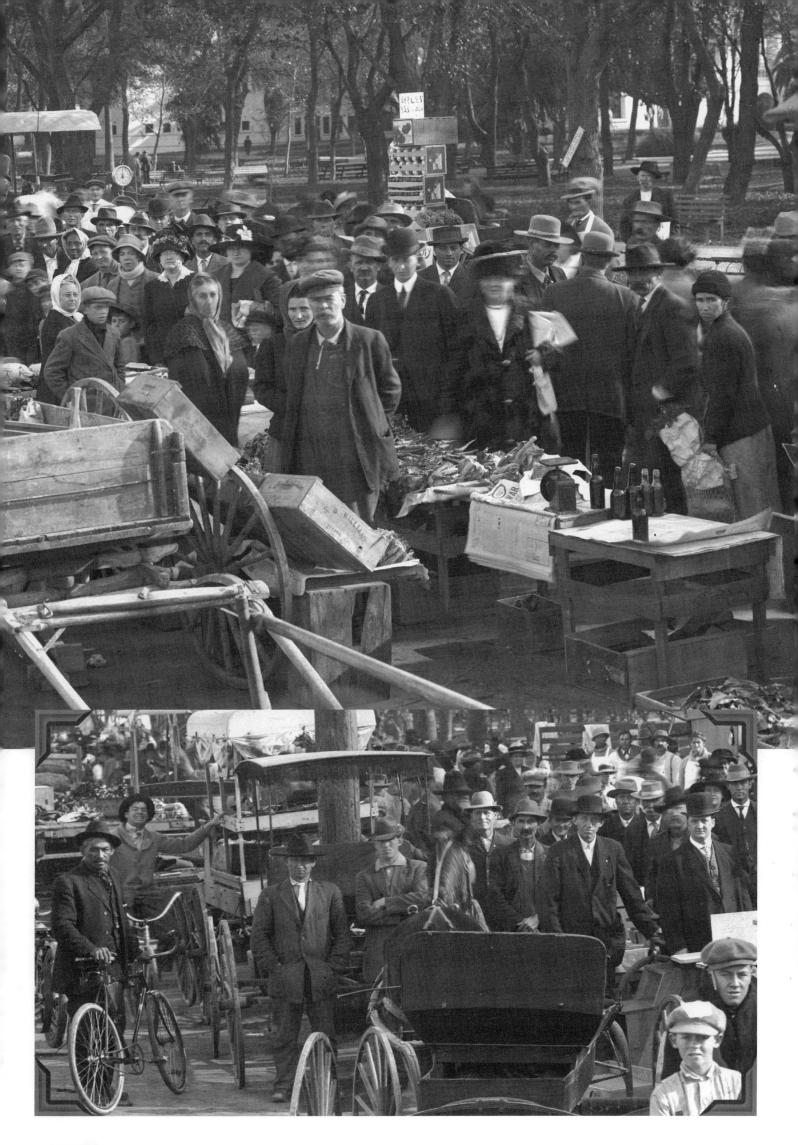

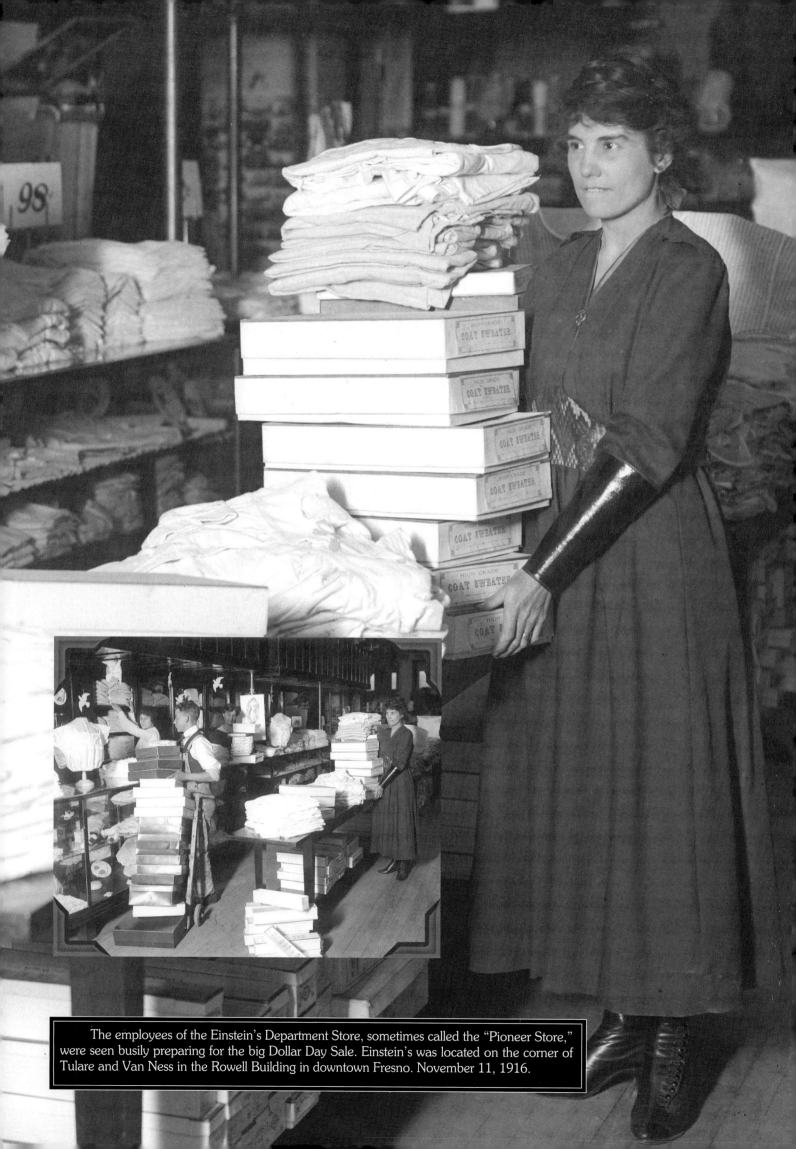

The employees of the Einstein's Department Store, sometimes called the "Pioneer Store," were seen busily preparing for the big Dollar Day Sale. Einstein's was located on the corner of Tulare and Van Ness in the Rowell Building in downtown Fresno. November 11, 1916.

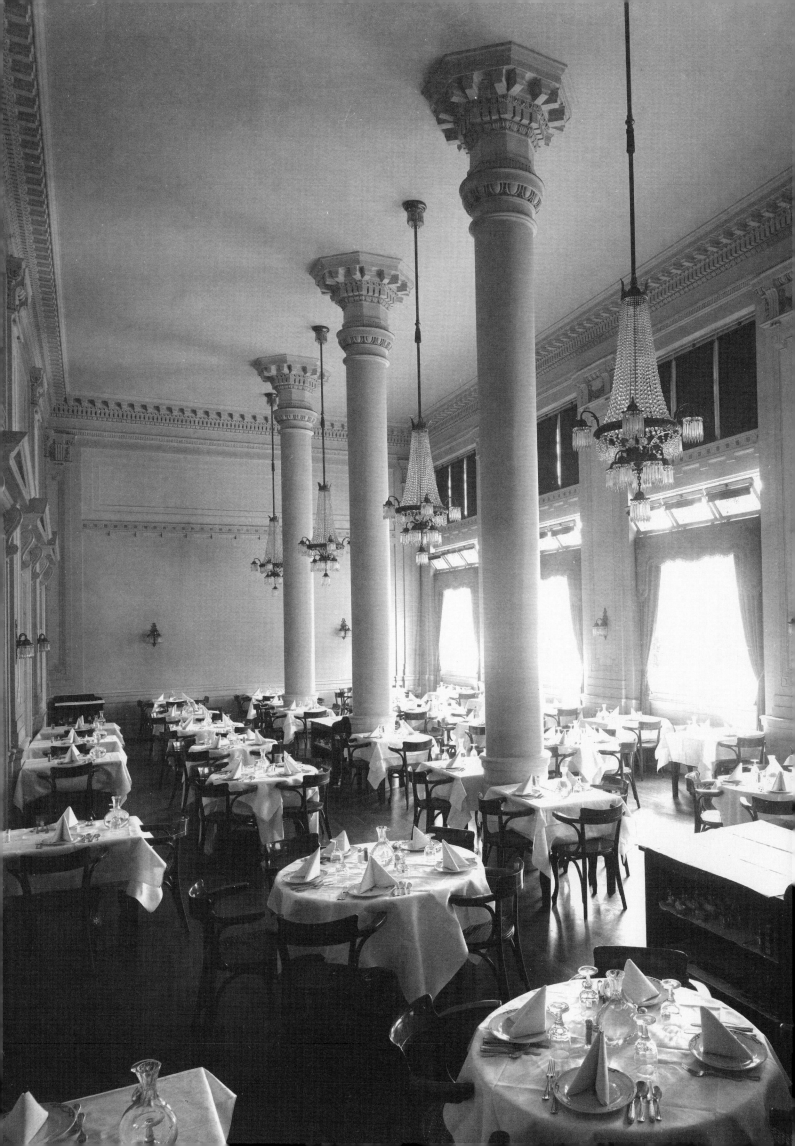

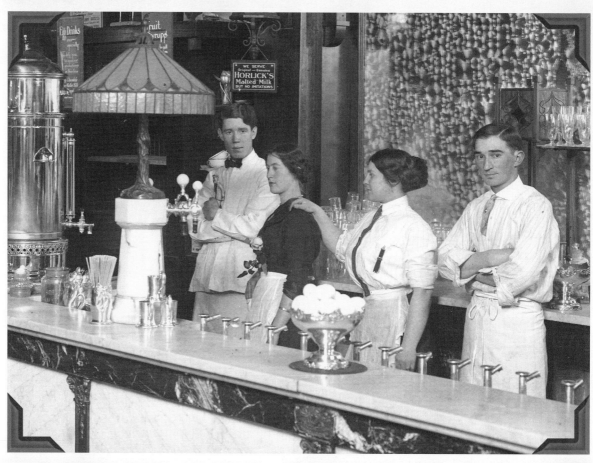

Previous page:
The elegant dining room of the Fresno Hotel was a grand place to take a client for lunch. Date unknown.

Thirsty and tired shoppers looked forward to an ice cream delight at the Monroe Drug Store and Soda Fountain where one could order "Original– Genuine, Horlick's Malted Milk." Date unknown.

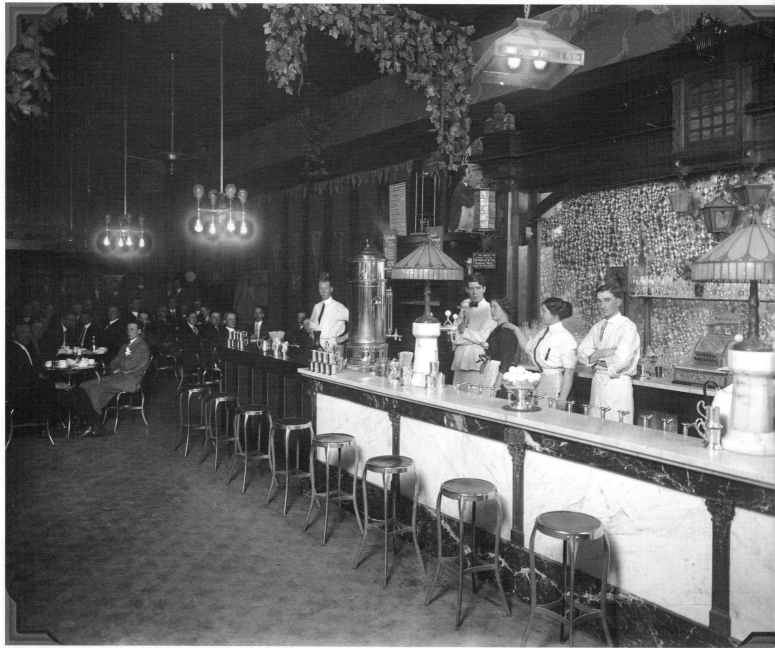

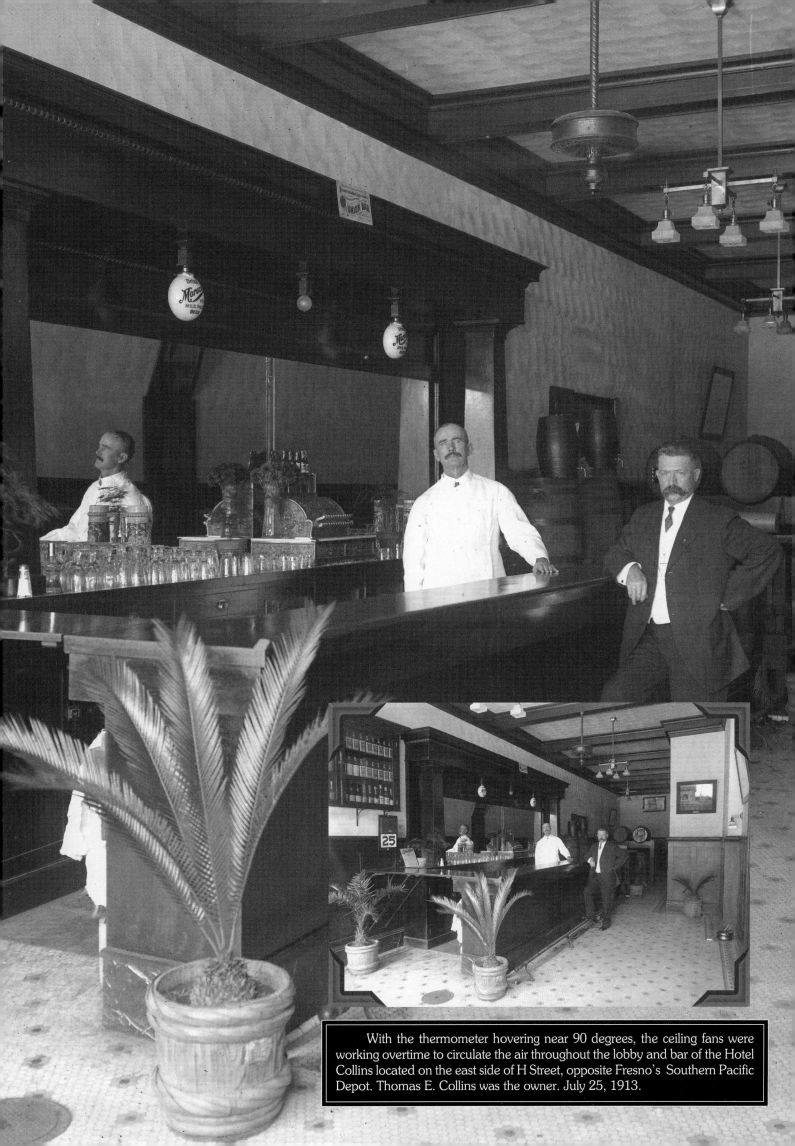

With the thermometer hovering near 90 degrees, the ceiling fans were working overtime to circulate the air throughout the lobby and bar of the Hotel Collins located on the east side of H Street, opposite Fresno's Southern Pacific Depot. Thomas E. Collins was the owner. July 25, 1913.

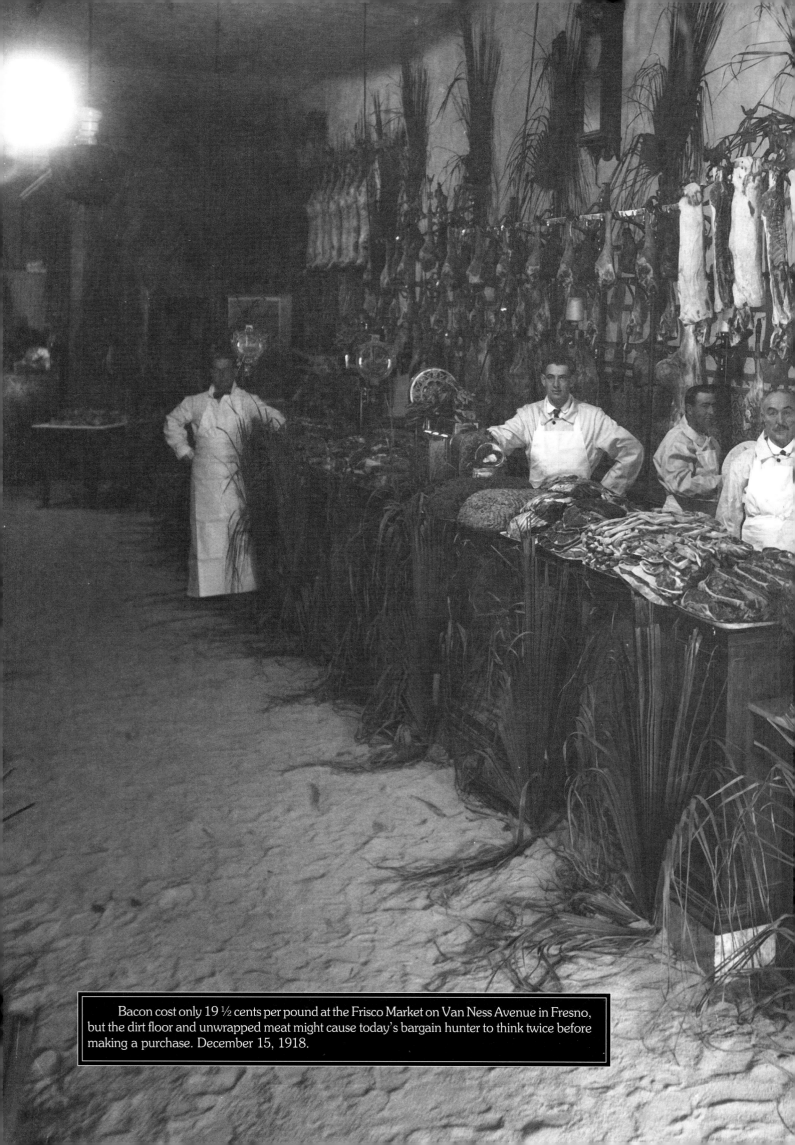

Bacon cost only 19 ½ cents per pound at the Frisco Market on Van Ness Avenue in Fresno, but the dirt floor and unwrapped meat might cause today's bargain hunter to think twice before making a purchase. December 15, 1918.

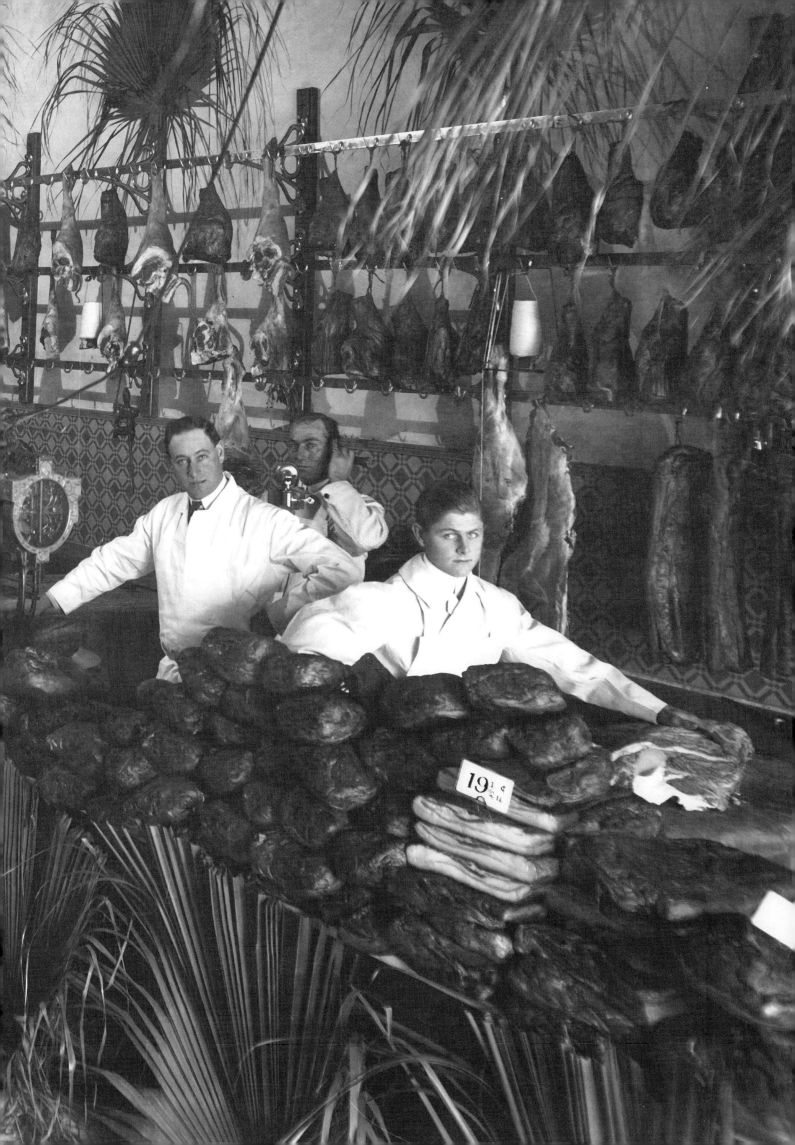

"Pony up to the bar, boys"—patrons in the Mecca Bar were still unaware of the looming shadow of the prohibition era, which would soon overtake them, putting an end to congenial evenings such as this. The reason for the presence of the Shetland ponies is anybody's guess. Circa 1913.

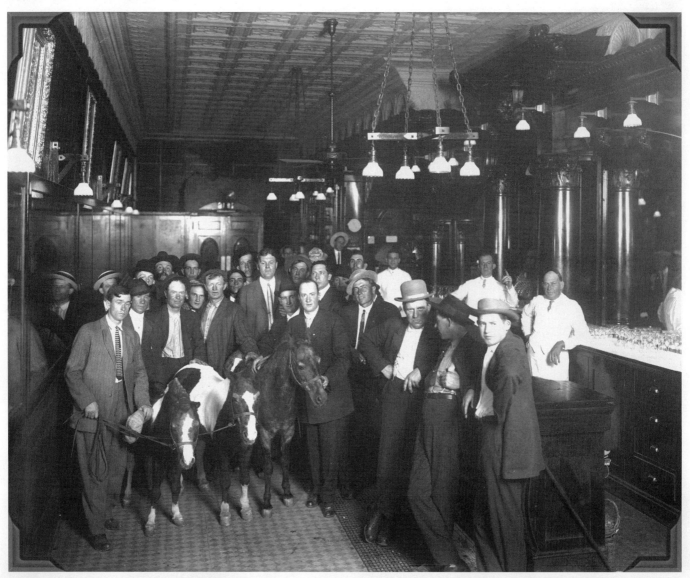

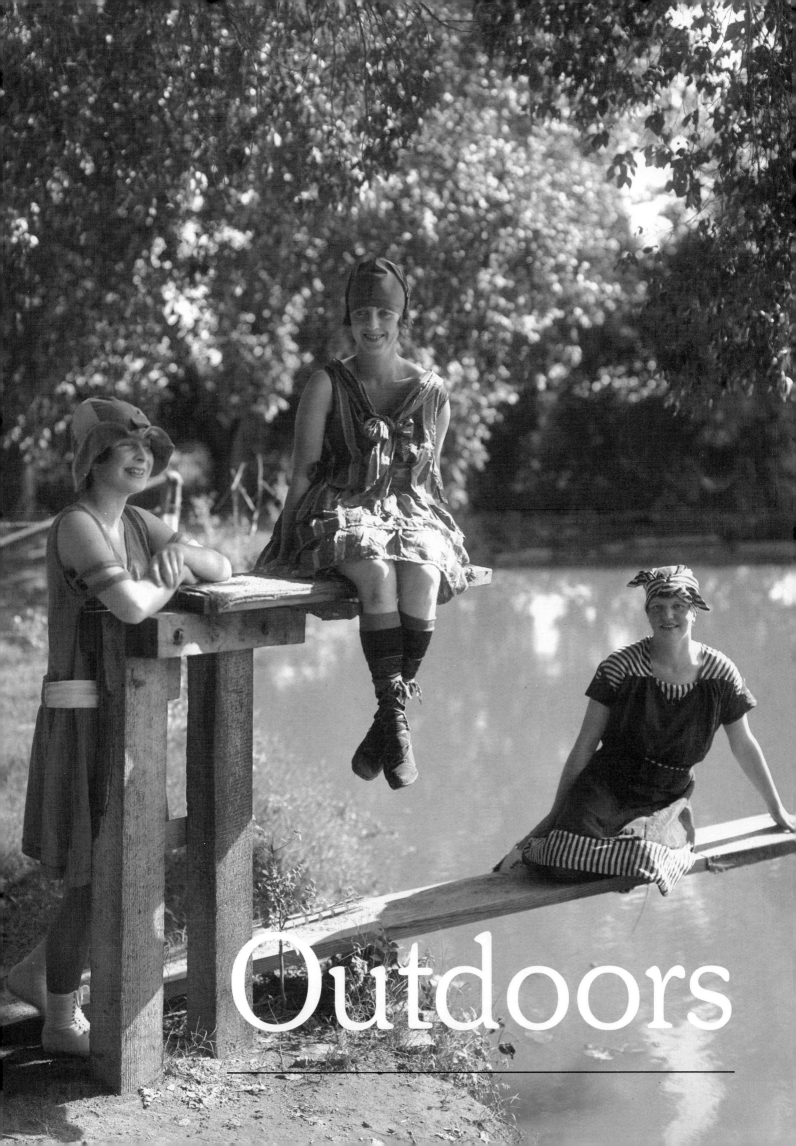

Outdoors

Previous page: Three winsome lasses pose by the an unidentified swimming hole. June 27, 1917.

Miss Bunty and her furry friend take a cooling dip in the lake at Forsyth Ranch. June 27, 1917.

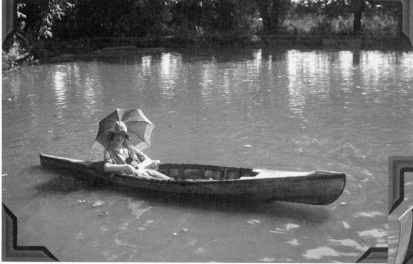

Doris Shaver, daughter of Charles B. Shaver, placidly reclined in a canoe on the lake at the Forsyth Ranch near Fresno. A popular and privileged young lady, Miss Shaver relished being the focus of photographic attention. On this day, she and several friends, called the "Society Belles" by "Pop" Laval, posed for five recreational shots. June 27, 1917.

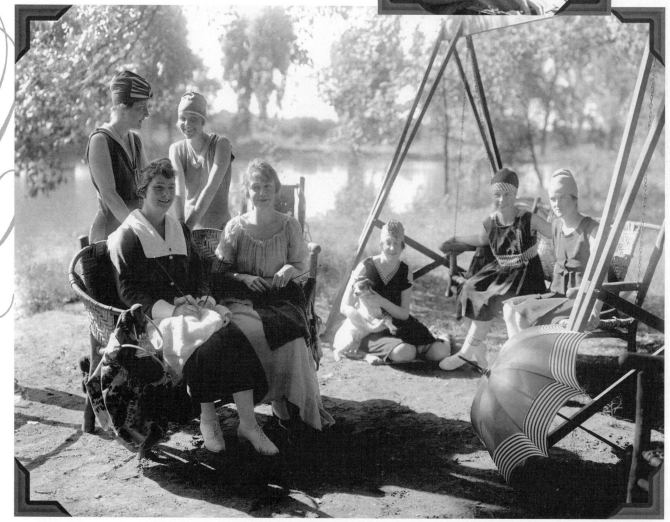

The 160-acre Forsyth Ranch east of Fresno had raisin vineyards as well as an orange grove. The ranch featured a large lake that provided the ideal location to while away many pleasurable summer afternoons for Dorothy Forsyth and her friends. Standing, Mrs. Gerald Thomas and Mrs. Wyman Taylor. Seated, from left to right, Mrs. Everett Wilcox, Dorothy Forsyth, Helen Rogers, Ann Beveridge and Ruth Sample with young boy. June 27, 1917.

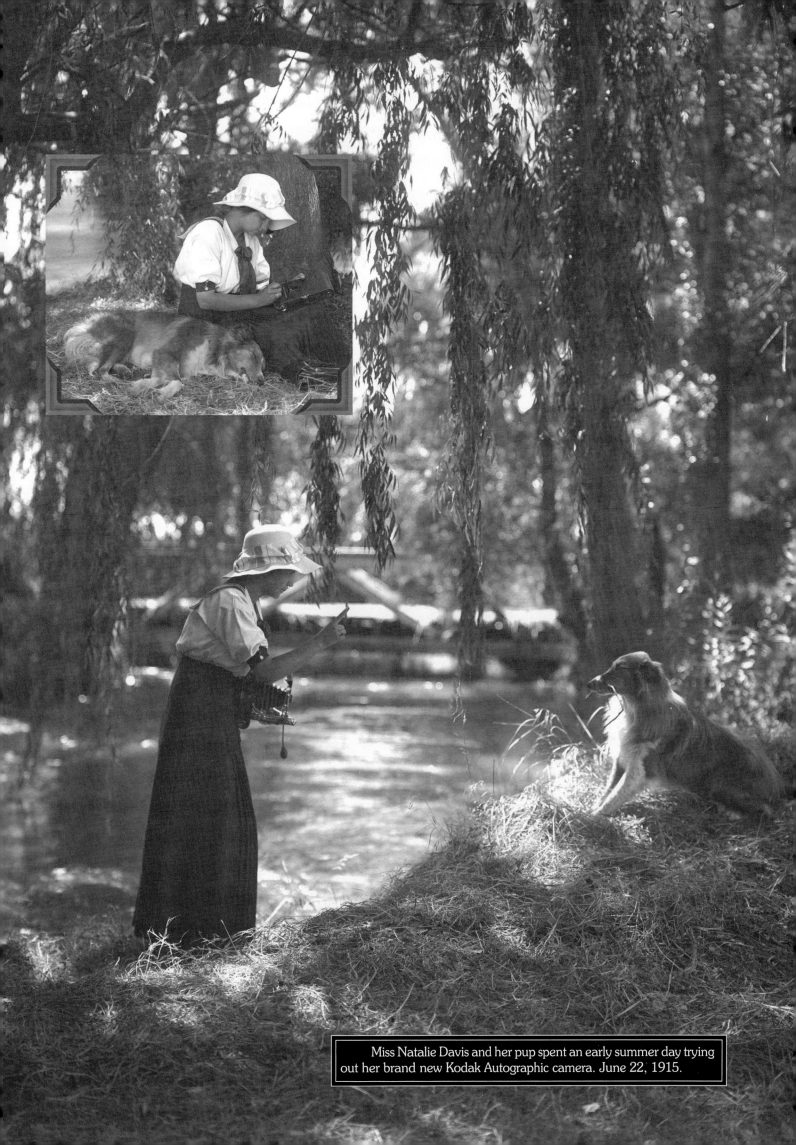

Miss Natalie Davis and her pup spent an early summer day trying out her brand new Kodak Autographic camera. June 22, 1915.

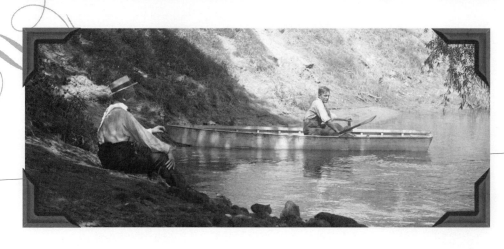

Pop Says...

Hot Diggity Dog

Day after tomorrow. May the 3rd, the TROUT SEASON opens, and I just bet every red-blooded fisherman has itchy feet, anxiously waiting to get started off to his favorite spot. The old creel has been cleaned out, all their fishing gear has been carefully gone over, every one of their pet flies has been carefully looked over, perhaps caressed a bit lovingly, for where is there a real he-man fisherman, especially a fly man, who hasn't got a pet fly he doesn't claim is the ONLY ONE that will bring the big fellows to strike? It may be a Royal Coachman, Grey Hackle, Black Gnat, or a McGinty, the latter being especially good for afternoon or evening fishing. Then, of course, there's the fisherman who has gone modern, using a spinning reel and lures, instead of the fly, such as the small Super Duper, or some variety of spinning lure. The Good Lord knows there are literally hundreds of different lures turned out by the tackle manufacturers, each one claiming that they never fail.

Be that as it may, this is ONE DATE each year that is checked off on the calendar, and woe be to the individual who selects this date to make any kind of a business appointment—he sure will not be a welcome individual.

This also is the time of the year that if you happen to be within hearing distance of a group of two or more of these PISCATORIAL GENTS, you'll hear some real tall

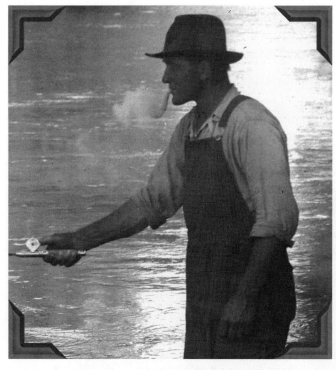

tales about how the big one got away. It is said that a fish is an animal that grows fastest between the time it is caught and the time the fisherman describes it to his friends. And when it comes to the fishermen themselves, there are two kinds, those who fish for sport and those who catch something.

Then you may hear one tell the yarn about the two Irishmen, Pat and Mike, fishing buddies. Pat said to Mike, "Sure and begorrah, you should have been with me the other day. I was fishing in our favorite spot when, WHAMMO, I gets a strike, and the way he takes off, I begin to think all me line and me pole was going with him. But I finally turns him and after quite a battle, I finally brings him in. Oh, you should have seen him, Mike, he sure was a beauty, weighed all of THIRTY POUNDS."

"That he was, Pat, that he was. But let me tell you what happened to me in the self same spot. I makes a good long cast, starts to reel in, when suddenly I latch on to something, so I braces myself for a fight, but no soap. I know he's a big one from the way the pole bends over, so I reel him in slowly. And what do you think I came up with? A lantern, and the date on it was 1882, but what's more, it still was lit. Now, Pat, I tell you what, if you'll take twenty pounds off your fish, I'll blow out the lantern."

Yes, many a tall tale is spun, but what sport is more RELAXING, INVIGORATING, AWAY FROM ALL CARES, a clear fresh stream, or on the shores of a lake, the water reflecting the blue sky, the thrill you experience when the big fellow breaks water! What a healthy, tired feeling at the end of the day.

So, to all you LUCKY PEOPLE who are going to be able to get away to your favorite lake or stream this coming Saturday, GOOD FISHING. And whether you catch any fish or not, always remember this motto:

ALLAH DOES NOT DEDUCT FROM THE ALLOTTED TIME OF MAN THOSE HOURS SPENT IN FISHING.

'Bye, now, I'll be seeing you.
"Pop."

From The Fresno Guide, May 1, 1958

Top: J. B. Welliver and his wife operated the club at the River View Park's Fresno Beach on the San Joaquin River where R. Shubert spent a lazy summer afternoon in a rented rowboat. July 7, 1916.

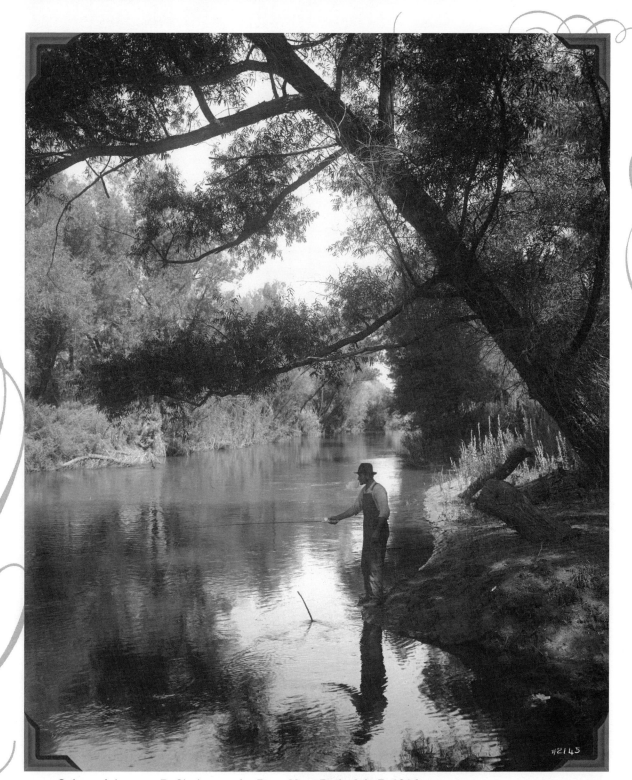

Solitary fisherman R. Shubert at the River View Park. July 7, 1916.

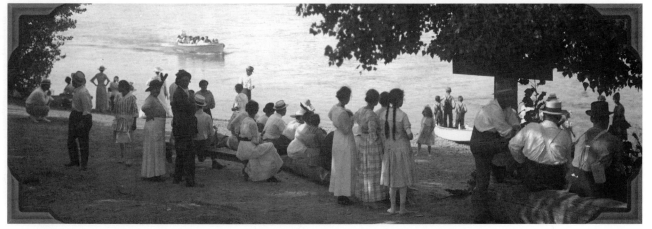

River View Park, on the banks of the San Joaquin River, near the end of Van Ness Boulevard, was originally conceived by J. C. Forkner as a way to enhance his massive Fig Garden development. July 23, 1916.

Before the sun was very high, Mr. Ed Linz had bagged his limit of plump ducks and was ready to head back to his Los Banos homestead. In 1918 the U.S. bag limit was 25 birds for any type duck. October 15, 1914.

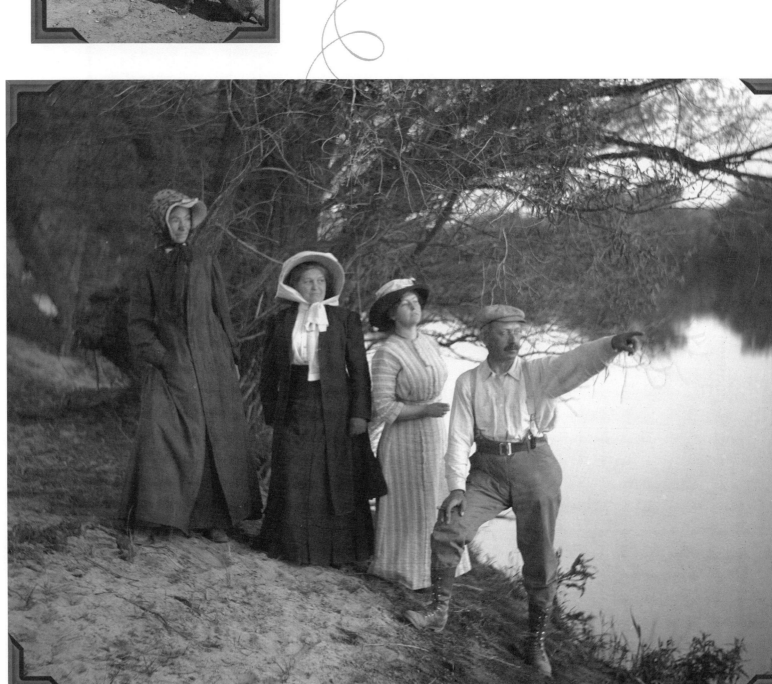

Josephine Laval, mother of "Pop," looked on skeptically as her companions seemed utterly fascinated by some occurrence across the lake. Date unknown.

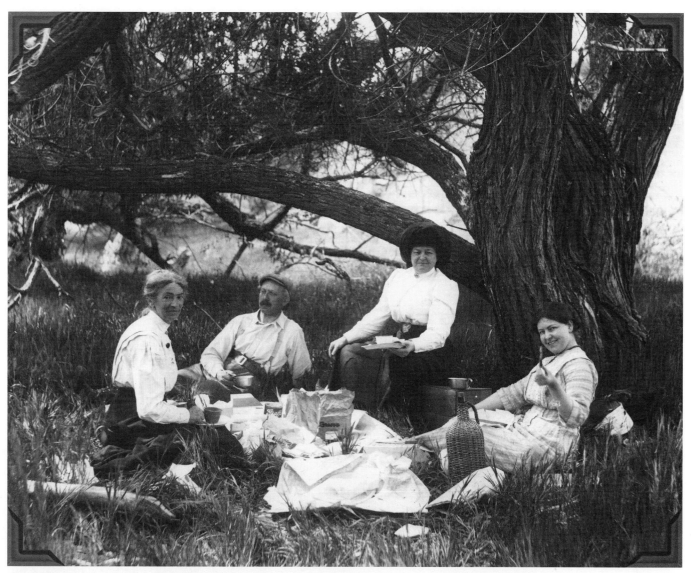

Whether by horse and carriage or by automobile, picnicking with family and friends was always a favorite pastime of Valley residents. Circa 1914.

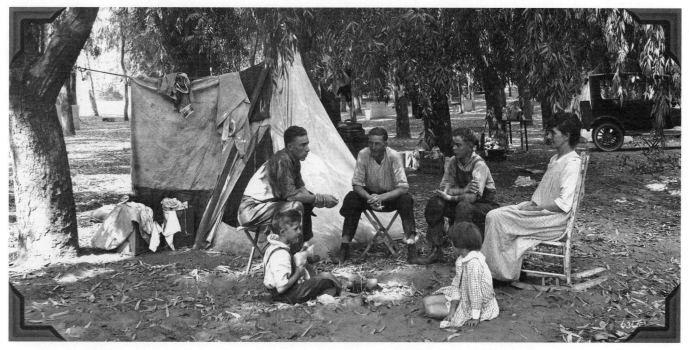

The eucalyptus tree was first planted in the San Joaquin Valley in 1889. Its rapid growth and shade made it an excellent tree for planting in Fresno's Roeding Park. Though hard to believe now, camping was permitted in the eucalyptus grove on the east side of the park and, for many residents, the experience was the closest they would ever come to communing with the great outdoors. July 30, 1918.

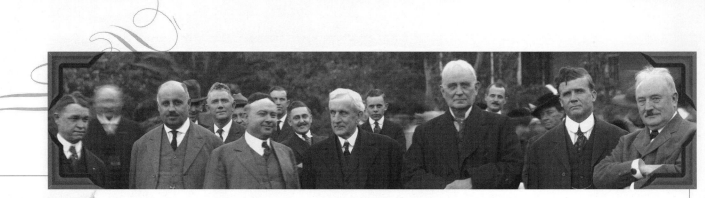

"Pop" Says...

Chalk Up One for the Old Timers

Last Sunday, July 17, I attended a meeting of the Fresno County Historical Society which was held in the beautiful offices of the Fresno Guarantee Savings and Loan Association at Blackstone and Ashlan Avenues, in what is called the Guarantee Room; air conditioned, fitted out with comfortable chairs, and heard an interesting discussion regarding the old historical M. Theo Kearney mansion at Kearney Park and my mind went back through the years as far back as the nineteen hundreds when I was then living in Pittsburgh, Pennsylvania. I remembered reading an article in the *Saturday Evening Post* regarding all the activities of this remarkable man, his eccentric ways, living alone in this beautiful mansion, how he had built Kearney Boulevard eleven miles long, winding triple driveways, lined and shaded with palm, alternating white and red Oleanders, pampas grass clumps and eucalyptus trees, which today is a show drive over which visitors are taken to view Kearney Park, little did I dream at that time that ten years later I would have the pleasure of making a series of photographs of this remarkable place. Sometime I shall try and give you a thumbnail sketch of the life of this remarkable man, M. Theo Kearney, known to all as a man of mystery. Cold and impartial history must record that no man in Fresno County was more generally disliked and yet after his death, which occurred on May 26, 1906, and his will was made public, in the entire history of Fresno, of all the rich men that had died before him, none had made such a princely public gift as did M. Theo Kearney, the man from whom it was least expected when be bequeathed everything to the regents of the University of California.

It's an interesting chapter in the history of Fresno and Fresno County. But as I said before, that's a grand story in itself so let's get back to the present. But, you can readily understand why I was so vitally interested in the proceedings that were taking place at this meeting of the Fresno County Historical Society.

In their endeavors to preserve this grand old mansion which represents another character line in the face of this great community of ours and from news reports which have appeared since the meeting, this is one effort on the part of the historical society that has been successful in their endeavors to convince the board of supervisors that some thought should be given to preserving some of the few remaining historical landmarks in our community.

I have photographed many groups in front of this old Kearney Mansion, and here is a reproduction of one that is quite timely, seeing as how the politicians are stealing the limelight in the news today, this picture was taken on November 4, 1915, the occasion being a visit to our fair city by the then speaker of the House of Representatives, the Honorable Champ Clark. Reading from left to right in the front row, you will see my good old friend Syd Shannon, U.S. Marshall, George Roeding, who gave us Roeding Park, Russel Uhler, county purchasing agent. Judge George Church, Champ Clark, Congressman Denver S. Church, and, ending the line, M.F. Tarpey, in the background. Peering over the right shoulder of Judge Church, you can see the smiling face of Deputy District Attorney Bud Gearhart and looking over the left shoulder of Champ will be seen the face of my good friend Judge Strother. One must admit on looking this group over, that here were men who at that time were doing an outstanding job in helping lay the foundation that helped build this community to what it is today, and I feel a certain amount of pride in the fact that I enjoyed a personal friendship with each and every one of them, with exception of the Honorable Champ Clark, who was a visitor in our midst. At any rate, let's chalk up one for the old timers.

'Bye now I'll be seeing you.

"Pop."

From *The Fresno Guide*, July 7, 1960

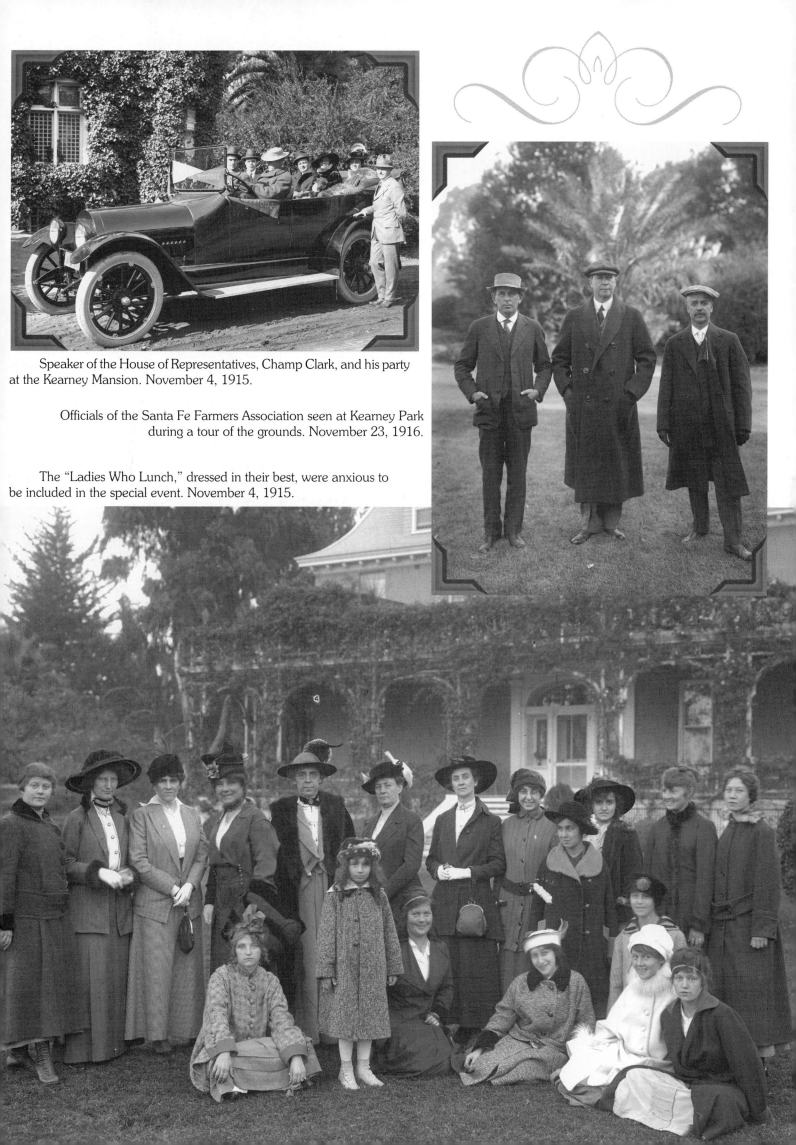

Speaker of the House of Representatives, Champ Clark, and his party at the Kearney Mansion. November 4, 1915.

Officials of the Santa Fe Farmers Association seen at Kearney Park during a tour of the grounds. November 23, 1916.

The "Ladies Who Lunch," dressed in their best, were anxious to be included in the special event. November 4, 1915.

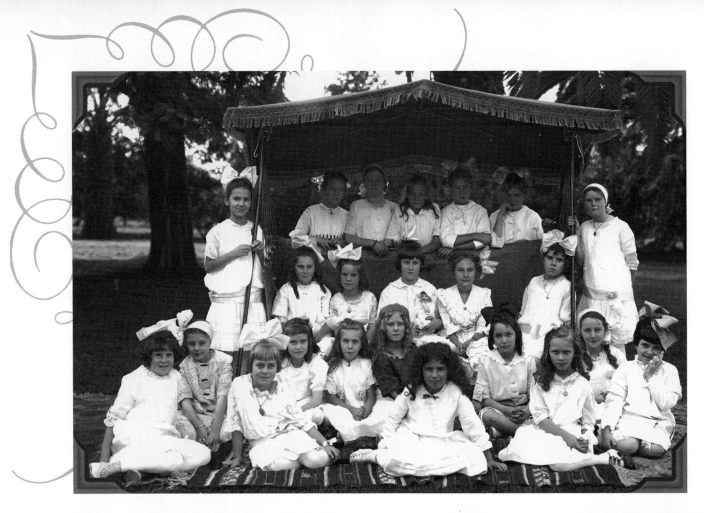

Ten-year-old Eleanor Roeding (second from left, front row) celebrates her first decade in style with sister Evelyn (seated next to her) and a bevy of friends at the park bearing her family's name. November 6, 1915.

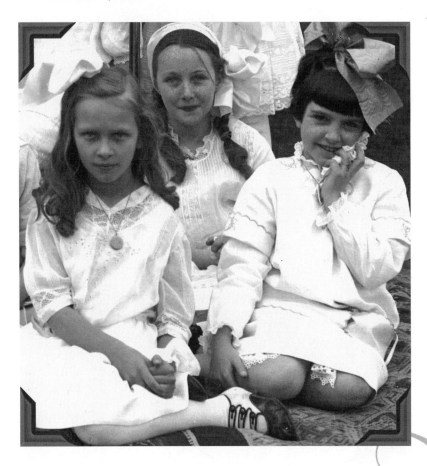

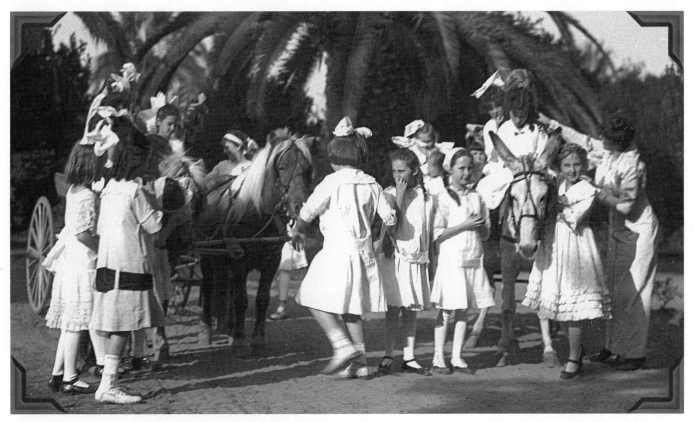

Pony carriage rides thrilled the young ladies lucky enough to be included in Eleanor Roeding's birthday celebration. November 6, 1915.

Happiness for these three young siblings was spelled out in having their own pony and carriage, hitched and ready for an afternoon drive around the neighborhood. Date unknown.

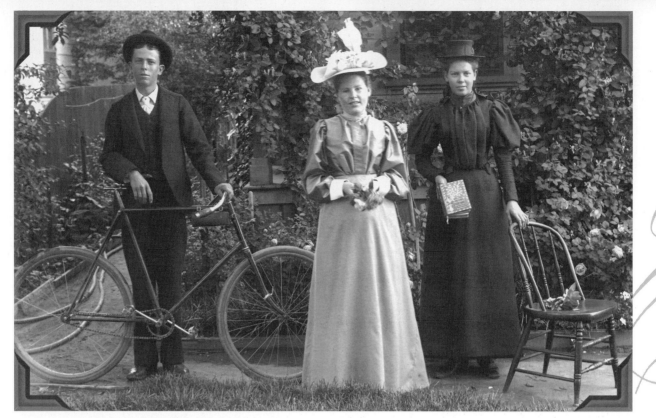

Simple pleasures from days gone by.... Three young family members were found in this relaxing garden setting, filled with anticipation as they pursued an afternoon of leisure. The lady on the right is poised to resume her reading of "Pride and Prejudice," while brother eagerly wants to fly away on his "wheels." Date unknown.

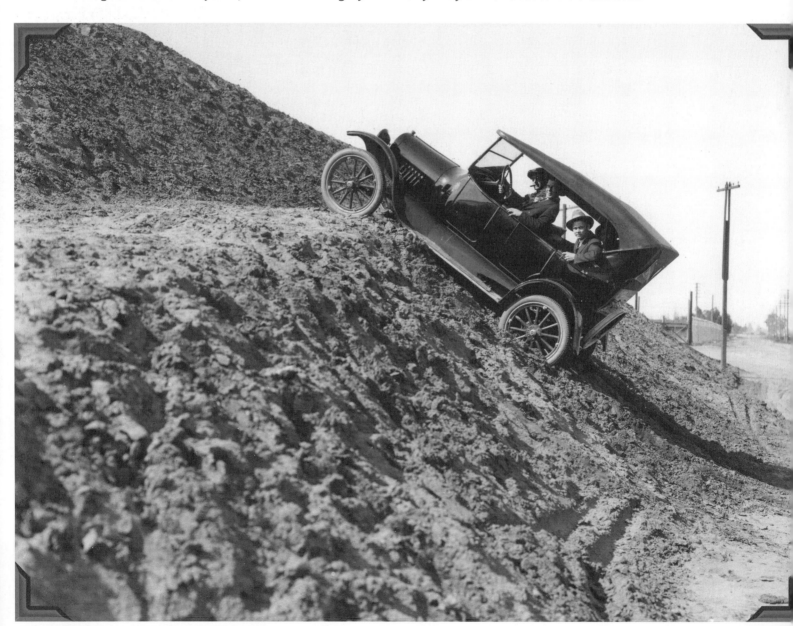

Well, it seemed like this would be quicker. Date unknown.

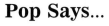

Pop Says...

The Story Of Zapp's Park

Let's go back through the years now. Most of you are acquainted with the southwest corner of Olive and Blackstone Avenues. I am sure many of you old-timers will remember that wonderful recreation area known as Zapp's Park. I know that ever so many of you new-comers will be surprised to know that here was located one of the finest amusement parks anyone could ask for: a large swimming pool, a giant roller coaster, Ferris wheel, a small zoo, pony carts, and a dance platform. In the zoo were lions and bears, wild birds of various kinds, lunch tables along the lake where families used to come and enjoy an evening picnic lunch during the summer evenings and, believe it or not, there were no entrance fees to this amusement park (although you might have to fork over a dime to rent a bathing suit). The only other fees were those for rides on the merry-go-round or in the pony carts, the Ferris Wheel or on the roller coaster. Oh, yes! There was a small fee for the dancers.

This magnificent park was owned by Mr. & Mrs. John Zapp. Mrs. Zapp was a former circus performer, performing on two beautiful white horses, on which she often appeared in parades downtown, and her husband used to also join in these parades—always bringing with him his pet performing bear.

I must tell you of one incident that happened to the family and myself. We were enjoying a family picnic along the shore of the lake one evening when a youngster who was playing too close to the water fell in, and he went under a couple of times before I had jumped in and pulled him out. We soon pumped the water out of him and he seemed none the worse for wear for his mishap. His father, who it turned out was a local tailor, came rushing up to me and, of course, thanked me profusely for saving his son and offered to clean and press all my clothes for me. This incident appeared in a short item written in the *Fresno Morning Republican*. I had forgotten the incident, but it seems the Associated Press had picked it up. It got over the wires and by the time the Eastern papers had picked it up, my little stint had reached the proportion of one of great heroism. I knew nothing about this until later when I received a large package from the Carnegie Institute. It seems the story had been read by former associates in Pittsburgh, Pennsylvania, and they immediately appealed to the Carnegie people to secure a life-saving medal for me. I certainly got a big kick out of it, and I also learned how a simple, small incident can be written up to a point where it is pictured as a great heroic deed. It goes without saying that I soon set the Carnegie people straight and thanked them profusely for having taken such a great interest in the matter.

This all happened in 1912—and I never pass the southwest corner of Olive and Blackstone Avenues without living over the happy moments the family and I used to enjoy at OLD ZAPP'S PARK.

'Bye now, I'll be seeing you.
"Pop."

From *The Fresno Guide*, March 5, 1964

Although no entrance fees were requested, rental of a suit would cost the bather ten cents ($1.90 in 2004 dollars). Reports of the time indicated that skinny dippin' was not unheard of in the canal just outside the park for boys who lacked the fee. Summer 1912.

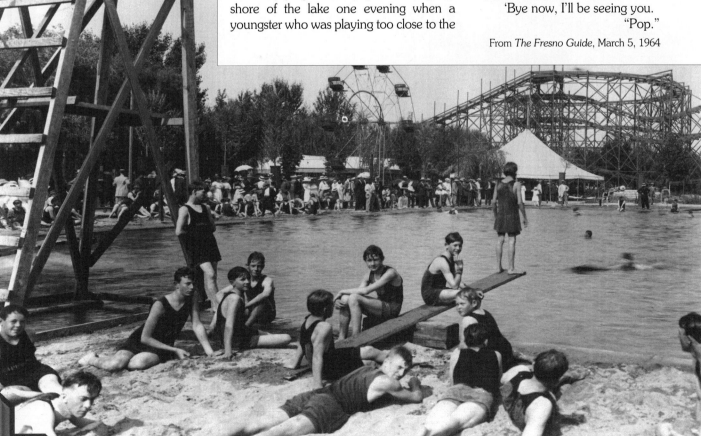

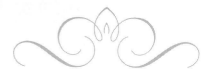

John Zapp used the Dry Creek canal to fill this swimming lake, which he created to be a central attraction of his park north of town on dusty Blackstone Road. In the evening of the first County Day, a special event featured one of the bathing girls from Alameda performing a high dive while trailing fire from her body. September 10, 1917.

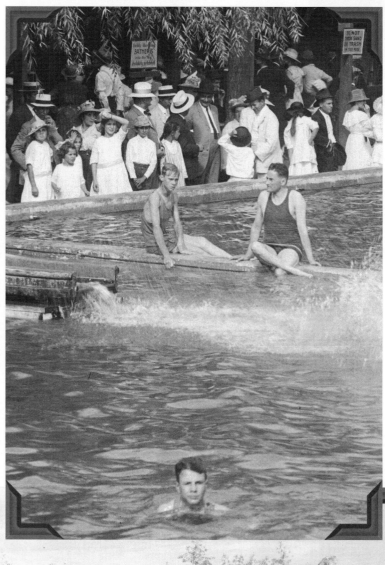

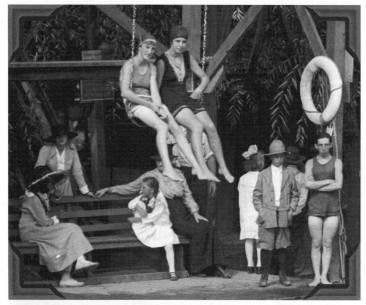

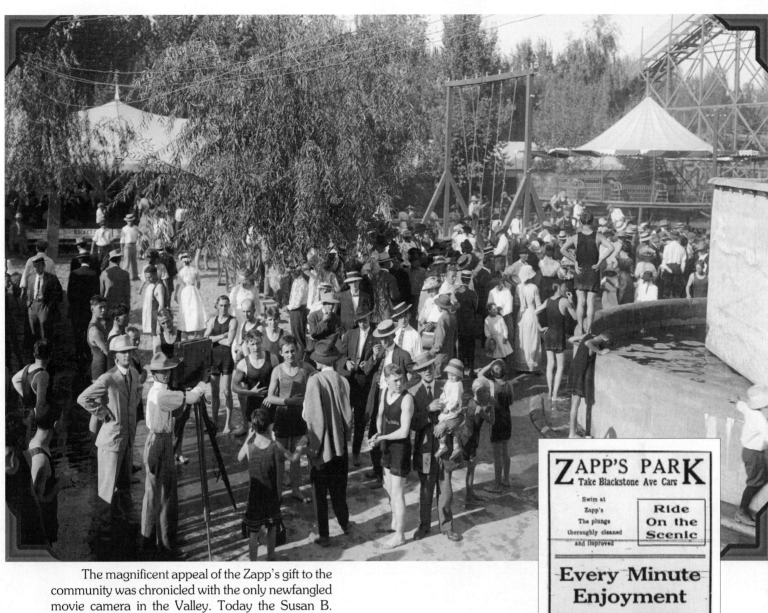

The magnificent appeal of the Zapp's gift to the community was chronicled with the only newfangled movie camera in the Valley. Today the Susan B. Anthony Elementary School, at Blackstone and Webster, now occupies most of the south portion of the original park. Circa 1913.

Zapp's newspaper advertisement. September 29, 1912.

ZAPP'S PARK
Take Blackstone Ave Cars

Swim at
Zapp's
The plunge
thoroughly cleaned
and improved

Ride
On the
Scenic

Every Minute Enjoyment

Swimming	Pony Drive
Rowing	Bowling
Zoo	Picnicking
Billiard Parlors	Shooting Gallery
Scenic Railway	Motion Pictures
	Dancing Pavilion, Etc.

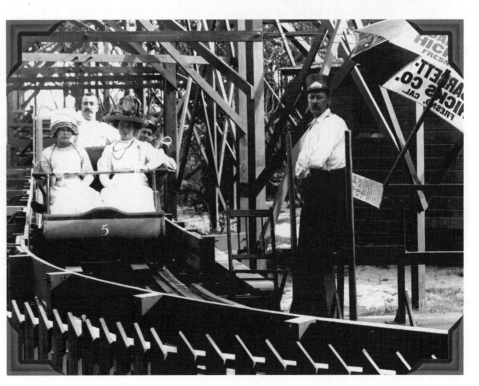

Two lovely park visitors prepared to risk their designer millinery as they were about to be hurtled through the afternoon skies of Fresno onboard car No.5 of Zapp's roller coaster. Circa 1912.

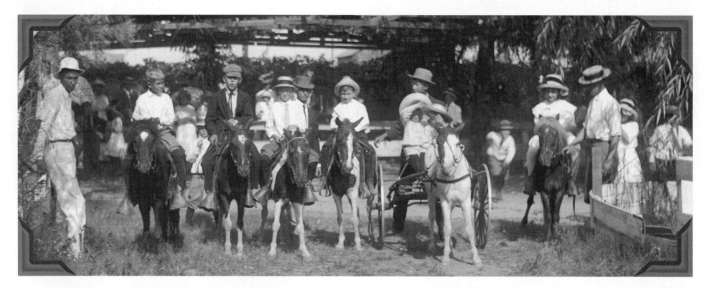

Children were especially welcome at Zapp's Park, with many attractions such as the Shetland pony saddle rides and carts tailor-made to bring delighted smiles of amazement and wonder to the eyes of visiting nippers. Date unknown.

Zapp's zoo denizens included this magnificent king of the jungle, a beast that did not have any interest in the request made by the lion tamer and his lovely assistant for play time frolic. It is interesting to note that the man is outside the cage, while the woman is inside with the beast. All attractions at Zapp's were free except for the zoo and rides. Circa 1913.

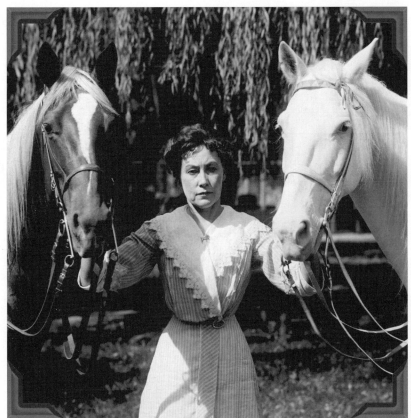

John and Leota Zapp originally ran a horse and cattle ranch on her father's 17 acres, which later became Zapp's Park. Because of her love of horses, she took up circus performing and rode two beautiful white horses during her act. Leota often appeared in parades downtown, with her husband bringing along his performing pet bear. Circa 1912.

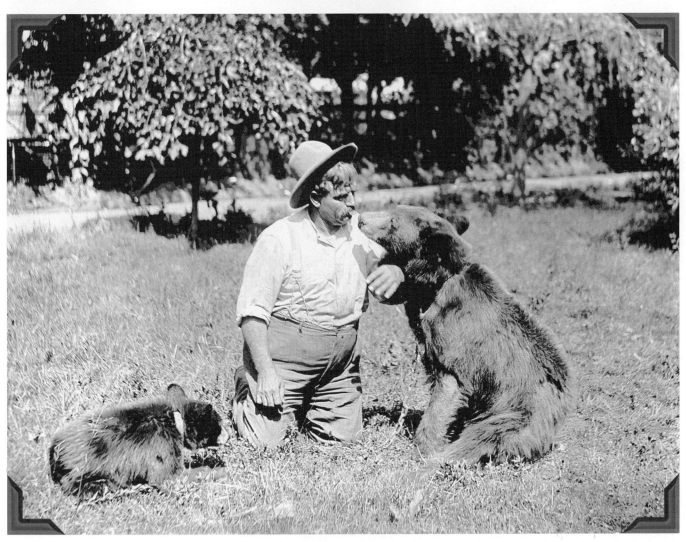

John Zapp and his trained pet bears could often be seen in parades and shows away from the park. John died in 1918, soon followed by Leota in 1919. The park "disappeared" in 1921. Circa 1912.

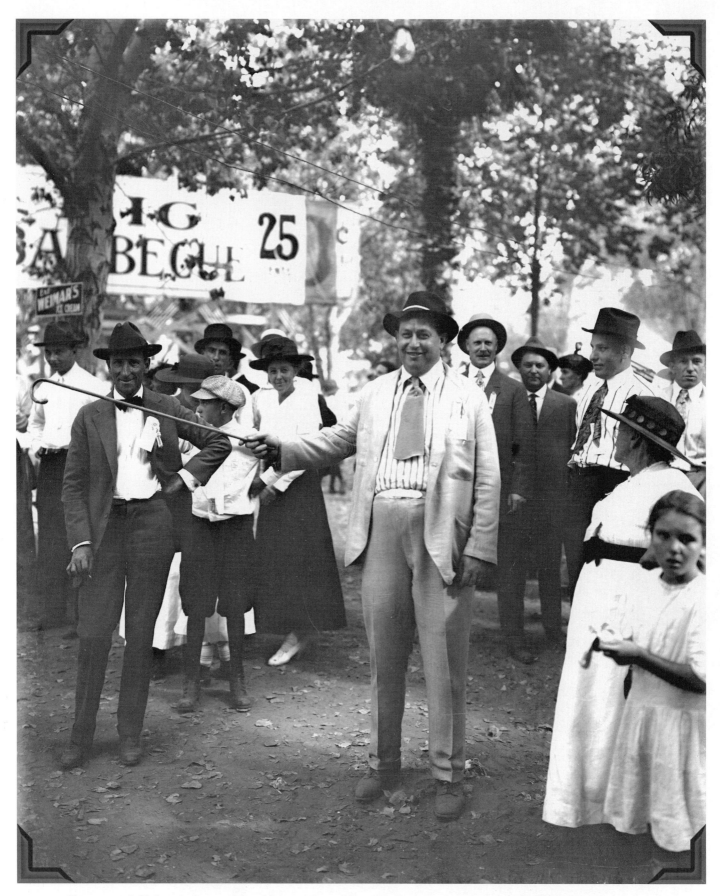

Commercial Club member and local businessman Harry Coffee consented to don the red hat and yellow tie of a vaudeville barker, leading his band of spielers who gleefully needled patrons crossing over onto the island where the 100-foot by 200-foot big top tent had been erected. Barbed observations could be personalized since each guest had received a handshake and name tag from County Day officials at the park entrance. September 10, 1917.

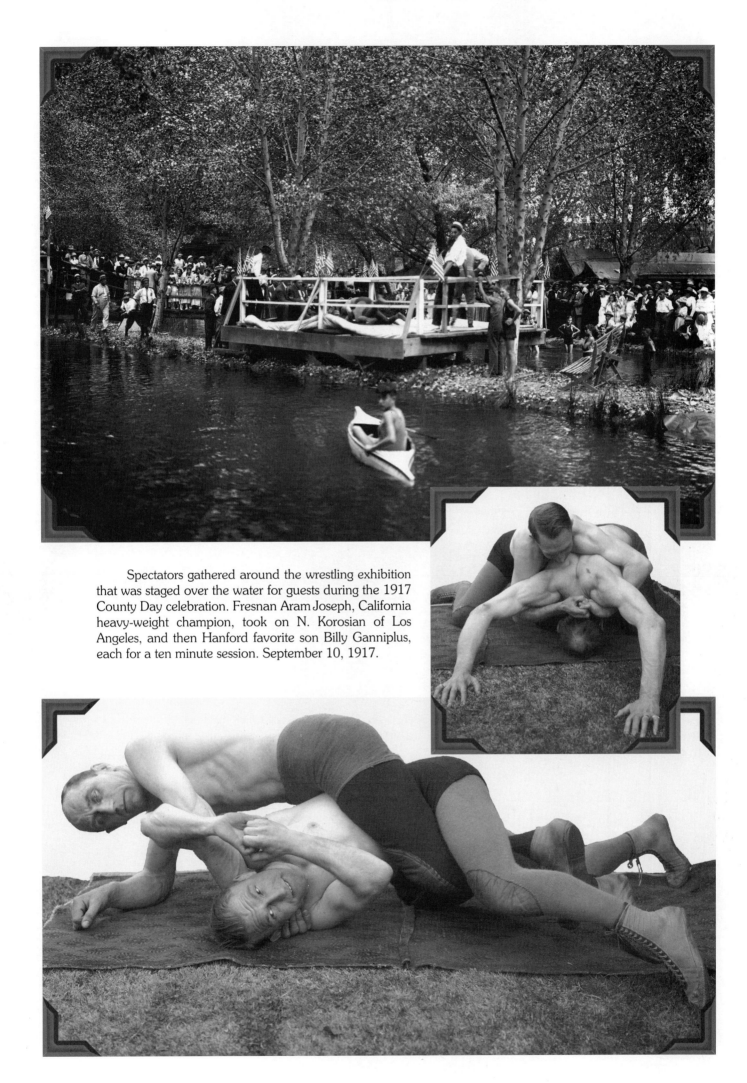

Spectators gathered around the wrestling exhibition that was staged over the water for guests during the 1917 County Day celebration. Fresnan Aram Joseph, California heavy-weight champion, took on N. Korosian of Los Angeles, and then Hanford favorite son Billy Ganniplus, each for a ten minute session. September 10, 1917.

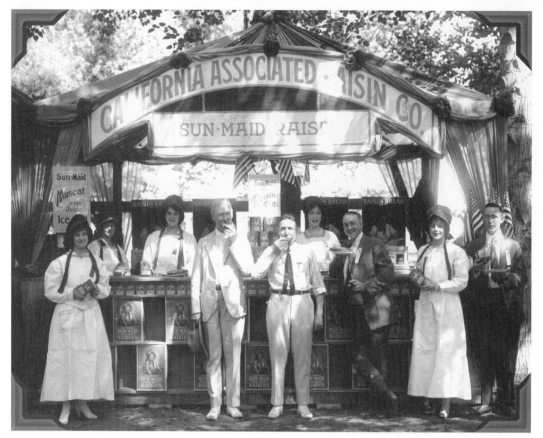

Ice cold grape juice for five cents was in great demand, but the raisin pies—fat ones like mother used to make—had first call throughout the County Day event, as reported in *The Fresno Morning Republican*. The Sun Maid girls, representing the California Associated Raisin Company, gave away the prized pies, which were made with seeded muscats. September 10, 1917.

Carl Leonard, Sun-Maid band leader. August 17, 1918.

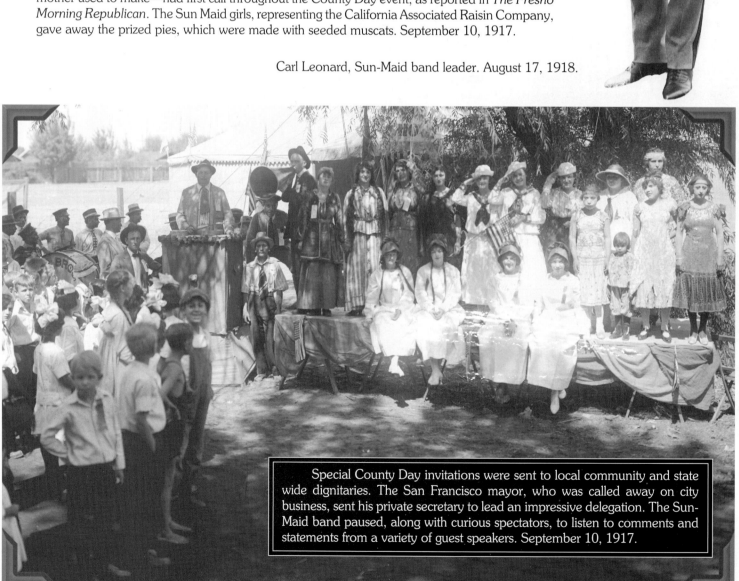

Special County Day invitations were sent to local community and state wide dignitaries. The San Francisco mayor, who was called away on city business, sent his private secretary to lead an impressive delegation. The Sun-Maid band paused, along with curious spectators, to listen to comments and statements from a variety of guest speakers. September 10, 1917.

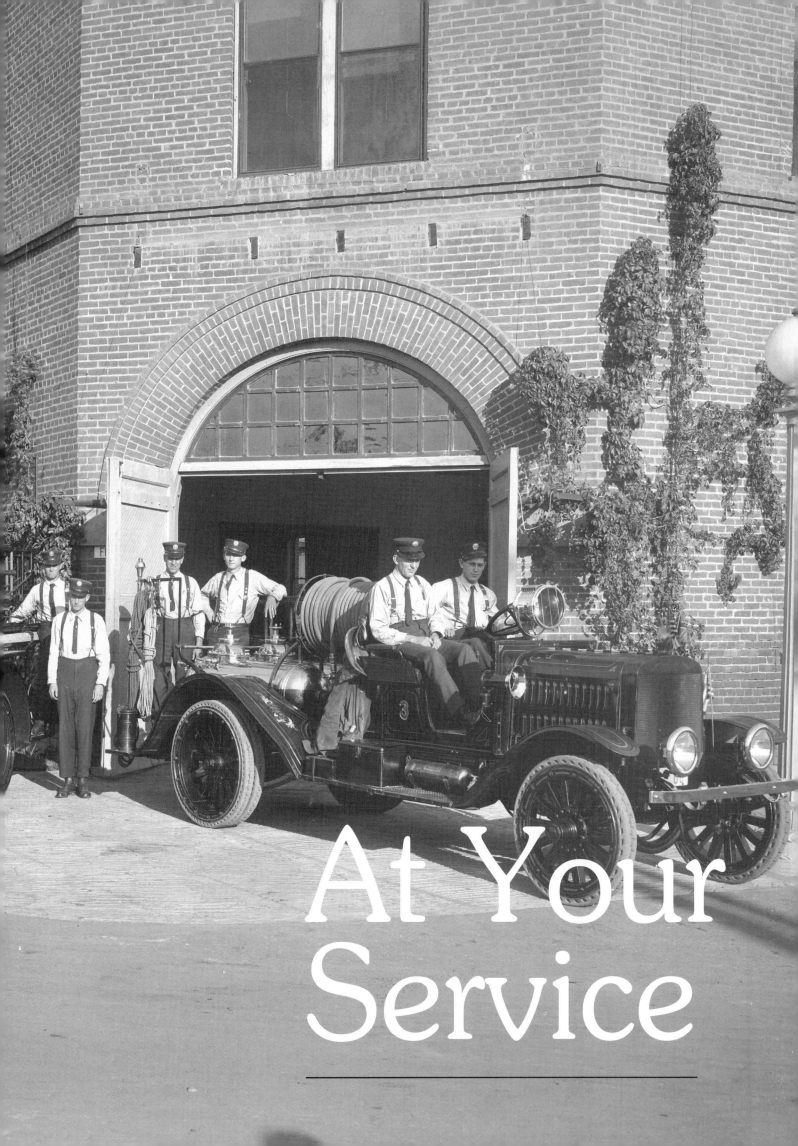

At Your
Service

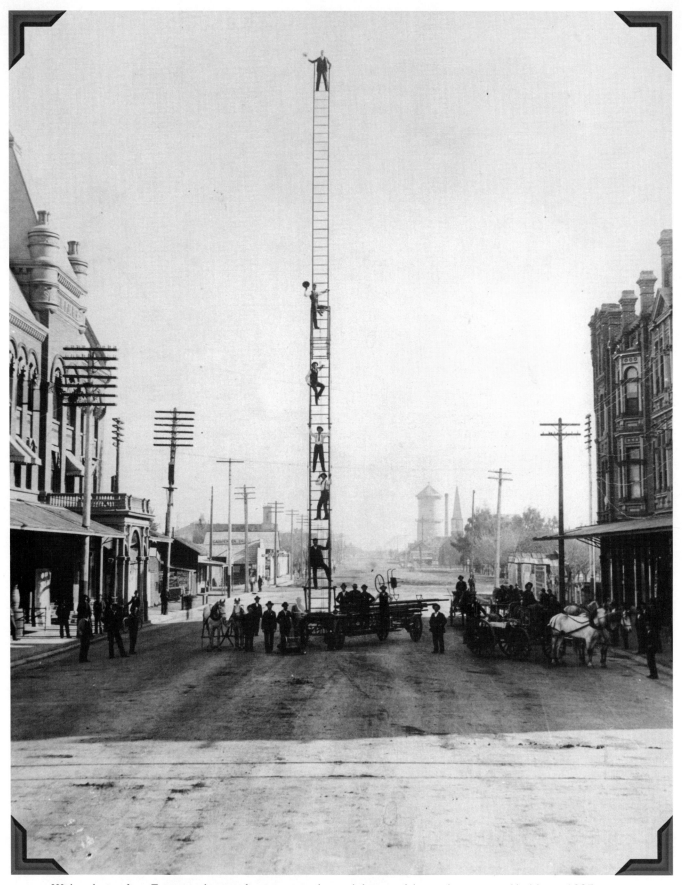

With a daring feat, Fresno volunteer firemen staged an exhibition of the city's new aerial ladder in 1895, stopping what little traffic was moving on Fresno Street, between J (Fulton) and K (Van Ness). Fresno's famous water tower can be seen in the background. Circa 1895.

Previous page: The Fresno Fire Department shows off its 1918 state-of-the-art chemical truck. October 12, 1918.

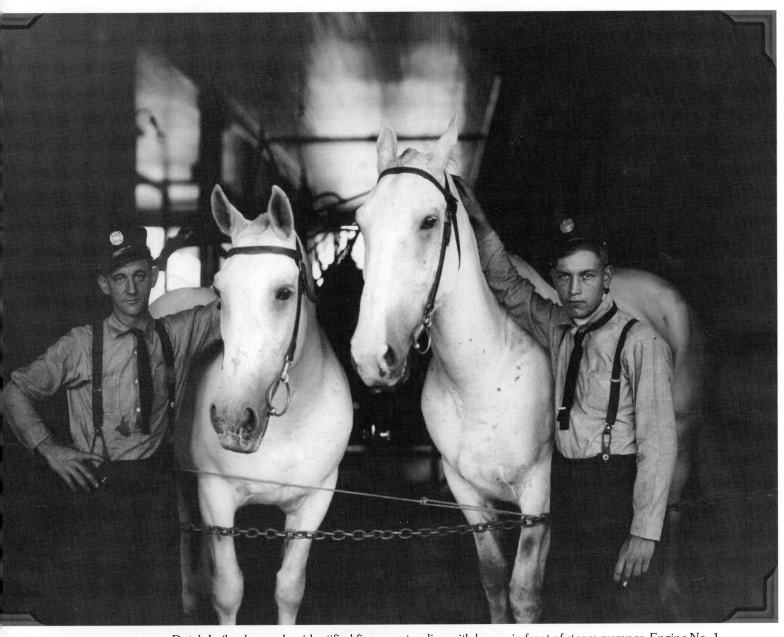

Dutch Leibacher and unidentified fireman standing with horses in front of steam pumper, Engine No. 1, located at 1240 J Street (Fulton). Date unknown.

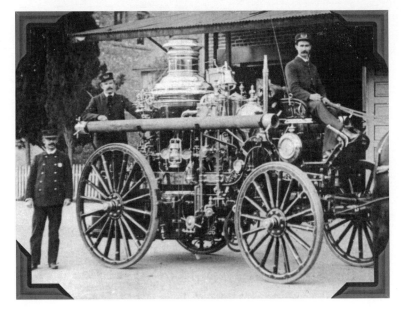

During the late 1890s, Fresno acquired a new pumper which, in this picture, is proudly displayed in front of the city hall and firehouse at 1244 J (Fulton). Assistant Chief James A. Ward stands near the rear of the pumper. Charles Maxwell rides the back step, and James Cronkhite holds the reins from the driver's seat. Circa 1900.

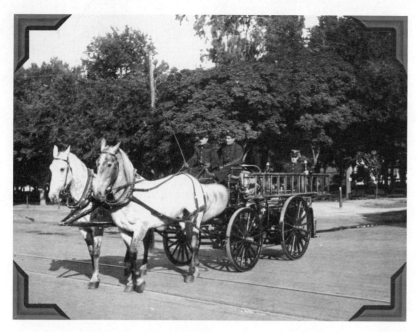

Driver Smitty, Nig Normart and Ace Hunter rode their chemical wagon through the intersection of Tulare and K (Van Ness) streets. Circa 1908.

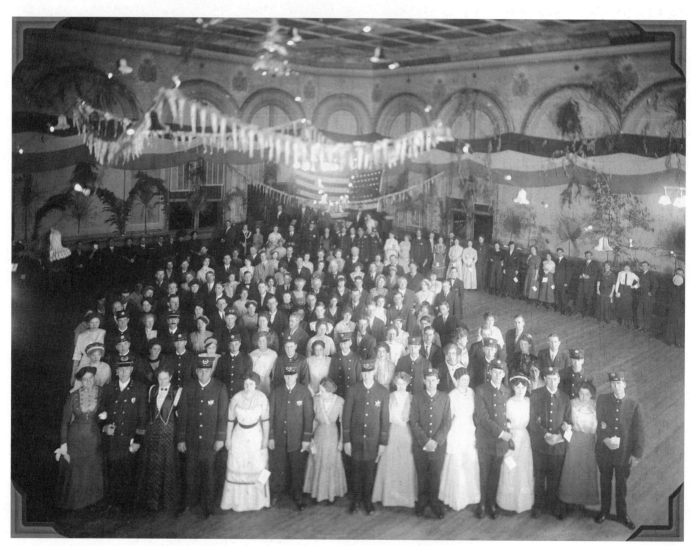

The Firemen and Policemen's Ball at the old Armory Hall was the highlight of Fresno's social calendar in 1910. Circa 1910.

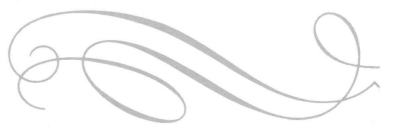

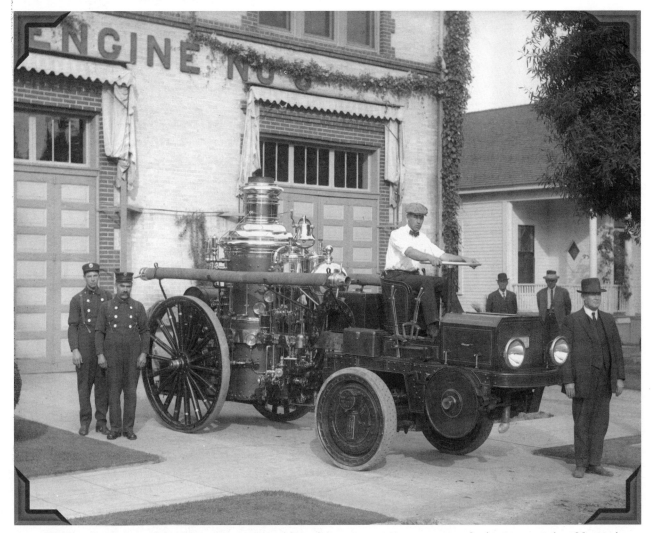

Engine 5 was one of the first to be converted from horsepower to motorpower. In this picture taken November 16, 1914, the new front wheel drive engine stands in front of the firehouse at Divisadero and San Pablo streets. The front section was a two-wheel drive machine which replaced the horses that pulled the steam pumper.

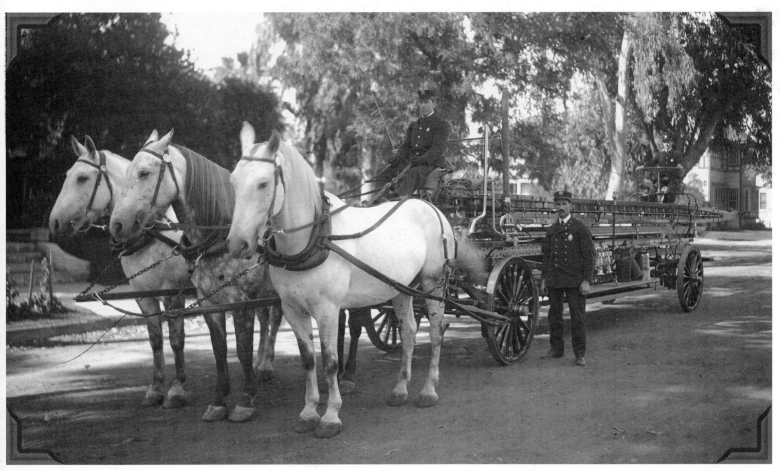

Thomas Baird stood by Hook and Ladder Wagon No.1 as driver A.L. Stevens prepared to return to the firehouse. Circa 1910.

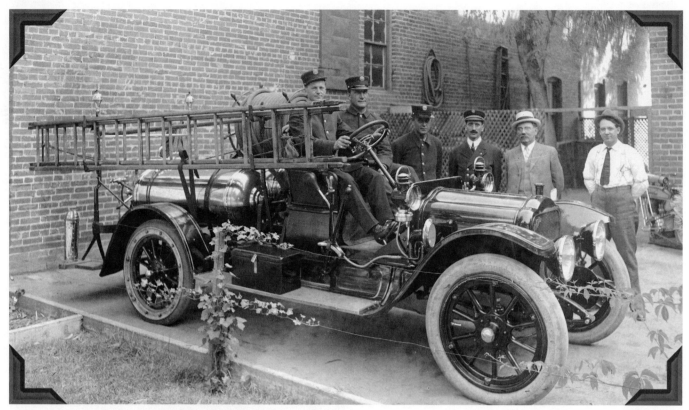

A group of officials gather to examine one of Fresno's first motor-driven chemical trucks. Circa 1914.

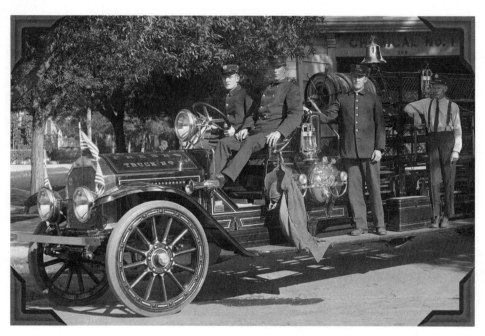

Fresno's Engine No. 1 of Chemical No. 1, on the corner of Effie and McKenzie, was eagerly rolled out by firemen A. Spencer, R. Lacy, L. Burkhart, and an unidentified fireman. August of 1918.

Fresno received new fire fighting equipment in the summer of 1916. Truck No. 2, with its impressive ladder, was immediately shown off in front of Station No. 4, at Kern and U Streets. August 1916.

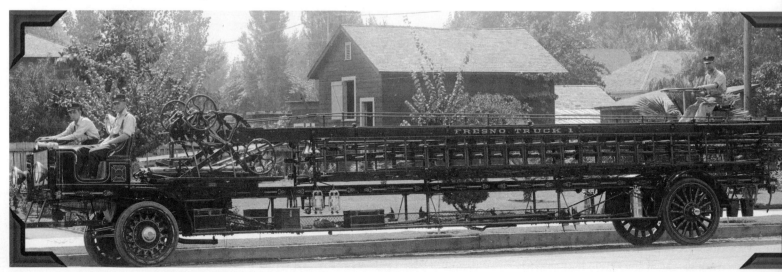

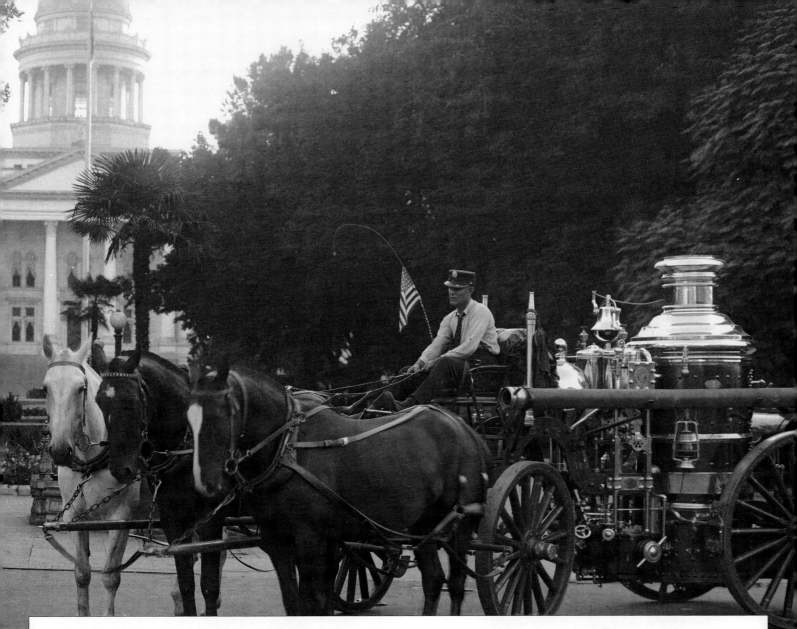

Pop Says...

Remember When?

I know many of you old timers will sit back and recall the days when ENGINE AND HOSE CART No. 2, drawn by these good old faithful horses, was called "Fresno's Pride." I took this picture one August day in front of the Court House Park, back in 1917.

To many of you younger folks, that could be the time when two folds and a safety pin was all your mom needed to dress you up; and again, it could be about the time when some of you were sporting your first pair of KNEE PANTS and the little girls were running around in their little pink or white dresses.

Whichever it was, I just bet you can remember the thrill you used to experience when those faithful old horses were dashing down the street on their way to a fire with the fireman standing on the rear step of the engine, hanging on with one hand and pulling the cord clanging the old bell, smoke and sparks pouring out of the stack of the engine.

Yes, those were the good old days. The headquarters for Engine No.2 was located on J Street, [now Fulton Street] in the 1200 block. It was a two-story building, sleeping quarters for the firemen were on the second floor.

Adjoining them to the south was a one-story building, and then came the Barton Opera House, later occupied by Roos Bros. This one story building had a tin roof, which proved quite handy for our firemen, for you see, the rear of the old Barton Opera House adjoining was where the dressing rooms for the actors and actresses were located.

Believe you me, those firemen were NO DIFFERENT than the men of today! They used to tiptoe over the tin roof on the one-story building adjoining and take PEEK, or a good look, at what was going on in those dressing rooms.

Well, you know the old saying, "BOYS WILL BE BOYS."

Coming back to those wonderful

horses, I also took a picture of the firemen bidding them good-bye the day they were, shall I say, discharged, when the department was through with their services and replaced them by auto driven equipment.

One couldn't help but feel a tug at one's heart strings, it was like the parting of old friends. As one of the firemen remarked at the time, "Here goes our oatsmobile replaced by a gasmobile."

Yes, this is just one of the scenes depicting the early days of our fire department. One of these days, I shall have to chat with you and tell you about the time when Fresno held the reputation of being the worst community of its size when it came to fire losses, to the day when the fire department came up NUMBER ONE, winning the Thomas Ince Trophy.

'Bye now, I'll be seeing you.

"Pop."

From *The Fresno Guide*, January 29, 1959

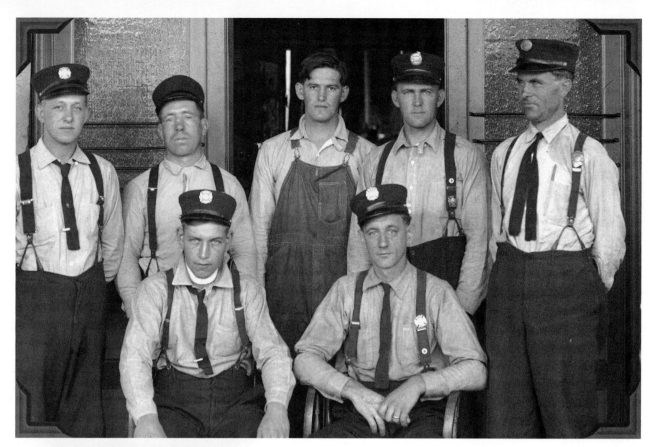

The firemen at Station No.1 are mostly unidentified. Standing second from left is William Uren, also known as Dick Hyland, a well known boxer in the early 1900s. Seated on the right is Dutch Leibacher. This station was used as a firehouse downstairs, with living quarters and Fresno City Hall occupying the upstairs. August 25, 1917.

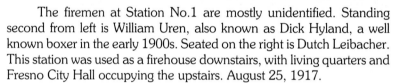

An Engine No. 4 hoseman pumps water on a fire at the California Products Company near the corner of Butler and O Streets. The fire raged for more than twenty-four hours as it consumed bins of raisins used in the production of alcohol, prompting Chief Berkholtz to consider the use of dynamite to control the conflagration. November 8, 1917.

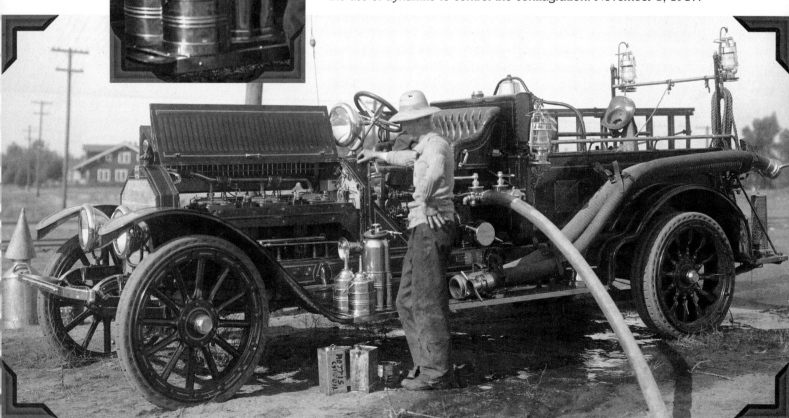

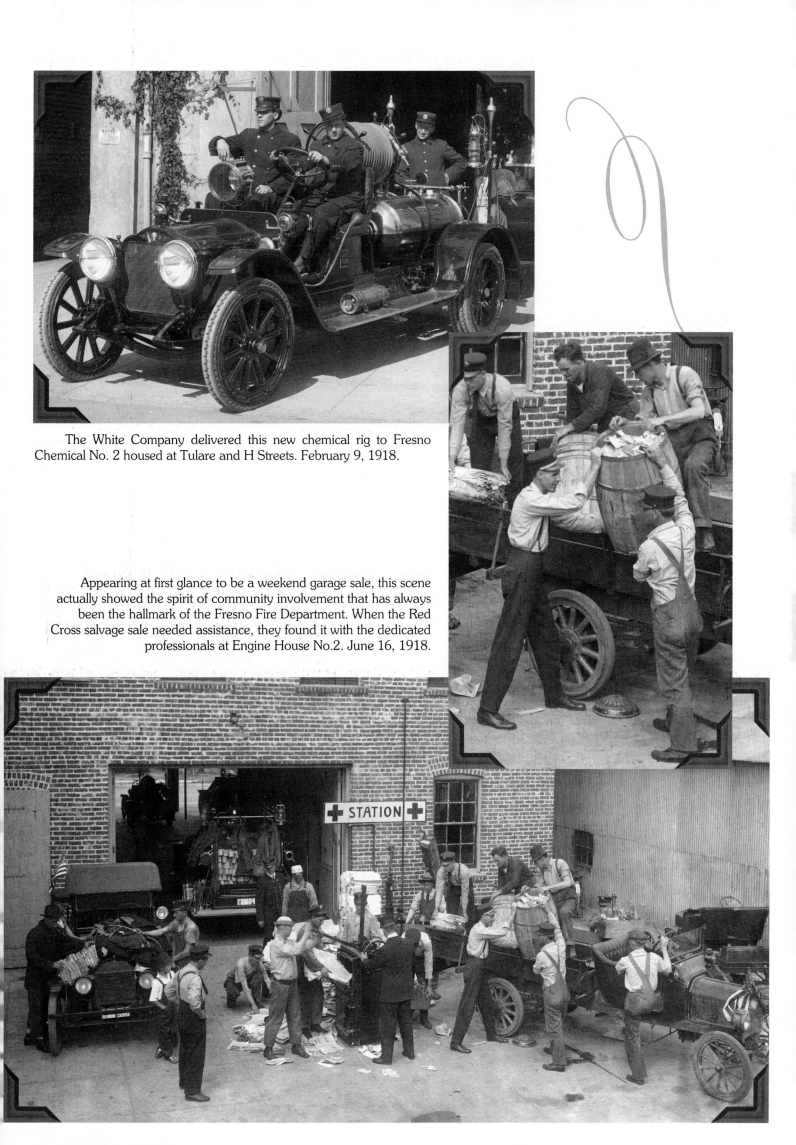

The White Company delivered this new chemical rig to Fresno Chemical No. 2 housed at Tulare and H Streets. February 9, 1918.

Appearing at first glance to be a weekend garage sale, this scene actually showed the spirit of community involvement that has always been the hallmark of the Fresno Fire Department. When the Red Cross salvage sale needed assistance, they found it with the dedicated professionals at Engine House No.2. June 16, 1918.

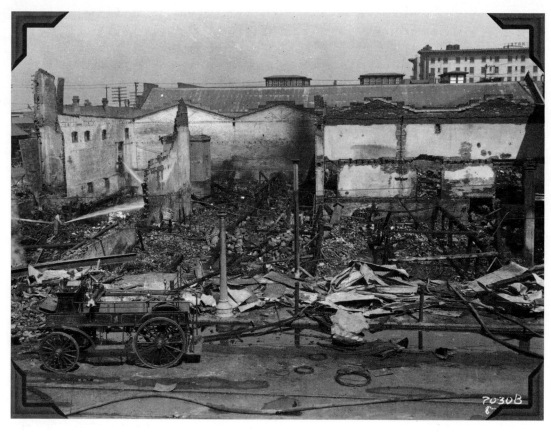

This hot summer morning found fire fighters battling to extinguish a massive blaze that completely consumed the Kutner-Goldstein store located on Mariposa between H and I (Broadway). The company, one of Fresno's most respected merchants, boldly proclaimed themselves "The Universal Providers" until that fateful dawn. August 9, 1918.

In the early morning of March 19, 1918, the recently completed Studebaker Garage at Tuolumne and Broadway was gutted by fire. The loss of building and autos totaled an estimated $50,000 ($620,000 in 2004 value). March 19, 1918.

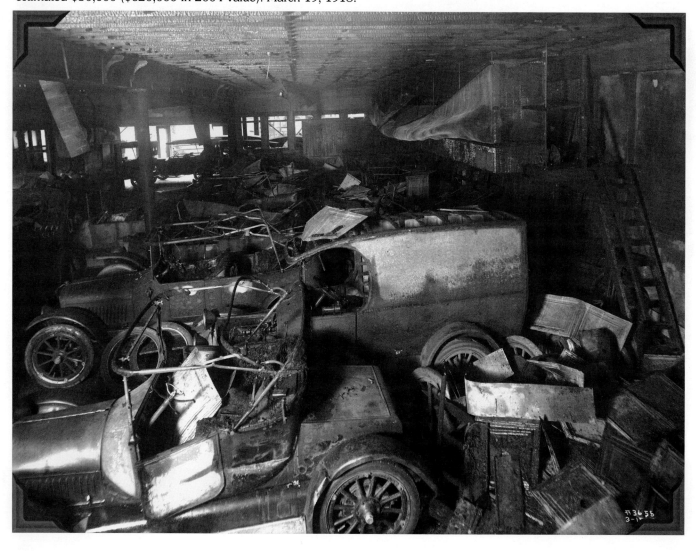

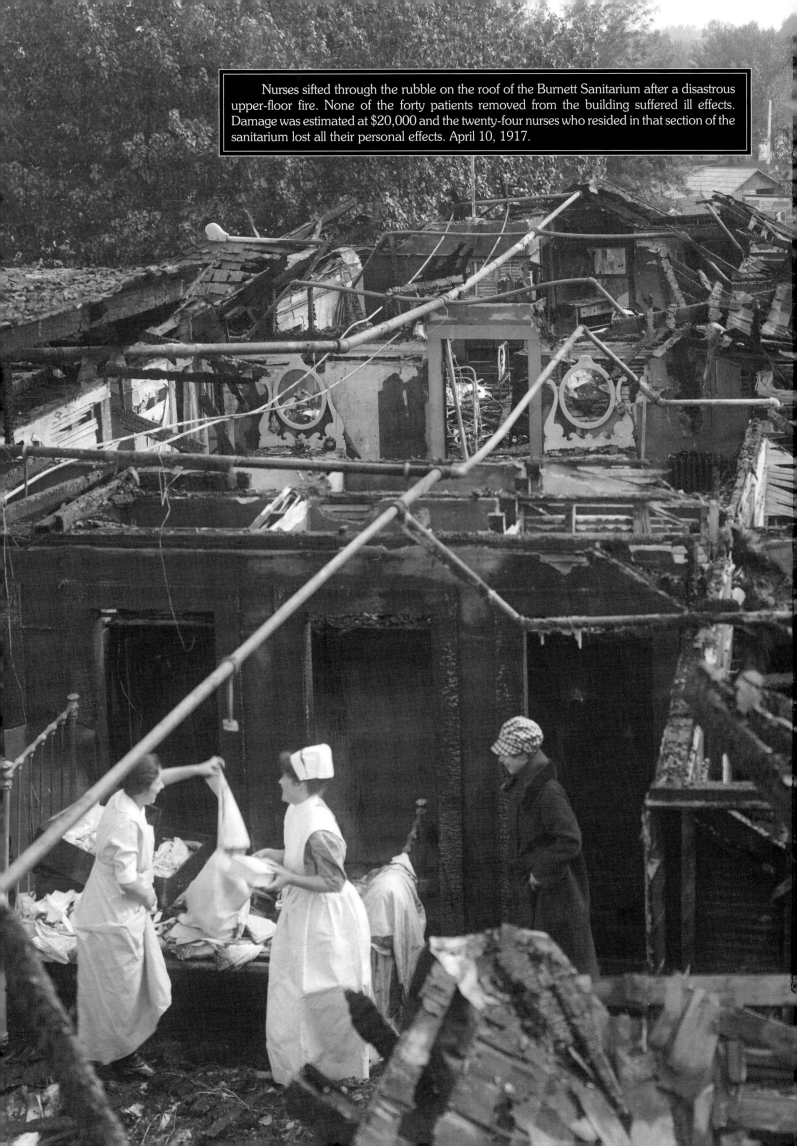

Nurses sifted through the rubble on the roof of the Burnett Sanitarium after a disastrous upper-floor fire. None of the forty patients removed from the building suffered ill effects. Damage was estimated at $20,000 and the twenty-four nurses who resided in that section of the sanitarium lost all their personal effects. April 10, 1917.

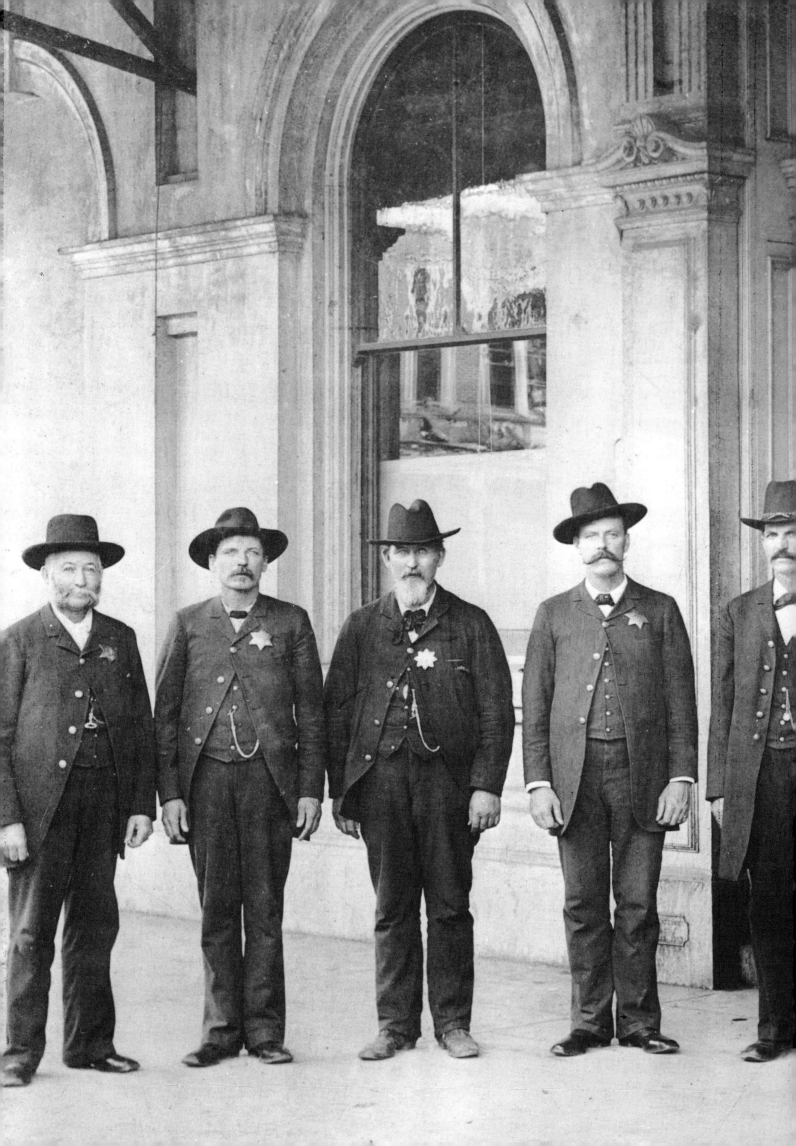

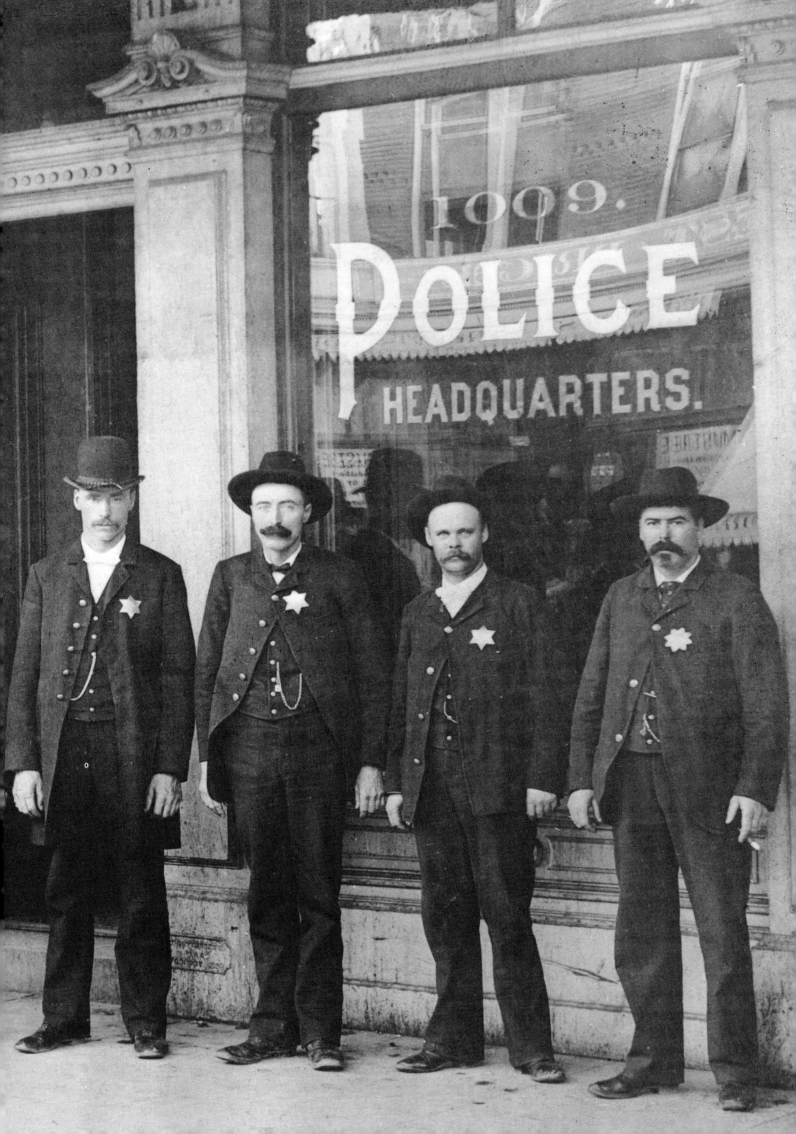

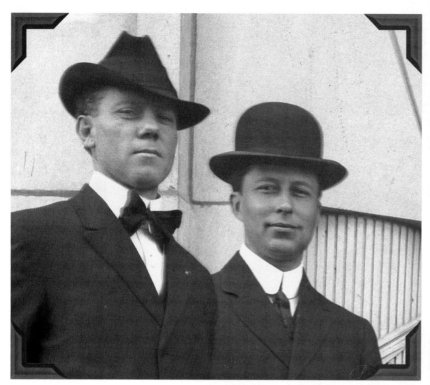

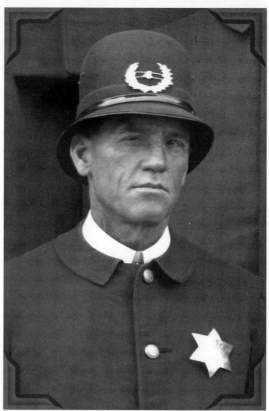

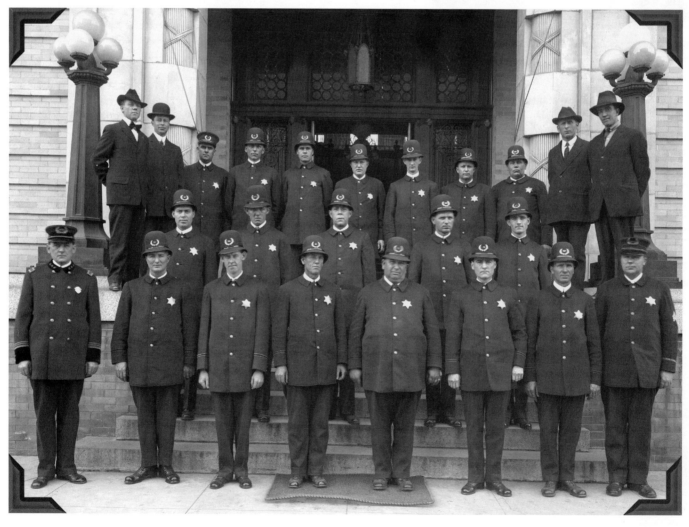

Fresno's finest of 1913 included: front row, left to right: Tom Coyle, Joe Merritt, unidentified, R. A. Rutherford, E. B. Bradley, unidentified, unidentified, Ben Wickstrom; second row, left to right: Chris Hansen, unidentified, unidentified, Al Truesdale, J. P. Murphy; third row, left to right: John Albin, Frank Truax, S. G. Davis, E. A. Fornes, unidentified, Milt Greening, Ralph L. Winsch, unidentified, Charlie Wickstrom, J. G. Goehring and J. L. Broad. Circa 1913.

Previous pages: A professional constabulary was recognized as needed when lawlessness and corruption began to threaten the safety and growth of the rapidly burgeoning metropolis. Fresno's final city marshall and first police chief, John D. Morgan (pictured center), handpicked a cadre that took their jobs seriously and came to work sober. Circa 1901.

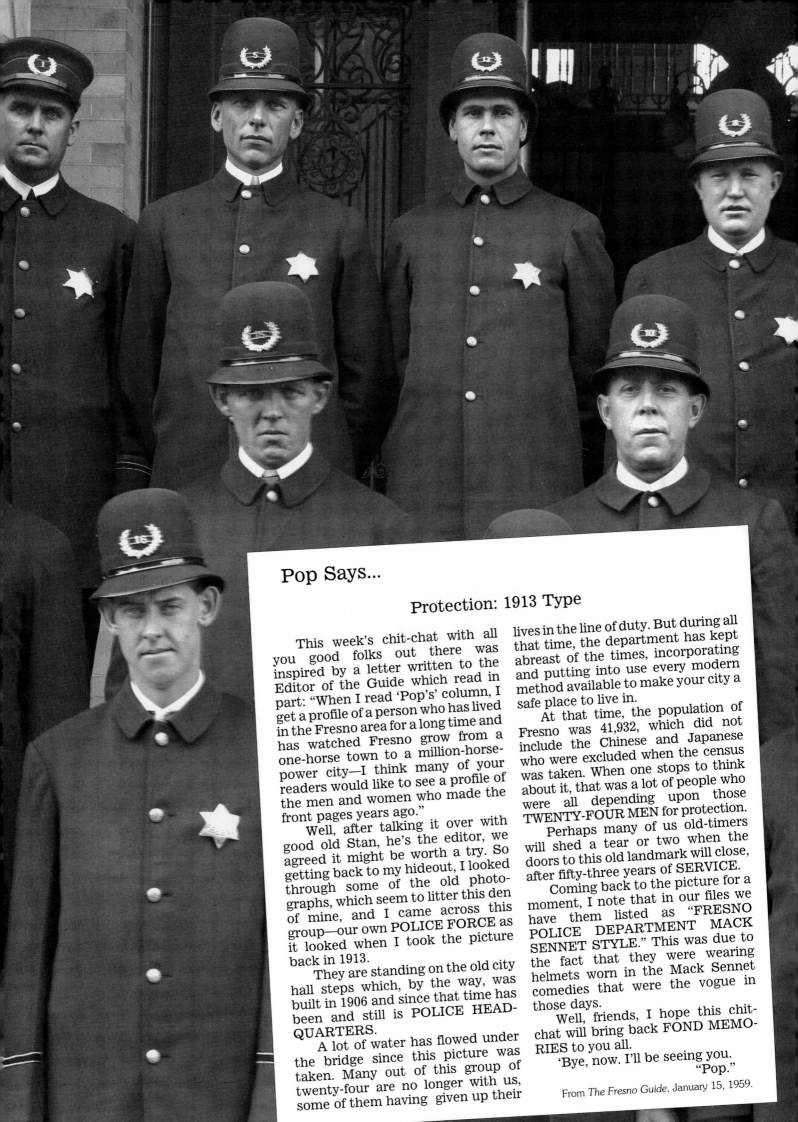

Pop Says...

Protection: 1913 Type

This week's chit-chat with all you good folks out there was inspired by a letter written to the Editor of the Guide which read in part: "When I read 'Pop's' column, I get a profile of a person who has lived in the Fresno area for a long time and has watched Fresno grow from a one-horse town to a million-horse-power city—I think many of your readers would like to see a profile of the men and women who made the front pages years ago."

Well, after talking it over with good old Stan, he's the editor, we agreed it might be worth a try. So getting back to my hideout, I looked through some of the old photographs, which seem to litter this den of mine, and I came across this group—our own POLICE FORCE as it looked when I took the picture back in 1913.

They are standing on the old city hall steps which, by the way, was built in 1906 and since that time has been and still is POLICE HEAD-QUARTERS.

A lot of water has flowed under the bridge since this picture was taken. Many out of this group of twenty-four are no longer with us, some of them having given up their lives in the line of duty. But during all that time, the department has kept abreast of the times, incorporating and putting into use every modern method available to make your city a safe place to live in.

At that time, the population of Fresno was 41,932, which did not include the Chinese and Japanese who were excluded when the census was taken. When one stops to think about it, that was a lot of people who were all depending upon those TWENTY-FOUR MEN for protection.

Perhaps many of us old-timers will shed a tear or two when the doors to this old landmark will close, after fifty-three years of SERVICE.

Coming back to the picture for a moment, I note that in our files we have them listed as "FRESNO POLICE DEPARTMENT MACK SENNET STYLE." This was due to the fact that they were wearing helmets worn in the Mack Sennet comedies that were the vogue in those days.

Well, friends, I hope this chit-chat will bring back FOND MEMORIES to you all.

'Bye, now. I'll be seeing you.

"Pop."

From *The Fresno Guide*, January 15, 1959.

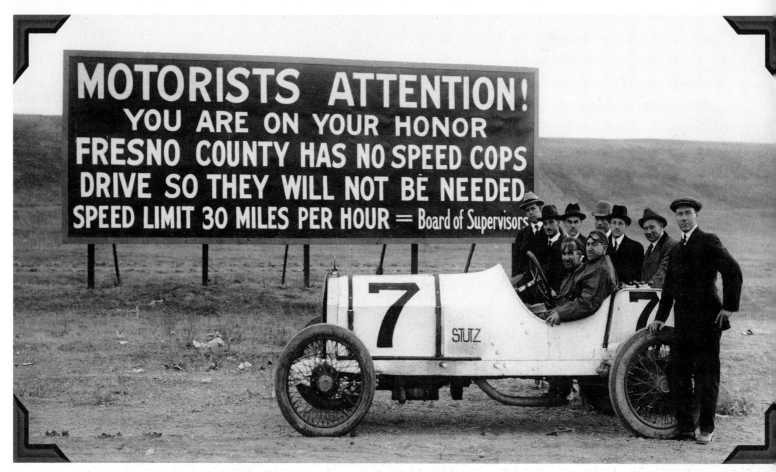

Posted on the highway at the Herndon and San Joaquin River Bridge, Fresno's famous "On Your Honor" billboard was advertised worldwide as a result of Governor Hiram Johnson stopping with his entourage to be filmed by a Pathe Weekly newsreel crew. The billboard, erected by local law enforcement officials, warned drivers to watch their speed. With the dawning of the automobile era, new safety laws had became necessary as fast cars were scaring the horses still used by many people as their primary means of transportation. Circa 1915.

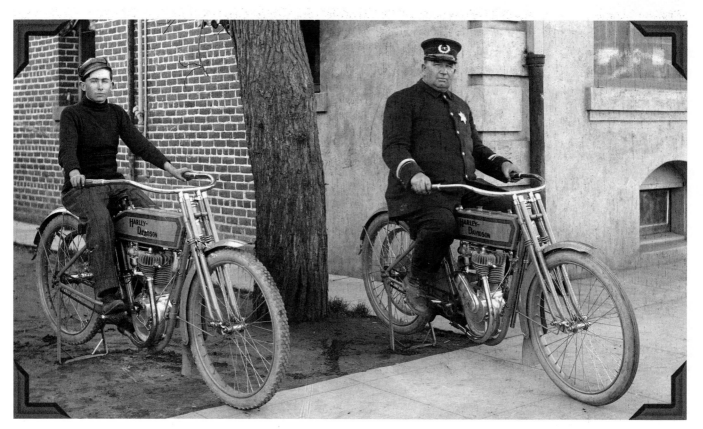

This youngster may soon be able to realize his career dreams with his heroes at the Fresno Police Department. Although radar guns and radios were the stuff of the future, the uncompromising stare of the motor officer is all too familiar even to today's scofflaws. Circa 1912.

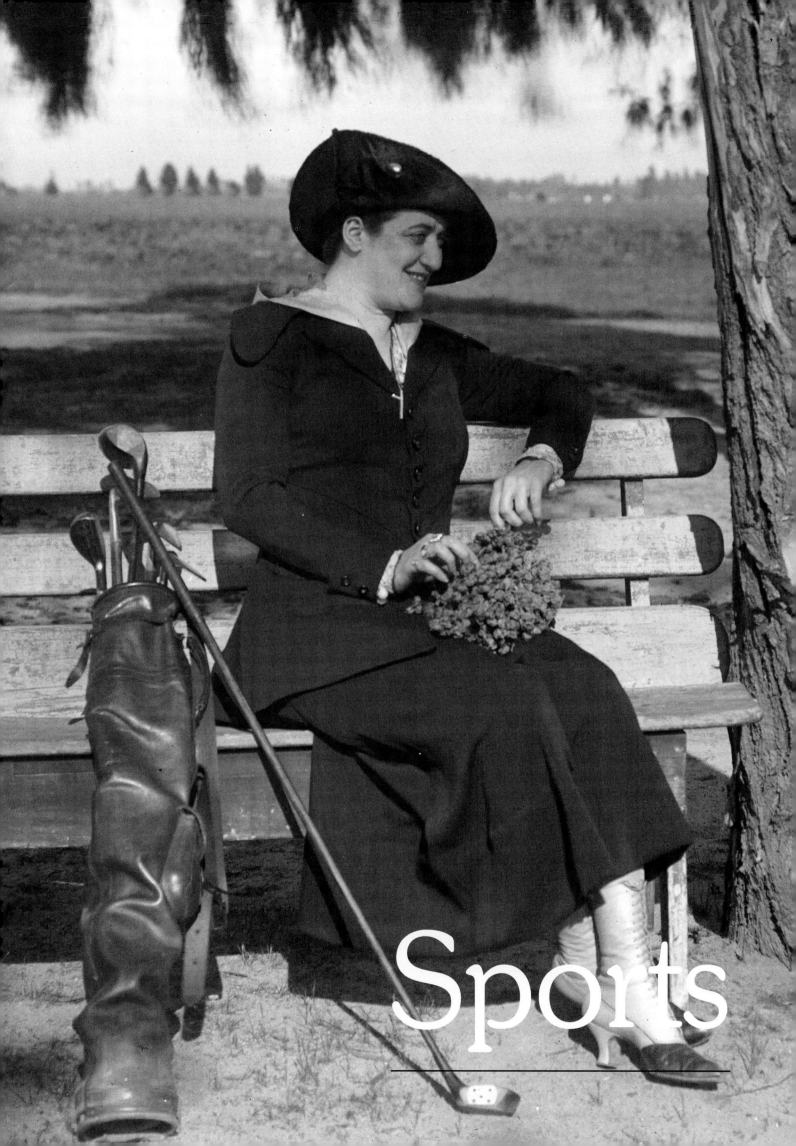

Sports

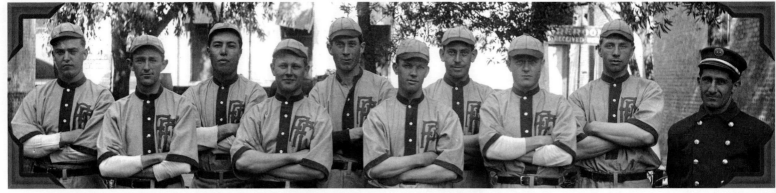

The nine-man Fresno Fire Department Baseball Team looks ready for action in this 1914 photograph. This was also the year that the department changed from horse-drawn fire equipment to motor-driven. Circa 1914.

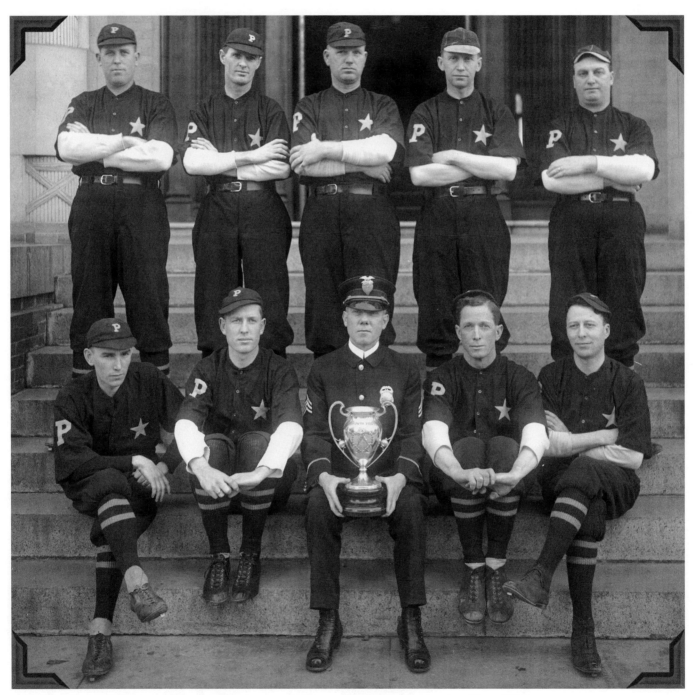

The Fresno Policemen's Baseball Team pose to show off their winning trophy. Circa 1918.

Previous Page: Dorothy Jardon, decked out in her golf attire, took a break from the links at the Sunnyside Country Club. March 16, 1917.

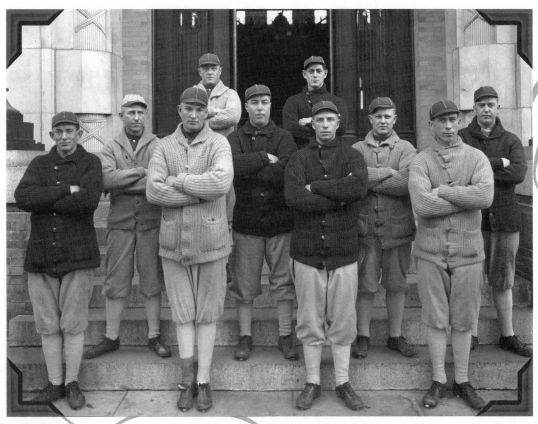

The Firemen's Baseball Team apparently wanted everyone who saw this picture to know that they meant business when it came to serious sport. Circa 1918.

Sperry Flour's baseball team was understandably proud of their hard-earned league trophy. November 11, 1917.

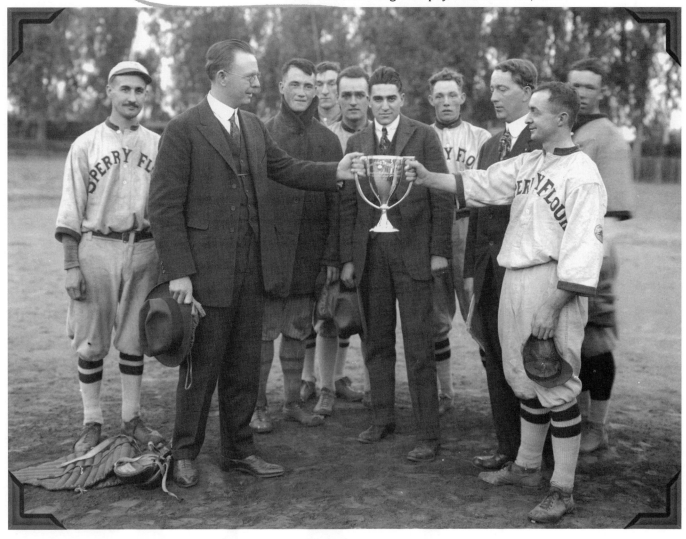

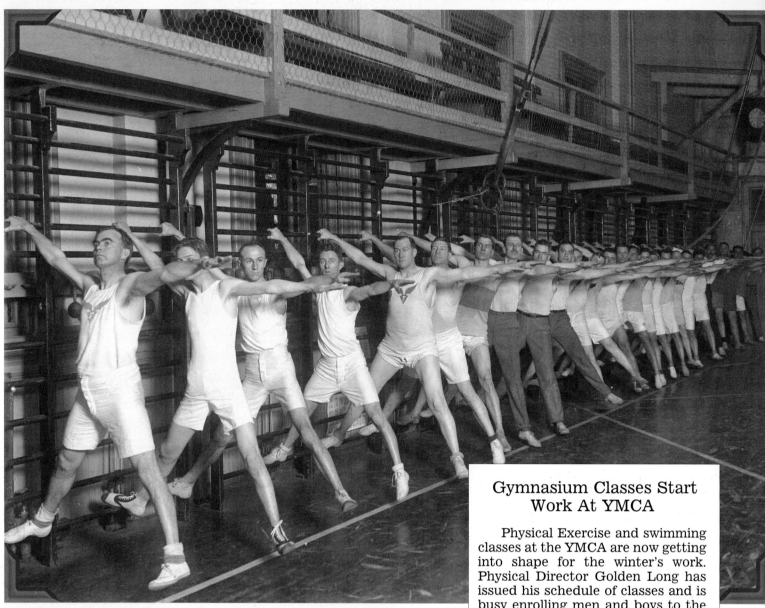

Gymnasium Classes Start Work At YMCA

Physical Exercise and swimming classes at the YMCA are now getting into shape for the winter's work. Physical Director Golden Long has issued his schedule of classes and is busy enrolling men and boys to the various sections.

The noon business men's gymnasium class has four teams in the field. All business men are invited to enter this class for competition in running, swimming, games and physical exercise.

There are also senior graded, business boys and cadets classes The cadet teams are Red, Blue, Green, and Purple. These teams meet on Saturday morning.

At the open house on Tuesday evening, the program will open with orchestral selections followed by a musical program and a demonstration of physical exercises. Physical Director Long will show a number of pictures illustrating the work of the association in the Philippine Islands.

From *The Fresno Morning Republican*, October 5, 1917

The YMCA conducted a weekly businessman's exercise program in the second floor gymnasium. Many local companies believed those who attended would make better employees and even paid part of the yearly dues. Circa 1918.

Next page: The game was volley-hand ball. The players, from left to right, Hanson, Moore, Palmer McAfee, Metzler and Johnson. March 13, 1918.

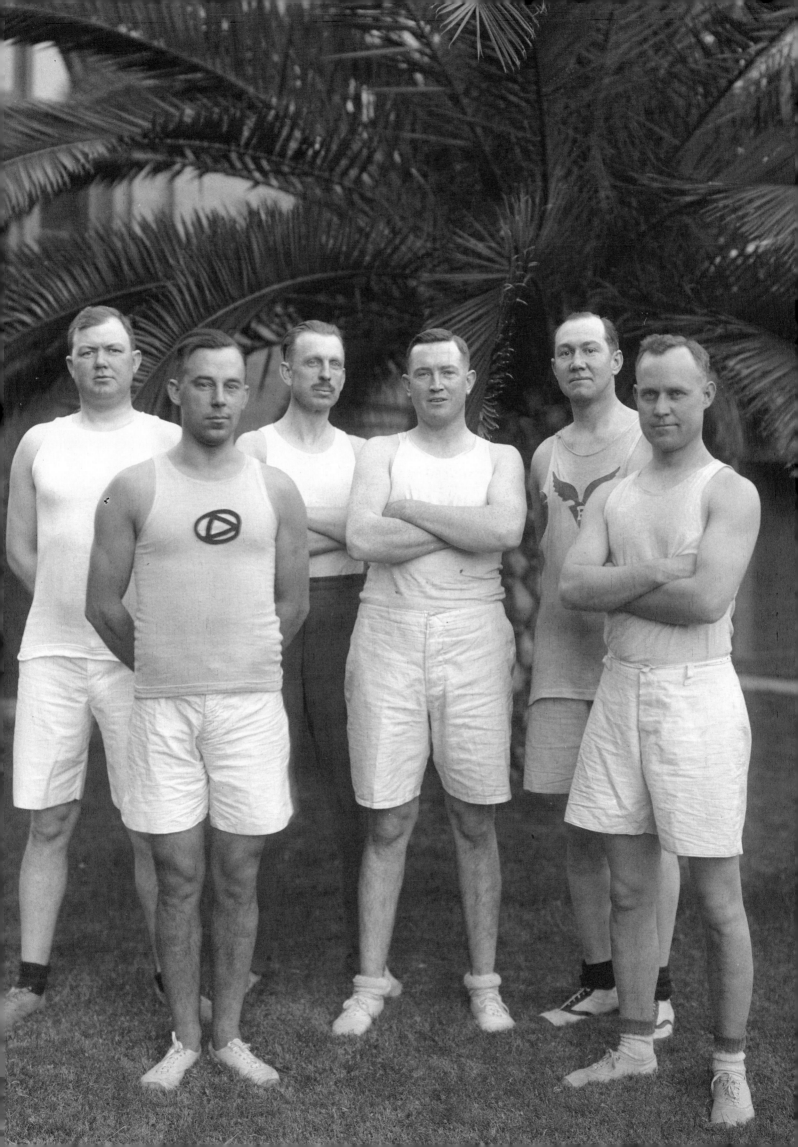

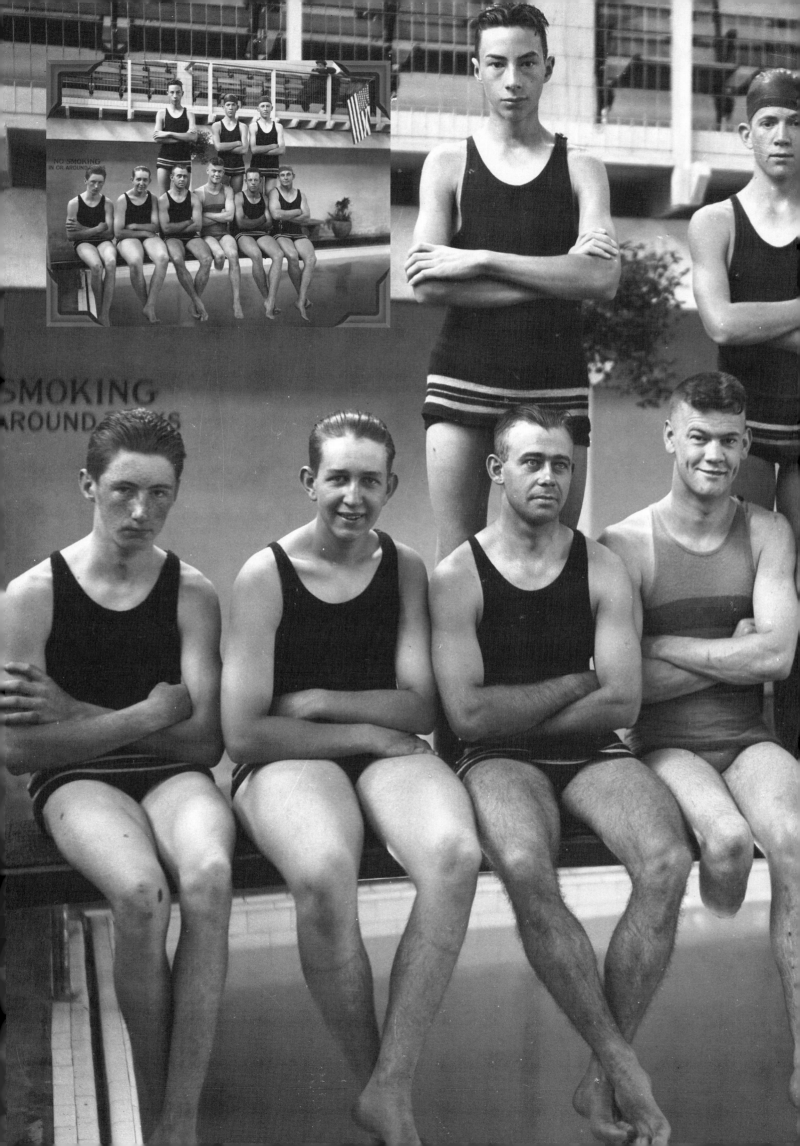

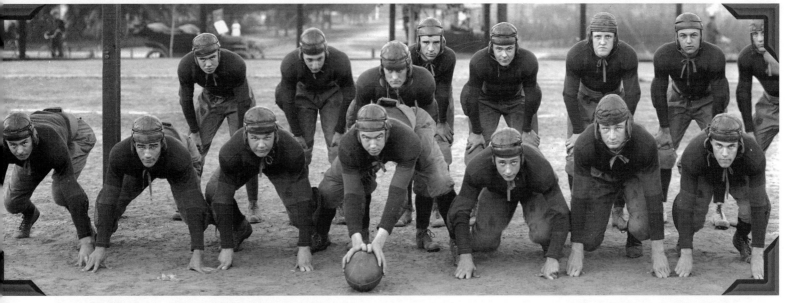

Fresno High's 1917 football team would have been a fearsome sight to opponents even with only these eleven players ready to charge across the line of scrimmage. Circa 1917.

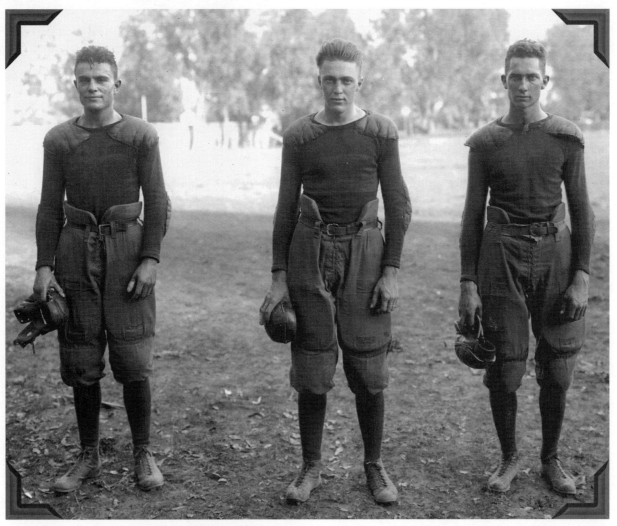

The ruggedly handsome backfield of Davis, Maupin, and Cowan were the men called on to put big points on the scoreboard for the 1916 FHS football team. October 21, 1916.

Previous page: During the 1880s, men's bathing suit styles stuck close to the traditional Skivvies. The first prototypes of "modern" swim trunks were cumbersome and made the action of swimming itself more difficult. The Jantzen Company's initial effort weighed nine pounds when fully soaked. Not only was the suit extremely heavy in water, but it also had the unfortunate tendency of slipping down. Modesty was an issue well into the 1920s. Under the "Bathing Suit Regulations" published in May 17, 1917, men's suits had to be worn with a *skirt* or have at least a skirt effect. The skirt had to be worn outside of the trunks. The other alternative was to wear flannel knee pants with a vest and a fly front. During this time, the knitting mills were rapidly churning out many styles of swim wear, including the "speed suit," a one-piece garment with deeply slashed armholes and closed leg trunks similar to the costumes proudly worn by the young men of the Fresno Natatorium Swim Club. July 14,1918.

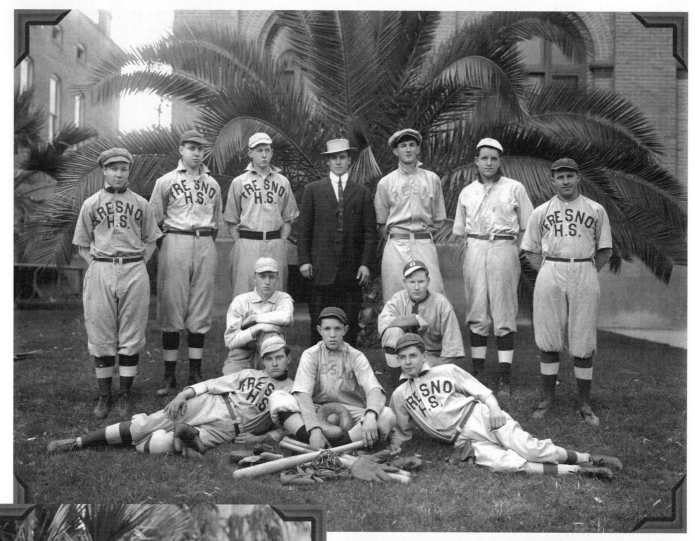

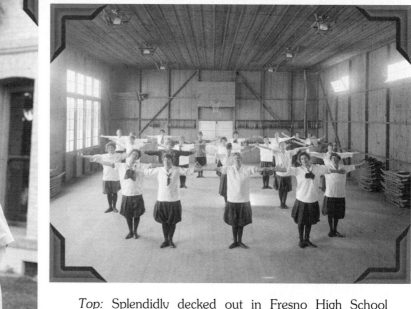

Top: Splendidly decked out in Fresno High School uniforms, the baseball team took a breather before the game. Since each man wore a different style hat, spotters and announcers could easily identify players during game action. The challenge on the field of play would be nothing compared to the struggles many of these boys would face on the field of battle within a couple of years. Circa 1913.

Above: The women's physical education department at Fresno State Normal School offered exercise to all students. November 1915.

Left: Team captains of Fresno High athletic squads met for an end-of-season photograph.

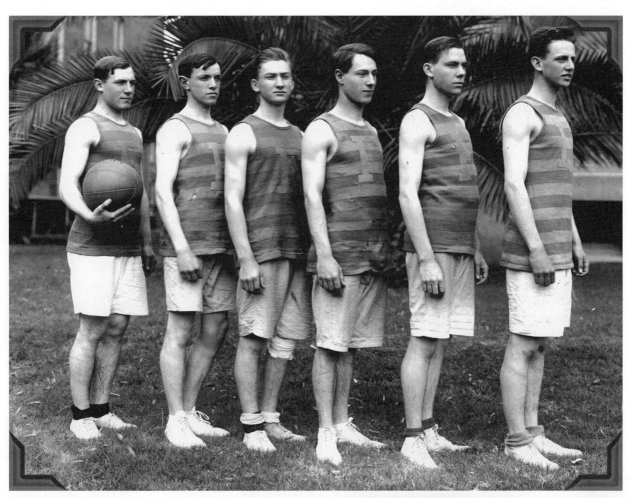

Members of the 1911 Fresno High School basketball team were poised and confident as they anticipated the upcoming hoops season. Circa 1911.

Normal Girls To Play Baseball

Young Women to Enter Fields Formerly Held By Men

Announcement was made in the students' assembly hall at the Fresno Normal School yesterday that the young ladies of the institution are planning to organize teams in baseball and hockey during the winter. A large number of girls are already playing baseball, and the sport is growing in popularity.

One of the principal purposes in taking up the game is to enable the young women to assist the pupils in the schools in learning the game in the various schools in which they will later teach.

From *The Fresno Morning Republican*, October 15, 1915

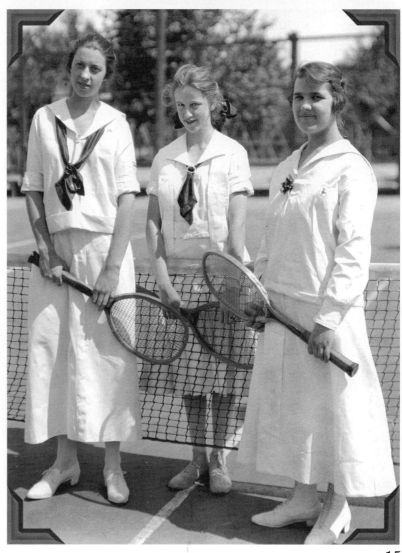

The fashionably dressed lasses of the Fresno High School tennis team graciously modeled their court wear before practice on a balmy June afternoon. June 17, 1918.

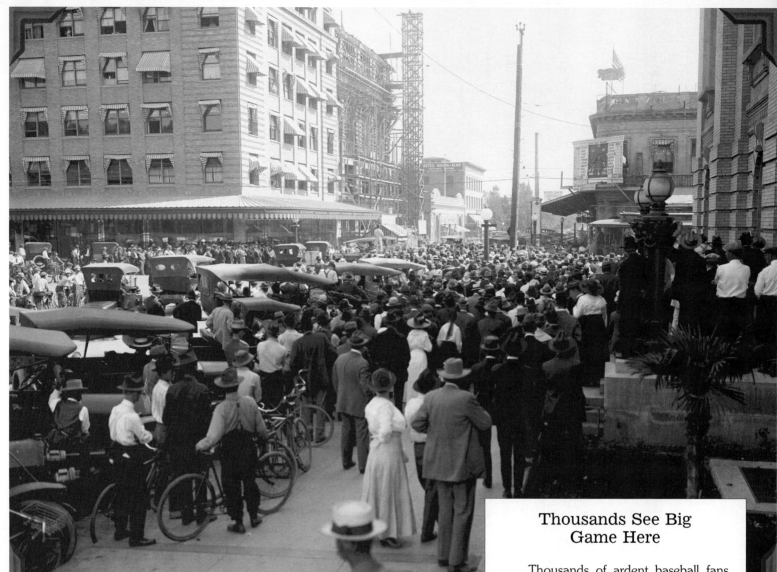

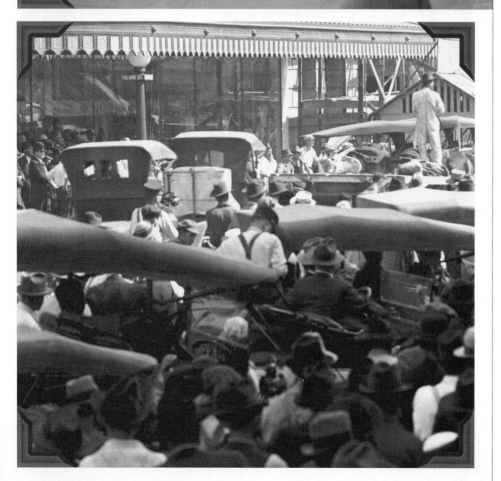

Thousands See Big Game Here

Thousands of ardent baseball fans gathered in front of the *Republican*'s big score board yesterday and saw the world's series play by play. And they saw each play recorded on that board less than a minute after it had been executed in Comiskey's ball park in Chicago.

The Associated Press, which furnished the excellent service that made the operation of this board such a success, established a single loop all over the United States from the Chicago park. The operator at the park sent it to every member of the Associated Press, direct from the park, without relay.

The same service will be given today when the *Republican*'s board will play the second game of the big series.

In order that there might be the least possible delay in flashing the story of the game, the Associated Press wire has been installed directly behind the score board.

The popularity of the *Republican*'s service, first by giving the people of Fresno the news many minutes before it was chronicled anywhere else and secondly by passing it out in such a way that the fans were able to keep track of the game as well as though they were in the park was attested by the size of the crowd and the fact that those who left did so only because they were forced to return to their occupation.

From *The Fresno Morning Republican*, October 7, 1917

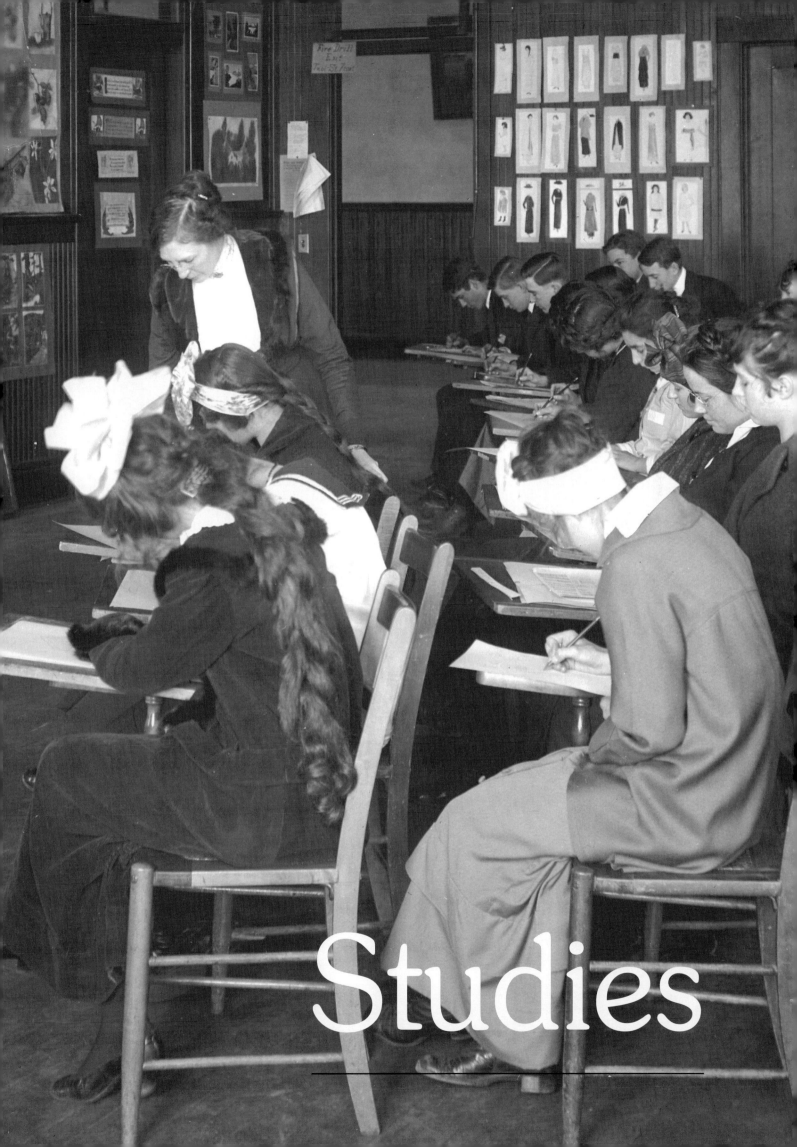

Studies

Pop Says...

Here We Go Again

While they may not say it in exactly those words, by this coming Monday there will be thousands of young folks who will not only be thinking along those lines but will be doing it, the reason being that this coming Monday will see the beginning of the fall semester for the secondary and elementary schools, also the high schools and colleges as well. Again, the time of the year has rolled around when that good old song, "SCHOOL DAYS, SCHOOL DAYS, GOOD OLD GOLDEN RULE DAYS," will be the popular tune of the day.

There's going to be a lot written about the opening of all these schools and classes, but how often do we find anything written about those wonderful people who make up the administration and staff, the thousands of patient teachers, both men and women, on whose shoulders rests the responsibility for the education of our children, the people we, the parents, count on to enlighten their minds from the first day in kindergarten. All the way through to their graduation from high school, the responsibility is theirs.

Truly they are a wonderful group of men and women who give so much and receive so little in the way of remuneration for their labors. One could almost classify it as a LABOR OF LOVE when one stops to think of how many of their younger years they gave up to prepare themselves for their qualifications as teachers. Even during vacation time, they devote a portion of it to further enlighten their minds so they can do a still better job for our children.

I think it's high time a tribute should be paid to these grand people, that they should receive the recognition due them. Yes, all you young folks, HERE WE GO AGAIN, so start singing that old song, "READIN' AND WRITIN' AND 'RITHMETIC," but no longer do we add "TAUGHT TO THE TUNE OF A HICKORY STICK," for today, children are taught by people who have infinite patience, who are kind and encouraging, who work with the children. I don't doubt there are moments when the teacher would like to go back to the early days and really use a hickory stick, but in these modern days, that just isn't done. These wonderful men and women have been trained to deal with situations that arise, where the hickory stick used to be the order of the day, by being patient and understanding.

So HERE WE GO AGAIN, placing our children in the hands of all these wonderful people, the administration, the staff, the principal, and the thousands upon thousands of teachers, looking to them, depending on them to help make our children, the men and women of tomorrow, educated to a degree that they may carry on the problems of this great country of ours. So I say, let us never forget the gratitude we owe them, let's never pass up an opportunity for singing their praises. GOD BLESS EACH AND EVERY ONE OF THEM.

'Bye now, I'll be seeing you.

"Pop."

From *The Fresno Guide*, September 11, 1958

Aggressive or shy, athletic or demure, *every girl "got game"* at the Emerson School during recess. February 15, 1915.

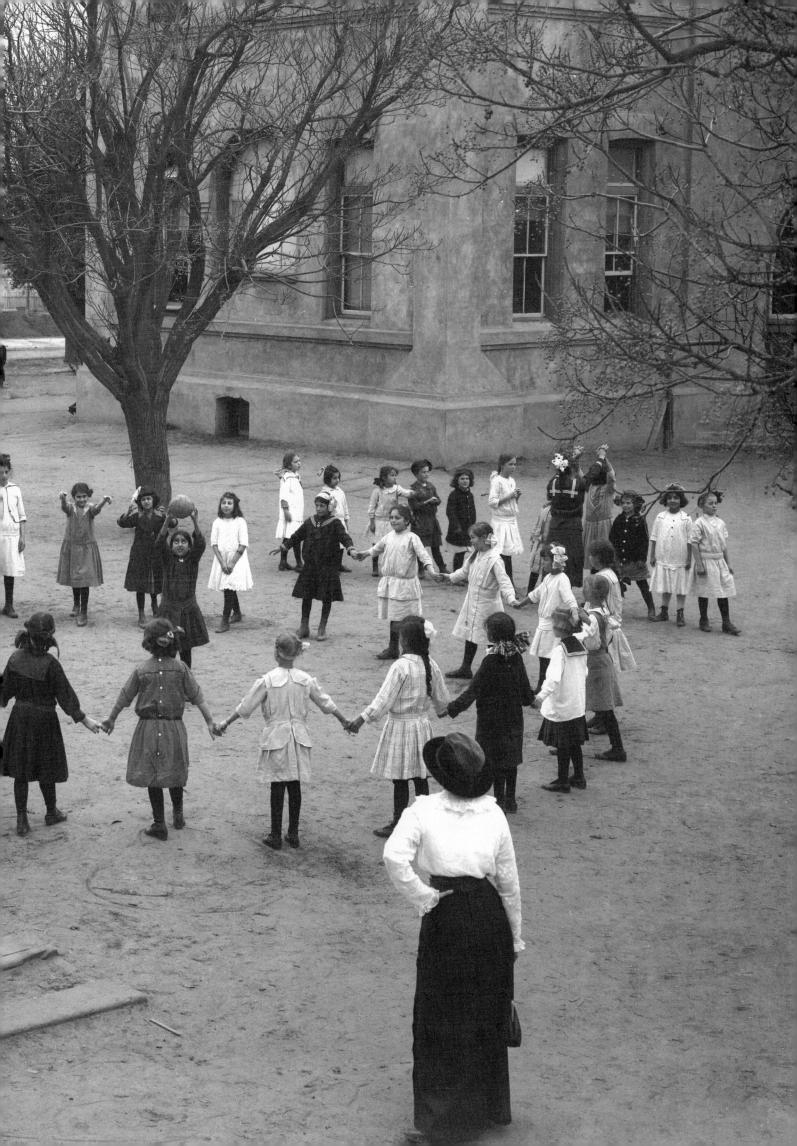

Lincoln District School, built in 1909, from its early days, was known as the "woodpecker school," according to information provided by Peggy Bos, 2004's president of the Clovis-Dry Creek Historical Society. The destructive birds would peck under the eaves, drilling into the wood until the building was ringed with holes. When the pecking noise became intolerable, a student was sent out to chase away the birds with rocks and blackboard erasers. Other wildlife, like opossums, often nestled among old books stored in the tank house at the rear of the building.

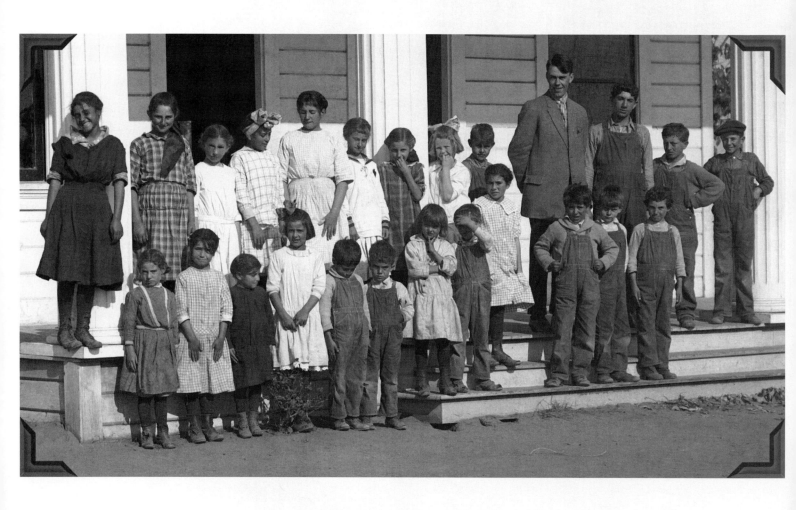

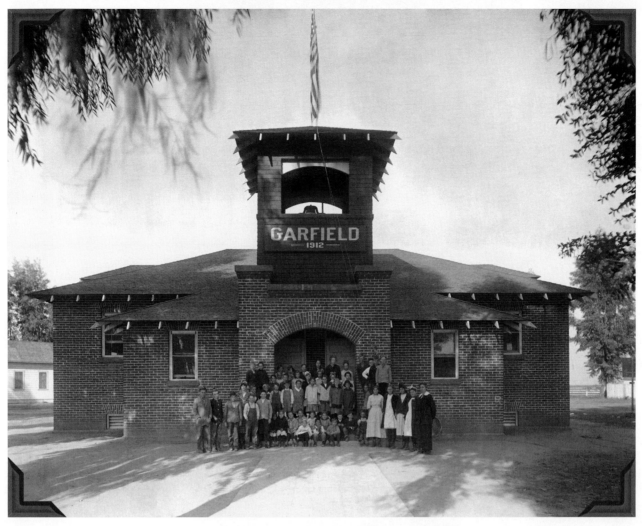

Garfield District School, a part of the Clovis community, was built in 1912.

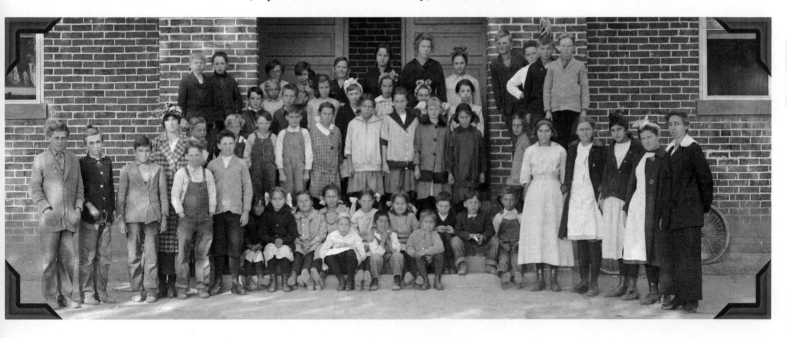

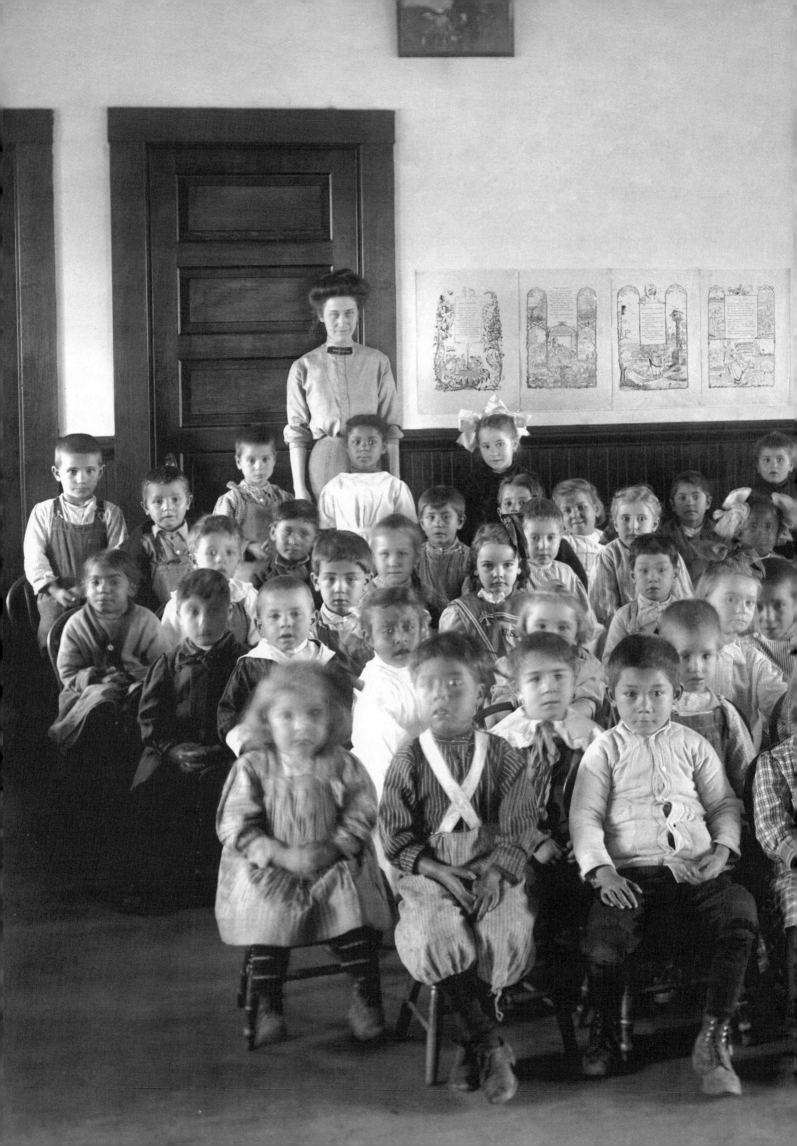

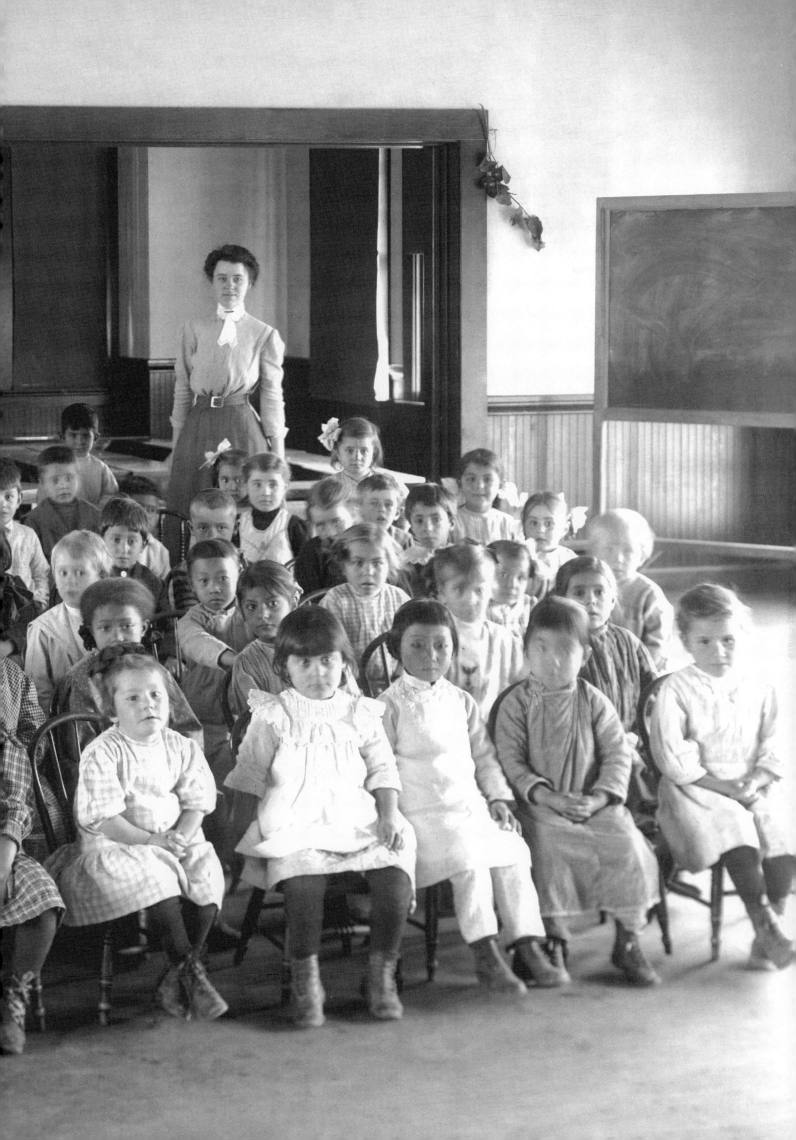

Kindergarten As Melting Pot
Tots Of Many Nations Learn Citizenship

In the northeast corner of the Columbia school grounds stands an attractive little bungalow with long porches covered with vines. In it, there is a species of entertainment going on daily from nine until twelve in the morning that is not so well known as it should be.

The participants are the children of the kindergarten, wee tots of all nationalities, all sorts and conditions of children fitting the roles assigned them and performing the parts with the awful seriousness only possible in childhood. During the morning, two circles are held, the first one being formed by the wee scholars marching around the room, each with a tiny chair until the circumference is made and then seating themselves to listen to the story lesson for the day. Usually the story is one of the Bible stories and so an early love for this cornerstone in the foundation of English literature is being roused.

The second circle is made with the children standing and they choose their games with an eager enthusiasm that is wonderfully devoid of boisterousness. A tuneful little song about a rose, a chrysanthemum, and a persimmon demands that one little child stand in the center of the ring and, with eyes tightly shut, smell whichever of the three articles is placed under his miniature nose and determine if it is a persimmon or not. If he is correct in his surmise, he is clapped back into the ring by his admiring friends.

In a courtly little game, where a gallant knight bows to a "lady faire" from the center of the ring, she returns the bow with grave courtesy and assumes his place in the center and bows to some other little friend. In the course of the play, one little Willie, in his haste to get to the middle of things, neglected the acknowledging bow and upon being reminded of it was so bitterly humiliated that he turned his face to the wall while copious tears ploughed little furrows down his aggrieved countenance.

After Thanksgiving, the Christmas spirit is to be properly developed and a spirit of giving is to be emphasized as opposed to that of receiving. Small gifts are to be fashioned for presentation to the children's parents. In such a manner are the lessons of life instilled into these baby minds.

Over the seventy-one enrolled children are in charge, Miss Marie Houston and Miss Elizabeth Nason to whose sympathetic interests are largely due the success of this branch of Fresno's public schools.

From *The Fresno Morning Republican,*
November 19, 1911

Previous two pages and this page: Columbia School, located on C Street, was the first exposure to the American way of life that many of these children ever had. Circa 1911.

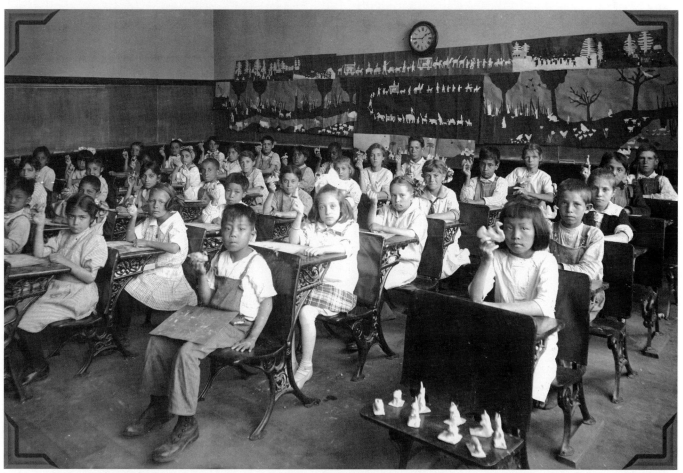

Columbia Elementary School classroom just after an art lesson with clay. May 12, 1916.

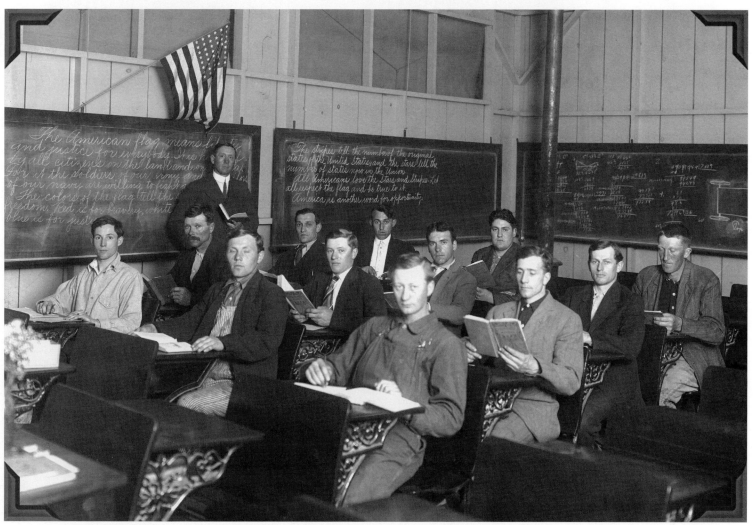

The United States has long been known as the "melting pot" of the world. The fact that our Valley thrives on this phenomenon is evident in this citizenship class at Edison School. March 28, 1917.

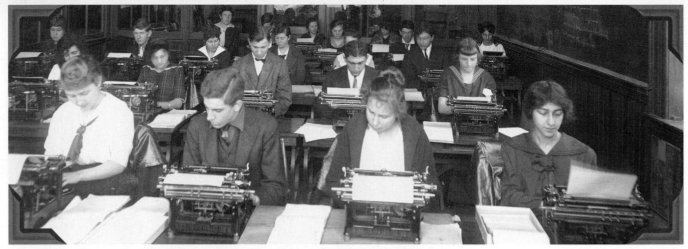

Students in Fresno High's Business Department typing lab were admonished to follow good typing techniques and develop production-enhancing habits. February 10, 1915.

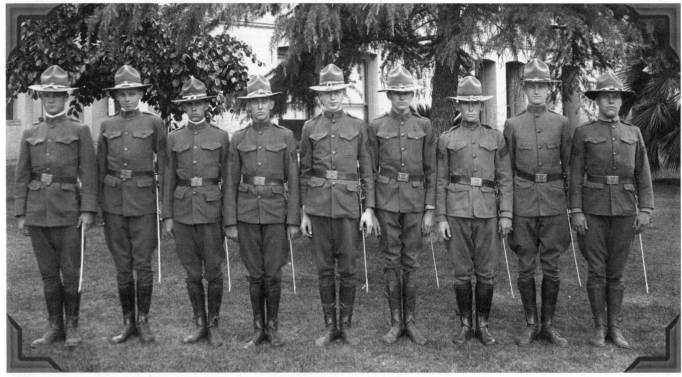

Battalion officers of the 1918 Fresno High Cadet Corps stood confidently at attention. While too young to serve in the "War to End All Wars," many who were not in critical jobs in the early 1940s would see duty in World War II. May 22, 1918.

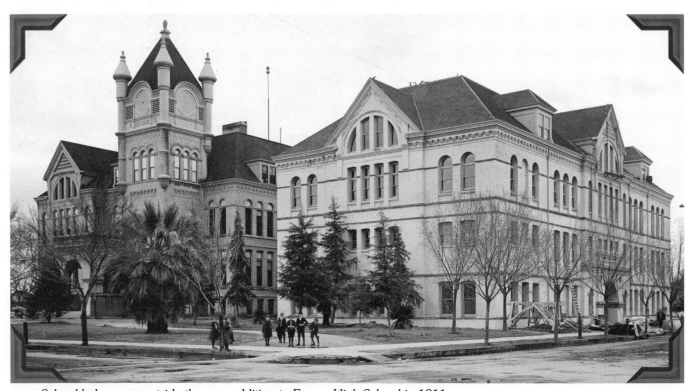

School lads pause outside the new addition to Fresno High School in 1911.

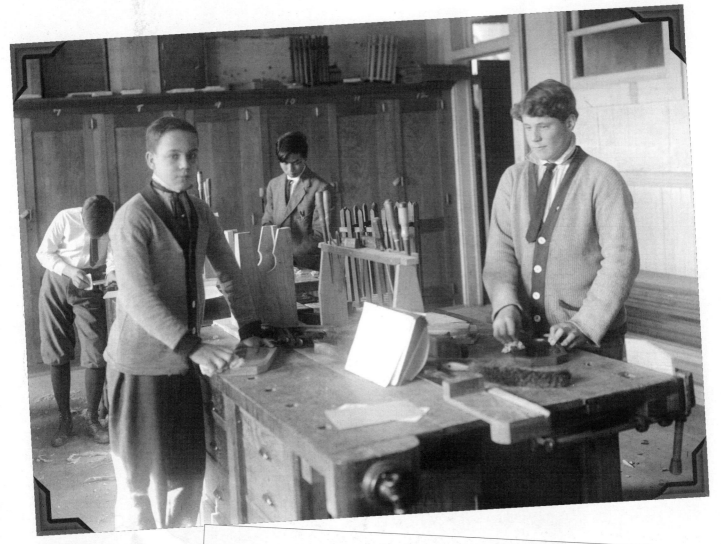

In Manual Training, Fresno High woodworking students skillfully applied themselves to their projects, one of which was a small stool near the lad's elbow. Each period's work was ended in time for a quick room cleanup, since a janitorial staff was a limited luxury. Circa 1911.

City Schools Open With Enrollment of 7,429
Nearly 1,000 More Than On Opening Day Last Year
Some Schools Are Up To Limit Of Their Accommodation

With an enrollment of 7,429 pupils, Fresno opens her school year with a registration of nearly one thousand more than on the opening day of last year. Everything was ready for the pupils to begin the work of the term yesterday the moment they entered the school. The increase of enrollment has put some schools in a crowded condition which, superintendent of schools, Jerome C. Cross announced, will receive the attention of the board of education. He also stated that more teachers will be required to take care of the increased number of pupils.

In all the schools, the enrollments are an increase over last year. Following are the figures for some schools: Columbia–551; Edison–233; Emerson–598; Washington–535; and Kirk–376. The high school lists enrollment at 1,300.

At every school, work began with the opening hour and with every pupil in place.

During the assembly period at the high school, Principal Walter O. Smith was welcomed by the students as principal of the school. Principal Smith was introduced to the students by Vice-Principal John A. Nowell in a speech in which he bespoke the cooperation of the students with the principal in carrying on the work of the school.

The cadet corps of the high school has already enrolled 175 students. It is intended to bring the corps up to a strength of 350. There were sixty members of the cadet corps last year. About forty of these members have returned to school and rejoined, and five have enlisted in the regular army.

From *The Fresno Morning Republican*,
October 2, 1917.

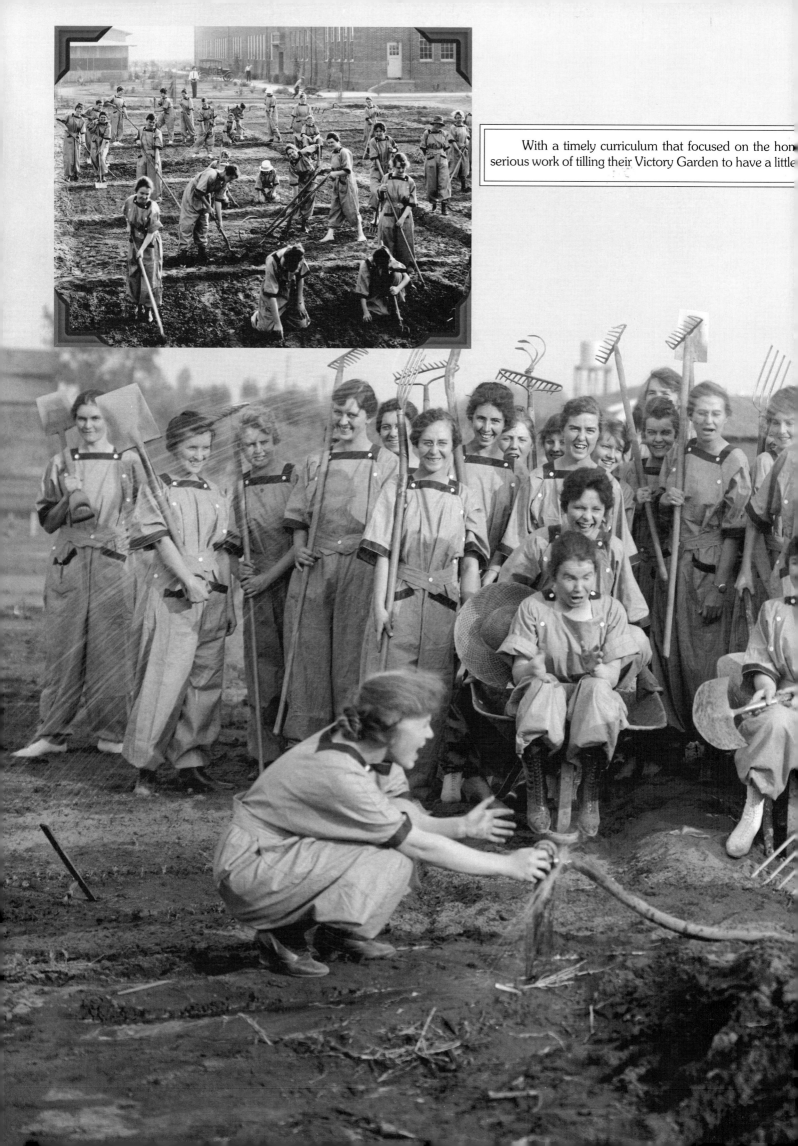

With a timely curriculum that focused on the hon
serious work of tilling their Victory Garden to have a little

School's Farmettes took time from the
rsity Street campus. October 25, 1917.

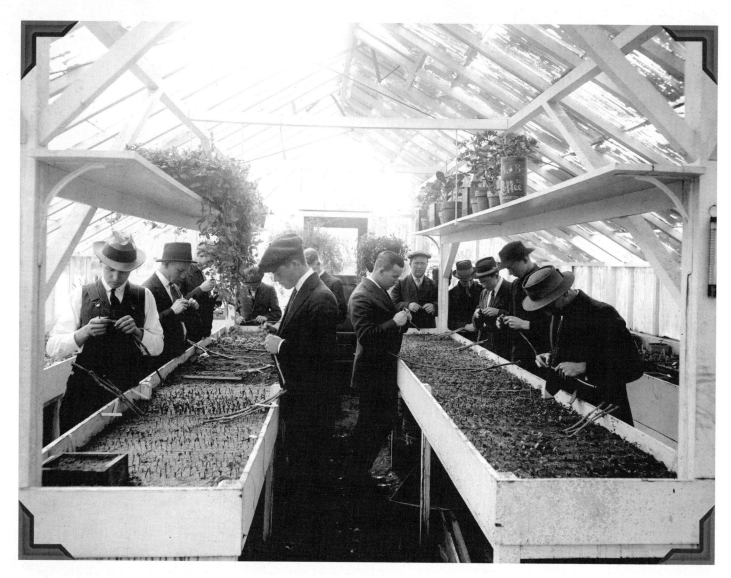

Above: Students in the 1915 Fresno High School Agricultural Department learned skills and techniques that would help lift the Valley's farm output to levels exceeding most countries' of the world. February 9, 1915.

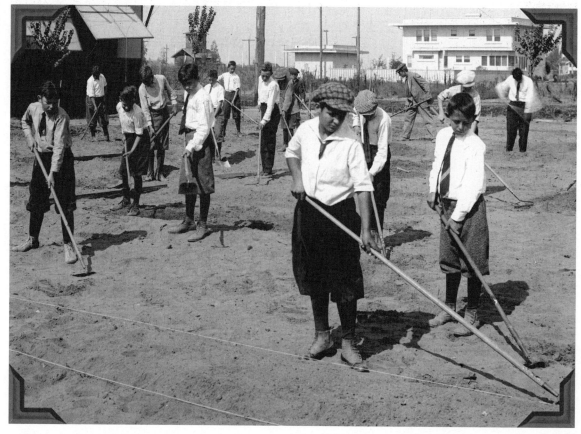

Particularly during the war years, the importance of gardening as a means of feeding the nation was instilled even into the youngest of grammar school students. October 15, 1915.

The Fresno High School faculty of 1917 gathered on the campus for a group shot. The women, from left to right, are: Josephine Colby; Helen Redington; Charlaine Furley; Sara B. F. Rabourn; Maude E. Price; Alice Dillon; Pearl Cessna Kellogg; Mrs. A. M. Grainger; Jeanette Minard; Katherine Lindsay; Laura Falk; Marie Bradford Briggs; Mary Ella Robinson Thurstone; Frances Slatter; Pearl M. Small; Lucia Meter; Isa C. Moodey; Etta Louise Paris; Ida Bernard; Lucy A. Thomas; Florence Robinson; Dorothy Clark; Lillie H. Dahlgren; Alice Smith Fowler; Arretta L. Watts; Mabel Guernsey; Annie E. Durkee; Mary M. Wasson; and Maud Minthorn. The men—front row, left to right, are: F. M. Fulstone; H.H.R. Hunt; W.M.A. Austin; J. G. Van Zandt; G.H. Bardsley; T.J. Penfield; W.O. Smith, the principal; S.S. Judd; H.C. Wienke; Francis C. Kellogg; and Mitchell P. Briggs. Second row: Paul M. Levy; Carl M. Melom; Robert Schafer; G.G. Allee; W.A. Otto; J.E. Tarbell; W.M.Coleman; Arthur Sorenson; W.D. Wallis; J.W. Warner; J.A. Nowell; V.A. Rohrer; W.E. Allen; and Henry Kerr.

The 1918 Fresno High Girls Glee Club attracted a large group of young ladies who loved the companionship of those with an interest in music. May 23, 1918.

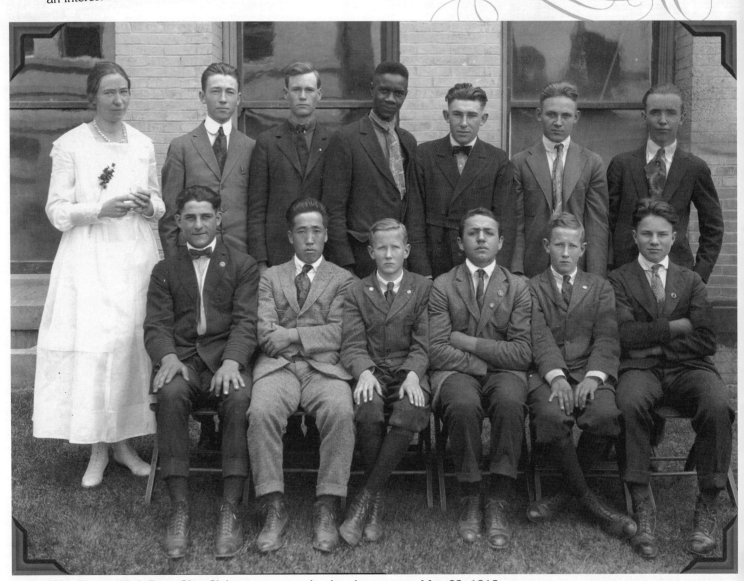

The Fresno High Boys Glee Club appear poised to break into song. May 23, 1918.

Theater

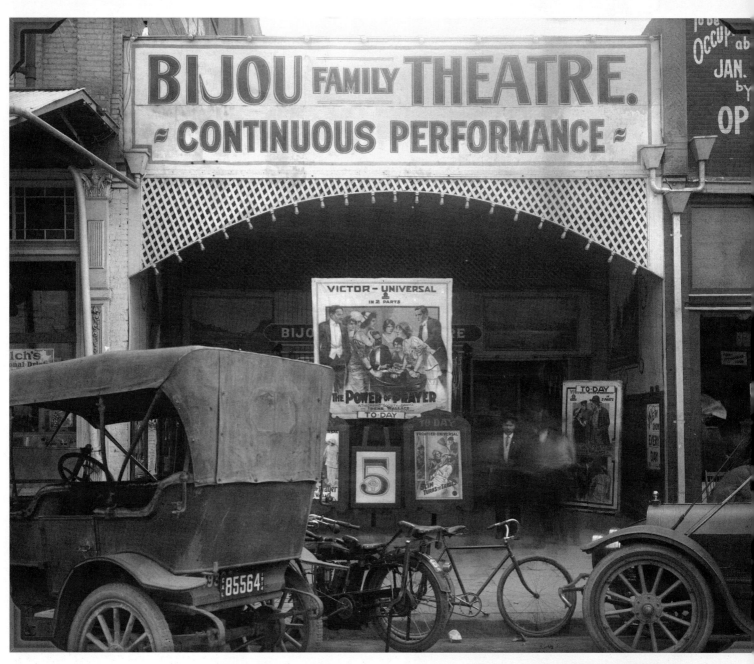

The Bijou Theater advertised movie short features and a new show every day, all for five cents. April 7, 1914.

Previous page: These two lovers are believed to, in reality, be actors on the stage of the old Barton Opera House. Date unknown.

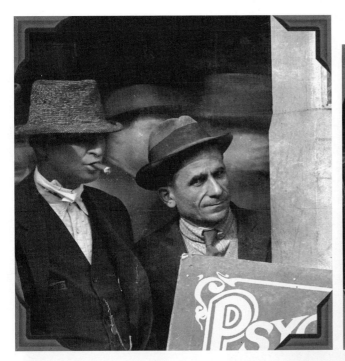

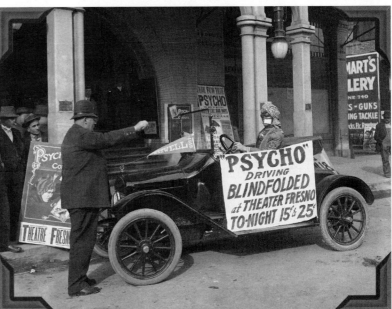

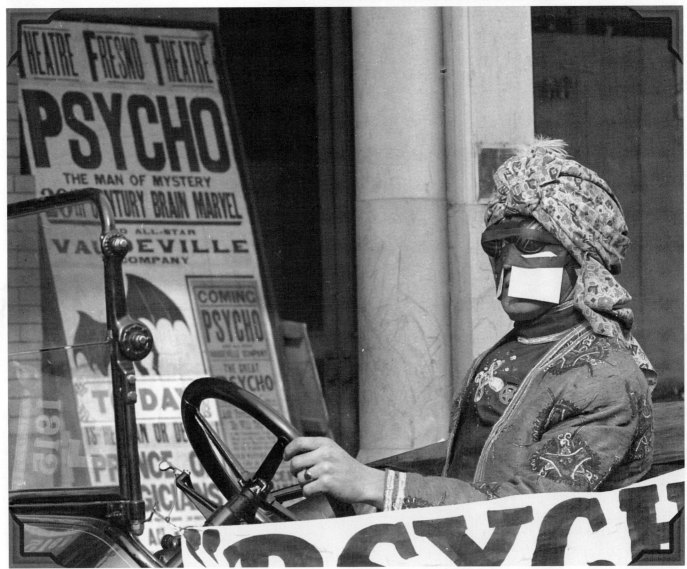

"Psycho," billed as the "20th Century Brain Marvel" and "The Man of Mystery" advertised his evening performance during which he drove a Maxwell auto around the Theater Fresno while blindfolded. Truant Officer E. Bradley aided the promotion of the daring exhibition. December 18, 1914.

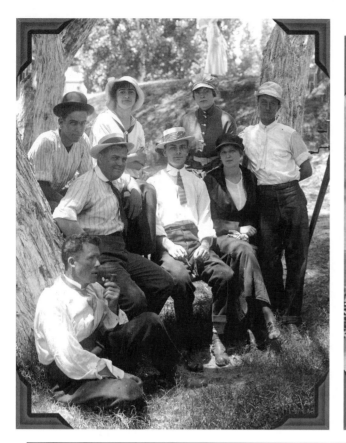

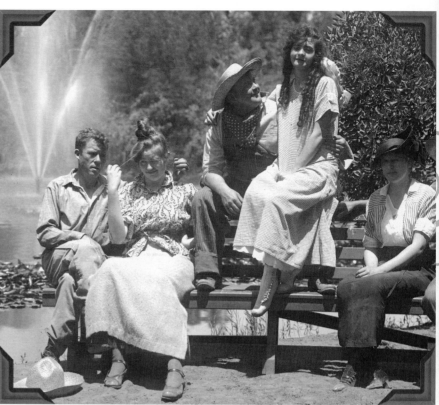

Both pages: Fresno's home-grown movie troupe, the Keynote Motion Picture Players, were always ready to star in "Pop" Laval's dramatic and comedic presentations. Once "Pop" introduced the movie camera to the Fresno area, businesses lined up to make use, not only of "Pop's" skilled vision and state-of-the-art equipment, but to take advantage of the acting troupe's ability to attract attention as well. The four "main characters" were B. M. Anderson, Netta Sunderland, Lorraine Laval and Ray Cooper. Summer 1915.

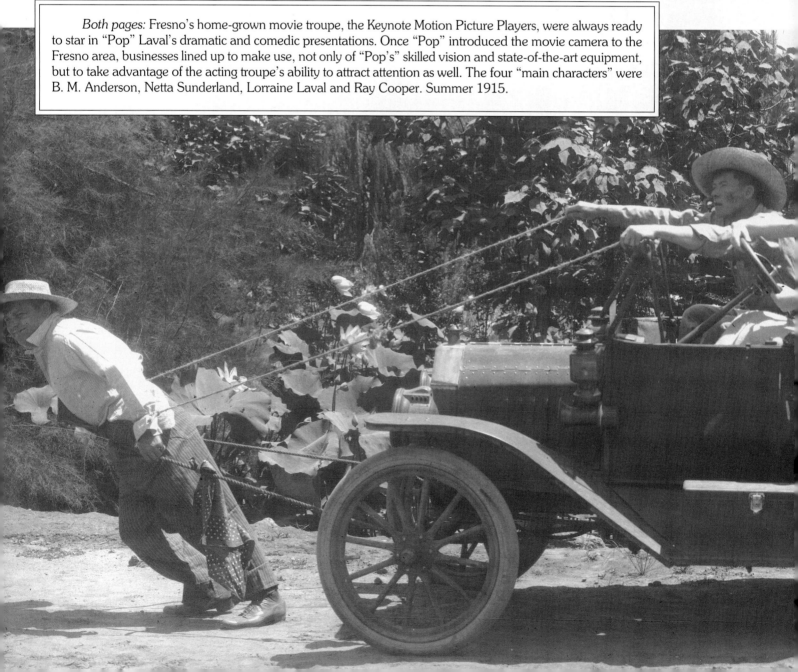

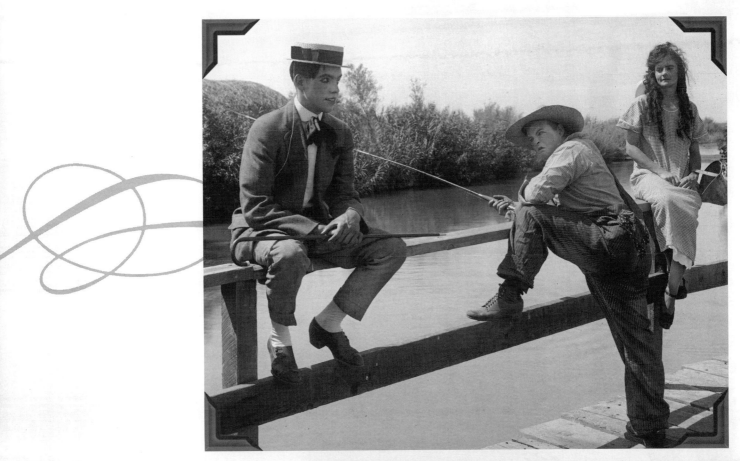

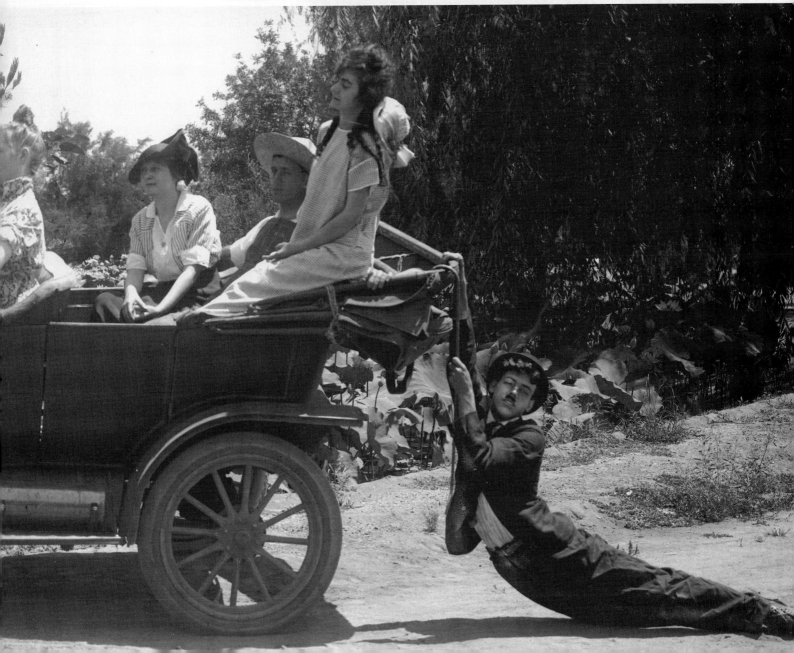

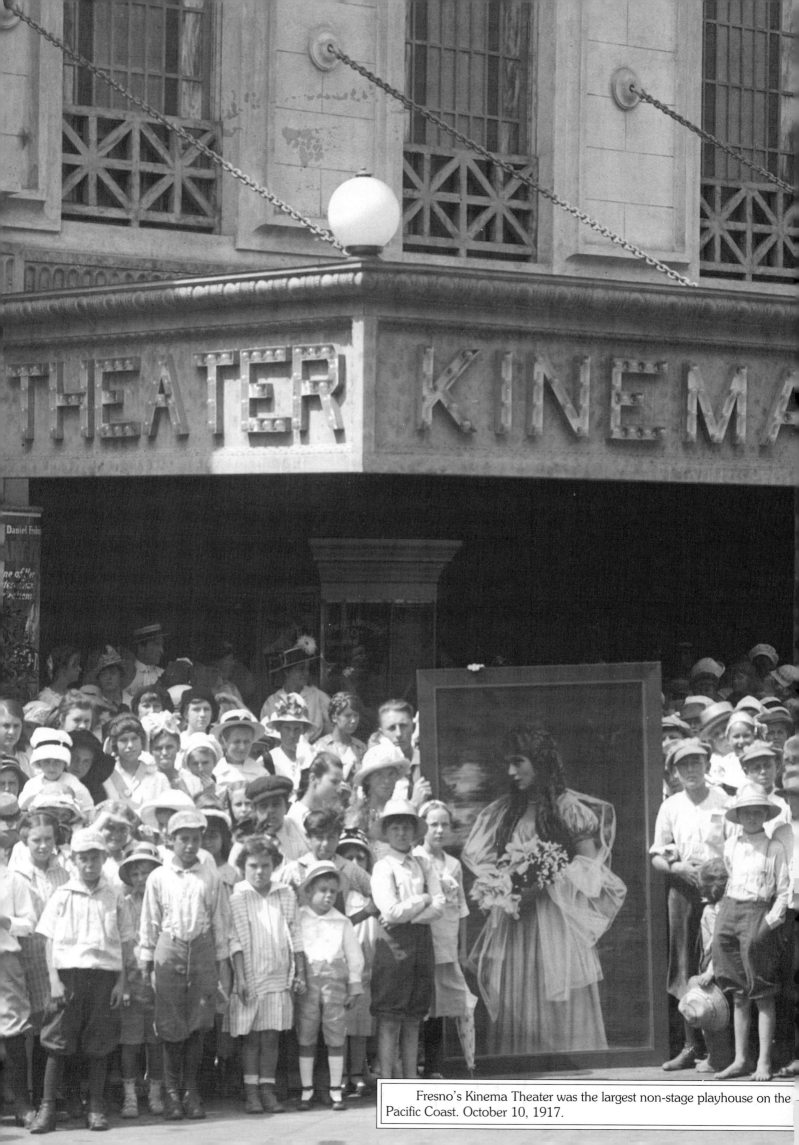

Fresno's Kinema Theater was the largest non-stage playhouse on the Pacific Coast. October 10, 1917.

Brilliant Season Is Inaugurated At Kinema
Geraldine Farrar, the Season's Most Startling Dramatic Coup—The World's Youngest and Greatest Diva to Appear in "Carmen" and other Operas

Prophets are frequently without honor in their own country. Fresnans are, perhaps, so used to seeing the Kinema every day, that they little realize that right in their midst, they possess one of the most unique monuments to the motion picture industry in the United States. When the Kinema was erected, skepticism was rampant in motion picture circles. It took courage to build a huge amusement palace without a stage for, had the venture failed, there was no stage to fall back upon for the purposes of exploiting vaudeville or stage drama.

Big Plant and Huge Force of Employees for Efficiency and Comfort

The attractive exterior is but a beautiful shell for a practical and efficient photoplay house on the inside. Again, the layman can scarcely be expected to analyze wherein the difference lies between one theater and another.

In the Kinema, however, every thought, architectural line, tones, and colorings, orchestral style of organ—every minute detail had but one thought in mind and that was the environment of the picture on the screen. For instance, soft color tones and mellow lighting effects tend to concentrate the attention to the screen. The Kinema's screen is devoid of eyestrain.

Also, the Kinema balcony is a departure in theater construction. It is extraordinarily level (more so than any other in the United States) which avoids "keystoning" on the screen, and allows a more attractive vision line than for those seated in the orchestra seats.

The Kinema maintains a regular army of men and women on its weekly payroll to ensure perfect service and safety.

The influence of the picture theater upon any community cannot be overestimated. It contains the germ of the greatest world literature that will ever be achieved in the history of letters.

The motion picture educates the people to appreciate a well-woven plot and to deride a story in which the plot is poor. It is the same with actors. If their stilted mannerisms or their lack of real dramatic ability can be covered up with words, the camera will find them out if they lack facial ability.

Many of America's Greatest Stars Now Numbered Among the Devotees of the Motion Picture

The coming season witnesses a tremendous rush toward filmdom. Great actors and actresses are forsaking their former occupations to devote their entire attention to the new art. The greatest single-handed scoop of the year is that of the Lasky-Paramount organization. They have entered the sacred portals of the mighty Metropolitan Opera House and have captured the brilliant Geraldine Farrar. Young, beautiful, gifted with true genius, Farrar is called the second Patti—one of those rare beings that are born but once in a life time. The voice will not be heard, 'tis true, but to the many millions who will never see Farrar at the Metropolitan is now given the privilege of seeing this queen in her gorgeous operas. Her first opera will be "Carmen" and will be presented at the Kinema next week.

The idolized Mary Pickford will appear in four new plays this season. "Madam Butterfly," "Esmerelda," "The Foundling" and "The Girl of Yesterday" are human, tender and full of the true Pickford spirit.

All in all, the Kinema promises a brilliant season of star performers and stellar attractions. Many of these plays have been and are playing to greatly advanced prices in the big cities. No change is contemplated in the Kinema's policy for the present for, although the above attractions and stars naturally command heavy rental prices, still, these prices have not soared so far out of sight that the Kinema is compelled to increase the high cost of living.

The public, however, should not lose sight of the fact that their motion picture entertainment is immeasurably greater now than it ever has been. They are witnessing many of America's most brilliant artists for remarkably small admittance prices.

From *The Fresno Morning Republican*, October 1, 1915

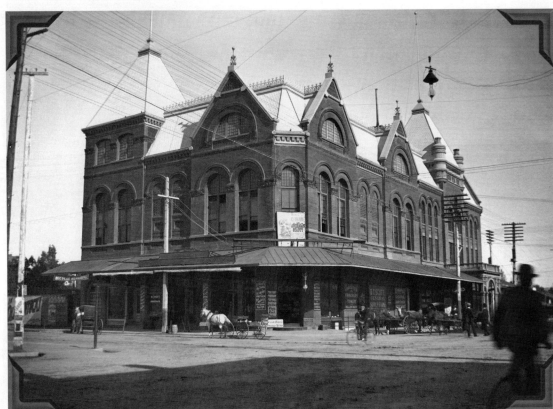

The Barton Opera House opened September 29, 1890 on the northeast corner of Fresno and J (Fulton) streets with an audience of 1,500. The opera house had a plush interior with many small lights on the high domed ceiling. The box seats on each side of the stage were lavishly decorated. The three story building was also occupied by the Fresno Armory. Date Unknown.

The Barton House interior. Date unknown.

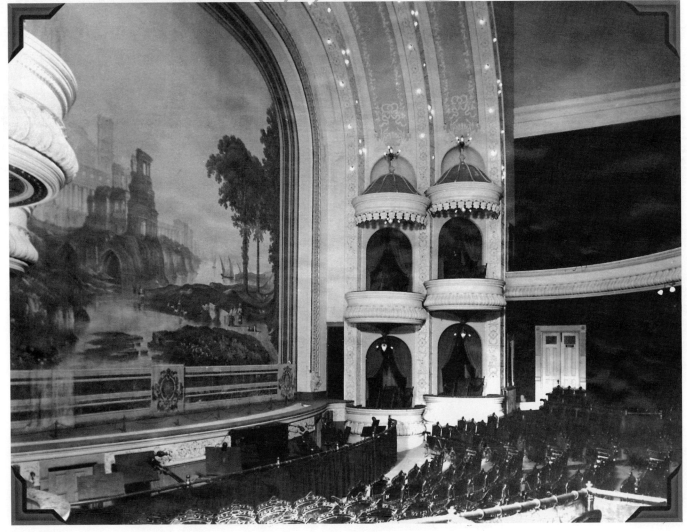

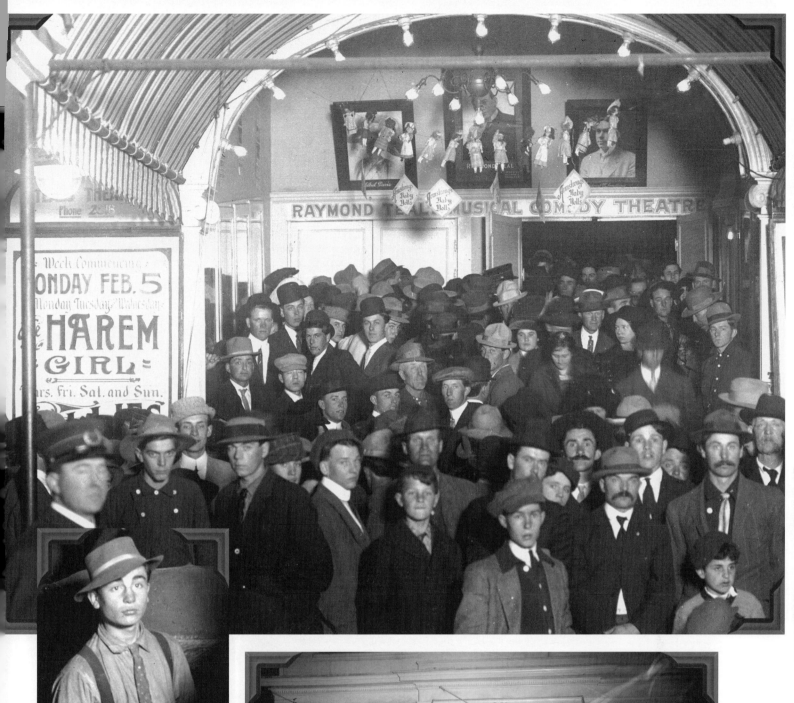

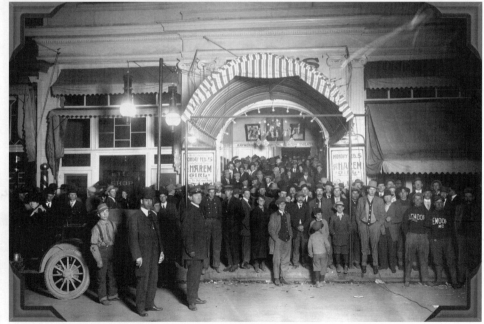

The "Harem Girl" production at Raymond Teal's Musical Comedy Theatre did not seem particularly amusing to this group of mostly male attendees. Circa 1912.

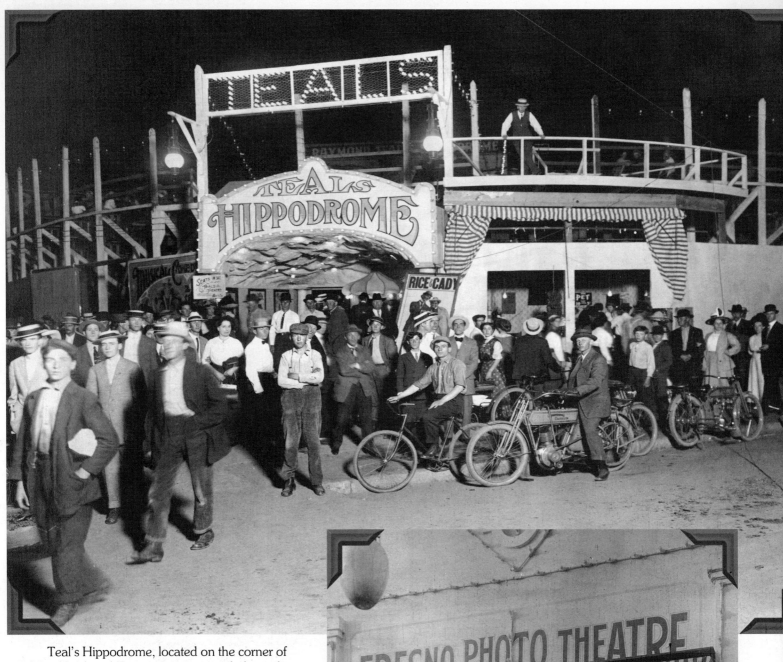

Teal's Hippodrome, located on the corner of K (Van Ness) and Fresno streets, provided a wide variety of outdoor entertainment including "A Real Girlie Show" and "Chorus Girl Contest" along with "High Class Musical Comedy" and an amateur night. What could be better than a refreshing evening under the stars during Fresno's hottest season? The arrival of a couple of fresh dandies by Harley-Davidson created as much of a sensation as the multitude of shows offered. Circa 1912.

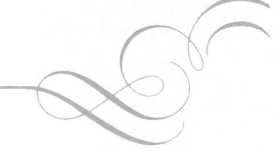

The Fresno Photo Theater, located on Fulton Street, charged adults a dime and children a nickel. August 1918.

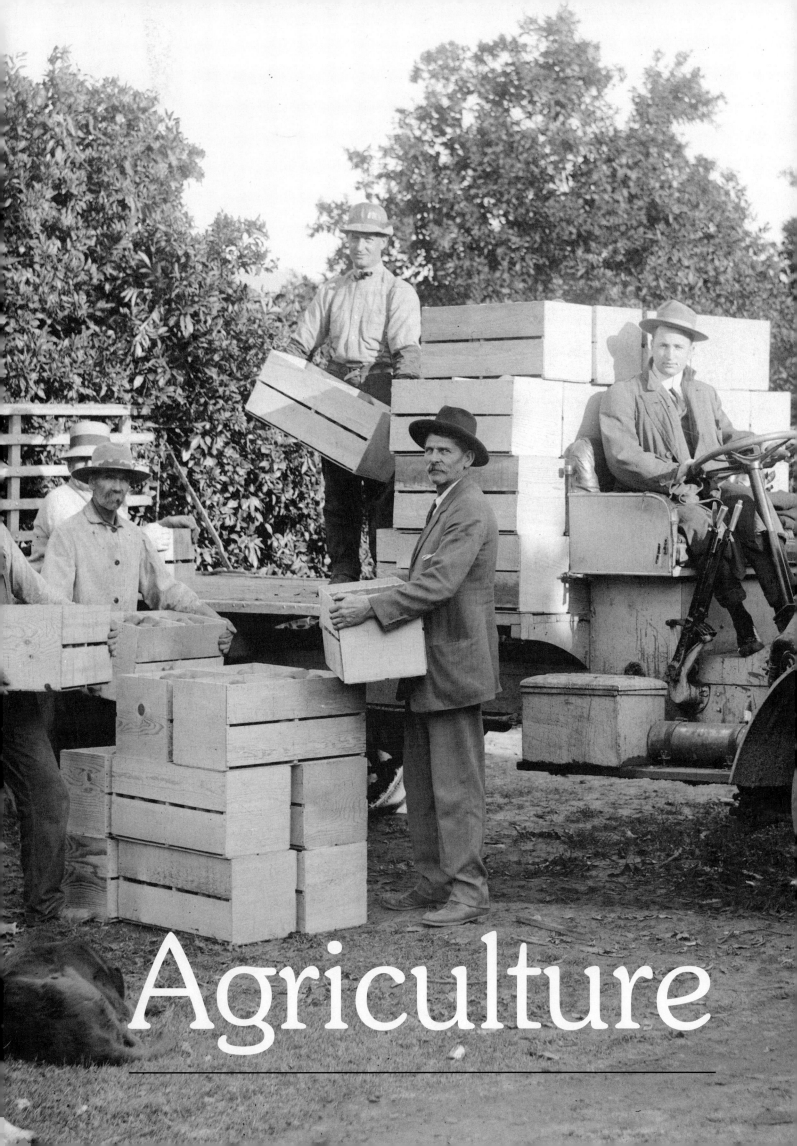

Agriculture

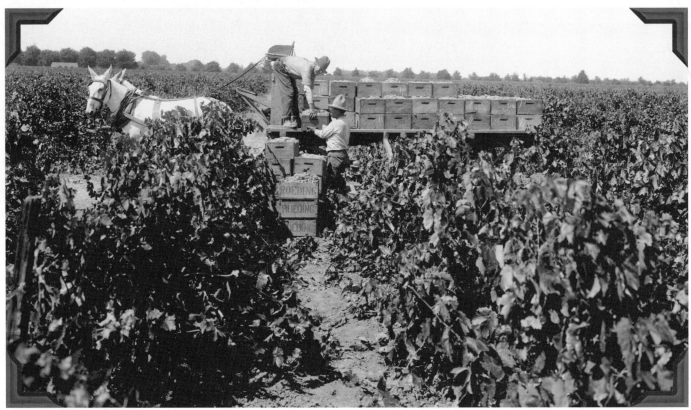

Two handsome, white mules wait patiently as their wagon is loaded with grapes from the Roeding Ranch vineyards. September 12, 1916.

Acres of grape-drying trays cover the fields at Roeding Ranch. September 2, 1916.

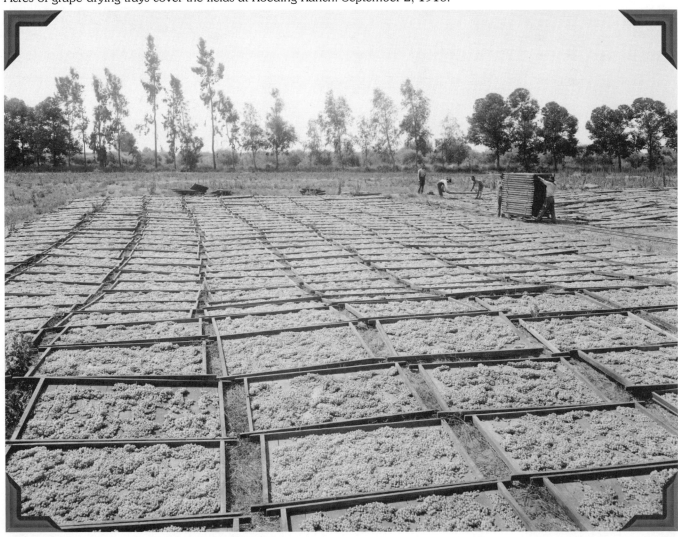

Previous page: This orange orchard was located along the Kings River. By the late part of the first decade of the Twentieth Century, motor vehicles such as the one pictured here had—to a great degree—replaced horse-drawn farm and ranch equipment. Date unknown.

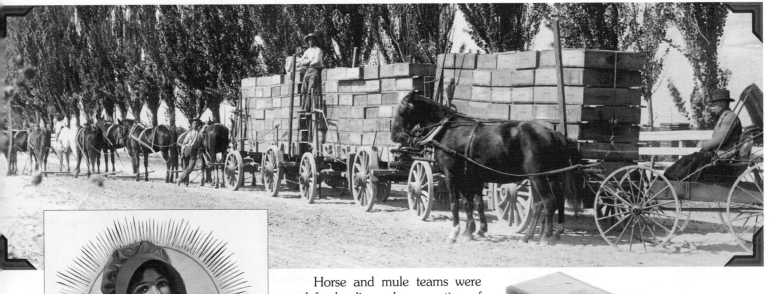

Horse and mule teams were used for hauling a large portion of each season's output of raisins to the packing house for packaging and shipping. September 17, 1915.

The Sun-Maid herself.

This promotional Sun-Maid Raisin box was made for the California Raisin Association. November 14, 1915.

Employees of the Bonner Packing Company remove the seeds from raisins on specially made equipment. April 22, 1916.

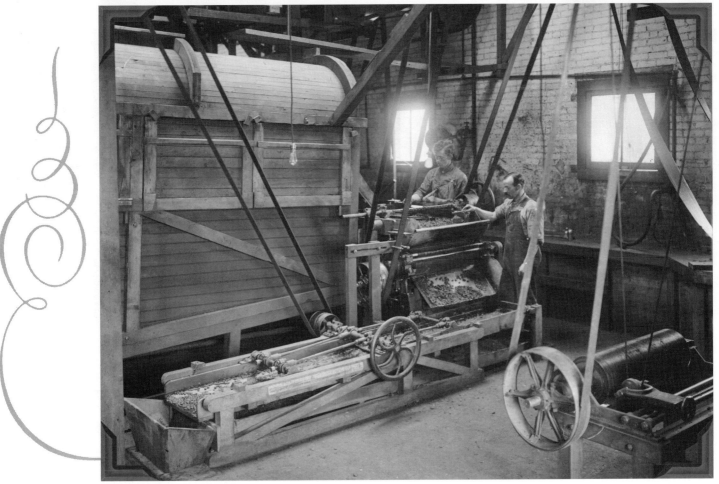

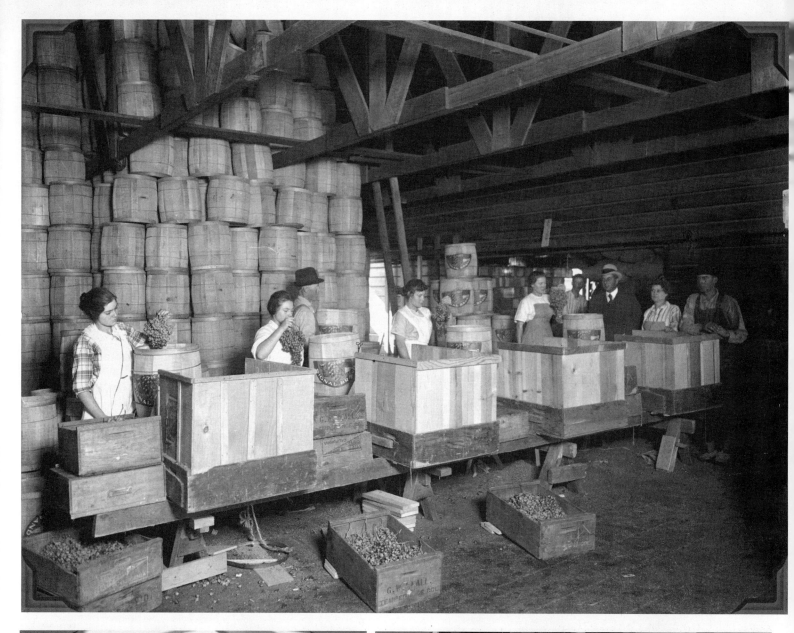

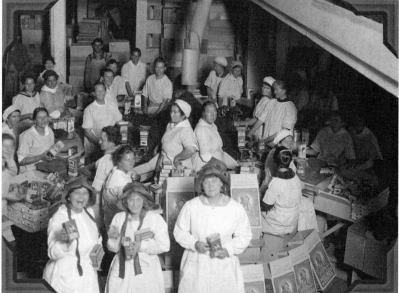

Top: Crews put fresh grape clusters into small kegs for the Signal Brand Company to ship to the East. Date unknown.

Above: The Sun-Maid ladies visit the Sun-Maid packing house. November 20, 1916.

Left: Three Sun-Maid Raisin girls pose outside the Associated Raisin Company plant. November 20, 1916.

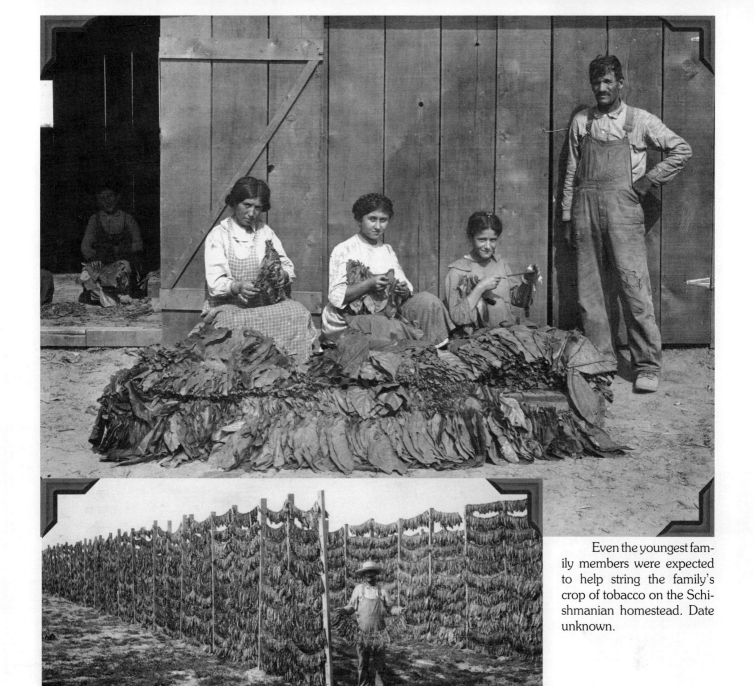

Even the youngest family members were expected to help string the family's crop of tobacco on the Schishmanian homestead. Date unknown.

Tobacco dries in the sun on the Schischmanian Ranch. Date unknown.

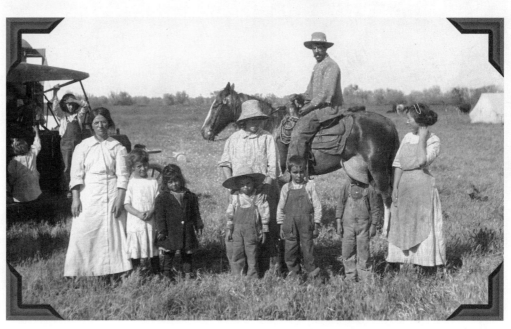

Hard-working ranch families were the bedrock upon which the great agricultural wealth of the San Joaquin Valley was built. Date unknown.

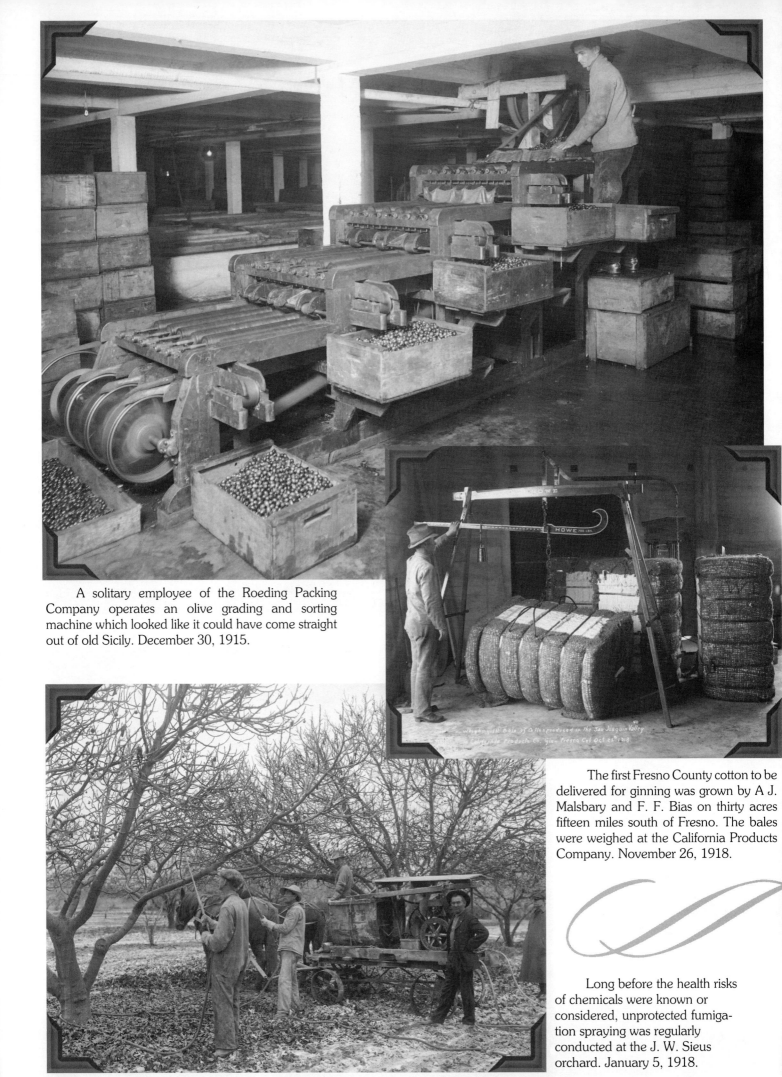

A solitary employee of the Roeding Packing Company operates an olive grading and sorting machine which looked like it could have come straight out of old Sicily. December 30, 1915.

The first Fresno County cotton to be delivered for ginning was grown by A J. Malsbary and F. F. Bias on thirty acres fifteen miles south of Fresno. The bales were weighed at the California Products Company. November 26, 1918.

Long before the health risks of chemicals were known or considered, unprotected fumigation spraying was regularly conducted at the J. W. Sieus orchard. January 5, 1918.

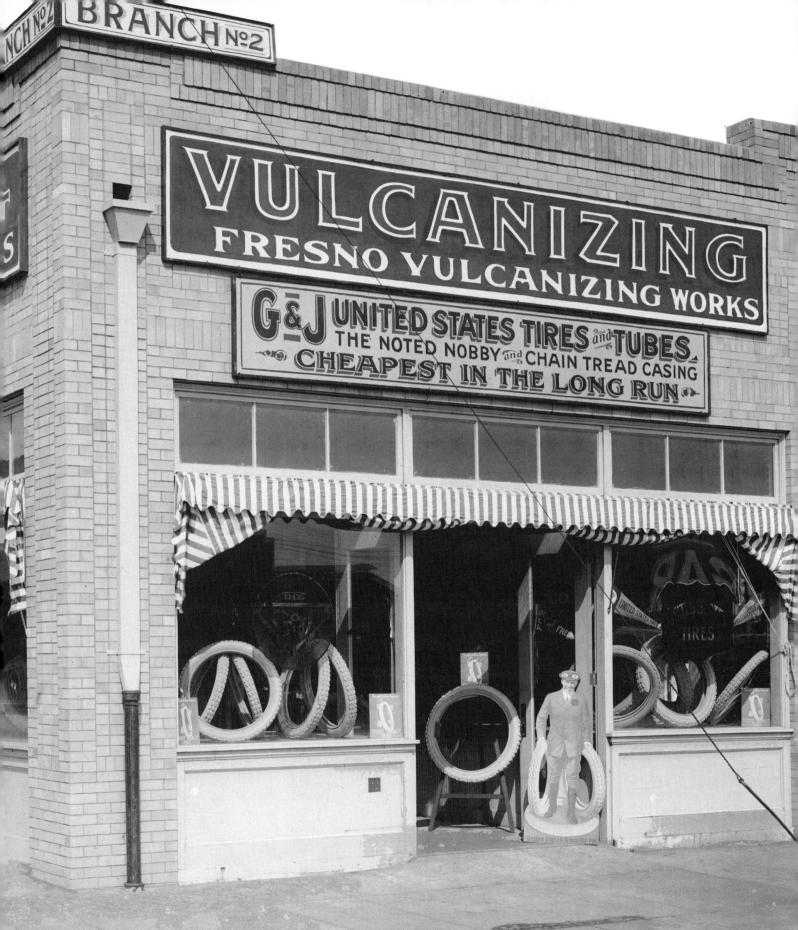

Business

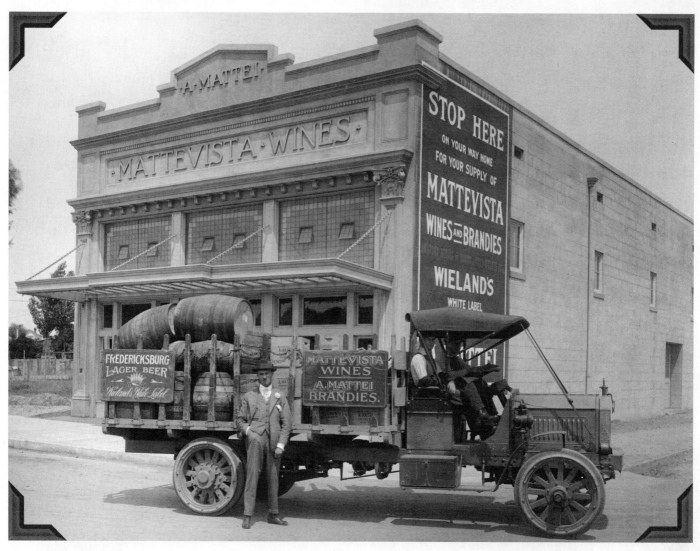

Mattevista Wines and A. Mattei Brandies Packard delivery truck. According to Andrew Mattei, the wineries he had painstakingly built up over his lifetime were so disliked by his children that he knew they were likely to be sold off immediately upon his death. It was because of Mattei's wish to "leave behind a legacy" that he commissioned the construction of a building that would withstand devastation by his heirs. Unfortunately, the Mattei building, constructed on the site of the original wooden water tower on the southwest corner of Fresno and Fulton streets, only bore his name for a couple of decades before it became the Fresno-Fulton Building and later the Guarantee Savings Building. April 21, 1916.

Mr. Moore and his assistant made their daily delivery rounds in this attractive GMC panel truck. The San Joaquin Baking Company was founded by F. D. Bradford in 1914, with a two-oven plant at the corner of P and San Benito streets. By 1918, a new building at L and Los Angeles had a daily capacity of 40,000 to 50,000 pounds of product per day. Advertisements stated that Kleen Maid bread was baked every morning and every evening, and proudly touted the company's loaves as containing "1,180 calories of food value to the pound." October 3, 1915.

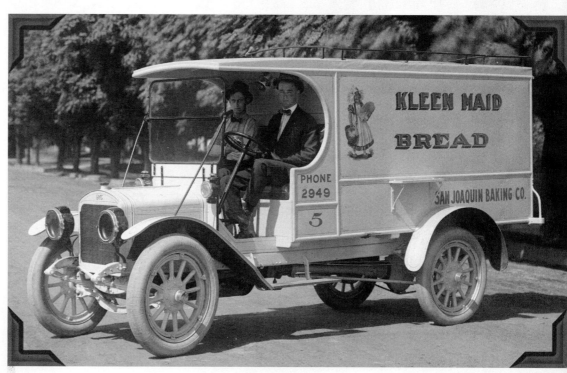

Previous page: The thriving Fresno Vulcanizing Works, located at 760 I Street, right next door to the Eye Street Garage, made and sold an impressive selection of brand name tires. May 8, 1915.

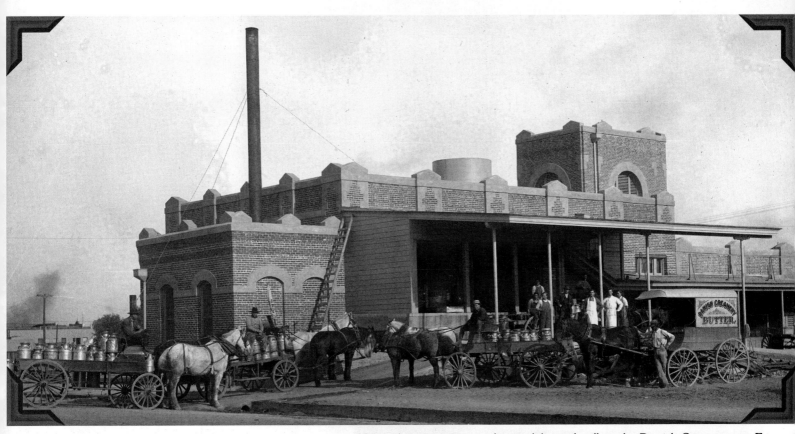

Horse-drawn wagons and carts delivered milk to the Danish Creamery on E and Inyo streets in Fresno as well as milk and other dairy products to hungry customers at their homes. Circa 1911.

About six thousand pounds of butter a day emerged from this room at the Danish Creamery. Circa 1911.

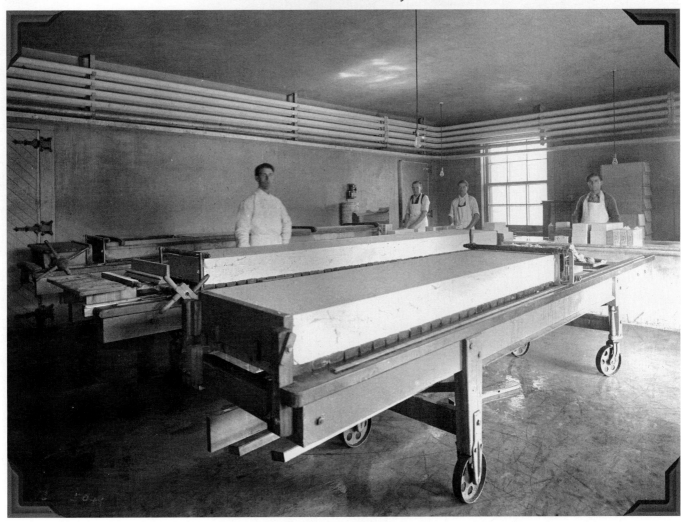

Valley Becomes Manufacturing Center
Varied Industries Are Developed from Soil Products

Agriculture has been and will probably continue to be, for many years to come, the principal industry of the San Joaquin Valley. Within the past few years, however, manufacturing has been developed in many of the cities, and from present indications, the next few years will see a great deal more development.

The city of Fresno is the most important manufacturing center in the San Joaquin Valley and, according to the census of 1910, stood sixth in the state in the value of its output. It is estimated that the manufactured products of the city today are worth nearly $15,000,000, while the total value of manufactured products in the valley is something over $20,000,000.

In preparing these figures on manufacturing, the census bureau has not included creameries, wineries, etc. Including these, of course, the value of manufactured products of the valley would be nearer $45,000,000.

Mattei Winery Story

The manufacture of sweet wine and grape brandy has developed in the San Joaquin Valley more than in any other part of the state. The California Wine Association controls the bulk of the sweet wine and brandy output of the San Joaquin Valley and has about $10,000,000 invested in wineries. A large manufacturer of wine is A. Mattei. Until a few years ago, Mattei sold most of his output in bulk but in the past few years, he has established selling agencies and his wines may now be found all over the United States. His winery is among the largest in the state.

Dairy

The dairy industry has developed into one of the largest of the Valley's industries and with its

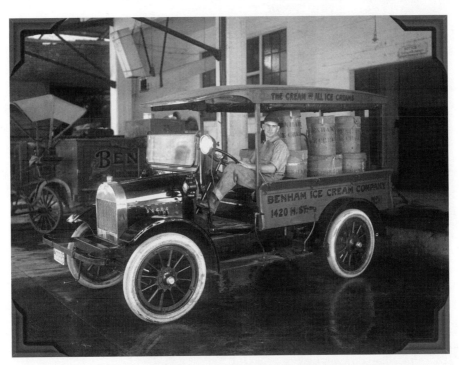

development, the development of the manufacture of butter and cheese has increased in accordance.

From seven counties in the San Joaquin Valley, nearly $32,000,000 worth of butter is produced every year. One of the largest of the San Joaquin Valley creameries is the Danish Creamery, located on the corner of Inyo and E streets in the city of Fresno. With its big, modern plant, the creamery has a capacity of nearly 4,400,000 pounds of butter a year. At the present time, it is manufacturing about 6,000 pounds, or three tons of butter a day. There isn't a train leaving Fresno that doesn't carry Danish Creamery butter, and it is sold all over the state.

This concern pays out nearly $500,000 annually to farmers for butter fat and gives employment to 35 people. The payroll is about $42,000 a year.

Ice Cream Industry

The ice cream industry has also been built up in the valley and, in the city of Fresno is located the largest ice cream factory in California, and one of the largest and most modern in the United States. There are two factories in the city that distribute to all parts of the state.

The Benham Ice Cream company, which boasts of the largest

factory in the state, has an average output of 5,000 gallons of ice cream a day. In 1908, this plant, after operating for two years, had an output of 200 gallons a day.

To put out this great amount of ice cream requires a factory three stories in height, with every modern piece of machinery known to the ice cream trade. All the ice used is manufactured in the plant and the cream is frozen in freezers lined with German silver to insure wearing qualities and sanitation. The cream is hardened in silver-lined store rooms that have a capacity of 7,000 gallons.

Every ounce of cream is purchased from local dairymen To produce this enormous amount of ice cream requires 500 gallons of cream daily and 4,000 pounds of sugar a week. The sugar is purchased from Visalia. The plant employs 32 people and has an annual payroll of $15,000.

San Joaquin Bakery

Practically every town in the valley has its bakery and these, of course, become a part of the manufacturing of the valley. The city of Fresno maintains the largest bakeries and several of them distribute to many of the smaller towns.

The San Joaquin Baking company has established a big bakery here and sells all its output at wholesale. It was established last December in one of the most modern plants in the west. With the aid of modern machinery, the bread is kneaded and baked and is scarcely ever touched by hands.

Its output at the present time is about 15,000 loaves a day and these loaves are distributed through the valley. Within a radius of 15 miles, the distribution is done by auto trucks, and within a radius of 100 miles, practically every town receives some of this bread daily.

From *The Fresno Morning Republican,* October 1, 1915

Previous page and above: One of the "coolest" jobs in town was delivering Benham Ice Cream in a modern Vim Truck. July 25,1916.

The front of Kerr Brothers' emporium at 539 G Street proclaimed, "Weavers of Fancy Rugs." As this book went to press nine decades later, the company was still conducting business from the same location. September 19, 1915.

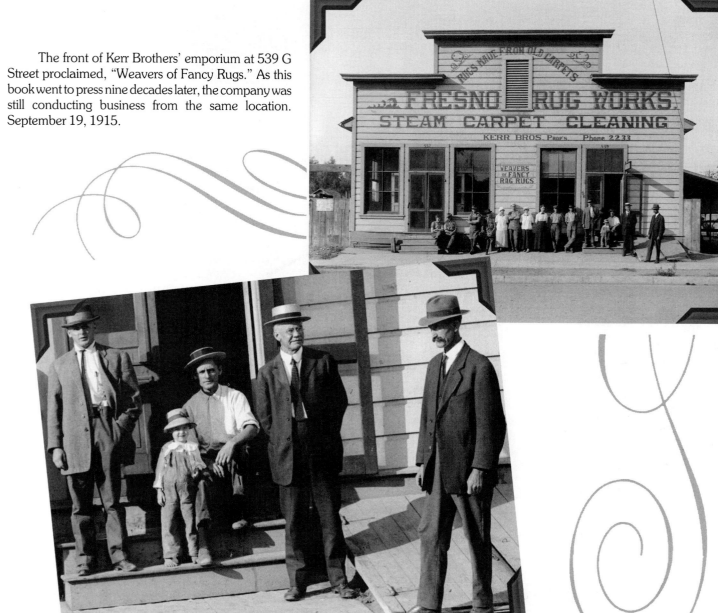

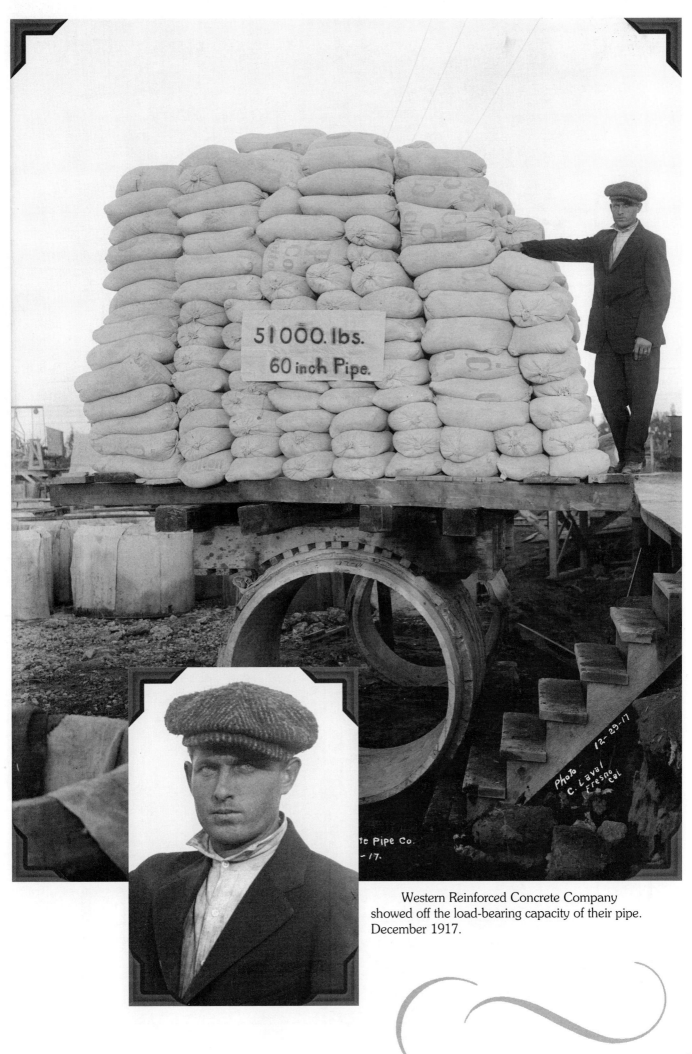

51000. lbs.
60 inch Pipe.

Western Reinforced Concrete Company
showed off the load-bearing capacity of their pipe.
December 1917.

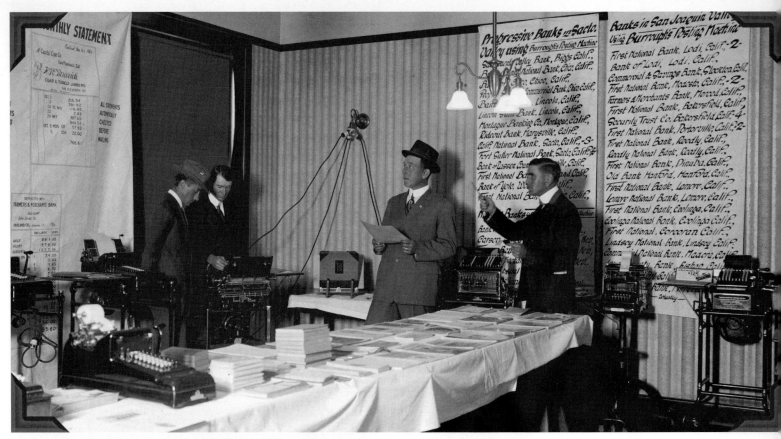

To create new sales, the Burroughs Adding Machine Company demonstrated its posting machines to Valley bankers at a display in the Fresno Hotel. October 21, 1915.

Twining Labs has maintained a presence in Fresno since early in the twentieth century, originally in the Griffith-McKenzie building. Their reputation for professional, top quality testing has remained as solid into the Twenty-First Century as when they were operating the lab pictured here in 1917.

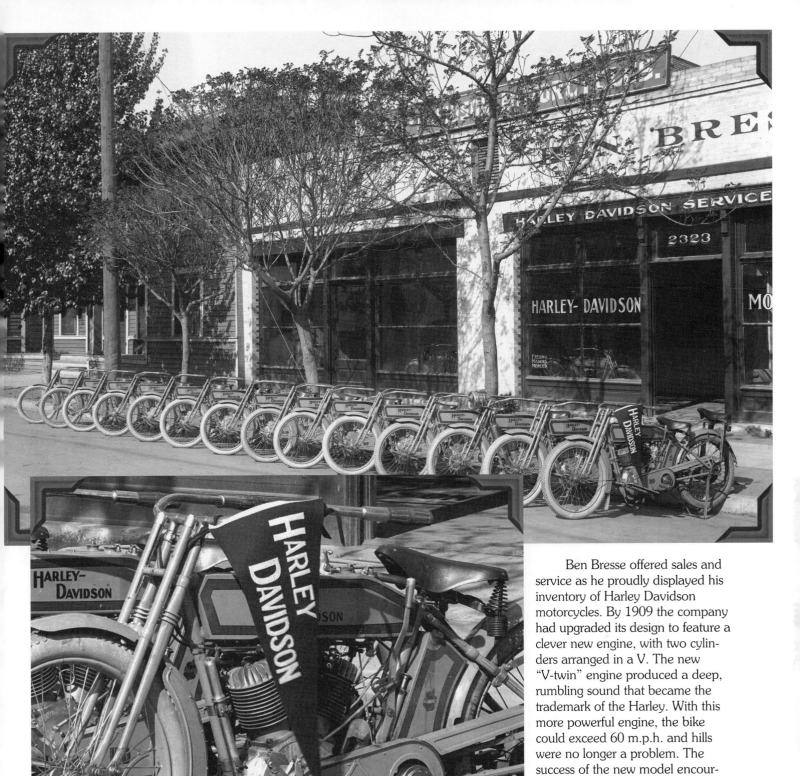

Ben Bresse offered sales and service as he proudly displayed his inventory of Harley Davidson motorcycles. By 1909 the company had upgraded its design to feature a clever new engine, with two cylinders arranged in a V. The new "V-twin" engine produced a deep, rumbling sound that became the trademark of the Harley. With this more powerful engine, the bike could exceed 60 m.p.h. and hills were no longer a problem. The success of the new model encouraged other manufacturers to enter the market, and by 1913 Harley and the Davidson brothers had over 150 competitors. Circa 1914.

About the Contributors

Elizabeth Laval

Elizabeth Laval, a fifth generation Fresnan, is the great-granddaughter of "Pop" Laval. Elizabeth moved abroad for a decade and produced international sporting events in more than forty countries. Fluent in written and spoken Japanese, Elizabeth spent five years in Tokyo at Dentsu, Inc. She later became a vice president of the men's Association of Tennis Professionals Tour and opened their International Group office in Sydney, Australia. Elizabeth returned to the United States in 1993 and, following her father Jerry's death in 1995, became curator of the Claude C. "Pop" Laval Photographic Collection. As such, she is active in the collection's restoration. She also produces special events and DVD projects. She currently resides in Fresno with her husband, Bob Leyva, son, Alex Laval-Leyva and daughter, Daniele Laval-Leyva.

Stephen L. Brown

Stephen L. Brown has been preserving Fresno's history since the early 1970s. As partner to the late Jerry Laval for more than twenty years, Steve was the designated caretaker of the collection as it passed into the current generation of the Laval Family Trust. He is a partner in the restoration project as well. In addition, for the past twenty two years, Steve has been a business presentation producer and consultant. His company, iMAG Live! produces many live events across the west coast each year. Steve and his wife, Linda reside in Clovis, California.

W. J. (Joe) Conway Jr.

Joe is a 37-year resident of Fresno, a retired United Airline captain and a retired USAF and ANG fighter pilot. He is married, with two married sons and a young grandson, Liam. Joe met Jerry Laval, Jerry's wife Darlene, and their children in 1976, forging a lifelong bond. In early 2004, Elizabeth Laval and Joe discovered a mutual interest in preserving the priceless "Pop" Laval collection and together formed Windows On the Past, LLC to pursue that goal.

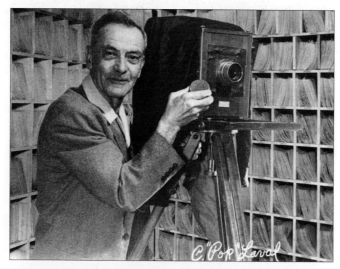

Proceeds from the sale of this book benefit the restoration project of the Claude C. "Pop" Laval Photographic Collection. The goal of Windows on the Past is to ensure that future generations can enjoy seeing the Valley as "Pop" saw it.